TURNER

TURNER

Michael Lloyd

Editor

NATIONAL GALLERY OF AUSTRALIA

TURNER

An exhibition organised by
Michael Lloyd, Evelyn Joll and Lyn Conybeare

made possible by

QANTAS

HOLDEN

Edited, designed and produced by the Publications Department
of the National Gallery of Australia, Canberra.
Designed by Kirsty Morrison.
Edited by Pauline Green.
Colour separations by Pep Colour.
Proudly printed in Australia by Inprint Ltd.

Cataloguing-in-Publication data
Turner, J.M.W. (Joseph Mallord William), 1775–1851.
Turner.
ISBN 0 642 13047 7.
1. Turner, J.M.W. (Joseph Mallord William), 1775–1851 —
Exhibitions. I. Lloyd, Michael, 1950–. II. National Gallery
of Australia. III. Title.
759.2

Distributed by:
Thames and Hudson (Australia) Pty Ltd,
11 Central Boulevarde, Portside Business Park,
Port Melbourne, Victoria 3207, Australia.

Thames and Hudson Ltd,
30–34 Bloomsbury Street, London WC1B 3QP, UK

Thames and Hudson Inc.,
500 Fifth Avenue, New York, NY 10110, USA.

ISBN in USA 0-500-97437-3
Library of Congress 95–61908

This catalogue is published on the occasion of the exhibition
TURNER held at the National Gallery of Australia, Canberra,
16 March – 10 June 1996;
and the National Gallery of Victoria, Melbourne,
27 June – 10 September 1996.

Front cover:
The Burning of the Houses of Lords and Commons, 16th October, 1834 1835
Philadelphia Museum of Art John Howard McFadden Collection (cat. no. 19)

Back cover:
The Burning of the Houses of Lords and Commons, October 16, 1834 R.A. 1835
Cleveland Museum of Art Bequest of John L. Severance (cat. no. 20)

Contents

Directors' Foreword

J.M.W. Turner painted some of the most exciting and best-loved images in all Western art. Yet this is the first major exhibition of Turner's oils and watercolours to be held in Australia; it comes three decades after the only other exhibition in Australia of his oil paintings, and a decade after the last major exhibition here of his watercolours. The remarkably enthusiastic response to our proposal to assemble a new exhibition of Turner's work has reinforced our belief that he continues to occupy a special place in people's affections. It seems timely therefore to look at Turner again.

During the last ten years a number of marvellous exhibitions in this country have focused on the great masters of French Impressionism. Perhaps this has placed undue emphasis on France's contribution to landscape painting — an odd situation, particularly in Australia where the origins of our landscape tradition belong more to Turner and a generation of English artists that includes our own John Glover, who knew the master sufficiently well to suggest a joint exhibition.

Assembling a great exhibition of Turner's works is no easy task: the oil paintings especially are often fragile and therefore require the specialist attention of conservators to ensure their successful transportation; furthermore, these works invariably occupy central positions of display in their home museums throughout the world. That this exhibition has managed to secure the loan of so many of Turner's prime paintings in oil and watercolour is a tribute to the professional skills of the exhibition's initiator and curator, Michael Lloyd. Michael has headed an outstanding team: eminent Turner scholar, Evelyn Joll, has been our London-based adviser, and Lyn Conybeare has coordinated from Canberra the many logistical complexities of the exhibition. Notwithstanding the impact of the 1960 exhibition on artists and public alike, this is by far the most significant exhibition of Turner's works ever to come to Australia. It represents the latest in a series of fruitful collaborations between our two institutions — it is particularly appropriate in this instance in view of the significant Turner holdings in the National Gallery of Victoria.

The costs involved in an exhibition of this scale and ambition are formidable. From the outset, it was clear that the exhibition could be realised only with the support of major sponsors. In Holden, Qantas and The Seven Network we have found an ideal partnership without whose generous support this exhibition would not have been possible. Of equal importance in bringing exhibitions of this value to Australia is the generous assistance of the Australian Government Indemnity program; we gratefully acknowledge the support of this scheme.

Turner is remarkable among great artists in engendering fondness as well as admiration. Our final salute belongs to the artist.

Betty Churcher
Director,
National Gallery of Australia

Timothy Potts
Director,
National Gallery of Victoria

Sponsors of the Exhibition: In Appreciation

I am delighted that three major Australian companies have agreed to unite with the National Gallery of Australia to bring to our country this spectacular exhibition of paintings by one of England's most important artists.

J.M.W. Turner led the way in developing modern European art, harnessing the dynamics of his own time and place — England of the Industrial Revolution — as his inspiration and subject matter.

Our three sponsors also represent the forefront of innovation and vision: in the Australian automobile industry, air transport, and telecommunications.

Holden is making its debut in art sponsorship with this exhibition; I know the company is proud to assist an exhibition which will be a source of such interest and enjoyment to all Australians. It also seems appropriate to link the name of Holden with an artist who was a spectacular success in his own time, and whose influence has never waned. Turner's ability to seize what was topical and innovative can capture today's imagination as dramatically as it did in the early nineteenth century. His resourceful creativity could almost be seen to be Holden's credo, as such creativity, after all, is the story of the Holden car in Australia.

Qantas has a long and happy association with the National Gallery of Australia. For many years the airline has carried priceless works of art to the Gallery from all parts of the world, and, with equal care and attention to detail, it has transported the scholars, curators, and art museum personnel associated with our very successful exhibitions. It is fitting therefore that we share the success of this great exhibition with Qantas.

This is not the first time that The Seven Network has supported a major cultural event. As is the case with The Seven Network's programs, we believe that all Australians should have the opportunity to see the best local and overseas product. We are delighted that the exhibition will parallel the programming strategy of The Seven Network in that it will please, excite and inspire all who come to see it — and the memory of the exhibition will remain long after the paintings have been returned to the many art galleries and private collectors who have generously lent their prized possessions.

The many thousands of Australians who will see this exhibition in their National Capital and in Melbourne will share with me our great appreciation for the efforts of our three major sponsors in helping to bring this spectacular exhibition to Australia and for their continued support of cultural events; a support that is central to the success of such ambitious and rewarding undertakings.

Betty Churcher
Director, National Gallery of Australia

Acknowledgements

The exhibition that occasioned the publication of this catalogue would not have been possible without the extraordinary generosity of museums and private collectors who agreed to lend their cherished works. A list of lenders follows, but on behalf of the National Gallery of Australia, Canberra, and the National Gallery of Victoria, Melbourne, I would like to take this opportunity to thank especially those who encouraged this exhibition from the outset and, by their early commitment to lend, transformed our enthusiasm into a reality; in particular, Nicholas Serota, Director, and the Trustees of the Tate Gallery, London; Neil MacGregor, Director, and the Trustees of the National Gallery, London; Duncan Robinson, first as Director of the Yale Center for British Art, New Haven, and more recently as Director of the Fitzwilliam Museum of Art, Cambridge; and Richard Feigen.

I owe a special debt of gratitude to those friends, colleagues, and scholars, some of whom have contributed essays to this catalogue, all of whom sharpened my understanding and appreciation of Turner: Rachel Adler, Julian Agnew, David Blayney Brown, Roger Butler, Alan Chong, Betty Churcher, Stephen Coppel, Judy Cotton, Sonia Dean, Judy Egerton, Rene Free, John Gage, John Golding, Ted Gott, Margot Heller, Franklin Kelly, Yale Kneeland, Martin Krause, Ellen Lee, Larry Nichols, Patrick Noon, Ian North, Margaret Plant, Ron Radford, Joe Rishel, Andrew Sayers, Janet Skidmore, Nicholas Turner, Bret Waller, Ian Warrell, Andrew Wilton, and Irena Zdanowicz.

Carrying through an exhibition of this scale involves the entire institution, and my colleagues in every area of the National Gallery of Australia have been unfailingly helpful and have contributed their expertise to the betterment of the final result. I would particularly like to thank the following: Betty Churcher, Director, Jan Meek and Elizabeth Malone; Geoffrey Major and Susan Bioletti (Conservation); Ron Ramsey, Peter Naumann, Jenny Manning, David Sequeira and Roy Forward (Education, Public Programs); Renfred Pryor, Jos Jensen, Harijs Piekalns (Exhibitions); Lydia Ronnenkamp and Barbara Reinstadler (Finance); Sylvia Jordan (Membership); Bruce Moore (Photographic Services); Inge Rumble and Helen Power (Public Affairs); an especially big thanks to Kirsty Morrison, Pauline Green and Theresa Willsteed (Publications); John Payne (Reception); Helen Young (Records Management Unit); Warwick Reeder, Maxine Esau and Michelle McMartin (Registration); Mark Nash and Sandra Williams (Security); Vivienne Dorsey (Travel); and Kay Watts. In particular I thank Margaret Shaw, Chief Librarian, the staff of the National Gallery of Australia Research Library, and Michael Watson, Art Reference Library, National Gallery of Victoria, for their enthusiasm and expertise in facilitating research for the exhibition and this publication.

Finally, I would like to thank my co-curators in this exhibition, Evelyn Joll and Lyn Conybeare. Without their knowledge and hard work, indomitable spirits and good humour, this exhibition would never have happened.

Michael Lloyd

Lenders to the Exhibition

Australia
Art Gallery of South Australia, Adelaide
Ron Radford, Director

National Gallery of Victoria, Melbourne
Timothy Potts, Director
Sonia Dean, Senior Curator of International and European Art
Irena Zdanowicz, Senior Curator of Prints and Drawings

Art Gallery of New South Wales, Sydney
Edmund Capon, Director
Rene Free, Senior Curator of European Art

Canada
National Gallery of Canada, Ottawa
Shirley L. Thomson, Director
Kate Laing, Head, Art Loans and Exhibitions

France
Musée du Louvre, Paris
Pierre Rosenberg, Director
Jean-Pierre Cuzin, Conservateur Général du Patrimoine,
Chargé du Département des Peintures
Olivier Mesley, Conservateur au Département des Peintures

Great Britain
City of Aberdeen Art Gallery and Museums Collection
Alexander Hidalgo, Head of Arts and Museums Services
Lindsay Errington, Keeper of Fine Art

The Trustees of the Holburne Museum
and Crafts Study Centre, Bath
Barley Roscoe, Curator
Barbara Milner, Assistant Curator, Fine Art

The Trustees, The Cecil Higgins Art Gallery, Bedford
Lady Halina Graham, Curator
Caroline Bacon, Assistant Keeper

Blackburn Museum and Art Gallery
Adrian Lewis, Head of Arts Services

Bury Art Gallery and Museum, Lancashire
Richard Burns, Curator

The Fitzwilliam Museum, Cambridge
Simon Jervis, former Director
Duncan Robinson, Director
David Scrase, Keeper, Department of Paintings,
Drawings and Prints

National Museum and Gallery of Wales, Cardiff
Colin Ford, Director
David Alston, Keeper of Art

Glasgow Museums: Art Gallery and Museum, Kelvingrove
Julian Spalding, Director
Jean Walsh, Curator, British Art, Department of Art

University Art Gallery, Liverpool
Janice Carpenter, Curator, Art Collections

Trustees of the British Museum, London
Robert G.W. Anderson, Director
Antony V. Griffiths, Keeper, Department of Prints and Drawings
Stephen Coppel, Assistant Keeper, Department of Prints
and Drawings

College Art Collections, University College, London
Derek Roberts, Provost
Nicola Kalinsky, Curator of the College Art Collections

Abbreviations

BJ Martin Butlin and Evelyn Joll, *The Paintings of J.M.W. Turner*, revised edition, New Haven and London: Yale University Press, 1984, 2 vols.

D Tate Gallery accession number for works on paper in the Turner Bequest.

F Alexander J. Finberg, *The History of Turner's Liber Studorium, with a new catalogue raisonné*, London: Ernest Benn, 1924.

R William George Rawlinson, *The Engraved Work of J.M.W. Turner, R.A.*, London: Macmillan and Co., 1908–13, 2 vols.

TB The number assigned to works on paper in the Turner Bequest by Alexander J. Finberg in *A Complete Inventory of the Drawings of the Turner Bequest, with which are included the Twenty-three Drawings bequeathed by Mr Henry Vaughan arranged chronologically*, London: HMSO, 1909, 2 vols.

W Andrew Wilton, *The Life and Work of J.M.W. Turner* (with a catalogue of watercolours outside the Turner Bequest), London: Academy Editions, 1979.

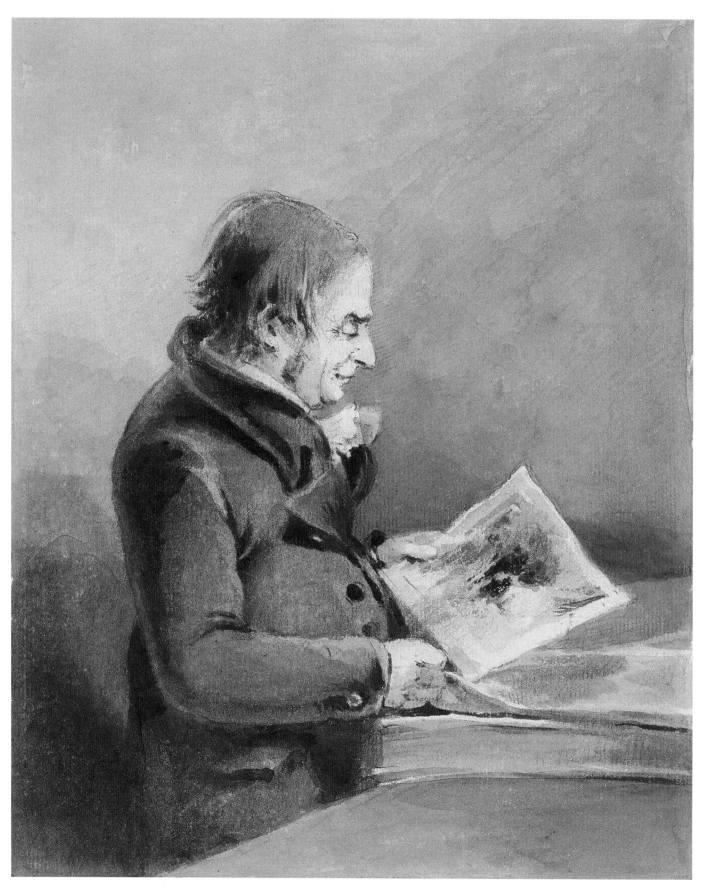

John Thomas Smith 1766-1833 *Turner in the Print Room of the British Museum* late 1820s watercolour and pencil 22.2 x 18.2 cm (8-3/4 x 7-1/4") British Museum, London

Past and Present:
Turner and his Brother Artists

Andrew Wilton

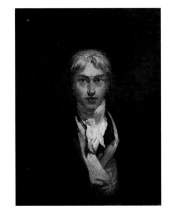

Self-portrait *c.*1798
oil on canvas
74.5 x 58.5 cm (29-1/4 x 23")
Tate Gallery, London
Bequeathed by the artist, 1856 (BJ 25)

Among the provisions in Turner's complicated and oft-redrafted will was a stipulation that 'whatever sums of money may be standing in my name in the three percent, Consols Bank of England' should be used to build 'a Gallery to hold my Pictures' and a 'Charitable Institution' for the 'Maintenance and Support of Poor and Decayed Male Artists being born in England ...'

When he died in 1851, his family contested the will, and that provision, along with all the others Turner had made, was overturned. By a ruling of the Court of Chancery, his considerable fortune went to various not very close cousins — in contravention of his wishes — and all his paintings and drawings became the property of the nation. The National Gallery, London, was then in a position to install the single room of pictures — the 'Turner's Gallery' — that he had asked for in a later modification of his bequest, but the philanthropic scheme providing almshouses for indigent artists was no longer possible.[1] With that Chancery ruling, Turner's dearest wishes were flouted. His family had never meant much to him, and he allocated only small legacies to the two women in his life, neither of whom ever became his wife. On the other hand, his brother artists were of the greatest importance to him. They were brothers in a more than purely professional sense — sharers in a great inheritance that had come down to them from the Italian Renaissance: the inheritance of European art.

The institution that embodied this tradition — the mother of the family to which Turner really felt he belonged — was the Academy. The Royal Academy in London was of recent growth compared with the great academies of Europe; it had been founded in 1768 under the presidency of Sir Joshua Reynolds, and Turner joined its Schools as a boy of fourteen in 1789. His allegiance to the Academy and to Reynolds was enduring. He first sent a work to its annual spring exhibition in 1790, and continued to show there until the penultimate year of his long and productive life. Precocious as it was, that first submission, a topographical watercolour, was modest enough. But it betrayed the ambitions of the artist. He was keen to emulate, if not to surpass the most distinguished models to hand. The work in question was a view of *The Archbishop's Palace, Lambeth* (illus. p. 14) which, as any youthful essay is likely to be, was modelled on the style of an eminent contemporary. In this case Turner had in mind the topographical views of Edward Dayes, and succeeded in mastering his manner quite convincingly. This is no formal 'antiquarian view', but a lively composition in which a picturesque clutter of vernacular buildings has as much importance as the palace gateway that is the ostensible subject. A judicious selection of figures indicates types of humanity characteristic of the place, which is evoked in all its variety, both architectural and human, with careful and humorous observation.

All these features were typical of the most intelligent topographical painting of the time. It is significant that Turner so quickly and unerringly recognised and mastered them. Each was to remain important in his work, despite the great changes that it would undergo. Most important, the perception that places are inseparable from the people who inhabit them was to become the driving force in his art.

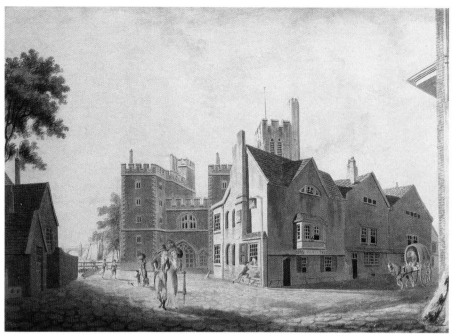

Architecture is meaningful only as product and determinant of human thought and experience; nature supplies the unavoidable conditions in which we live our lives. But Turner had no intention of confining himself to topography. That same year he was among the audience at the last address delivered by Reynolds to the students of the Academy's Schools. Knowing that he would never speak to that audience again, Reynolds delivered himself of a self-consciously grand peroration, recapitulating the lessons of his entire life's teaching and practice.

The artist, he laid down, should hold before him the highest goals, and follow the most outstanding examples — that is to say, the acknowledged giants of European painting. In particular, Reynolds recommended the 'Style of Michael Angelo, which I have compared to language, and which may, poetically speaking, be called the language of the Gods'.[2] He devoted the rest of this Discourse to a panegyric upon Michelangelo, 'that truly divine man', and congratulated himself on 'knowing myself capable of such sensations as he intended to excite'.[3] Later in his life, when Turner too came to lecture the Royal Academy students, he recalled that last address, and spoke in his turn of Reynolds, 'whose Discourses must be yet warm in many a recollection',[4] with the reverence of a profound admirer.

Reynolds's literally religious awe in the presence of the great artists of the past was an essential element of the intellectual climate in which Turner grew up. Michelangelo was far from being the only master that he recommended for close study. Raphael, Titian and Veronese, the Bolognese school, Rubens, van Dyck and Rembrandt, Poussin, Claude and Salvator Rosa, all illustrated excellences that the ambitious student should emulate.[5]

Turner took Reynolds's lesson well and truly to heart. In a memoir of Turner written just after his death, George Jones, a longstanding friend and colleague, recounted:

> When Turner was a very young man he went to see [Sir John Julius] Angerstein's pictures. Angerstein came into the room while the young painter was looking at the Sea Port by Claude, and spoke to him. Turner was awkward, agitated, and burst into tears. Angerstein enquired the cause and pressed for an answer, when Turner said passionately, 'Because I shall never be able to paint anything like that picture'.[6]

The fact that, at his death, he bequeathed two of his own canvases to hang beside works by Claude in the National Gallery shows that in the course of his career he satisfied himself that he could, after all, meet Claude's challenge.[7] But we may still be surprised by the emotional intensity of his sense of rivalry, which is only partly explained by Reynolds's teaching. It is due in great part to Turner's own personality. He had been persuaded that the works of Claude and the other old masters held the ultimate secret of greatness. He also knew that he was destined to become one of their number.

His career was dedicated to demonstrating that contention. Nothing that he did, from the slightest sketch from nature to the most adventurous experiment in expressive paint, can be entirely divorced from

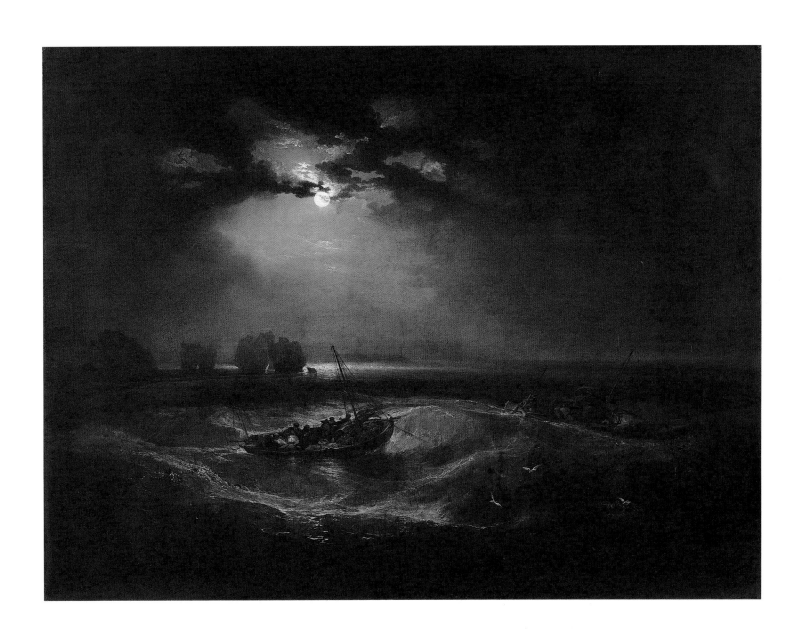

Fishermen at Sea R.A. 1796 oil on canvas The Tate Gallery, London (cat. no. 1)

the overarching influence of the old masters. On his first visit to France in 1802, he filled a notebook with copies of pictures in the Louvre,[8] and with perceptive annotations that provide us with evidence enough that he was a penetrating analyst of the painted surface, deeply appreciative too of the aesthetic and emotional power of a wide range of artistic personalities. His account of Titian's *Death of St Peter Martyr* (destroyed) is rhapsodic:

> This picture is an instance of his great power as to conception and sublimity of intelect [sic] — the characters are finely contrived, the composition is beyond all system, the landscape tho natural is heroic, the figure wonderfully expressive of surprise and its concomitate [sic] fear. The sanguinary assassin striding over the prostrate martyr who with uplifted arms exult in being acknowledged by heaven ...[9]

This passage can be taken as an indication not only of what he saw in Titian, but of what he aimed at in his own work of the first decade of the nineteenth century, which often speaks Titian's language. What particularly interested him was the 'natural' yet 'heroic' landscape, and 'the historical colour which moderates sublimity ... where the subject and *Nature* must accord ...'

In this preoccupation with the grandeur of the natural world, Turner was at one with the teaching of Reynolds and with those more theoretical eighteenth-century aestheticians who proclaimed the human implications of the Sublime as a stimulus to the most exalted states of contemplation. They began by singling out exemplary elements of human endeavour — great historical events, noble deeds, epic literature — as Sublime, but in the eighteenth century nature also began to be seen as yielding similar qualities. 'Picturesque tours' involving places far too wild to be attractive to any previous generation — to the Lake District, to Snowdonia, even down coal mines — suddenly became the fashion, and a growing middle class joined the aristocracy and gentry on rambles along upland paths or beside tumbling torrents. A whole literature sprang up to cater for the new market, explaining, with much assumed pedantry, what should and should not be admired. The paradigm of the picture was invoked — hence 'picturesque' — as a means of determining criteria for the judgement of natural effects. The artists whose work was most frequently cited for this purpose were Claude, Poussin (that is, usually Gaspard Dughet, known as Poussin, though his brother-in-law and teacher the great Nicolas Poussin was also referred to) and Salvator Rosa. Since the parallel between painting and poetry as 'sister arts' had also become a popular idea — not to mention the need for illustrations to the new guide books — the depiction of mountains and waterfalls now became a commonplace. Not only was this the language any serious and high-minded landscape painter must speak, there was a substantial market for such images.[10]

Turner was as conscious of the commercial side of art as he was of the greater glory. He quickly developed technical resources with which he could give expression to the new view of nature in ways not previously realised. First in watercolour and later in oil, he performed evocative miracles that astonished his colleagues and the public. One commentator pointed out in 1799 that the watercolours he exhibited that year had 'a depth and force of tone, which I had never before conceived attainable with such untoward implements'. This would have pleased the artist, for Turner was particularly concerned to increase the expressive repertory of a medium he regarded as peculiarly his own, and which was seen as the poor sister of oil painting. The reviewer went on: 'Turner's views are not mere ordinary transcripts of nature: he always throws some peculiar and striking *character* into the scene he represents.'[11]

The watercolours of 1799 perfectly illustrate his aims. One was a view of Caernarvon Castle at sunset (private collection; W 254) clearly suggesting the impact of Claude's *Seaport with the Embarkation of the Queen of Sheba* (illus. p. 20) that he had seen at Angerstein's in the same year. That a topographical view should have been treated so grandly was something; that it was executed in watercolour was astonishing. It embodies another important point. The echo of an admired old master was central to Turner's intention;

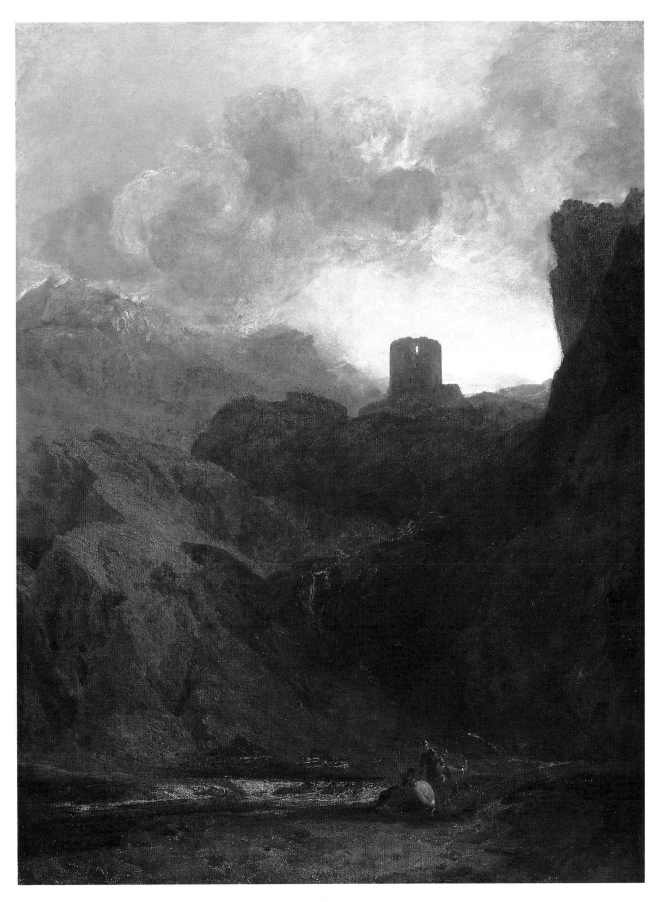

Dolbadern Castle, North Wales R.A. 1800 oil on canvas Royal Academy of Arts, London (cat. no. 5)

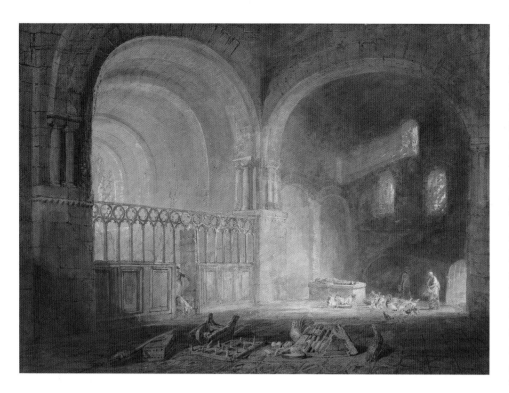

Transept of Ewenny Priory, Glamorganshire R.A. 1797
watercolour and pencil with scratching out
40.0 x 55.9 cm (15-3/4 x 22")
National Museum and Gallery of Wales, Cardiff (W 227)

but at the same time the picture alluded to a more recent painter whom Turner also revered, the Welshman Richard Wilson. Wilson had painted Caernarvon from much the same viewpoint, and had indeed created a substantial body of works presenting Welsh scenery in the grandiose language of Claude. He had also produced the definitive British statement of the classic power of landscape to embody and express human emotion. This was the *Destruction of the Children of Niobe,* 1760, (Yale Center for British Art, New Haven), which was essentially a paraphrase of Poussin on an epic scale: lightning and thunderclouds, lashing waves and bending trees create a symphony of sympathetic lament for the fate of Niobe's children, slaughtered by Apollo and Diana to punish her for her pride. Wilson was the modern British master who most convincingly demonstrated the continuity of the European tradition into Turner's own country and period.

Niobe was an oil painting, and Turner's dependence on Wilson is disguised in the Caernarvon watercolour: it is more apparent in the pictures he was sending to the Academy at the same time. An instance is the canvas of *Dolbadern Castle* (illus. p. 17) that he presented as his Diploma piece on becoming a full member of the Royal Academy in 1802. The handling of the richly applied, sombre pigment is evidently derived from Wilson's technique, while the grandiose scale of the composition, with its monumental wall of rock thrusting the ruined tower of the castle up against the dramatic sky, owes much to the 'savage' style of Salvator Rosa, though characteristically Salvator's influence is absorbed through another contemporary of Turner's, Philip James de Loutherbourg. De Loutherbourg worked in watercolour as well as in oil, and Turner had already, at the early age of seventeen or eighteen, executed a number of romantic landscape scenes in his style.[12] His manner of handling oil paint, however, was very different from that of Wilson. Trained in France (he came originally from Alsace), he had evolved a very Continental smoothness of finish, the product of intensive training at the hands of established artists like Carle van Loo, rector of the Académie Royale. That elegance of finish Turner had imitated in his earliest exhibited oil painting, the remarkable *Fishermen at Sea* (illus. p. 15), which appeared in 1796. This was a night scene and may well have been a homage to another French painter, Claude-Joseph Vernet, whose coastal subjects in the tradition of Claude were among the most celebrated of eighteenth-century landscapes.

But Turner's fascination with effects of twilight or darkness went deeper than a response to an esteemed older contemporary. Once again, the crucial stimulus came from a true old master — Rembrandt. Rembrandt, like Claude, was extensively collected by the English aristocracy and gentry in the eighteenth century, and Turner had plenty of opportunities to study his work.[13] A very early watercolour, showing children in a cottage interior and dating from about 1790 (Tate Gallery, London; TB XVII-L), already pushes the medium to an extreme in its determination to express dark shadows, firelight and moonlight in one composition. The immediate inspiration here may have been the rustic genre subject matter of a contemporary like William Redmore Bigg, who had exhibited

a cottage scene, for example, at the Academy in 1789. But Rembrandt supplied the ultimate sanction for such effects of strong chiaroscuro in low-life subjects, and in the ensuing decade several works show Turner developing this aspect of his art. An important patron of these years, Sir Richard Colt Hoare, of Stourhead in Wiltshire, brought him into contact with the paintings of Rembrandt and, simultaneously, with another 'modern' exponent of Rembrandtian ideas, Piranesi.[14] The looming vastness of the ruined monuments of antiquity surviving in modern Rome are recorded by Piranesi in his masterly etchings with an impressive power that brings them firmly into the orbit of the Sublime. Turner adapted that lesson to his own exercises in antiquarian grandeur undreamed of by most watercolourists. The view of the *Transept of Ewenny Priory, Glamorganshire* (illus. p. 18), that he showed at the Academy in 1797, combines the sonorous tonal harmonies of Rembrandt with Piranesi's monumental architecture, and was to provide a pattern to which Turner would revert many years later when he was experimenting with Rembrandtian themes in the 1830s.

Turner's study of Rembrandt may also have affected his handling of oil paint in the 1790s. He certainly did not repeat the polished surfaces of *Fishermen at Sea* in any other pictures of that decade; a rougher, more expressive touch with rich impasto was more to his purpose in these years. Even in the watercolours there are attempts to imitate that texture: the studies of Dunstanborough Castle in this exhibition (illus. pp. 38,39) show him exploring the interrelation of paper and pigment in vigorous new ways. Later, he revived the sophistication of the smooth Continental manner of painting, usually when imitating other Continental artists, notably in his greatest salute to the Claudian harbour subject, *Dido building Carthage: or the Rise of the Carthaginian Empire* of 1815 (illus. p. 21), and his equally splendid homage to Cuyp, the *Dort, or Dordrecht, the Dort Packet-Boat from Rotterdam becalmed* of 1817 (Yale Center for British Art, New Haven; BJ 137). But it was his aim now, when his reputation was still to be established, to paint with an energy and directness that brought his dramatic subjects vividly home to the viewer. In the great Sublime works of his early career, the freedom of Turner's handling matches their turbulent effects. A small canvas of 1810 which shows the *The Fall of an Avalanche in the Grisons* (illus. p. 22) was noticed by a critic as being 'not in his usual style'. Sizeable areas of paint are almost devoid of articulation, yet applied with an energy and breadth that perfectly convey the immensity and violence of the natural phenomenon they depict. Broad sweeps of stormy colour are placed in immediate juxtaposition to the most delicate detail: the swaying branches of the uprooted fir trees, even a terrified cat on the roof of the cottage about to be crushed by a flying rock.

For all its novelty of handling, the *Avalanche* equally illustrates Turner's habit of looking back into the past in order to comment on the present. He seems to have had in mind a passage of verse from a classic poem of the early eighteenth century, from James Thomson's *The Seasons* (1726–30), which he was fond of quoting. He did not actually cite Thomson's *Winter* in the exhibition catalogue, but composed his own verses in Thomsonian style. There are many hundreds of draft lines of poetry in Turner's sketchbooks; their subject matter ranges from pastoral lyrics to epic mythological descriptions and topographical 'tours'. They often illustrate his feeling for natural phenomena, and show him attempting to express that feeling in a medium very different from paint. The *Avalanche in the Grisons* prompted this description:

> The downward sun a parting sadness gleams,
> Portentous lurid thro' the gathering storm;
> Thick drifting snow on snow,
> Till the vast weight bursts thro' the rocky barrier;
> Down at once, its pine clad forests,
> And towering glaciers fall, the work of ages
> Crashing through all! extinction follows,
> And the toil, the hope of man — o'erwhelms.[15]

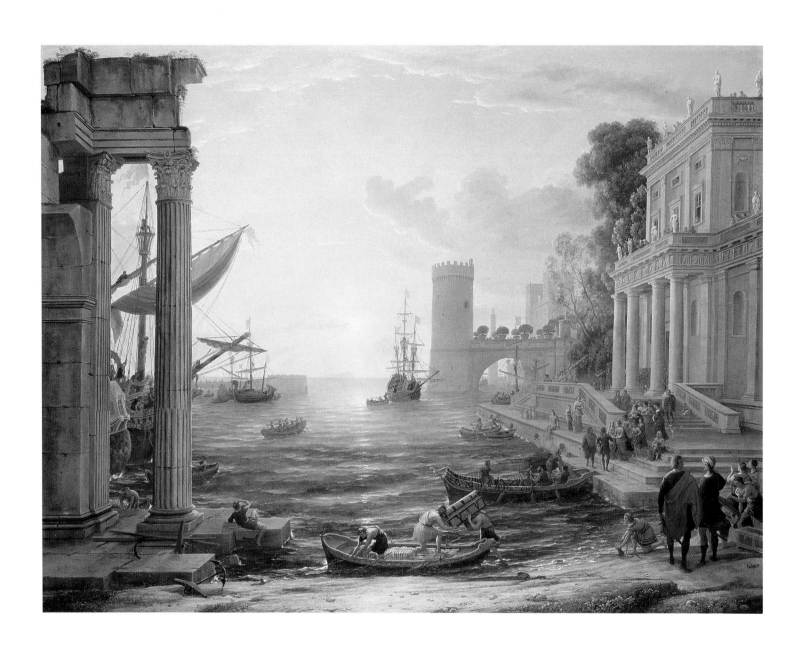

Claude Lorrain 1600-1682 *Seaport with the Embarkation of the Queen of Sheba* 1648 oil on canvas 148.6 x 193.7 cm (58-1/2 x 76-1/4") National Gallery, London

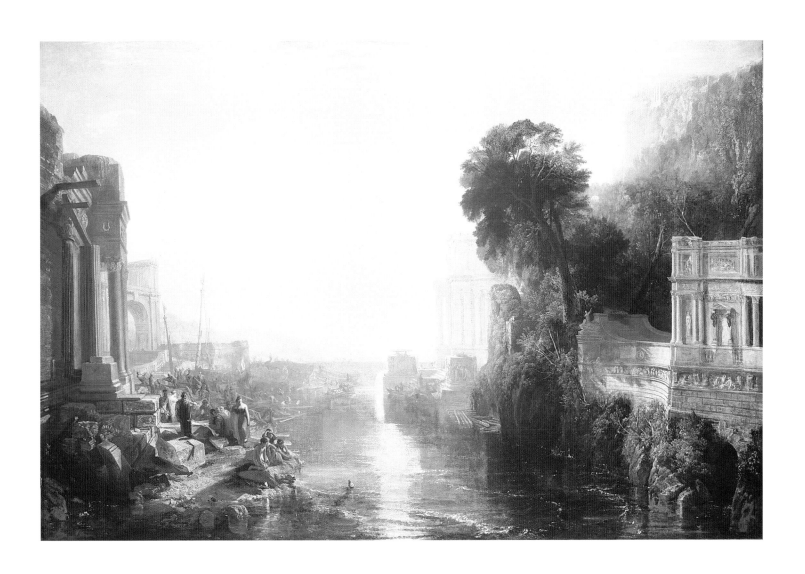

Dido building Carthage: or the Rise of the Carthaginian Empire R.A. 1815 oil on canvas 155.5 x 232.0 cm (61-1/4 x 91-1/4") National Gallery, London Bequeathed by the artist, 1856 (BJ 131)

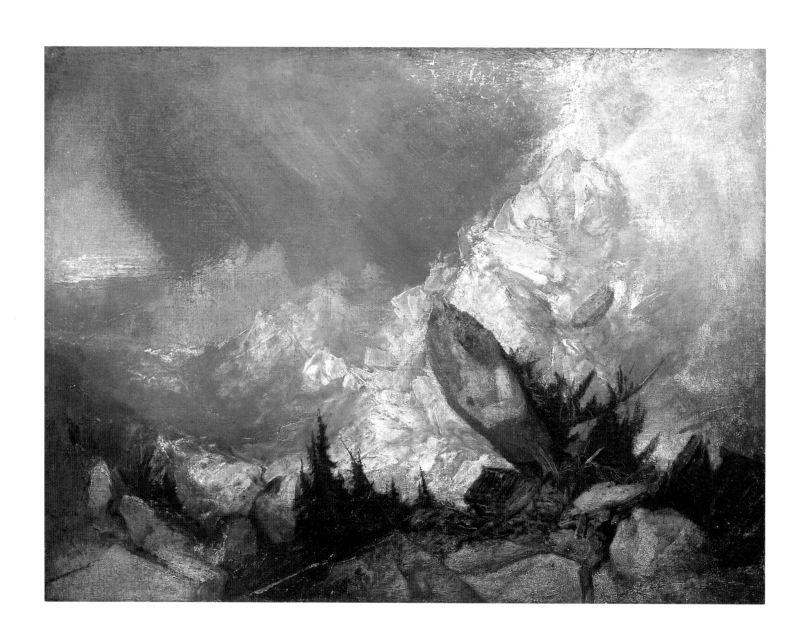

The Fall of an Avalanche in the Grisons 1810 90.0 x 120.0 cm (35-1/2 x 47-1/4") Tate Gallery, London Bequeathed by the artist, 1856 (BJ 109)

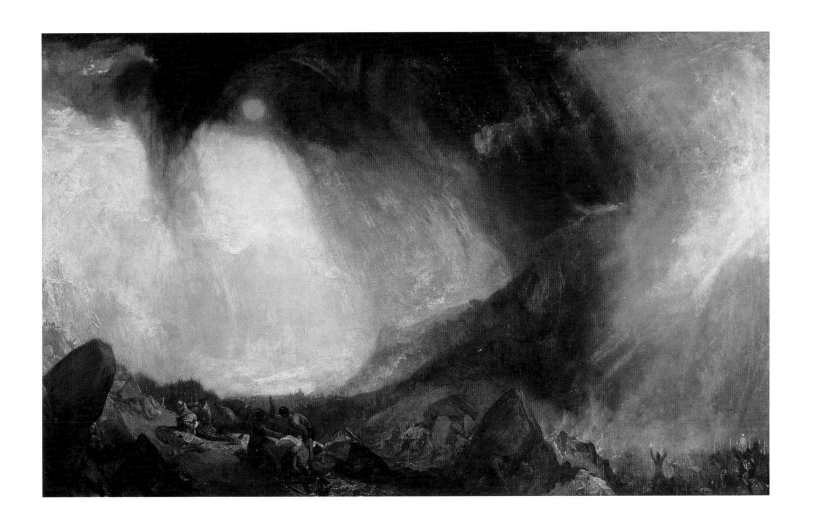

Snow Storm — Hannibal and his Army crossing the Alps R.A. 1812 oil on canvas 146.0 x 237.5 cm (57-1/2 x 93-1/2") Tate Gallery, London Bequeathed by the artist, 1856 (BJ 126)

Yet there was a more immediate and recent prompting for the choice of subject: there had been reports of an avalanche in eastern Switzerland in December of 1808, giving details that Turner has adopted in his picture. The classic poem and the contemporary press-cutting interact in his imagination in a way that parallels and complements the cross-fertilisation of old and modern masters of painting.

A more important case of self-quotation combined with reference to past and present is *Snow Storm — Hannibal and his Army crossing the Alps* (illus. p. 23) of 1812, which was exhibited at the Academy with some verses in the style of James Thomson but ascribed to 'MS.P' (presumably standing for 'manuscript poem'): 'Fallacies of Hope'. This notional poem, from which Turner continued to quote fragments for the rest of his life, supplied him with glosses on numerous subjects. He never acknowledged it as his own work, but it was universally understood that he was the author, and it occasioned many jokes at his expense. Although derivative, it is not always without merit, and often, in conjunction with the pictures, the poetry comes alive and constitutes an important element in the artist's total purpose.

Hannibal puts the startling technical devices of the *Avalanche in the Grisons* to the service of perhaps the grandest of all romantic landscapes. It is the archtypical adaptation of the old masters to new purposes. The self-conscious echoes of both the Poussins that had resonated through Wilson's *Niobe* are transformed in *Hannibal* to create a new dramatic language. Even so, the unruly sweeps of pigment across the turbulent surface of the canvas are prophetic of a new manner — one that was not to come fully into its own until the 1840s. They are again contrasted with highly specific detail: the rape and pillage presented in individual groups in the immediate foreground, the seething progress of the army in the smoky defile beyond. The parallel between Hannibal's march into Italy and Napoleon's invasion of Russia in the year this picture was exhibited has often been noted; just as Turner renewed the aesthetic of the old masters, so he intended his historical landscapes to be observations on the modern world.

Despite the tutelary presence of Poussin and Salvator Rosa in this great work, the astonishing freedom of technique is Turner's own. He is thought of as a unique revolutionary in this respect, but he could not have evolved his expressive language without the conditions prevailing in England at the time. There was no established system of studio training in London, and the Royal Academy was a very new institution. Painters were encouraged by the likes of Reynolds to entertain grand ideas, but they were offered precious little practical guidance in developing a professional technique. It is for this reason that the great moments of British painting have so often been achieved by dint of bold — even rash — experiment. Indeed, painting in a sense was looked on as a branch of the technological sciences which were evolving so rapidly in the white heat of the industrial furnaces of the Midlands and the North. It is only possible to understand the heady flowering of original genius in Britain at this time if the visual arts are seen in the context of the Industrial Revolution. Reynolds himself was a pioneer of technical innovation, and experiment was the stimulus for a generation of great watercolourists — John Robert Cozens, Thomas Girtin, John Sell Cotman, Samuel Palmer and many more. A modern Hannibal, Turner took his place at the head of this army, and provided an example to nearly all of them.[16]

The clash of these principles — reverence for the work of past masters on the one hand and on the other an almost undisciplined experimentalism — was one of the essential prerequisites for the originality that pervaded British painting in the Romantic period. It was of particular significance for Turner, who throughout his life embodied that conflict — the friction between revered past and experimental future constituting the very essence of his inspiration.

The early canvases, with their storms and wrecks and floods, are conceived in the grandest manner, explicitly invoking the old masters. Gradually their huge dimensions shrink to a fairly standard format, about 36 by 48 inches (92.0 x 122.0 cm) — though there are plenty of exceptions, both smaller and larger. Within that format Turner was as experimental as he was in watercolour. He shared the inquiring spirit of his age and investigated every new pigment or painting medium that was introduced, at a time when the artists' colourmen were flooding the market with novelties. We find him adopting the new chrome yellow as soon as it became available in 1814 — a colour he was to appropriate very much as his own — and the equally startling emerald green, which came into use in the 1820s and can be found in many of his paintings and watercolours in the following decades. In his search for ever more vivid and striking effects of light, he thickened his paint for highlights with a dense mixture of mastic and linseed oil, known as megilp, which was popular for much of the early nineteenth century. Unfortunately megilp darkens over time and has left unsightly clouds and smears on some of his later canvases.[17] These, however, are the honourable scars of the romantic battle for new and heightened forms of expression.

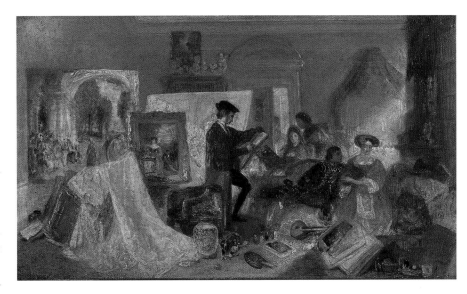

Watteau Study by Fresnoy's Rules
R.A. 1831
oil on panel
40.0 x 69.5 cm (15-3/4 x 27-1/4")
Tate Gallery, London
Bequeathed by the artist, 1856 (BJ 340)

The range of this new language can be seen in the canvases that Turner was exhibiting in the 1830s, when he was around sixty years old. The whole tenor of painting in Britain was undergoing a transformation at this date. The old Sublime ideals had been largely replaced by an aesthetic more congenial to the lively middle class that had begun to prosper after the close of the Napoleonic wars. The high-minded gave way to the middle-brow, and genre subjects — either contemporary, historical or literary — took over from heroic drama. Landscape became an art of personal introspection rather than of public rhetoric, and whimsical fantasy gained ground as a popular alternative to all these. Turner, whose temperament was irreversibly eighteenth-century in its preference for the grandiose and the operatic, nevertheless responded energetically to the new fashions.

As early as 1822 he had painted a small decorative scene based on Shakespeare's *Twelfth Night* that he exhibited with the title, *What You Will!* (private collection, UK; BJ 229), referring to the subtitle of the play and punning on the names not only of Shakespeare but also of Antoine Watteau, whose style it imitates. The fragile, poignant scenes of courtly love that characterise Watteau's paintings were by the 1820s affecting fashionable taste, and many artists were influenced by them, none more so than Turner's fellow Academician, Thomas Stothard. Typical of Stothard's vast and charming output of illustrative work is a series of plates for an edition of Boccaccio that appeared in 1825. These elegant images draw heavily on Watteau, and it is entirely characteristic of Turner that he should have signalled his appreciation of the great French master via this successful contemporary: in 1828 one of his submissions to the Academy's exhibition was *Boccaccio relating the Tale of the Birdcage* (Tate Gallery, London; BJ 244). This is a painting that clearly evokes Stothard and his recent book while at the same time saluting Watteau himself.

Watteau recurs in another picture of this time, *Watteau Study by Fresnoy's Rules*, which shows Watteau in his studio, surrounded by his work, prominent among which is the *Bal Champêtre* that Turner knew from the Dulwich Gallery. Dulwich was among the first public picture galleries in England;

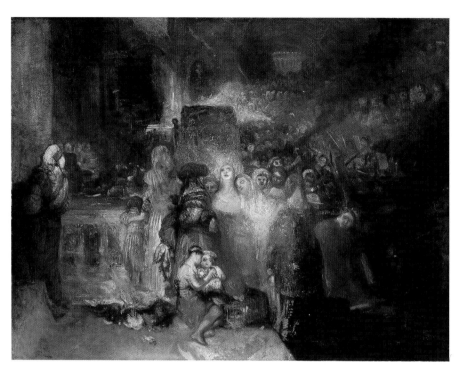

Pilate washing his Hands R.A. 1830
oil on canvas
91.5 x 122.0 cm (36 x 48")
Tate Gallery, London
Bequeathed by the artist, 1856 (BJ 332)

it had opened in 1817 and housed a distinguished collection of old masters that had been assembled for the King of Poland, but, as a result of the Russian invasion of Poland in 1792, had never been delivered. The architect of the gallery was Turner's colleague John Soane, and Turner needless to say knew the collection well. In the *Watteau Study* once again there is a contemporary dimension: the picture is not really a pastiche of Watteau, but is very much in the spirit of a modern painter of historical genre, Charles Robert Leslie, one of the bright new spirits of the younger generation on whom Turner evidently kept a close eye.

Leslie's sentimental scenes from history and literature were painted at least in part with a view to engraving, and these subjects now became particularly popular as plates in the illustrated annuals that blossomed in the late 1820s and 1830s with names like *Keepsake, The Gem*, or *Friendship's Offering*. Turner contributed landscapes to these volumes, which came out at Christmas time each year and epitomise the bourgeois taste of the epoch. At the same period, he was devoting much time and patient labour to the execution of watercolour vignettes, to be engraved as illustrations for volumes of poetry. It was these exquisite miniatures that first attracted the attention of the young John Ruskin and, as he said, 'determined the main tenor of my life'.[18]

The vignettes testify to Turner's wish to be involved with the flourishing business of illustrated book publishing, and he evidently aspired to succeed in other aspects of this new branch of art. In the years around 1830 he began, but rarely finished, numerous canvases that seem to be attempts at anecdotal genre painting. A typical example is the canvas showing *Two Women with a Letter* (Tate Gallery, London; BJ 448), which seems to tell a brief sentimental narrative of rivals in love while beguiling the eye with youthful female charms. This was a recipe favoured by the illustrated annuals. In all these pictures, finished or unfinished, the influence of Rembrandt is to be felt. All are rich-toned, and make use of brilliant new pigments, notably chrome yellow, chrome orange and emerald green.[19] Sometimes a subject is worked up to a high degree of finish, and in a few instances Turner actually exhibited the result — *Pilate washing his Hands* of 1830 is perhaps the most Rembrandtian of all his works, dangerously close to mere pastiche, with swirling crowds in biblical costume and a dramatic partial illumination of shadowy arched spaces that looks back to the interior of Ewenny Priory in Turner's watercolour of 1797.

Yet the impression that *Pilate washing his Hands* apes Rembrandt is misleading. Turner was responding as much to contemporary styles as to the seventeenth-century master. In this case, his model was George Jones, a longstanding friend and colleague who contributed subjects to the annuals, and with whom Turner had a famous 'competition' in 1832 when he set himself to paint the same subject that Jones was submitting to the Royal Academy exhibition. What he did was to produce a deliberate pastiche of Jones's style: *Shadrach, Meshech and Abednego in the Burning Fiery Furnace* (Tate Gallery, London; BJ 346), which has nevertheless always struck commentators, rightly, as Rembrandtian.[20] Despite the clear echoes of the old master, the intention to imitate a modern one is also apparent.

The pull towards the anecdotal, or at least the narrative, can be detected in other paintings of the 1830s. *Juliet and her Nurse* (private collection, Buenos Aires; BJ 365) was one of the pictures in the 1836 Academy exhibition so mauled by critics that the young John Ruskin was goaded into penning his first defence of Turner. Many people were upset that the artist used a sumptuous nocturnal roofscape in Venice as the setting for a scene from Shakespeare's Veronese story; but the splendour of the *mise-en-scène* transcends any petty cavils of that sort. Even so, the sentimental, illustrative element in the subject betrays its origin among the annual-inspired ideas that were flooding Turner's creative channels at the time. Another Venetian subject, this time drawing on *The Merchant of Venice*, is clearly from the same stable. *Scene — A Street in Venice* of 1837, also known as *The Grand Canal, Venice*, which was exhibited with a quotation from the play, presents so complex a crowd of figures that the precise narrative is indecipherable, but its mood of opulent romance, combined with the Shakespearean allusion, makes an unmistakable bid for the illustrated annual market.[21]

It was in the 1830s that Turner adopted Venice as a major recurring theme. The first picture in this new sequence was *Bridge of Sighs, Ducal Palace and*

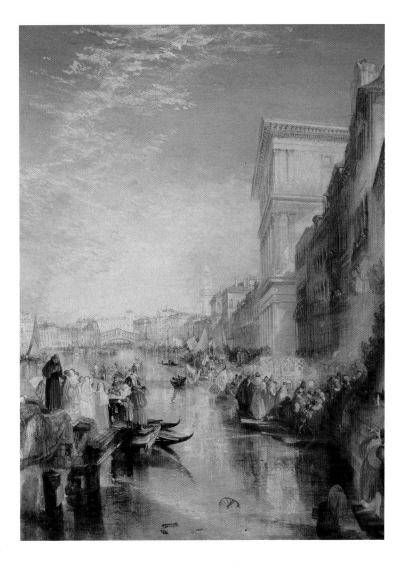

The Grand Canal, Venice R.A. 1837
oil on canvas
148.0 x 110.5 cm (58-1/4 x 43-1/2")
Henry E. Huntington Library
and Art Gallery, San Marino, California
(BJ 368)

Custom-house, Venice: Canaletti painting (illus. p. 152) of 1833. The title itself tells us that Turner's intention here is, at the outset, to acknowledge the great master of Venetian view-painting, Canaletto, and he includes the artist at his easel in the foreground. In addition to these obvious tributes, the whole composition of the picture is effectively a homage to Canaletto, with its brilliant blue sky and crisply delineated buildings. These characteristics can be seen gradually metamorphosed into Turner's own vision of the place as the series proceeds, so that by the mid-1840s, when he was sending two Venetian subjects each year to the Academy, the view had dissolved into golden light.

Even in so clear an acknowledgement of an old master as we have in *Canaletti painting*, Turner approaches his objective through the channel of a contemporary. In this case it was Clarkson Stanfield, whose much larger picture showing the almost identical subject, hanging in the same Academy exhibition, prompted Turner to dash off his own version in a spirit of frank rivalry.[22] We are confronted at every point with the evidence of his determination to tackle as wide a variety of styles and subjects as possible, and to treat the achievement of every new star at the Academy as a challenge. It should be borne in mind that he regarded his younger colleagues as 'brothers in art' no less than those of his own generation. Stories of his discreet helpfulness to fellow exhibitors in difficulties are as common as the tales of his competitiveness. It was all in the family.

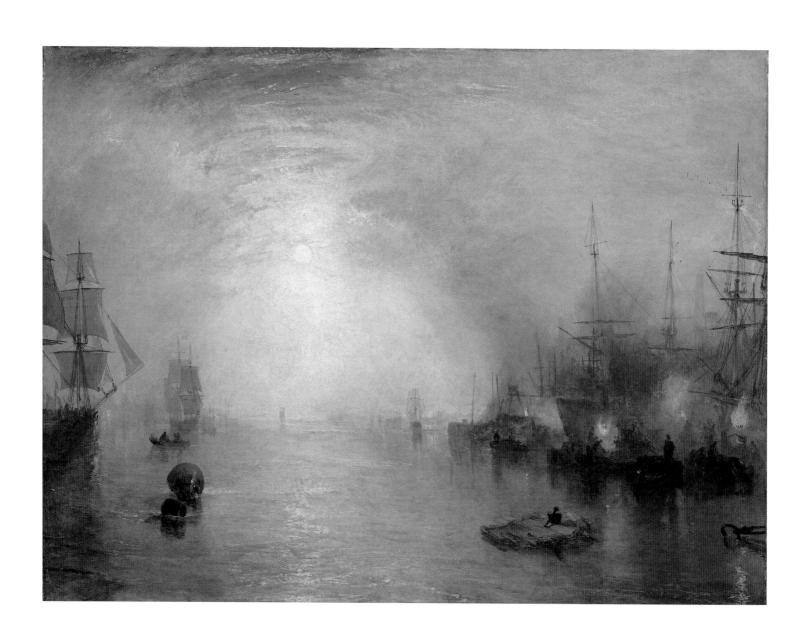

Keelmen heaving in Coals by Moonlight R.A. 1835 oil on canvas National Gallery of Art, Washington DC Widener Collection (cat. no. 18) *detail right*

Shields, on the River Tyne 1823
watercolour
Tate Gallery, London
Bequeathed by the artist, 1856
(cat. no.55)

Turner had not lost the reverence for the old masters that had impelled him to the great achievements of his youth; but he also retained a need for the stimulus of the new. By the 1830s that involved a far greater modification of his natural style than had been required in the first decades of his career. He had recently lost his father (who died in 1829) and several close friends; he was beginning to feel the onset of old age. His almost frantic striving to be avant garde at this crucial moment in his career is quite understandable. But in an important sense it was beside the point. He had within himself his own means of adapting to innovation, and in the greatest canvases of this decade he demonstrated an entirely original ability to weld the nineteenth century on to the eighteenth in a convincing and significant way. A particularly telling indication of the flexibility of his thinking is *Keelmen heaving in Coals by Moonlight* (illus. p. 28) which appeared at the Academy in 1835. Turner's vivid response to a modern industrial scene is placed securely in a historical perspective by his organisation of the subject as though it were a harbour scene by Claude. Coal-black ships replace the palaces, terraces and trees of *Dido building Carthage*; cool silvery moonlight is substituted for the warm sunrise. The continuity of past and present is celebrated by means of art — the long European tradition of painting embodies the evolution of civilisation into a world that, for Turner, was undoubtedly brave and new.

This is surely the message of the two set-pieces of the burning of the Houses of Parliament (illus. pp. 88,89) which appeared at the Royal Academy and the British Institution in 1835.

They illustrate the fertile response of Turner's imagination to a single striking modern event. Compositionally they are quite different ideas, although they both deploy his favourite contrast of warm and cool areas of colour — a motif going back to Vernet and Joseph Wright of Derby, and indeed to Turner's own first exhibited canvas, *Fishermen at Sea*. The heat of the fire reflects off the crowd in the foreground of the version now in the Philadelphia Museum of Art, so that we feel it palpably ourselves. In the second painting of this subject, now in Cleveland, the fire is a majestic flare of light in the distance, a beacon in the night — a symbol of political change. The great Reform Bill had been passed only three years earlier and many people looked on the fire as a divine visitation. We may perhaps also read a personal meaning here: Turner's dear friend and most ardent patron, Walter Fawkes, had died in 1825 after a lifetime spent in campaigning for parliamentary reform. The destruction of the old Houses of Parliament in such a theatrical manner gave Turner the opportunity to celebrate the Reform Bill in a way that he could otherwise never have done; the forces of nature itself came to his aid, enabling him to create a modern historical landscape of the grandest variety. This sense of personal as well as professional excitement may explain why he painted two different interpretations of the subject.[23]

The theatricality of both canvases is unmistakable. It is the sign of Turner's continuing consciousness of the old masters. Their pictorial formulas still prevail, albeit in wonderfully dynamic new guises. They are an integral part of Turner's visual language, projecting his ideas on to a deliberately wide public stage. The swarming crowds who witness the event are the audience at the opera, and at the same time the human cast of the drama. They even create the compositional dynamics that make up the structure of the picture: every surface, ledge and deck is encrusted with humanity, as thick as moss on an apple branch, yet the painting retains its clear architectural definition of volumes, planes and receding perspective. The crowded bridge-parapet or jam-packed steamer provides a clear geometry guiding the eye to the heart of the subject, the fire itself. But the crowds are no mere compositional device. They are the people for whom parliamentary democracy is being created, the immediate beneficiaries of the disaster they watch with such excitement. Turner painted innumerable views of towns and cities; nowhere does he more coherently treat of their human, natural and cultural complexities.

The geometrical precision that emerges even through the smoke of the conflagration is characteristic of Turner's careful planning of his dramas. The Claudian balance, the Poussinesque geometry is nearly always present — even in so 'modern' a work as *Rain, Steam and Speed — The Great Western Railway* (illus. p. 48) of 1844, whose receding perspective can be traced to a Poussin *Landscape with Roman Road* in the Dulwich Gallery.[24] It is only occasionally, and usually in scenes of storm and shipwreck at sea that we find him adopting a different, less orthodox system. In his important early *The Shipwreck* (illus. p. 32) of 1805, a sense of lurching and heaving instability is created very largely by the conscious abandonment of classical structures. Verticals and horizontals are replaced by broken diagonals, and these, combined with the low eye-level (so that we ourselves seem to be wallowing in the water), induce an almost physical sense of terror — precisely the intention of a painter of the Sublime.

Such a disruption of the old-masterly order of Turner's pictorial structures is hardly encountered again in his work.[25] Even so wild a subject as the *Wreckers — Coast of Northumberland, with a Steam Boat assisting a Ship off Shore* of 1834 (illus. p. 45), for instance, retains the distinct horizon and emphatic foreground diagonal that anchor the design firmly in a classical perspective. A watercolour, *The Storm,* that he exhibited in 1823 (British Museum, London; W 508) uses devices similar to those of the 1805 *Shipwreck*. And in the 1840s he frequently had recourse to a circular, or even spinning, compositional type, the famous 'vortex' best exemplified in the two Deluge pictures, *Shade and Darkness — The Evening of the Deluge* and *Light and Colour (Goethe's Theory) — The Morning after the Deluge — Moses writing the Book of Genesis* (whereabouts unknown; BJ 404, 405). But it is only in another snowstorm,

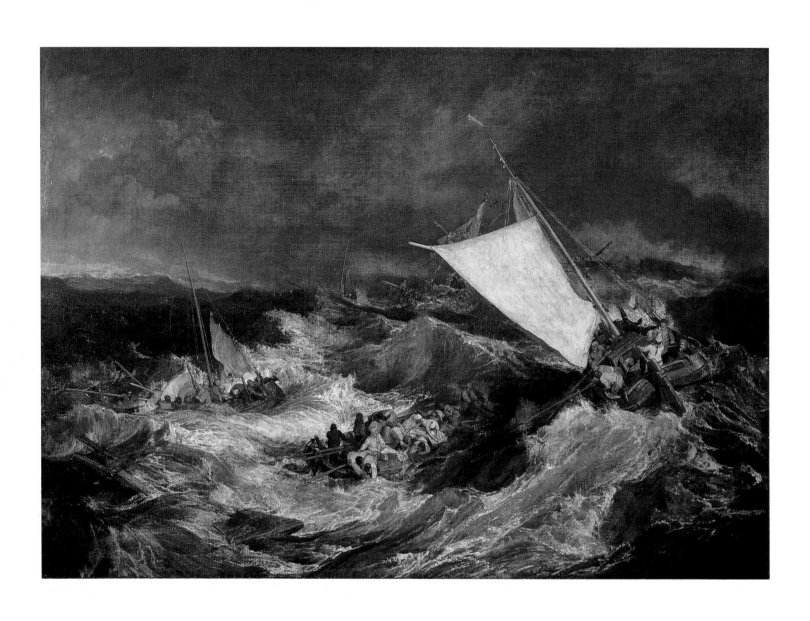

The Shipwreck 1805 oil on canvas 170.5 x 241.5 cm (67 x 95") Tate Gallery, London. Bequeathed by the artist, 1856 (BJ 54)

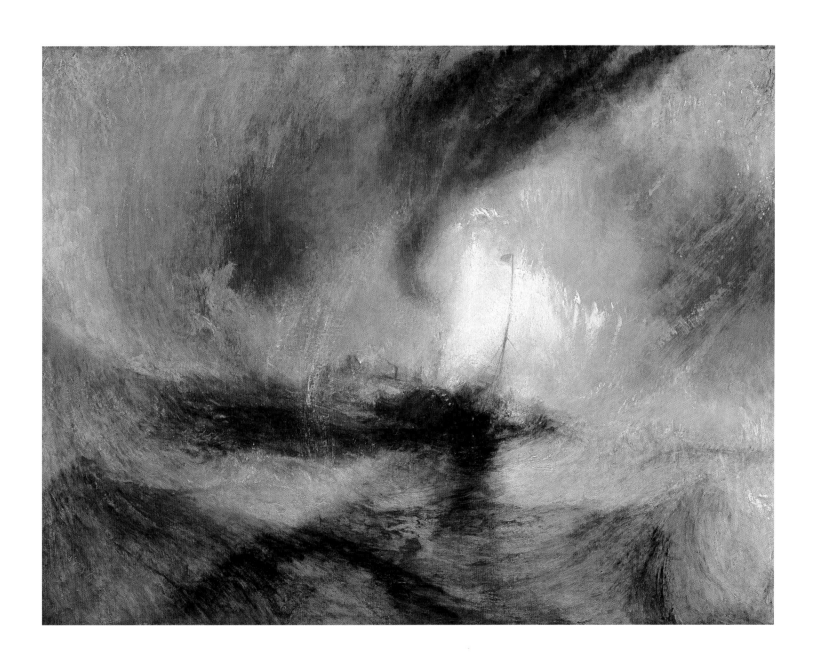

Snowstorn — Steam Boat off a Harbour's Mouth making Signals in Shallow Water, and going by the Lead. The Author was in this Storm on the night the Ariel left Harwich R.A. 1842
oil on canvas Tate Gallery, London Bequeathed by the artist, 1856 (cat. no. 25)

33

Mercury sent to admonish Æneas
R.A. 1850
oil on canvas
90.5 x 121.0 cm (35-1/2 x 47-3/4")
Tate Gallery, London
Bequeathed by the artist, 1856 (BJ 429)

that of the 1842 *Steam Boat off a Harbour's Mouth* (illus. p. 33) that Turner completely eliminates a coherent geometry from his design.

Steam Boat off a Harbour's Mouth marks the climax of Turner's lifelong fascination with the seventeenth-century Dutch marine painters. By his own account, they were among the earliest influences on his art. Of a print after Willem van de Velde the younger showing a ship scudding before the wind, he once said: 'This made me a painter.' His great early canvas of *Calais Pier, with French Poissards preparing for Sea: An English Packet arriving* (National Gallery, London; BJ 48) was a salute not only to the perils of sea travel as he had just experienced it on his first journey across the Channel, but also to the Ruysdaels he had admired in the Louvre.[26] A long series of marines painted in the 1830s and 1840s paid homage to Dutch marine history as well as to Ruysdael and van Goyen, whose names occur in some of the titles just as Canaletto's had done in the 1833 Venice subject. The creamy monochrome palette of these works seems to have been transferred, charged with new significance, to the 1842 *Steam Boat*.

In this canvas, all the lines are broken, tentative, diverging from any horizontal or vertical. The minimal chromatic range — everything is grey or white, or dull bluish and yellowish variants of grey and white — combines with this structure to produce a sense of dislocation, or rather of non-location, of being in a chaotic void. This is precisely what Turner wished to convey: 'I wished to show what a scene was like', he told a friend,[27] and even claimed to have been lashed to the mast to witness the scene. His elaborate title, including the precise nautical activities the ship is engaged in — 'making signals and going by the lead' — the name of the vessel and her port of origin, reinforces the clear intention to be thoroughly realistic: 'true to nature'.

It was this truthfulness that Ruskin found so admirable; though his contemporaries, used to a crisper, more fashionable German style, who dismissed *Steam Boat off a Harbour's Mouth* as 'soap-suds and whitewash',[28] failed to appreciate that phenomena like storms and mist cannot well be expressed with jewel-like precision of technique. Thus it was that in the field of landscape — and, one might add, in the field of modern industry and technology — the British experimental approach to painting found its rightful subject matter, and in Turner its natural master.

The last pictures that he exhibited at the Royal Academy, in 1850, were four subjects from a well-tried source: the story of Dido and Æneas. They are all more or less direct tributes to Claude, but are none the less original for that. In their iridescent bursts of apparently uncontrolled brilliance they look forward to the later work of Renoir, even to the Expressionists. They are the product of a lifetime's passionate observation of the world, and of the way light affects our perception of it. When he bequeathed his pictures to the nation, Turner knew he had achieved more than his old ambition to out-Claude Claude. He had also done more than simply anticipate the future. He had demonstrated that the British school of landscape artists — those professionals for whom he so anxiously wished to provide in their senility — could rival all the schools of Europe. He had justified his place in the noble profession of painters.

Notes

1. For a discussion of Turner's will and its implementation, see A.J. Finberg, *The Life of J.M.W. Turner, R.A.*, 2nd edn rev., London: Oxford University Press, 1961, chap. 30, and Michael Kitson, 'The Debate on the Clore Gallery', *Turner Society News*, 43, February 1987, pp. 8–13.

2. R.R. Wark (ed.), *Sir Joshua Reynolds — Discourses on Art*, New Haven: Yale University Press for the Paul Mellon Center for Studies in British Art, 1975, p. 278.

3. Ibid., p. 282.

4. British Library, Add. MS 464151,C,f.3; see also Maurice Davies, *Turner as Professor: The artist and linear perspective*, London: Tate Gallery, 1992, p. 16.

5. See John Gage, *J.M.W. Turner: 'A Wonderful Range of Mind'*, New Haven: Yale University Press, 1987, pp. 97ff. The whole of Gage's chap. 4 is a discussion of Turner's use of the old masters to which this essay owes much.

6. George Jones, 'Recollections of J.M.W. Turner', in John Gage, (ed.), *Collected Correspondence of J.M.W. Turner, with an Early Diary and a Memoir by George Jones*, Oxford: Clarendon Press, 1980, p. 4.

7. See A.J. Finberg, 1961, p. 330.

8. The *Studies in the Louvre* sketchbook, TB LXXII.

9. Ibid., f.28.

10. See Michael Clarke, *The Tempting Prospect: A social history of English watercolours*, London: British Museum Publications, 1981.

11. A.J. Finberg, 1961, p. 57.

12. See Andrew Wilton, *Turner in Wales*, Llandudno: Mostyn Art Gallery, 1984, p. 10.

13. See Michael Kitson, 'Turner and Rembrandt', *Turner Studies*, 1988, vol. 8, no. 1, pp. 2–19.

14. See John Gage, 'Turner and Stourhead: The making of a classicist?', *Art Quarterly*, 37, 1974, pp. 59–87.

15. For transcripts of much of Turner's verse, see Andrew Wilton and Rosalind Mallord Turner, *Painting and Poetry: Turner's Verse Book and his work of 1804–1812*, London: Tate Gallery, 1990, and Jack Lindsay (ed.), *The Sunset Ship: The poems of J.M.W. Turner*, Lowestoft: Scorpion Press, 1966.

16. A detailed nineteenth-century account of the technical progress of watercolour in the period is to be found in John Lewis Roget, *A History of the 'Old Water-Colour' Society*, 2 vols, London: Longmans, Green and Co., 1891.

17. See Joyce Townsend, *Turner's Painting Techniques*, London: Tate Gallery, 1993, esp. pp. 41,50.

18. Edward Tyas Cook and Alexander Wedderburn (eds), *The Works of John Ruskin*, 39 vols, London: George Allen, 1903–1912, vol. 35, p. 79 (hereafter, Ruskin *Works*); for the illustrative work, see Jan Piggott, *Turner's Vignettes*, London: Tate Gallery, 1993.

19. Joyce Townsend, 1993, pp. 36,43.

20. See Michael Kitson, 'Turner and Rembrandt', 1988, p. 15.

21. See Andrew Wilton, 'The *Keepsake* Convention: *Jessica* and some related pictures', *Turner Studies*, 1989, vol. 9, no. 2, pp. 14–33.

22. See John Gage, 1987, pp. 133–135.

23. See Katherine Solender, *Dreadful Fire! Burning of the Houses of Parliament*, Cleveland: Cleveland Museum of Art, 1984, and Richard Dorment, *British Painting in the Philadelphia Museum of Art*, Philadelphia: Philadelphia Museum of Art, 1986, pp. 396–405, entry for *The Burning of the Houses of Lords and Commons*.

24. See Andrew Wilton, 'Turner at Bonneville', in John Wilmerding (ed.), *In Honor of Paul Mellon*, Washington: National Gallery of Art, 1986, pp. 403–427. John Gage has pointed out that the *facture* of *Rain, Steam and Speed* owes much to Rembrandt, see John Gage, *Turner: Rain, Steam and Speed*, London: Allen Lane at the Penguin Press, 1972.

25. *The Wreck of a Transport Ship* of about 1810 (Fundação Calouste Gulbenkian, Lisbon; BJ 210) is a powerful example which repeats the effects of the 1805 *The Shipwreck*.

26. See A.G.H. Bachrach, 'Turner, Ruysdael and the Dutch', *Turner Studies*, 1981, vol. 1, no. 1, pp. 19–30.

27. Ruskin, *Works*, vol. 7, p. 445, note.

28. Ibid., vol. 13, p. 161.

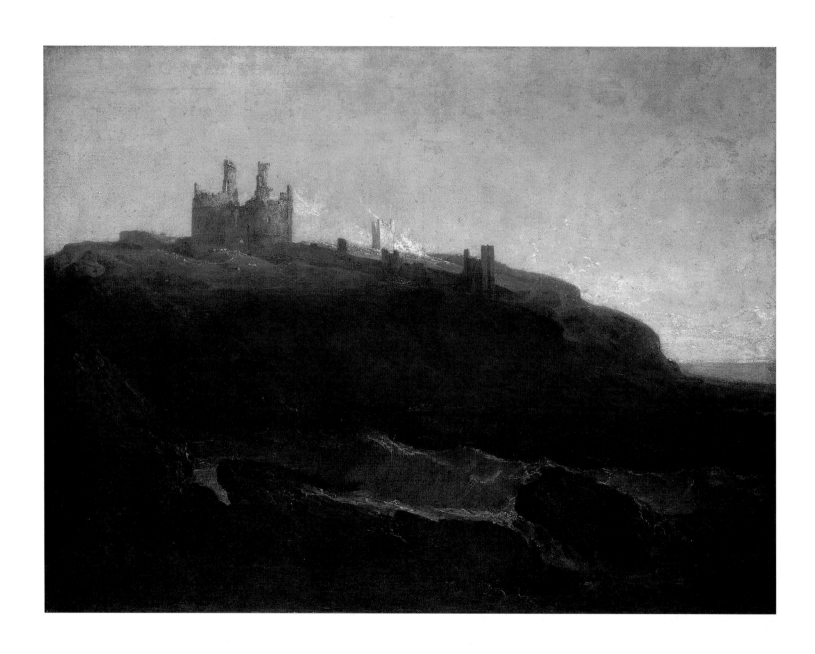

Dunstanborough Castle, N.E. Coast of Northumberland. Sunrise after a Squally Night R.A. 1798 oil on canvas National Gallery of Victoria, Melbourne
Gift of the Duke of Westminster, 1888 (cat. no. 2) *detail right*

Turner and Dunstanborough, 1797–1834

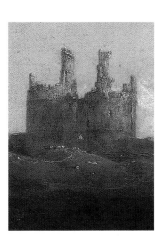

Evelyn Joll

By the mid-1790s Turner's summers had taken on an established pattern: he usually remained in London until the close of the Royal Academy exhibition and then left on a sketching tour to execute any commissions he might have and to gather material for future exhibitions. In 1795 he made two such expeditions, the first to South Wales, and the second to the Isle of Wight which led to the exhibition of his first oil painting at the Royal Academy in 1796, *Fishermen at Sea* (illus. p. 15).

In 1797 he went to the north of England. There is no need to trace his itinerary in detail but, after fulfilling commissions for drawings in Yorkshire for the *Copper Plate Magazine*, he went on to Durham and from there to Northumberland. Then, after visiting Melrose and Dryburgh, he turned south to the Lake District. This was a trip which offered endless scope to an ambitious landscape painter and Turner's progress is recorded in the 'North of England' and 'Tweed and Lakes' sketchbooks, each containing about a hundred drawings.

We are concerned here with Northumberland in general and with Dunstanborough in particular. Northumberland has some of the finest scenery in Britain and in Turner's time was very sparsely populated. Even today its beaches and roads are empty compared to the south of England. Above all, the county boasted a great many romantic and ruined buildings of the kind most likely to appeal to Turner: among them Holy Island Cathedral, Tynemouth Abbey, and Alnwick, Bamburgh, Dunstanborough, Norham and Warkworth castles. Turner drew them all.

Turner's choice of the north of England may well have received additional encouragement from Thomas Girtin who had visited it the year before. This was just the time when Turner and Girtin were together working for Dr Thomas Monro and, as Girtin was naturally forthcoming, he would surely have described his trip to his fellow artist and may even have brought along some of the watercolours that resulted from his journey to show Dr Monro. This is pure conjecture, but what is certain is that Girtin had made two drawings of Dunstanborough before Turner went there. If Turner did see these, he must have been impressed by the grandeur of the scene and no doubt made a resolve to draw the subject himself, for his competitive spirit must always be borne in mind. Furthermore, Dr Adele Holcomb has shown that it was just at this date that Turner was indebted to Girtin for what she describes as 'the image of the heroic castle';[1] and no castle presented a more heroic image than Dunstanborough.

The castle was built between 1313 and 1322 by Henry III's grandson, Thomas of Lancaster; in 1380 his son-in-law, John of Gaunt, altered it by turning the gatehouse into a keep. During the Wars of the Roses the castle changed hands several times, but by the middle of the sixteenth century it was in ruins; and so it has remained. It is one of Northumberland's largest castles, covering eleven acres in all. For Nikolaus Pevsner, in his guide to the county, 'the gaunt ruins of Dunstanborough on their dolerite promontory are one of the most moving sights in Northumberland'. It is no wonder that the subject fired Turner's imagination.

Turner's first drawings of Dunstanborough occur in the 'North of England' sketchbook. There are two crisp pencil sketches, taken from the south, with the keep as the main feature.

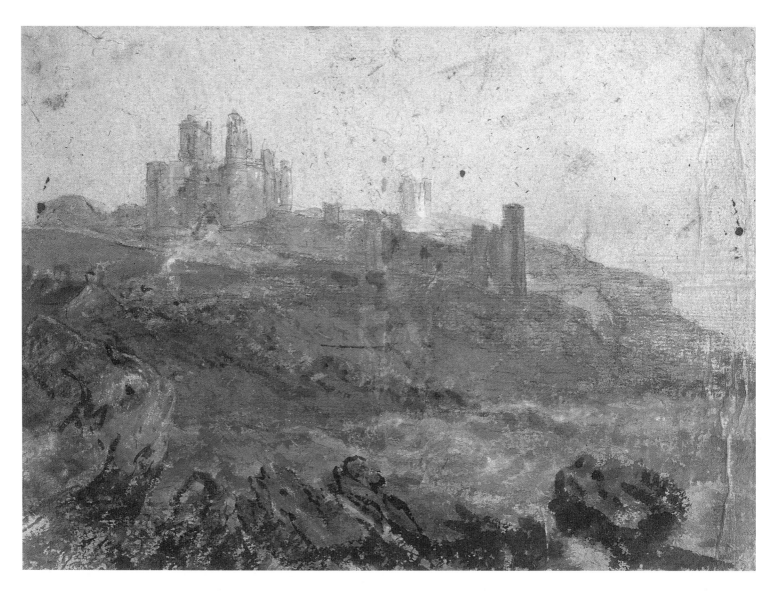

*Dunstanborough Castle from
the South* 1797
pencil, watercolour and bodycolour
Tate Gallery, London
Bequeathed by the artist, 1856
(cat. no. 37)

One sketch shows two cottages, prominently placed on the slope below the keep and to its right. Turner seems to have regarded them as an unwelcome intrusion there and either omits them from some of his later views of the castle or, as in the print of 1808 from the *Liber Studiorum* (illus. p. 42), moves them to the left and places them in shadow. The sketchbook also contains a watercolour taken from the north and showing the Lilburn Tower, so that one senses that Turner was exploring possible vantage points. He evidently soon opted for a view from the south, and during the winter of 1797–98 he began to develop his pencil studies into compositions which would form the basis for exhibitable works in either watercolour or oils. In the exhibition there are two studies (illus. pp. 38,39) for the picture now in Melbourne, which is based quite closely on them. In both, the cottages are moved almost out of the composition to the left with only their roofs and chimneys visible.

At the same time Turner experimented with another view of the castle, but from further to the left and making much more of the rocks in the foreground. There is also quite a large study for this in the Turner Bequest which prefigures very closely the composition of the oil, *Dunstanborough Castle c.*1798, now in Dunedin (illus. p. 41), but it is so stained and blotted as to be unexhibitable. This study was also used for the watercolour now in the Laing Art Gallery, Newcastle upon Tyne (illus. p. 43). Andrew Wilton dates this *c.*1801–02, but I would put it nearer the oil in date and therefore rather earlier.

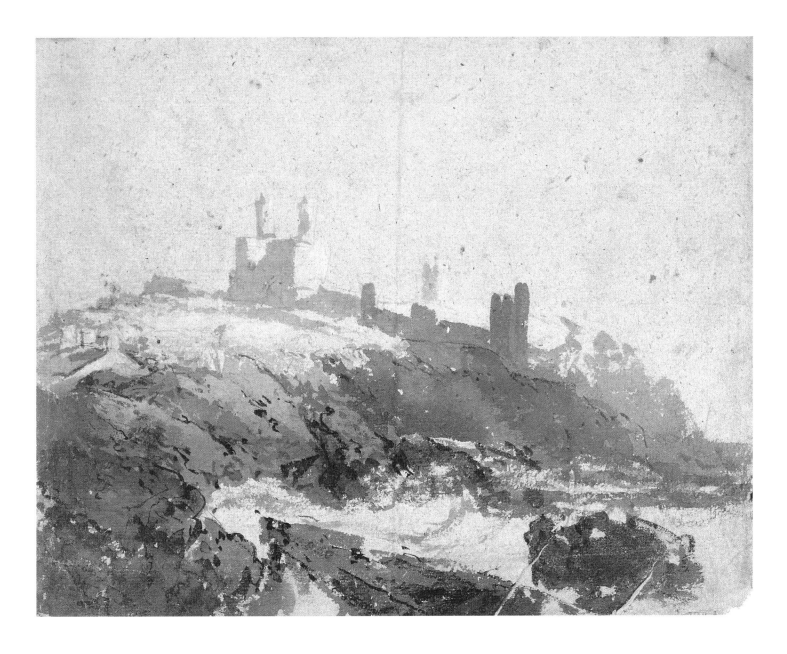

Dunstanborough Castle from the South 1797
pencil, grey wash and bodycolour
Tate Gallery, London
Bequeathed by the artist, 1856
(cat. no. 38)

At some moment during his planning for the 1798 exhibition, Turner must have decided to paint Dunstanborough in oil. In wondering why, I think the principal reason was that by then he must have become aware that his reputation among his fellow artists, and particularly among the senior Academicians, depended on making a name for himself as a painter in oils. A possible subsidiary reason may have been that oil was a medium that Girtin had not yet attempted.

Turner's 1798 exhibits at the Royal Academy were his most ambitious to date for they included four oils — more than he had ever shown — and six watercolours. Besides *Dunstanborough Castle, N.E. Coast of Northumberland. Sunrise after a Squally Night* (illus. p. 36), the oils were: *Morning among the Coniston Fells, Cumberland* (BJ 5) and *Buttermere Lake, with part of Cromackwater, Cumberland, a Shower* (BJ 7), both now in the Tate Gallery.[2] The fourth oil, *Winesdale, Yorkshire, an Autumnal Morning* (BJ 4), has not been heard of since and no place of that name is known in Yorkshire. Among the watercolours were two Northumbrian subjects, *Norham Castle on the Tweed, Summer's Morn* (private collection; W 225) and *Holy Island Cathedral, Northumberland* (whereabouts unknown; W 236).

The importance that Turner attached to Dunstanborough as a subject is proved by his painting two versions of it, and it seems likely that both were in hand at the same time. The smaller Dunedin picture is certainly freer and more summary in handling; perhaps it was never seriously intended by Turner as a candidate for the Royal Academy exhibition. In any case, by now Turner had probably decided that 36 by 48 inches (92.0 x 122.0 cm) canvases were to be his stock size for exhibitions.

The exhibition of 1798 was the first time that exhibitors were allowed to append quotations to their work. Turner took full advantage of this, for five of his exhibits had lines of poetry attached: Milton's *Paradise Lost* (1667) in one case and, in the other four, *The Seasons* (1726–30) by James Thomson. The latter was Turner's favourite source at the time, although this poem, 5,417 lines long, cannot be recommended as light reading today. The quotation that accompanied *Dunstanborough Castle* comes from *Summer*, lines 163–170, which describe the feeling of relief when dawn breaks after a stormy night:

> The precipice abrupt,
> Breaking horror on the blacken'd flood
> Softens at thy return. The desert joys
> Wildly, thro' all his melancholy bounds.
> Rude ruins glitter; and the briny deep,
> Seen from some pointed promontory's top,
> Far to the blue horizon's utmost verge,
> Restless, reflects a floating gleam.

Dunstanborough Castle was well received at the Academy: one critic described it as 'a really good picture', while another praised the water as 'finely painted', going on to observe that it was 'in the broad style of Wilson; nor is the colouring very different'. The two pictures now in the Tate were also warmly commended and this evidently encouraged Turner to enter his name for election as an Associate of the Royal Academy, despite the fact that the minimum age for candidates was twenty-four and he was only twenty-three. There were only two vacancies, and the result had Turner placed third; but the considerable support he received at his first appearance as a candidate shows how favourably his works in the exhibition had impressed the Academicians.

When considering the Melbourne and Dunedin pictures, one must bear in mind how very early they are in Turner's output in oils. Indeed, if 'The Mildmay Seapiece' (BJ 3), exhibited in 1797 but now untraced, was really painted on commission, then the Melbourne picture could be the first oil that Turner sold at a Royal Academy exhibition.[3]

As one might expect, Turner has exaggerated the height of the castle above the sea in the Melbourne picture, thereby stressing its 'heroic image'. But the critic who mentioned Wilson hit the nail on the head: Richard Wilson was certainly the dominant influence on Turner's style at this date. Of the three copies after other artists in the Turner Bequest, two are after Wilson, and one of these, *Tivoli: Temple of the Sibyl and the Roman Campagna* (private collection) has been assigned the same date as *Dunstanborough Castle*.

Wilson's key painting *The Destruction of the Children of Niobe* c.1760 (Yale Center for British Art, New Haven), would certainly have been known to Turner, if not in the original, then from the very popular print by William Wollett. In the background, waves are breaking against a rocky headland; beyond is a castle on the summit of a hill — all elements are present in Turner's pictures of Dunstanborough. Another dramatic Wilson, *Celadon & Amelia*, (whereabouts unknown) belonged to William Lock of Norbury whom Turner visited in September 1797 on his return from his northern trip. The engraving of the Wilson was accompanied by some lines from Thomson's *Summer*, a further link with the Melbourne Turner.

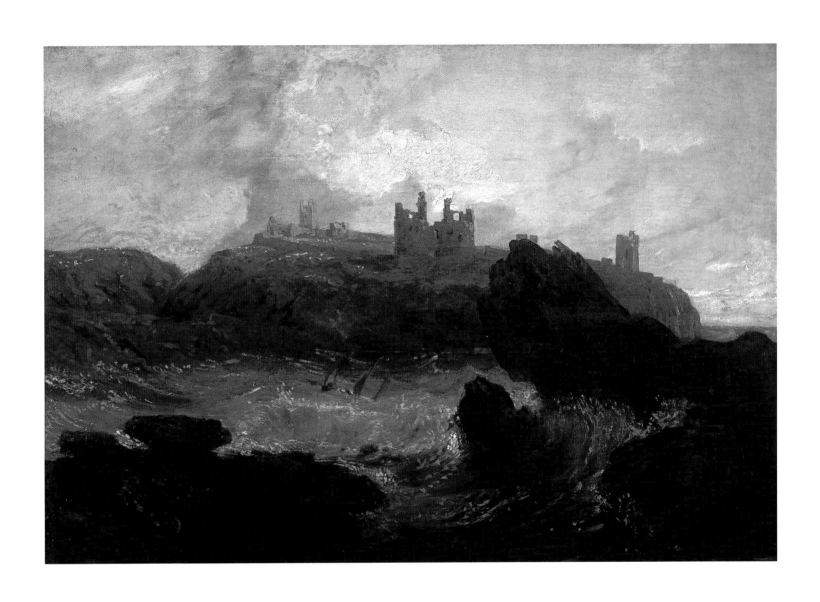

Dunstanborough Castle *c.*1798 oil on canvas Dunedin Public Art Gallery, New Zealand (cat. no. 3)

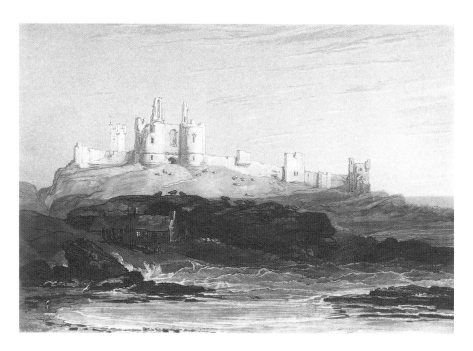

Turner possessed a magpie-like ability to borrow elements from other artists and to absorb them into his own work. While the source remained recognisable, the result was clearly stamped 'Turner'. In the case of the Melbourne painting, and while the composition and the colouring owe a good deal to Wilson, the painting of the waves and the way the light catches the top of the castle buildings unequivocally proclaim Turner's hand.

Although Turner never produced a finished oil or watercolour of Dunstanborough taken from the north, he must have contemplated doing so for there is, in the 'Studies for Pictures' sketchbook, a very summary sketch of the castle from this direction in pen and wash, heightened with white. It includes a yacht passing the headland on its way out to sea. Although this sketchbook is dated 1800–02 by Finberg,[4] it was clearly in use over several years as it contains studies for pictures exhibited in 1800 — so this sketch may well date from soon after the 1797 trip. Turner probably had a watercolour in mind here but never took it further.

The final result of Turner's 1797 visit is a watercolour of Dunstanborough, now at Wallington, the house in Northumberland which then belonged to the Trevelyan family but today is the property of the National Trust. This is taken from a little further inland than the Laing Art Gallery watercolour and further from the castle, so that more sea is visible. The sun is shining on the slope below the castle and the sea is calm; the effect is more benign than in the other versions of the scene. The most likely date is 1800–02.

The sepia drawing in the Turner Bequest for the *Liber* print is one of the most beautiful in that wonderful series. The engraving itself contains elements of both the Melbourne and Dunedin pictures but is closer to the latter. However, it reveals a new approach to the subject by being divided horizontally into three bands, reading from the top: light, dark, light. These alternating strips of light and shadow, in which the skilful interplay of tonal values compensates for the lack of colour, result in a most arresting image. It was published in the 'Architectural' category, although, in the 'Liber Notes (2)' sketchbook in use about 1816–18, Turner seems to have forgotten this as he includes it among other seapieces under the heading 'Marine'.

In September 1822 Turner again passed Dunstanborough as he sailed south down the coast from Edinburgh where he had been present during George IV's visit to the city. In the 'King's Visit to Scotland' sketchbook there are a number of very slight and rapid pencil sketches recording the coastline as Turner passed it. In order to do so he must have been on deck for long stretches at a time. On page 83 of the sketchbook there are eight such notations of which the sketch, one from the bottom, is inscribed 'Dunstanborough'; the inscription three sketches above is 'Coquet Island', which is some fifteen miles south of Dunstanborough. This means that the sketches, surely most unusually, start at the bottom of the page and then progress upwards. It also shows how compulsive was Turner's need to have a pencil to hand to draw whatever was before him despite the fact that, at least in the case of Dunstanborough, he already had all the material in his sketchbooks that he could possibly need.

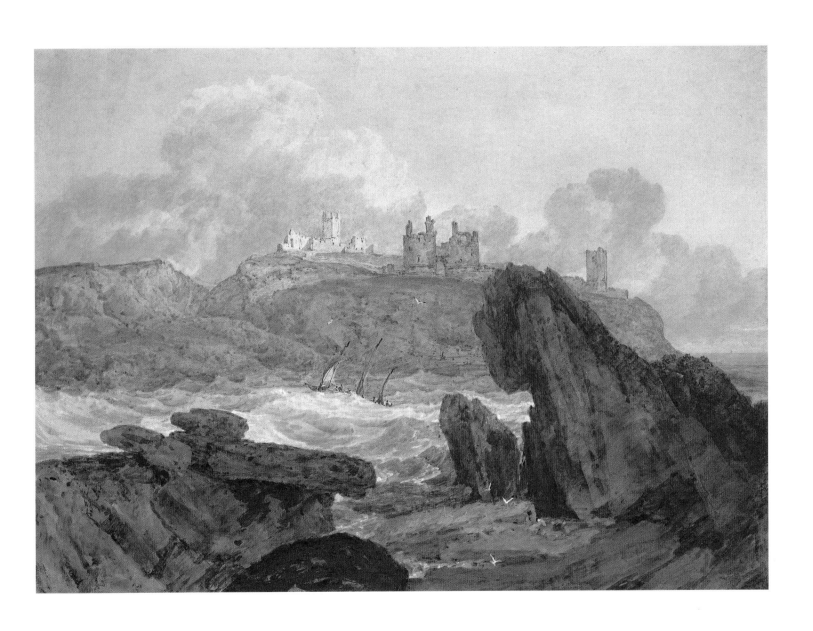

Dunstanborough Castle c.1798–1800 watercolour Laing Art Gallery: Tyne and Wear Museums, Newcastle upon Tyne (cat. no. 39)

Yarmouth Sands 1840 watercolour Yale Center for British Art, New Haven Paul Mellon Collection (cat. no. 82)

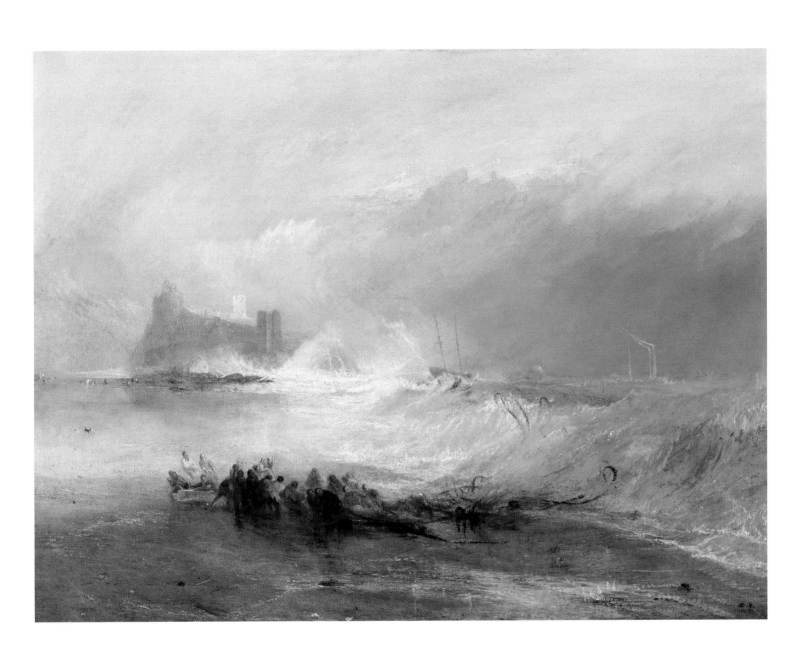

Wreckers — Coast of Northumberland, with a Steam Boat assisting a Ship off Shore R.A. 1834 oil on canvas Yale Center for British Art, New Haven Paul Mellon Collection (cat. no. 16)

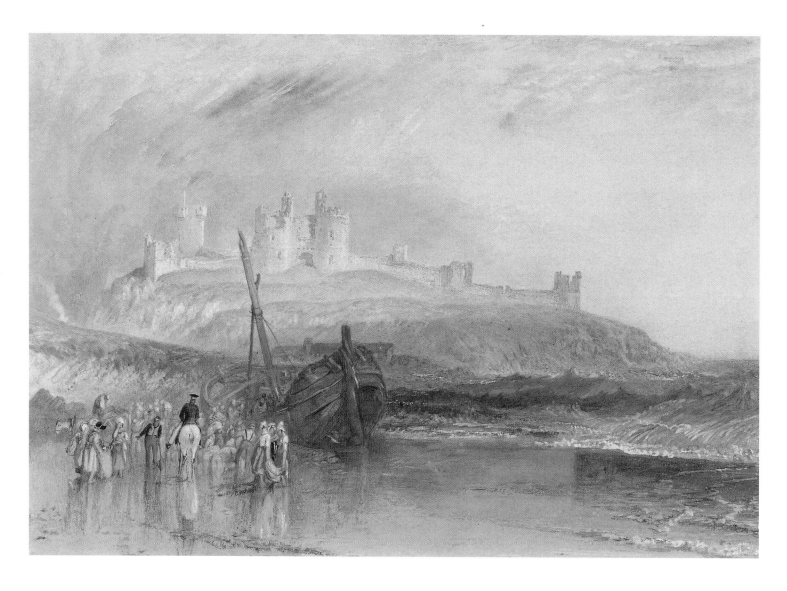

Dunstanborough Castle, Northumberland
*c.*1828
watercolour
27.0 x 43.0 cm (10-3/4 x 17")
City Art Galleries, Manchester (W 814)

Dunstanborough Castle appears next in the watercolour, probably executed around 1828, from the *Picturesque Views in England and Wales* series. The watercolour, *Dunstanborough Castle, Northumberland,* now in the City Art Galleries, Manchester, is one of the finest in the whole series and the condition is exceptional. Turner's painting of the wet sand indicates in a miraculous way just how long ago the tide has receded from it. Again he manages partly to mask the cottages with the beached wreck, while its broken mast leads our eyes upwards to the castle tinged with the delicate pink of early morning light. Eric Shanes sees the watercolour as 'a further example of ruin with wreck, the shattered castle looking down upon a scene of more recent human disaster'.[5] As always in this series, the figures play an important role in the composition: under the watchful eye of a soldier on horseback, they salvage what they can from the boat.

Dunstanborough appears for the last time in Turner's work in the picture he showed at the Royal Academy in 1834 entitled *Wreckers — Coast of Northumberland, with a Steam Boat assisting a Ship off Shore* (illus. p. 45), in which the castle is shown in the distance. *Wreckers* comes in the middle of a period of brilliant creativity in Turner's career in which he produced a string of masterpieces: *Staffa, Fingal's Cave,* 1832 (illus. p. 53); *Mouth of the Seine, Quilleboeuf,* 1833 (Fundaçao Calouste Gulbenkian, Lisbon; BJ 353); *Keelmen heaving in Coals by Moonlight* (illus. p. 28) and the two paintings of the burning of the Houses of Parliament (illus. pp. 88,89), all of 1835; and *Juliet and her Nurse,* 1836 (private collection, Buenos Aires; BJ 365).

Wreckers shows Turner at the height of his powers as a painter of the sea. As in the watercolour, the dark figures in the foreground play a vital part in creating the sense of drama as they strain, like a tug-of-war team, to heave their booty from the waves which, in their turn, seem to be trying to drag the figures back into their clutches. This produces an extraordinary tension in the foreground, a pent-up force which gains its release in the sea crashing against the cliffs below the castle. The strong diagonal of the shoreline leads our eyes to the castle, still as proudly heroic as in Turner's early pictures of it. However, while in 1798 the castle on its promontory appeared to be jutting *into* the sea, here it looks to be emerging, as Venus Anadyomene was said to do, from *out of* the very waves themselves.

Looking first at the two pictures of 1798 and then at *Wreckers* as, uniquely, one is able to do in this exhibition, one is struck as forcibly as almost never before by the extent that Turner's art had developed over thirty-six years and by the enormous range that it encompassed.

Notes

1. Adele Holcomb, 'The Bridge in the Middle Distance: Symbolic elements in Romantic landscape', *Art Quarterly*, 1974, vol. 37, pp. 31–58.

2. The portrait painter John Hoppner R.A., who had praised 'The Mildmay Seapiece', shown in 1797, thought little of these two pictures and, as a result, spoke of Turner as 'a timid man afraid to venture', an assessment which, in the light of Turner's subsequent career, must rank as one of the most monumental misjudgements in the history of art.

3. If the Melbourne picture was not bought at the time of the Royal Academy exhibition, by 1808, when published in the *Liber Studiorum*, the print was described as being taken from 'the picture in the possession of W. Penn Esq.' This is probably a misprint for 'J. Penn', as John Gage gives John Penn as the first owner of the picture. John and his brother Granville were grandsons of William Penn who founded Pennsylvania; they were acquainted with Turner — the diarist Joseph Farington twice records dining in London with the brothers in 1813 and 1814 when Turner was also present. John Penn was governor of Portland Island off the Dorset coast. So, it is all the more amazing that, when the Turner was sold by Granville Penn in 1851, it was catalogued as 'Corfe Castle from the sea'. Corfe Castle is also in Dorset, not more than twenty miles or so from Portland Island — but almost as far from Northumberland as it is possible to be in England.

 At the 1851 sale, the picture was bought by the dealer Ernest Gambart, and by 1857 it belonged to Colonel Birchall who lent it to the *Art Treasures* exhibition in Manchester that year. In 1870 Birchall sold it to Agnew's who resold it in the same year to the Manchester collector John Heugh. He sold it at Christie's on 25 April 1874 where it was bought by Colnaghi's on behalf of the first Duke of Westminster. Ten years later, on 10 May 1884, it appeared again at Christie's as 'The Property of a Nobleman' (the Duke in disguise). On this occasion the picture failed to attract a buyer and was bought in for only 900 guineas, less than half the price paid in 1874. In 1888, the Duke loaned three paintings by Turner, including *Dunstanborough Castle* to Melbourne's *Centennial International Exhibition* and, in the same year, presented the painting to the National Gallery of Victoria.

 The early history of the Dunedin picture is obscure, Sir Walter Armstrong's catalogue (*Turner*, 1902) gives the first owner as 'Sims', about whom nothing is known — Alastair Laing, the National Trust's adviser on Painting and Sculpture, has suggested that he may be the collector G. Simms of Bathwick Hill, Bath; however, he was not active until the 1850s. In 1899 A.G. Temple sold the picture to Agnew's, who resold it in 1900 to E.F. Milliken of New York for £1,320. Less than two years later Milliken put it back on the market, but with disappointing results: it was bought in at Christie's on 3 May 1902 for 820 guineas and again on 23 May 1903 for 600 guineas. Its really spectacular appearance at Christie's occurred on 21 February 1930, when it belonged to Mrs C.M. de Graff. Although it was catalogued as fully authentic, a dealer named Meatyard was able to buy it for only 30 guineas, an astonishingly low figure in view of the high prices brought by other Turner oils in the late 1920s. Meatyard then sold it to another dealer, Leggatt Brothers, who sold it to Dunedin in 1931.

4. A.J. Finberg, *The Life of J.M.W. Turner, R.A.,* 2nd edn rev., London: Oxford University Press, 1961.

5. Eric Shanes, *Turner's Picturesque Views in England and Wales, 1825–1838,* London: Chatto and Windus, 1979, p. 31.

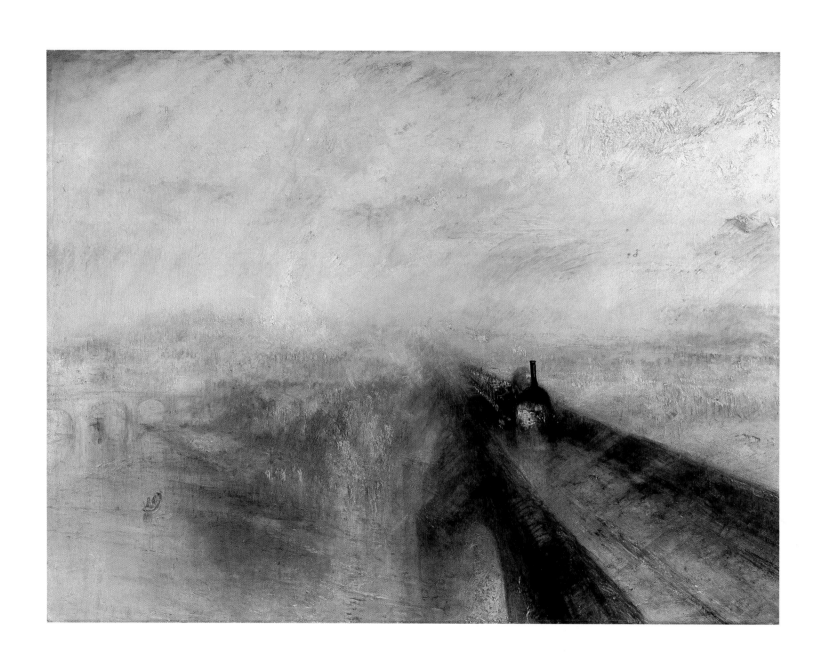

Rain, Steam, and Speed — The Great Western Railway R.A. 1844 oil on canvas 90.8 x 121.8 cm (35-3/4 x 48") National Gallery, London Bequeathed by the artist, 1856 (BJ 409) *detail right*

Rule, Britannia?
Patriotism, Progress and the Picturesque in
Turner's Britain*

David Blayney Brown

There is no telling whether, late in 1844, Turner read in the *Morning Post* some strident protests from Wordsworth at the incursions of the Kendal and Windermere railway into his beloved Lake District. The poet had chosen this journal partly because it reached 'the Aristocracy ... all Ladies, and ... a great number of the Landed Gentry'; in other words, much the same constituency as would have seen Turner's *Rain, Steam and Speed — The Great Western Railway* in the Royal Academy exhibition that spring.[1] Turner's sparkling tribute to the Great Western Railway crossing the Thames at Maidenhead was to be his last exhibited picture of the English landscape, and of the valley he had loved as much as Wordsworth loved the Lakes.

Fond as he was of poetry, Turner never seems to have cared for Wordsworth, whom he probably placed in the enemy camp, as the poet was the protégé of the most hostile and conservative critic of his pictures, Sir George Beaumont. But, as near contemporaries, their careers had marched more or less in step. One of the earliest pictures in this exhibition, *Dunstanborough Castle, N.E. Coast of Northumberland. Sunrise after a Squally Night* (illus. p. 36), was shown at the Royal Academy in 1798, the year Wordsworth wrote some of his most important early poems, the *Lyrical Ballads*, including *Tintern Abbey* in which a picturesque ruin awakens the powers of memory and imagination. (Turner had exhibited a watercolour of Tintern at the Royal Academy in 1794.) By the 1840s, poet and painter could expect their verdicts on the current railway mania to be taken seriously. Each was a grand old man whose output over many years had established enduring images of his country and its landscape.

Wordsworth's contributions to the *Post* (republished as a pamphlet the following year) included both a personal history of landscape appreciation in Britain — observing that 'the relish for choice and picturesque natural *scenery* is quite of recent origin' — and two sonnets. If Turner had read the second of these, he would have detected a more than coincidental similarity to the imagery of his own picture:

> Hear ye that whistle? As her long-linked Train
> Swept onwards, did the vision cross your view?
> Yes, ye were startled ...

But he would certainly not have endorsed Wordsworth's rhetorical conclusion: 'Mountains, and Vales, and Floods, I call on you / To share the passion of a just disdain.'

Wordsworth had once declared, in the company of painters, that 'figures are injurious to the effect which Landscape should produce as a scene founded on observation of nature'.[2] If, as seems likely, *Rain, Steam and Speed* had now provided him with the imagery of his anti-railway outburst,

* *This essay usually follows Turner in referring to 'Britain', unlike others, John Ruskin for instance, who preferred 'England'.*

he had evidently found it shocking both as a picture and a social document. His objections concluded with the pompous dictum: 'We have too much rushing about in these islands, much for idle pleasure and more from over activity in the acquisition of wealth.'

Turner would have recognised this as humbug. He had spent much of his life travelling in Britain and abroad by all available means of transport, and had never been ashamed to profit by the results. However, Wordsworth had touched on important issues: how, if at all, natural landscape was to admit man-made progress; whether technology was a legitimate source of national pride, simply the generator of profit, or an evil to be condemned; whether it was right that large numbers of people should have access to unspoilt scenery and thus risk spoiling the very thing they came to see. These questions had become urgent in a country transformed by the Industrial Revolution, where technology had made itself felt as nowhere else, and where leisure was already becoming an industry in its own right. But Wordsworth's contribution to the debate was unhelpfully simplistic: the landscape was all — to be admired through poetry, or pictures. It was one thing for him to be moved to solitary contemplation in the Lake District, quite another for the masses to arrive by public transport.

These posturings would have mattered less if they had not been taken up by John Ruskin, who, as Turner's greatest but most partial advocate, missed no opportunity to enlist the artist in his own condemnation of the machine age. Ruskin had already made a broad connection between Wordsworth and Turner for their respective truth to nature, expressed in the 'real language of men' and in a pictorial style supposedly freed from the restraint of outmoded convention. Wordsworth was a major inspiration; Turner the hero of Ruskin's *Modern Painters*, that great polemic addressed to 'the Landscape Artists of England' but intended to reawaken the lost soul of the British nation. Wordsworth's descriptions of picturesque British scenery provided Ruskin with prototypes of what might constitute good landscape painting; and in much of Turner he found it triumphantly realised. But not in *Rain, Steam and Speed*. He famously remarked that Turner had painted it 'to show what he could do with an ugly subject', and pointedly ignored it in all his published discussions of the artist's work; while in the second volume of *Modern Painters* (1846) he cited Wordsworth's railway protests with approval.

Ruskin's silence on *Rain, Steam and Speed* doubtless arose because the picture so vigorously resisted the interpretation of foreboding that he usually attached to such subjects — although other writers felt no such qualms and, without going so far as Theophile Gautiér, who likened Turner's train to a Beast of the Apocalypse, critics have continued to see in the picture a less than whole-hearted enthusiasm for rail.3 But Ruskin surely did not miss its festive air: the waving crowds beside the track seem to salute — even more than the passing train — the arrival of a new age. Even if we did not know that the engineer of this line, the great Isambard Kingdom Brunel, had married into the family of Turner's friend and fellow painter, Augustus Wall Callcott, and that Turner himself would soon make a handsome profit by the sale of some land to another railway company, we can still feel his own excitement. Those of his contemporary audience free of Wordsworth's prejudices would have seen a celebration of travel and leisure in modern Britain, and of the national achievements that brought them together; and in the crowds of passengers and spectators, they were invited to recognise themselves. Turner had given them a conspicuous stake in their own landscape. His picture united those aspects of natural beauty and manufactured progress, of the picturesque and the people who came to admire it, that Wordsworth and then Ruskin fought to keep apart. The linking of landscape and modern life would not be so vividly depicted again until Impressionism.

If it seems eccentric to dwell so long on a picture not in this exhibition, it should be said that it introduces issues very relevant to the British subjects that are included, and to their critical reception. Turner's Britain

displayed ever more striking contrasts between unspoilt or wild landscape, whose picturesque and historical credentials were constantly celebrated in literature and art, and a rapidly evolving urban and industrial culture. At home they were sources of constant debate, while for foreigners, for whom a visit to Britain was then a voyage into the future, they were often the main attraction. In no other developed country were traces of the past and apprehensions of the future to be experienced so closely together; and it was still far from clear which would gain the greater hold on the national consciousness. While it often seems today that 'heritage' has become the dominant industry in Britain, Wordsworth and Ruskin felt themselves swimming against a tide of opinion committed to progress. Any true portrait of the nation and its people at this period was bound to acknowledge the immense changes taking place. To wish them away, or condemn them outright, was to falsify the picture and deny a great swathe of human experience.

To be fair, Wordsworth had not always been so carping. His sonnet *Steamboats, Viaducts and Railways* (1833) had allowed such 'motions and means, on land and sea' a thrill of their own:

> Nor shall your presence, howso'er it mar
> The loveliness of nature, prove a bar
> To the mind's gaining that prophetic sense
> Of future change, that point of vision ...

Ruskin also, while still young, had accepted the advent of the railway for better or worse as part of the British scene, writing in the first volume of *Modern Painters* (1843) that 'if we are to do anything great, good, useful, religious ... it must be got out of our own little island, railroads and all'.[4] But both men soon hardened their attitudes, and in Ruskin's case there can be little doubt that his prejudices came to affect his appreciation of Turner, and to restrict the view of his work that he handed down to his readers. It was not only Turner's art that was at stake, but the image of Britain to be recovered from it.

Rain, Steam and Speed was far from being the only obviously significant painting by Turner about which Ruskin could find nothing or only negative things to say. This exhibition, as it happens, is rather well stocked with pictures that left him stumped, and it is no accident that they are often of British subjects. Something was clearly wrong with the critical framework that Ruskin was constructing for Turner if it left him evasive or silent about pictures as striking as *Keelmen heaving in Coals by Moonlight* (illus. p. 28) or the two canvases of the burning of the Houses of Parliament (illus. pp. 88,89). Although he would claim that his memories of *Keelmen* were 'confused' because it lacked 'charm in colour',[5] this is hardly convincing as a disclaimer; and, even if it were true, the sheer dazzle of the paintings of the burning of the Houses of Parliament should have been sufficient to impress them on his mind. It was surely neither their style nor their colouring that outlawed these pictures, but their subjects. Here were images of his country that Ruskin would rather were not admitted into the national consciousness.

As we have seen, the problem with *Rain, Steam and Speed* was relatively straightforward. Like Wordsworth, Ruskin believed passionately in the value of landscape: while the poet was moved to contemplation and communion with his inner life, Ruskin brought a range of disciplines to bear. Geology, botany or climatology could inform one's understanding of the various elements contained in a view. At the same time, underlying associations, historical, legendary or literary, were likely to enhance its value. With so much to give, it followed that landscape could only be understood by cultivated people. It would not yield its secrets in the course of a quick visit in a train or paddle-steamer, and the kind of new tourists who flocked on board should stay at home. As Ruskin severely declared in his introduction to *The Harbours of England* (1856) — a collection of Turner's coastal views — he had 'very little sympathy for people who want to *go* anywhere'.[6] The 'ugliness' of *Rain, Steam and Speed* lay in their conspicuous presence, and in Turner's evident identification with them. Ruskin simply could not understand why Turner, who of all painters had taught him most of nature and landscape, should endorse this invasion.

Steam Boat and Storm c.1841 watercolour Yale Center for British Art, New Haven Paul Mellon Collection (cat. no. 85)

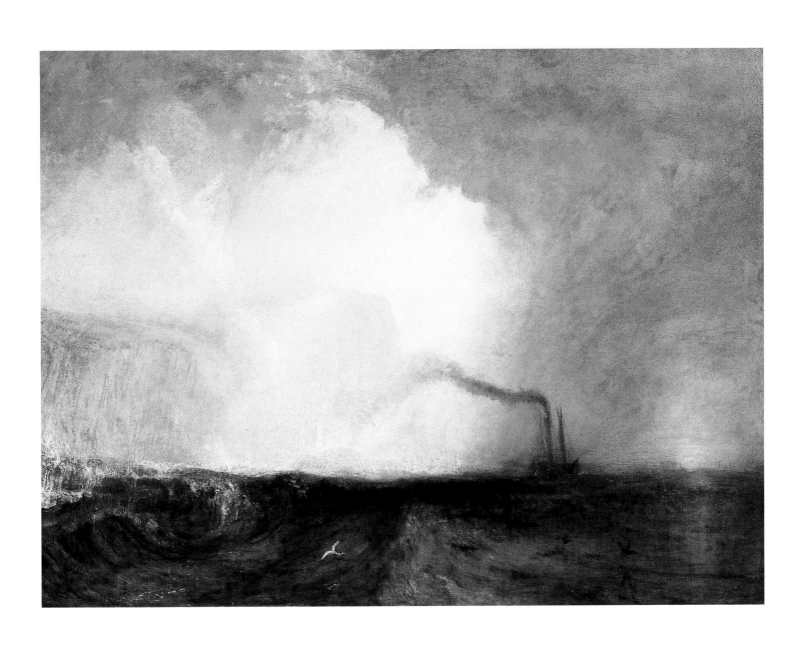

Staffa, Fingal's Cave R.A. 1832 oil on canvas 90.9 x 121.4 cm (35-3/4 x 47-3/4") Yale Center for British Art, New Haven Paul Mellon Collection (BJ 347)

Ruskin's comments in *The Harbours*, of course, applied to steamers and all they brought in their wake. Needless to say, he disliked them as much as trains. With disturbing smoke and clanking noise, they too brought the masses to the picturesque or remote spots that should remain the preserve of the educated traveller or the indigenous community. Typically, Ruskin thought it 'very notably capricious' of Turner to be so fond of Margate, the new resort on the Kent coast that had grown from a small fishing village as a result of the steamer services from London introduced in the 1820s. Turner had taken to steamers at once, both in his travels and his art. From the Pool of London to Lake Lucerne, on the Rhine and the Seine, steamers appear in his drawings and watercolours, and animate some of his most important later paintings.[7]

Steamers had first appeared in Turner's exhibited work in the celebrated *Staffa, Fingal's Cave* of 1832 (illus. p. 53) and the less well-known *Wreckers — Coast of Northumberland, with a Steam Boat assisting a Ship off Shore* of 1834 (illus. p. 45). The first was the result of a visit by steamer to the tiny Scottish island in 1831, the second a vivid reworking of a familiar subject, none other than Dunstanborough Castle. In *Staffa*, the steamer rather than the mist-shrouded cave seems the hero. In *Wreckers*, the steamer, giving aid to a sailing ship in difficulties, is cast in a benevolent role, leaving the viewer in no doubt as to the benefits of progress. And if style has meaning, the message was underlined in some of the most lively and impromptu handling to be found in exhibited pictures of this period.

So far little discussed save by Evelyn Joll,[8] *Wreckers* is a little masterpiece, prophetic in every sense, but perhaps specifically of a far more famous picture, the 1842 *Snow Storm — Steam Boat off a Harbour's Mouth making Signals in Shallow Water, and going by the Lead* (illus. p. 33). In a particularly interesting review, the critic of *Arnold's Magazine* observed that although no art form was more prone to exaggeration than marine painting, in *Wreckers* Turner had dealt with his subject entirely convincingly; and, praising the treatment of the waves, recalled the habit of the Dutch marine painter Backhuysen of putting to sea in storms to observe their real effects.[9] It is tempting to think that this was some inspiration for the autobiographical conceit that Turner added in his subtitle to *Snow Storm*, claiming that he had been in this very storm 'the Night the Ariel left Harwich'. He almost certainly wasn't, but the story was nicely calculated to stress the realism of the work, and to involve the artist and his Academy audience in a credible drama of modern life. It was characteristic of Ruskin that he admired the first aspect, not the second. He was lavish in his praise of 'one of the very grandest statements of sea-motion, mist and light that has ever been put on canvas, even by Turner';[10] but he overlooked its documentary narrative — the steamer methodically taking soundings to ensure its safe passage through rough, shallow water. As always, Ruskin located Turner's modernism in his truth to nature, not in his treatment of a modern subject.

No less than *Rain, Steam and Speed*, *Snow Storm* brought its art form spectacularly up to date. Just as the Thames Valley could be seen to resolve itself into the formal harmonies of classical landscape through the sparkle of mist and shower, so the motif of the storm-tossed boat had long been fundamental to marine painting. A similarly impressive transformation of tradition occurs in *Keelmen*. Classical landscape derived above all from Claude, and Turner had also made splendid use of another of that painter's favourite themes, the ancient seaport crowded with figures and shipping. As Andrew Wilton observes elsewhere in this catalogue, *Keelmen* is among other things a counterpart to the Claudean seaport. The familiar pictorial structure is all there, though we are transported from the ancient Mediterranean to Shields, on the Tyne near Newcastle, the ships are grubby colliers, and Claude's golden sunshine has given way to night. The result is a prototype of what might be termed modern industrial marine, and another picture that Ruskin preferred to avoid.

Both Wordsworth and Ruskin had turned to nature and landscape in a kind of despair: Wordsworth, disillusioned by the corruption of the revolutionary ideals he had embraced as a youth, Ruskin to escape the urban and industrial blight he saw destroying his country. Only in the fields, or surrounded by relics of a better past could something be salvaged of real humanity, of the true spirit of the British people, all but killed by the Napoleonic War and now 'trampled out in the slime of the street, crushed to dust amidst the roaring of the wheel, tossed carelessly away into howling winter wind along five hundred leagues of rock-fanged shore'. Ruskin wrote *Modern Painters* with an urgent sense of national purpose, to condemn the waste of life and soul that he termed the 'English death'.

It was inconceivable to Ruskin that Turner had not felt as he did: 'The English death was before him too.' The passages just quoted are taken from

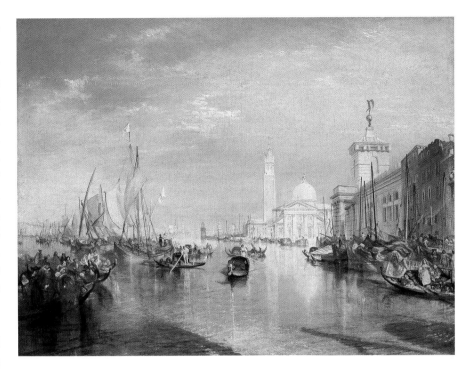

*Venice: The Dogana and
San Giorgio Maggiore* 1834
oil on canvas
91.5 x 122.0 cm (36 x 48")
National Gallery of Art, Washington DC
Widener Collection (BJ 356)

one of the most famous chapters of *Modern Painters*, 'The Two Boyhoods'.[11] Here Ruskin compared the growth of two artists, Giorgione in fifteenth-century Venice, Turner in eighteenth-century London — the one brought up in clear air in the heart of a trading empire that was nevertheless devoted to religion and beauty, the other among mean streets, the jumble of the Covent Garden market and the clamour of the Thames docks in a climate of scepticism and commerce. So vivid is Ruskin's evocation of the sounds and smells of old London that one wonders whether he heard of them from Turner himself; but they are fashioned to his own argument and prejudices. Abruptly transporting young Turner from the metropolis to rural Yorkshire, Ruskin shows him struck by his life's mission, to paint nature; 'there was no beauty elsewhere than in that'. Yet Ruskin so thoroughly mapped a darker human landscape of modern Britain, 'the labour and sorrow and passing away of men', that Turner must be made to acknowledge this too. Having created these two conflicting aspects of Turner's vision, Ruskin could never quite resolve them.

In a brilliant passage, Ruskin credited Turner with a comprehensive view of the nation at work: 'Labour, by sea and land, in field and city, at forge and furnace, helm and plough. No pastoral indolence nor classic pride shall stand between him and the troubling of the world; still less between him and the toil of his country — blind, tormented, unwearied, marvellous England.'[12] There might seem no better preparation for *Keelmen*, nor for the creative process behind it whereby the classicism of Claude is bent to a tougher contemporary purpose. Yet Ruskin seems to have found it another 'ugly subject'; it is as if he could not really allow Turner the pictorial scope implied in his own prose. We may guess that Ruskin would have found the theme acceptable only as the expression of a tragic sense of a fallen world.

It is true that *Keelmen* grew out of some of the grimmer realities of industrial Britain. Here was the produce of the Durham coal fields that had struck an American visitor as a vision from 'Dante's shadowy world'.[13] Here too was the hardship of labour by night, painted for a Manchester patron, Henry McConnel, who despite liberal spending on art and philanthropy kept employees at work in his vast cotton mill sixteen hours a day for miserable wages.[14] But Turner's message is neither negative nor condemning. Whether independently or at McConnel's suggestion — and anticipating Ruskin's juxtaposition of the trading empires of Britain and Venice —

he paired the moonlit *Keelmen* with a sunlit view of the Venetian lagoon, *Venice: The Dogana and San Giorgio Maggiore* (illus. p. 55) that McConnel had bought the previous year. By setting this scene in modern Venice, whose wealth and power had vanished and whose liberty had succumbed first to Napoleon and then to Austria, Turner reached a very different conclusion. 'In the fall of Venice think of thine, despite thy watery wall', Byron had addressed his countrymen in his famous poem *Childe Harold's Pilgrimage*; and this is Turner's message too. The labours of the Shields keelmen — whose coal fed the Midland factories, the engines of steamers and trains and the hearths of the capital — are contrasted to Venetian indolence; by their vigilance Britain might escape the decline that had befallen Venice. The fate of empire is at stake here, and it was fitting that it should be addressed in a modern paraphrase of Claude who, of all painters, had most vividly reconstructed the empires of antiquity.

As well as *Keelmen*, the spring of 1835 saw the exhibition of Turner's two pictures of the burning of the Houses of Parliament. On 16 October the previous year, a huge blaze had destroyed much of the Palace of Westminster but miraculously spared those ancient symbols of national pride and Christian faith, Westminster Hall and the Abbey.[15] The enormous crowds — including artists and students of the Royal Academy — who watched from the banks of the Thames and from Westminster Bridge, saw a Sublime spectacle and sensed a profound symbolism. For the politically-minded, the fire seemed a judgement on the hereditary peers, who had almost blocked the passage of the Reform Bill in 1832, and on the legislature that was now debating a Poor Law to end expensive relief for the sturdy unemployed and confine them to workhouses. Others lamented the loss of national history incurred by the destruction. Whether as purgative or punishment, as evidence of divine retribution or providence, 'the whole calamity', as the radical paper *The Examiner* declared, 'reads like an allegory'. Turner's decision to paint the fire twice from different positions, exhibiting one picture at the British Institution — largely painted *in situ* at the Institution on Varnishing Day — and the other at the Royal Academy, shows the special importance he attached to the subject and his determination to attract maximum attention to it. Recognising the national dimension of the theme, he was at first reluctant to sell the version now in Cleveland, having 'decided to give that one to the nation'.[16]

Both pictures include the crowds whose emotions he and his exhibition audiences would have well remembered. They are not merely spectators but commentators whose reactions are integral to the meaning of the pictures. We can only speculate how far Turner wished to acknowledge, let alone identify with the very political mood that was abroad that night; but his friends included supporters of reform like Walter Fawkes of Farnley, and a certain excitement at the symbolic passing of an old and divisive order can be safely read into the pictures. Among the watercolour studies of fire beside water usually associated with the burning of the Houses of Parliament is one that seems to include ancient buildings. Perhaps Turner had toyed with the historical parallel of the burning of Rome but decided not to pursue its connotations of decadence and *fin d'empire*, preferring instead to think of fire's role in nature and myth as a regenerative force leading to new life and growth. Maybe, in the Academy at least, he wished to offer a contemporary parallel with that other great poem of fire, moonlight and water, the *Keelmen*. It was well known that the Tyneside colliers and miners, together with the factory workers of Birmingham, had been among the main spearheads of reform through their formation of political unions. Is there a light burning darkly in *Keelmen* that leaps into a Promethean blaze beside the Thames at Westminster? This may seem a subversive extension of the message understood in *Keelmen* by McConnel, but need not be inconsistent with it. To acknowledge the national importance of labour and the creation of wealth could also be to argue for due recognition of those who bore the brunt of the task — which then meant, most urgently, the improvement and enfranchisement of the working man. In fact, although his fellow industrialists generally opposed reform, McConnel actually supported workers' education through the Manchester Mechanics Institute.

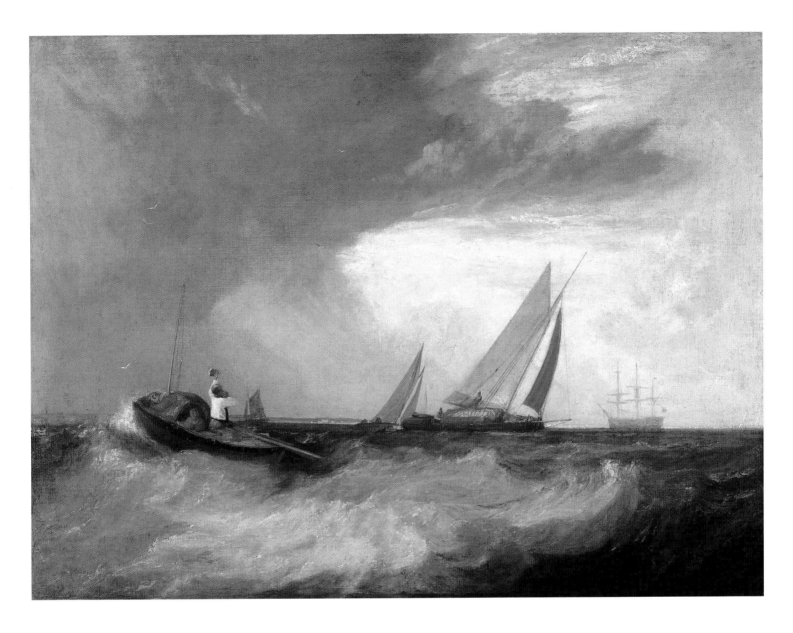

Wordsworth, who in youth welcomed the French Revolution, had threatened to retire to a 'safe and conservative country like Austria' if the Reform Bill were carried; John Constable was against it; so were Ruskin's parents and most of their friends. One wonders whether things were said in his household that put the young Ruskin off Turner's 1835 pictures — and if he later pushed them to the back of his mind because they recalled sensitive issues. His silence on these, as on *Rain, Steam and Speed*, shows him in difficulties with certain modern subjects, with aspects of his country's transition from an old order into a new.

Ruskin's only — and oblique — reference to the two Houses of Parliament pictures was a remark in a pamphlet on the new painters of the Pre-Raphaelite school (published in 1851) that the fire itself had provided Turner with his 'only new sensation' in a decade devoid of inspiration and productive of many works 'altogether unworthy of him'.[17] Although its introduction implied that the pamphlet would bring *Modern Painters* up to date, this comment might suggest to a cynic that Ruskin's earlier high claims for Turner had been built on sand. After all, it had been the exhibitions of the 1830s that had first introduced Ruskin to Turner's oils. It was a strange statement to make in the year of Turner's death, but a revealing one, for it embraces most of the paintings so far discussed here.

Shoeburyness Fisherman hailing a Whitstable Hoy 1809
oil on canvas
National Gallery of Canada, Ottawa
(cat. no. 10)

By this glib dismissal, Ruskin justified his critical omissions. A cynic might also observe that these neglected pictures were exactly those in which Turner had dealt with 'new sensations'. In essence, the pamphlet of 1851 signalled no change in Ruskin's critical framework, for it was another lecture on Turner — *his* Turner, the painter of nature and landscape.

The pamphlet had sprung from the most fruitful of Turnerian ground. While Turner was dying in London, Ruskin had gone to Yorkshire to stay at Walter Fawkes's seat, Farnley Hall. Turner's friend had died in 1825, but the house remained richly stocked with the artist's earlier works, including a patriotic oil of Nelson's *Victory* returning from Trafalgar (Yale Center for British Art, New Haven; BJ 57), the Thames marine *Shoeburyness Fisherman hailing a Whitstable Hoy* (illus. p. 57) and the glorious watercolour *A First Rate taking in Stores* (illus. p. 118) — made to show Fawkes's son what a man-of-war looked like; watercolours of Switzerland and the Rhine; and scenes of Farnley, the estate and the history of the family. There could be no better demonstration of the Turner that Ruskin admired than this collection with its views of the great rivers and mountains of Europe, and of the best of Britain's heritage on sea and land.

Ruskin's views of Turner cannot be separated from his passionate but intensely critical patriotism. Much as he loved continental Europe and prized Turner's pictures of it, the British landscape was especially precious to him. Where still intact, it preserved the best of the past, a memory of the land before the destructive advances of the modern world, where earlier generations worked in harmony with nature, taming and tending it only according to need, building upon it only by hand and craft. It was the dwindling legacy of a good society. In a lifetime of writing and lecturing, Ruskin proposed it as an object of national study, the source of an inspirational sense of identity and citizenship. In 1870, as first Slade Professor of Art at Oxford, he threw to his audience of privileged 'youths of England' the challenge of making making theirs once more 'a sceptred isle, for all the world a source of light, a centre of peace; mistress of Learning and of the Arts'. The British, and their empire-builders abroad, were to be sustained by 'an intense delight in the landscape of their country as memorial ... the local awe of field and fountain; the sacredness of landmark that none may remove, and of wave that none may pollute, while records of proud days, and of dear persons, make every rock monumental with ghostly inscription, and every path lovely with noble desolateness'.[18]

As so often with Ruskin, prophetic rhetoric contrasts with nostalgia. Rather as history painting had been proposed a century earlier as the moral inspiration for the nation's elite, Ruskin offered the historically suggestive landscape as the inspiration for the modern age. While it should be as scrupulous as possible in its portrayal of nature, it should, like history painting, be free of distracting contemporary details — particularly those that spoke of the forms of progress Ruskin hated most. The nation's self-image would not be served, for example, by rendering the conspicuous creation of wealth or profit, or the leisure and pleasure in which these were spent. Instead, Ruskin presented a frozen vision. It has required a perceptive American critic to see it for what it really was: 'England described not as a living land but as a memorialising representation of past history and natural beauty ... landscape as national cemetery — or rather, as national museum.'[19]

Turner could never be fitted whole into such a frame. It was true that countless early watercolours of cathedrals, castles and abbeys appealed to exactly that sort of historical imagination, while others of landscape topography, like the beautiful North Yorkshire subjects in this exhibition, the *Weathercote Cave* of *c.*1818 (illus. p. 59) made to illustrate a *History of Richmondshire*, and the nearly contemporary *High Force, Fall of the Tees, Yorkshire* (illus. p. 61), that Ruskin saw at Farnley in 1851, were calculated to inspire 'awe of field and fountain'. Ruskin could find plenty in Turner to justify his conception of landscape. But Turner had gone on to provide vivid answers to a question Ruskin did not address: how the 'museum' was to be brought up to date and admit fresh developments as a record for the future.

Weathercote Cave c.1818 watercolour British Museum, London (cat. no. 51)

Linlithgow Castle c.1801
watercolour
National Gallery of Victoria,
Melbourne
Gift of Sir Thomas Barlow, 1953
(cat. no. 42)

By concentrating on Turner as a painter of nature and landscape Ruskin could largely avoid the issue. But he was also able to take advantage of the fact that Turner belonged to a previous generation: by the time Ruskin came to study it, Turner's earlier work had itself become historical; it showed few of the changes he so deplored. Thus he could commend Turner's watercolour of Richmond (illus. p. 76) as a 'lovely rendering of old English life ... all now in reality, devastated by the hell blasts of avarice and luxury'.[20] This was an outrageous exaggeration as this Yorkshire town remains delightfully unspoilt to this day; but it is typical of the bias that increasingly infected his criticism. When his American friend Charles Eliot Norton proposed some Ruskinian instruction for his students at Harvard, Ruskin replied: 'I profoundly think it useless for Americans to look at Turner. He is English to the sole of his foot — every faculty of him pensive — and of days of old.'[21] Ruskin had now gone so far in locating Turner's 'Englishness' on territory taken from the past as to consider his art impenetrable to those who did not share the same cultural memory. Yet again, Turner's observations of a more recognisably contemporary Britain were implicitly set aside.

Scenting an unhealthy whiff of national superiority, Norton chided Ruskin for his 'narrow patriotism'.[22] On the other hand, Ruskin met with a more receptive response in Australia. In contrast to Norton's American — and patrician — independence of mind, Ruskin received a touching letter from an emigrant to New South Wales (posted to an intermediary as the writer felt too humble to address the great man himself). This new Australian professed admiration for all of Ruskin's works that he had read so far, including *Modern Painters*; his love of England above all despite loyalty to his adopted land which England did not value enough; and his vow to support as best he could (and he enclosed a small donation) Ruskin's work for the 'regeneration of England'. With unconscious irony, he declared himself most moved by the Oxford lectures, even though his account of his hard life showed he had nothing whatsoever in common with Ruskin's original audience. This lost voice of empire, still calling faintly from the footnotes of the collected Ruskin,[23] may well bring a blush today, but nevertheless reminds us how dependent a colonial community could be on images of a lost homeland — images that were bound to become idealised with time. Ruskin had exploited that connection when he spoke at Oxford of landscape, national memory and imperial destiny.

He would have been pleased that the Turners that were soon to arrive in Australia preserved fitting images of 'old England'. The then Duke of Westminster's presentation of the 1798 *Dunstanborough Castle, N.E. Coast of Northumberland. Sunrise after a Squally Night* to the new gallery in Melbourne was entirely in line with Ruskin's notions of imperial responsibility; while this noble ruin by an unpolluted sea was a fitting token of a long history. Had he known of it, Ruskin would also have approved of the Anglophile nostalgia of Alfred Felton, who since arriving in Australia in 1853 had been collecting British paintings, and whose great trust fund continues to enrich the Melbourne gallery to this day. In 1924, Felton moneys purchased another of Turner's oils, *Walton Bridges* (illus. p. 63), a serene and pastoral view of England's greatest river. Through Ruskin's perspective, these pictures offered visions of Britain that suggested history, picturesque landscape and impeccable architectural taste to a continent whose own history had been suppressed and whose colonial past was still short.

High Force, Fall of the Tees, Yorkshire 1816–18 watercolour Art Gallery of New South Wales, Sydney (cat. no. 48)

We can find this kind of imperial patrimony, involving the transfer of the mother nation's history, maintained — even if unconsciously — well into the present century, In 1953, the distinguished watercolour collector, Sir Thomas Barlow, presented Melbourne with the 1801 watercolour of the ruined Scottish palace of Linlithgow (illus. p. 60) that had belonged to Ruskin himself.

It may seem to do Turner little justice to discuss his work in this way, but he had always been acutely conscious of the potency of his British subjects for his British audience, while Ruskin had gone further and considered the application of British imagery in the larger arena of empire. Both artist and critic were intensely preoccupied with their country's character and destiny. But, while Ruskin dwelt on the exemplary values of the past, Turner was compelled to present a richer and more inclusive portrait of his land and its people that responded to constant change. This required him to completely transform the eighteenth-century tradition of picturesque or antiquarian topography, whereas Ruskin's concept of 'landscape as memorial' owed far more to that tradition than he would have cared to admit.

Their personal differences developed against very different historical backgrounds. If Ruskin was writing for a generation of Britons whose imperial and mercantile supremacy seemed assured, Turner's generation, and his father's, could take nothing for granted. Theirs were dangerous and uncertain times. Shaken first by the loss of the American colonies, and battered by the long years of war with Napoleonic France, nation and empire managed to survive and triumph, but at great loss. Victory at Waterloo was followed by economic hardship and social unrest. The new era of imperial, economic and industrial hegemony hailed by the Great Exhibition in the year of Turner's death had been hard won.[24] Throughout this period, the cultivation of national spirit was crucial. Old ideas of patriotism were dusted down, new ones formed. Advances in technology, manufacture, commerce and transport associated with the Industrial Revolution, reform and foundation of national institutions, and promotion of cultural life all contributed to a sense of identity and pride. No less in keeping with the patriotic mood of the time were investigations of the national history and landscape. Promoted by writers and theorists, the 'picturesque' movement created a context for the admiration of British scenery, so that it became no hardship to travel at home instead of abroad when the revolutionary wars cut links with continental Europe in 1793. Meanwhile antiquaries and historians combed the past for traces of the national roots.

Thus Turner grew up in an atmosphere in which the claims of progress and improvement, and of romantic, historical imagination and response to nature exerted equal force; the childhood impressions of London evoked by Ruskin were only part of the picture. Turner began his career as an architectural and antiquarian draughtsman and topographer in watercolour whose main business in the 1790s was the recording of buildings and picturesque scenery, both for private commissions and for engraving, and for exhibition at the Royal Academy. His formal painter's education came at the Academy itself, and here his professional ambitions were raised by the lofty objectives established by its first President, Sir Joshua Reynolds, to form a national school of art worthy of an empire that aspired to match those of Greece or Rome. Years later, Turner would conclude his lectures to a new generation of Academy students with the injunction to 'fix the united Standard of Arts in the British Empire'. By then he had risen to the challenge of history painting, considered the noblest rank of art for its didactic moral qualities; and it was no accident that comparison, explicit or implied, between modern Britain and the ancient empires of Rome or Carthage, or indeed Venice as in the pictures for McConnel, became a favourite theme. The war with France, from the Battle of the Nile to Trafalgar and Waterloo, would also inspire him to modern subjects of national significance. History, for Turner, was seldom an end in itself, but the medium through which he addressed issues of urgent contemporary import.

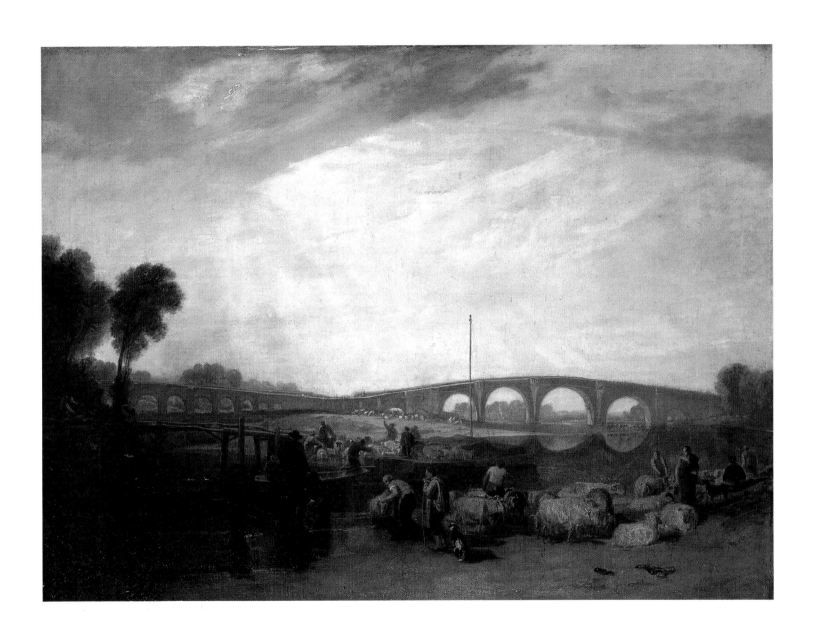

Walton Bridges c.1806 oil on canvas National Gallery of Victoria, Melbourne Felton Bequest, 1920 (cat. no. 9)

By the mid-1790s, when it was clear that his ambitions for his art could no longer be served if he confined himself to watercolour or topography, he marked a decisive break from both by exhibiting his marine, *Fishermen at Sea* (illus. p. 15) as his first oil at the Academy. This tenebrous nocturne was set off the Isle of Wight, and henceforth his depiction of Britain would be defined as much by its coasts, maritime life and sea defences as by the interior landscape. The silvery moonlight playing over a heaving swell, and the human interest of the fishermen and their lantern, announced the parallel directions of his development as both a marine and landscape painter in the coming years — a heightened awareness of natural phenomena and the recording of industry or activity specific to the place.

When introduced into Turner's increasingly dynamic pictorial world, historical associations suggest not so much Ruskin's landscape as memorial, as a sense of continuity from past to present. Turner's paintings of Dunstanborough Castle (illus. pp. 36,41) emphasise the dramatic setting with breakers rolling in to the rocky shore; the picture exhibited at the Academy bore the subtitle 'Sunrise after a Squally Night' as if to prove that hope is reborn with the flow of time and tide. As one of the greatest border castles, later strengthened by John of Gaunt and damaged but not destroyed by the Wars of the Roses, the fortress lost none of its historical interest by these developments, and it was certainly important to Turner who had made his first studies of it during a careful survey of the medieval castles of Northumberland. But surely no less important for the artist and his audience was the contemporary relevance of the castle as a symbol of survival in adversity. The first owner of the Melbourne painting, John Penn, was governor of Portland, off the Channel coast, and thus in direct line of a possible French invasion. He was doubtless comforted by Turner's fortress looking defiantly out to sea, and the clearing storm calculated to show that all dangers pass with time.25

The ancient castles that Turner drew and painted early in his career were more than antiquarian records — though they were certainly important as such, for before the modern age of conservation, these ruins were in the last stages of decay, eaten by ivy and plundered for building stone. Witnesses to history, they were also spurs to present endeavour. The defence of borders and coastline, the consolidation and protection of the kingdom, were the messages to be drawn from them in time of war. And there was surely a further sense in which they registered for Turner as patriotic images, for it had been the Welsh-born Richard Wilson, the one acknowledged British master of serious landscape painting in the past century, who had pioneered the depiction of them in a style more elevated than the topographic. Gallery-goers in Melbourne are fortunate to be able to compare Turner's Dunstanborough with one of the noblest of Wilson's castles, a view of Dolbadern painted in the early 1760s. Wilson has classicised Wales into a landscape reminiscent of Claude, thus exemplifying the process by which the untamed scenery and primordial history of 'wild Wales' was assimilated into the refined culture of George III's Britain. By the late 1790s, Turner was looking to Wilson for subjects and style. It was Wilson's example particularly that led him to explore Wales, and inspired him to select his own view of Dolbadern (illus. p. 17), first exhibited in 1800, and presented to the Academy in 1802 as his Diploma picture on his election as Royal Academician.

Turner's picture is more sombre and austere than Wilson's, and is given narrative to raise it in effect to the status of a history painting — and one with contemporary implications. Dolbadern was the stronghold of a Welsh prince, Llywelyn the Great, and had been built to defend the ancient route from Caernarvon to the Conway valley. Turner's picture refers to a later episode in its history when Owain Goch was imprisoned by his brother, Llywelyn the Last, until released by Edward's English army. A captive languishes under guard in the foreground, and in some lines of poetry added to the picture in the Academy catalogue Turner invites us to 'behold the tower / Where hopeless OWEN, long imprison'd, pin'd / And wrung his hands for liberty, in vain.' Although in a watercolour of Caernarvon, Turner included an ancient bard

singing to his audience as a tribute to the Welsh culture that the English had suppressed, here at Dolbadern we are reminded that the English came as liberators, to end a Welsh feud that had set brother against brother. It was a powerful and doubly suggestive message at a time when British liberty was threatened by Napoleon, and when the political freedoms of the British were ruthlessly curtailed by their own government, in fear of the revolutionary virus from Europe.[26]

For all that, *Dolbadern Castle, North Wales* is essentially a history picture. It was, and remains, open to the viewer to infer any connections with contemporary threats to liberty at home and abroad. It turns its back on modern Wales, and it is hard to believe that this was the same country where, since 1795, the great engineer Thomas Telford had been building the Ellesmere Canal, cutting through a mountain and crossing the Dee valley with a bridge of stone and cast iron; or, in 1804, Trevithick's Penydarren locomotive would make an epic journey that set a model for steam haulage throughout the world. Yet Turner had drawn the celebrated iron works of Richard Crawshays at Cyfarthfa, and a lime kiln near Llansteffan on the Towy estuary,[27] and he soon felt the need to assimilate such practical achievements. Abstract ideas like liberty must be justified not only by history, but by contemporary achievement.

In the same year that Turner presented *Dolbadern Castle* to the Academy, Wordsworth published his poems dedicated to National Independence and Liberty. In their allusions to the Napoleonic threat and their rallying cry to his countrymen, they should be read as counterparts to Turner's art at this period. But it was from the Augustan poets of early Georgian Britain that Turner probably borrowed his own ideas of patriotism. James Thomson, whose long nature poem *The Seasons* (1726–30) Turner quoted alongside *Dunstanborough Castle* in the 1798 Academy catalogue, was also the author of the lines to *Rule, Britannia* and of a more substantial effusion on *Liberty*; his verses enshrined a hallowed tradition that their ancient democracy gave the British a unique superiority in an ordered universe whose systems of trade and agriculture, even of climate and geography, seemed predestined to work to their advantage. While events late in the century shook such views to their roots, they did not destroy them; when threatened, Britannia's rule must be defended by all possible means, by brush and pen as well as by sword. Turner's resurrection of Thomson, and of that earlier and greater British poet, Milton, as sources for quotation or inspiration for no less than five of his exhibits in 1798, and his frequent references to these and other British poets thereafter, was surely a patriotic enterprise.[28] With his adoption of a robust painterly style based on the home-grown master, Wilson, rather than the slick and polished practitioners of the Continent, it showed him formulating a national rhetoric of landscape.

It was another Augustan poet, Mark Akenside, who helped to show Turner the value of associations of ideas; and the memory of poets, whether by quotation or by depiction of their houses or monuments, was to be one of the ways in which Turner added significance to his landscapes, especially those of the Thames Valley where many of them had lived. The ghosts of Thomson or Alexander Pope, no less than the signing of Magna Carta at Runnymede, the presence of Parliament at Westminster, or of the nation's foremost naval base at the Nore, endowed the Thames with special qualities of Britishness that underscored its beauty or picturesqueness. It was no accident that in the early years of the new century, at a low point in the war, Turner painted a series of pictures of the Thames, from its pastoral reaches west of London to the mouth of the estuary. This was manifestly a patriotic exercise, to raise national pride and confidence; and for all his appeal to historical or literary associations, he is not nostalgic — there is no resting on laurels. The land is under cultivation and improvement, the river securely defended by the navy and busy with fishermen. At Walton, farmers and their sheep are bathed in a serene summer light; in the breezy estuary, boats from the Kent and Essex shores hail each other, proclaiming that this vital waterway remains safe despite fears of invasion.

The Thames paintings were mainly exhibited in Turner's own gallery, which he had added to his London house in 1804. They were intended to be seen in groups; and the mixture of pastoral and marine subjects, dictated by the changing scenery of the river itself, formed a perfect realisation of the Augustan concept that even the smallest acts of cultivation and productivity at home had earned for the British their power over the seas of the world. After describing the sheep washing and shearing that perhaps suggested the activities depicted in Turner's *Walton Bridges*, Thomson's *Summer* concluded thus:

> A simple scene! yet hence Britannia sees
> Her solid grandeur rise: hence she commands
> The exalted stores of every brighter clime,
> ... her dreadful thunder hence
> Rides o'er the waves sublime.

When in 1811 Turner was asked by the publisher W.B. Cooke to make a series of watercolours of the south coast for engraving, he was able to expound these themes of national productivity and pride on a larger scale. The elaborate preparations he made for the task show how far his concept of British topography had advanced from its picturesque prototype. He not only toured the sites from London to Cornwall that summer, but read guides and gazetteers and made notes on history, antiquities, geology, manufacture and the character of the people. While indulging his love of marine subjects he would survey the condition of a vital maritime frontier in wartime. As published, *Picturesque Views on the Southern Coast of England* does not labour its defensive role, though it is understood; rather we learn that this most vulnerable part of the nation goes about its business — and its pleasures — undaunted. At Weymouth (illus. p. 67) they are combined in the fine bathing beaches and lobster pots, while at Lyme Regis (illus. p. 70) the sudden squall that surprises the bathers hints at larger dangers; at Teignmouth (illus. p. 69) an old ship is dismantled for its timber, dawn light signifying that it will be reborn anew. Begun in war, the project ran into peacetime, and the brilliant sunshine that sparkles in one of the later subjects, *Tor Bay, from Brixham* (illus. p. 68), reminds us that this principal port for Channel trawling may now freely resume its vocation.

Turner did not intend these subjects to carry their messages unaided. Having experimented with poetry for some years, he drafted a long letterpress that he hoped would accompany them. Mercifully rejected by Cooke, it contains among its ponderous reflections on history, geography and economy one of the clearest statements we have of his patriotism, and shows him adopting more or less wholesale the Augustan notion of national self-sufficiency and commercial dominance. Discussing the hemp industry of Bridport, which supplied rope to rig the ships that defended the nation and carried her international trade, Turner enjoins his countrymen to:

> Plant but the ground with Seed instead of Gold,
> Urge all our barren tracts by Agriculture skill
> And Britain Britain British canvass [sic] fill.[29]

As a meditation on the places he visited and drew, Turner's poem strove to anticipate the educated and imaginative response to his designs. In the event, they had to stand alone, and it was perhaps partly the failure of this literary enterprise that encouraged him to make the human and expository content of his later topographical pictures more specific. It was in his great series of *Picturesque Views in England and Wales*, begun in 1826, of which a specially fine group of watercolours are gathered in this exhibition, that Turner presented his richest and most informed portrait of the landscape, history and people of his country.

Weymouth, Dorsetshire *c.* 1811 watercolour Yale Center for British Art, New Haven Paul Mellon Collection (cat. no. 44)

Tor Bay, from Brixham *c*.1816–17 watercolour The Syndics of the Fitzwilliam Museum, Cambridge (cat. no. 47)

Teignmouth, Devonshire *c.*1813 watercolour Yale Center for British Art, New Haven Paul Mellon Collection (cat. no. 46)

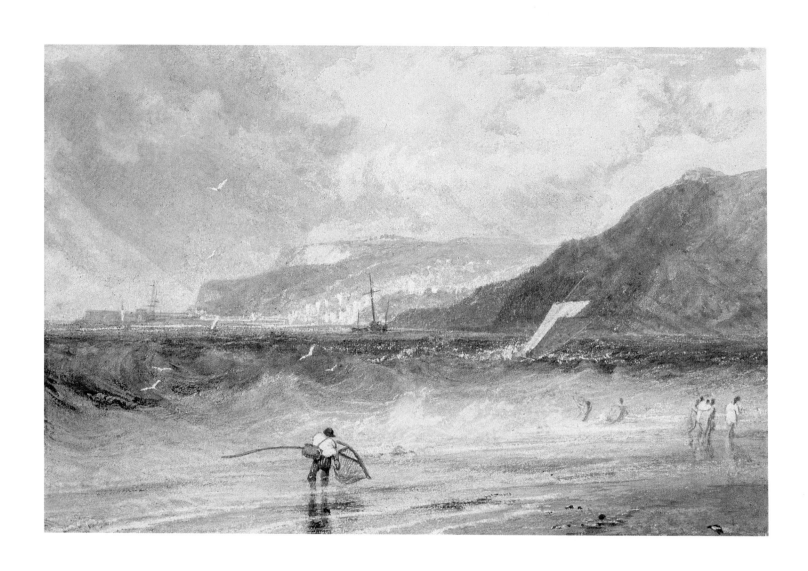

Lyme Regis, Dorsetshire: A Squall *c.*1812 watercolour Glasgow Museums: Art Gallery and Museum, Kelvingrove (cat. no. 45)

Peace is celebrated in the holiday view of Plymouth (illus. p. 80): marines are still stationed here, but appear at leisure on a sultry day, with an ale tent ready to relieve their thirst. Turner has fixed the scene firmly in the immediate post-war period by including the massive breakwater completed in 1820 to shelter the harbour — literal proof that the nation was now safe within its borders. Yet the domestic stresses of these years — economic and political — are registered in scenes of pensioned-off servicemen or a Reform meeting, and the storms that conspicuously rise and clear throughout the *England and Wales* series reminded viewers that they had lived — and might live again — through turbulent times. A squall rises at Lancaster Sands (illus. p. 75), sending figures crossing the treacherous quicksands of Morecombe Bay at low tide scurrying for the safety of the shore. With what Ruskin called 'undirected rage and anarchy of enormous power', a storm off Land's End condemns a ship to certain destruction despite the guiding beacon of the recently-built Longship's Lighthouse (illus. p. 122). In no more than a light breeze at Gosport outside Portsmouth Harbour (illus. p. 79), Turner allows a touch of humour; despite the naval semaphores that had been so necessary during the war, a near collision is only narrowly averted. Storms pass over at Pembroke Castle (illus. p. 78) and Holy Island (illus. p. 112). At Alnwick (illus. p. 77), a calm moon illumines the ancient castle — intact and inhabited as it remains today — and its Georgian Lion Bridge, while stags keep watch in the park.

Like the *Southern Coast* series, *England and Wales* is designated as a set of 'Picturesque Views', but the presence of these historic or architectural subjects again reminds us how far in the complete series Turner had moved on from the traditional understanding of the term. Not only are many of the subjects coast scenes, in recognition of the national importance of harbours, maritime trade and naval defence, but wherever appropriate there is a wealth of incident and activity. The historical presence is always acknowledged, to connect the nation to its past, but the emphasis is on the present. Turner's Britain, in these views at least, had not yet felt the sunset touch. We are a world away from the 'choice and picturesque natural *scenery*' of which Wordsworth wrote when railing against railways, from that territory of static and uninhabited beauty to be admired because pundits, poets or painters pronounced it admirable. We are not quite in the world of *Rain, Steam and Speed*, but well on the way as Turner lays out in all its richness the continuing life of the nation and its people. Many years earlier, writing of the launching of a merchant ship at Greenwich, Turner had asked:

> Why not in Britain Novelty is found
> Why should not novelty again resound
> Then try on Thamias fertile shore[30]

It is indeed ironic that Ruskin's praise of Turner's nature-painting should have so long defined the artist as a modernist, when his art embraced, both in its subjects and its style, all those contemporary imperatives of progress, change and improvement from which Ruskin hoped to sound a national retreat.

Notes

1. Letter no. 1560, W.W. to Edward Moxon, 23 January 1845, in *Letters of William and Dorothy Wordsworth*, Ernest de Selincourt (ed.), Oxford: Clarendon Press, 1939, vol. 3, pp. 1242–1243. For Turner's picture and Wordsworth's railway protests, see especially John Gage, *Turner: Rain, Steam and Speed*, London: Allen Lane at the Penguin Press, 1972.
2. Wordsworth as reported by Joseph Farington, 28 April 1807, in James Greig (ed.), *The Farington Diary*, London: Hutchinson, 1924, vol. 4.
3. Theophile Gautiér, *Histoire du Romantisme*, 3rd edn, Paris: Charpentier, 1877, p. 371. Mixed motives are attributed to the picture by John McCoubrey, 'Turner's Railway: Turner and the Great Western', *Turner Studies*, 1986, vol. 6, no. 1, pp. 33–39; the most positive view is persuasively argued by John Gage, 1972.
4. Edward Tyas Cook and Alexander Wedderburn (eds), *Modern Painters, I*, in *The Works of John Ruskin*, 39 vols, London: George Allen, 1903–12, vol. 3, p. 231 (hereafter, Ruskin, *Works*).
5. *Praeterita, I*, in Ruskin, *Works*, vol. 35, p. 217.
6. *The Harbours of England*, in Ruskin, *Works*, vol. 13, p. 26.
7. For Turner and steam boats, see most recently Judy Egerton, *Turner: The Fighting Temeraire*, London: National Gallery, 1995, pp. 56–70; a full discussion will appear in W.S. Rodner, *Turner and Steam: J.M.W. Turner, Romantic painter of the Industrial Revolution*, Berkeley and Los Angeles: University of California Press (forthcoming).
8. Evelyn Joll, 'Turner at Dunstanborough 1797–1834', *Turner Studies*, 1988, vol. 8, no. 2, pp. 3–7, discusses Turner's various views of the castle.
9. *Arnold's Magazine*, May–June, 1834, p. 136.
10. *Modern Painters, I*, in Ruskin, *Works*, vol. 3, p. 571.
11. *Modern Painters, V*, in Ruskin *Works*, vol. 7, pp. 374–388.
12. Ibid.
13. George Ticknor, *Life, Letters and Journals of G. Ticknor*, 2nd edn, 1876, London: Sampson Low, Marston, Searle and Rivington, vol. 1, p. 272.
14. For Henry McConnel, see Julian Treuherz, 'The Turner Collector: Henry McConnel, cotton spinner', *Turner Studies*, 1986, vol. 6, no. 2, pp. 37–42.; for adverse criticism of conditions in McConnel's mills, see Alexis de Tocqueville, *Journeys to England and Ireland*, G. Laurence and K.P. Mayer (trans.), J.P. Mayer (ed.), London: Faber and Faber, 1958, p. 108, and Karl F. Schinkel, *The English Journey: Journal of a visit to France and Britain in 1826*, David Bindman and Gottfried Riemann (eds), New Haven: Yale University Press, 1993, p. 175.
15. On the fire and Turner's pictures, see Katherine Solender, *Dreadful Fire! Burning of the Houses of Parliament* Cleveland: Cleveland Museum of Art, 1984, and Evelyn Joll, 'The Burning of the Houses of Parliament', in this catalogue, pp. 86–99.
16. Archives of the Cleveland Museum of Art; see Katherine Solender, 1984, p. 62.
17. *Pre-Raphaelitism*, in Ruskin, *Works*, vol. 12, p. 389.
18. *Inaugural Lecture*, in Ruskin, *Works*, vol. 20, p. 36.
19. E. Helsinger, 'Ruskin and the Politics of Viewing: Constructing national subjects', M. Victor Leventritt Lecture, Arthur M. Sackler Museum, Harvard, 1994, in *Harvard University Art Museum Bulletin*, 1994, vol. 3, no. 1, p. 26.
20. *Notes on his Drawings by Turner*, in Ruskin, *Works*, vol. 13, p. 430.
21. John Lewis Bradley and Ian Ousby (eds), *The Correspondence of John Ruskin and Charles Eliot Norton*, Cambridge: Cambridge University Press, 1987, p. 312.
22. Ibid., p. 192.
23. Ruskin, *Works*, vol. 30, pp. 26–28.
24. For a brilliant account of patriotism, national renewal and integration in this period, see L. Colley, *Britons: Forging the nation 1707–1837*, New Haven: Yale University Press, 1992.
25. On John Penn and his brother Granville, author of a book stressing the inspirational effects of history, see John Gage, *J.M.W. Turner, 'A Wonderful Range of Mind'*, New Haven: Yale University Press, 1987, pp. 211–212.
26. On Turner's Dolbadern, see Andrew Wilton, *Turner in Wales*, Llandudno: Mostyn Art Gallery, 1984, p. 69, and Eric Shanes, *Turner's Human Landscape*, London: Heinemann, 1990, pp. 60–63; for Wilson's picture, see David H. Solkin, *Richard Wilson*, London: Tate Gallery, 1982, pp. 91–94, 215–216, plate 105.
27. Turner's drawings of Cyfarthfa, near Merthyr Tydfil (made in 1798) are in the Turner Bequest, XLI, 1–4; his drawing of Llansteffan (1795) is Turner Bequest XXVIII D; see Anne Lyles, *Young Turner: Early work to 1800*, London: Tate Gallery, 1989, pp. 27,34.
28. On Turner's quotations from British poets, and his own poetry, see especially Andrew Wilton and Rosalind Mallord Turner, *Painting and Poetry: Turner's Verse Book and his work of 1804–1812*, London: Tate Gallery, 1990, and J. Ziff, 'Turner's First Poetic Quotations: An examination of intentions', *Turner Studies*, 1982, vol. 2, no. 1, pp. 2–11.
29. See Andrew Wilton and Rosalind Mallord Turner, 1990, pp. 60–61.
30. Ibid., p. 99.

Picturesque Views in England and Wales

Turner's largest and most ambitious series of watercolours was produced between 1824 and 1838 for Charles Heath's *Picturesque Views in England and Wales* — a comprehensive pictorial survey of British scenery comprising ninety-six engravings after the artist's work. Many of these watercolours rank among the most wonderful objects of their kind. The series of engravings came out in twenty-five parts between 1827 and 1838, when the scheme, having met with poor response from the public, ended in Heath's bankruptcy.

R. Brandard engraver, after **J.M.W. Turner** *Lancaster Sands* 1828 from *Picturesque Views in England and Wales* engraving Art Gallery of New South Wales, Sydney
Gift of Mrs Arthur Acland Allen, 1940 (cat. no. 115)

Lancaster Sands *c.*1826 watercolour British Museum, London (cat. no. 60)

Richmond, Yorkshire *c.*1826 watercolour British Museum, London (cat. no. 61)

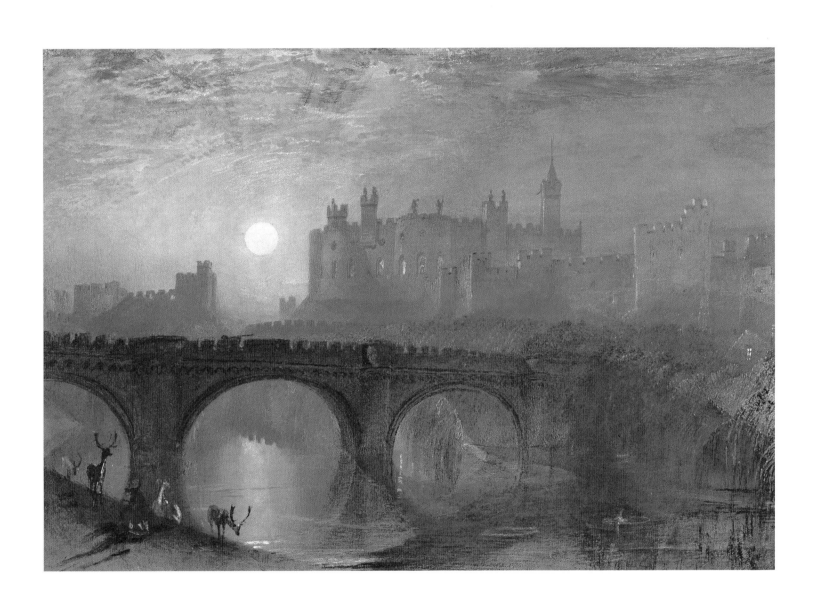

Alnwick Castle, Northumberland *c.*1829 watercolour Art Gallery of South Australia, Adelaide South Australian Government Grant, 1958 (cat. no. 63)

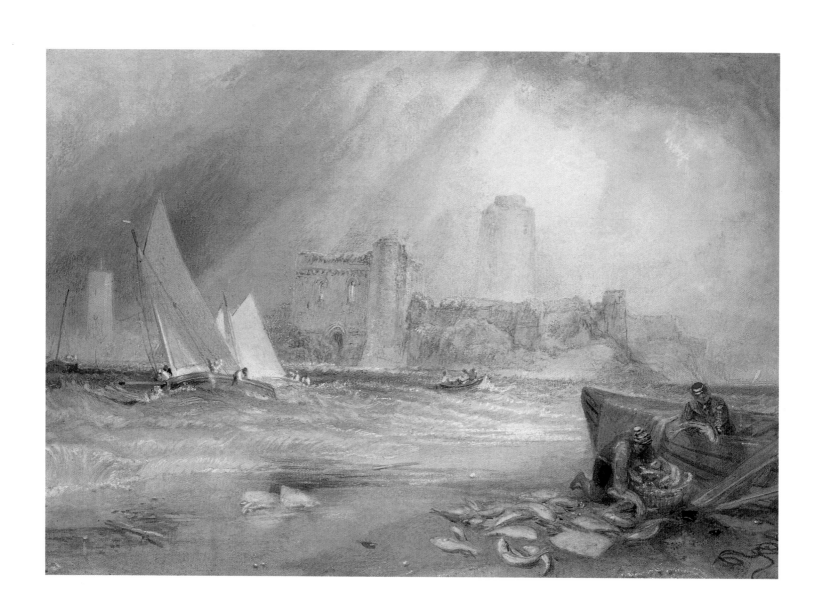

Pembroke Castle, Wales *c.*1829 watercolour Holburne Museum and Crafts Study Centre, Bath, Somerset (cat. no. 66)

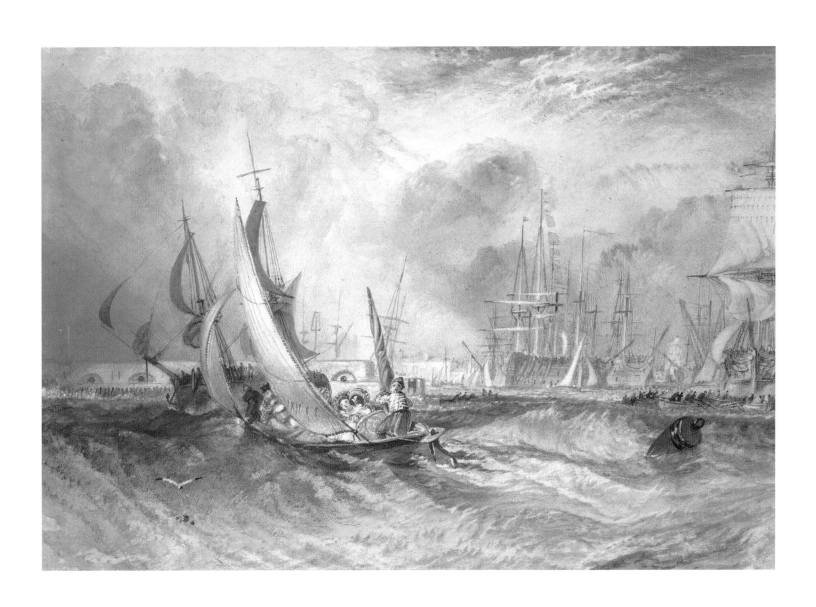

Gosport, Entrance to Portsmouth Harbour *c.*1829 watercolour Private Collection (cat. no. 65)

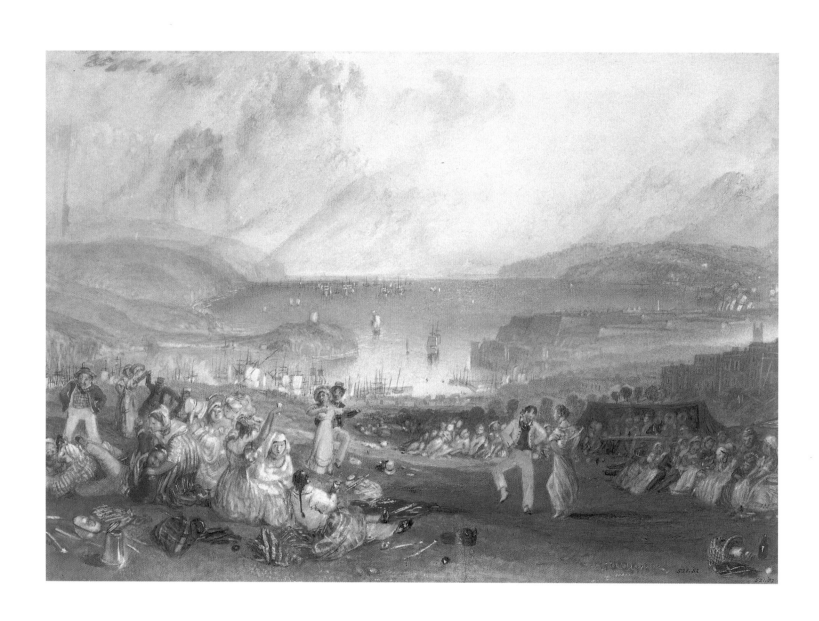

Plymouth, Devonshire *c.*1830 watercolour Victoria and Albert Museum, London (cat. no. 67)

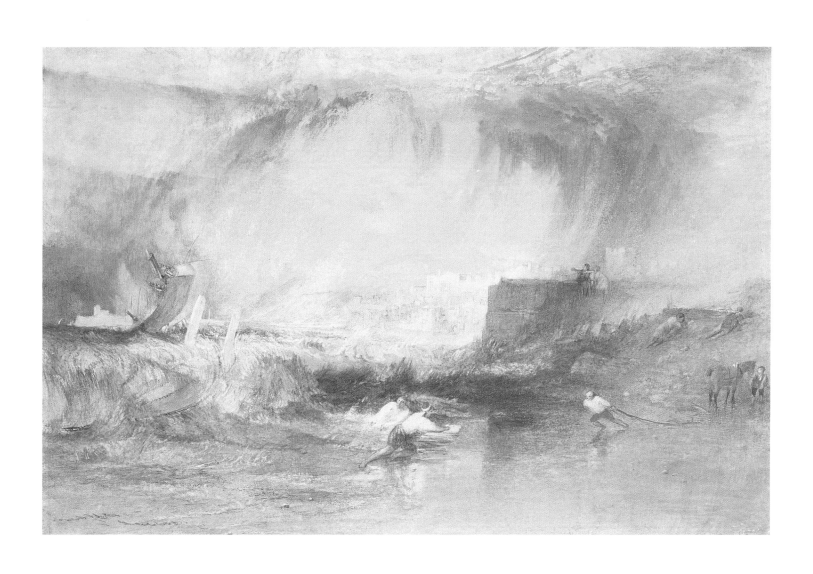

Lyme Regis, Dorsetshire *c.*1834 watercolour Cincinnati Art Museum Gift of Emilie L. Heine in memory of Mr and Mrs John Hauck (cat. no. 72)

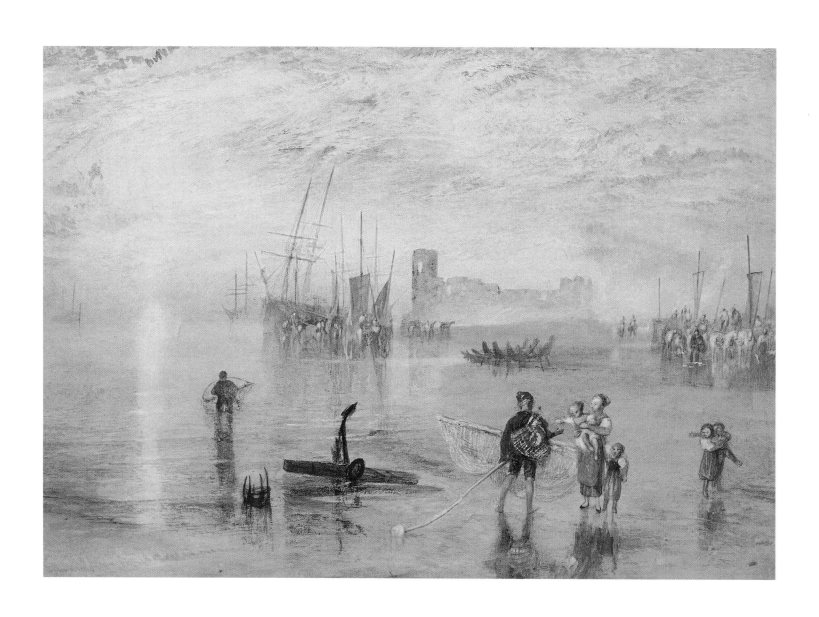

Flint Castle, North Wales c.1834 watercolour National Museum and Gallery of Wales, Cardiff (cat. no. 73)

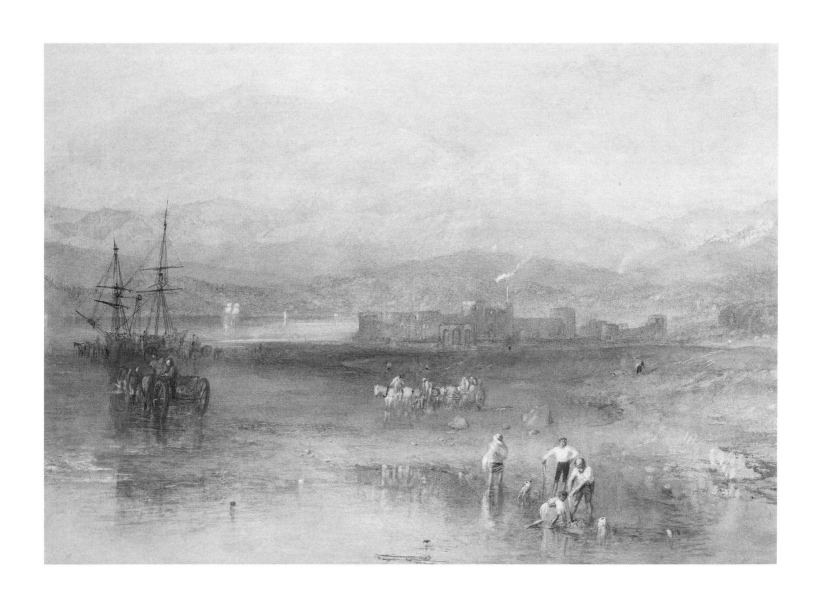

Beaumaris, Isle of Anglesey c.1835 watercolour Henry E. Huntington Library and Art Gallery, San Marino, California (cat. no. 75)

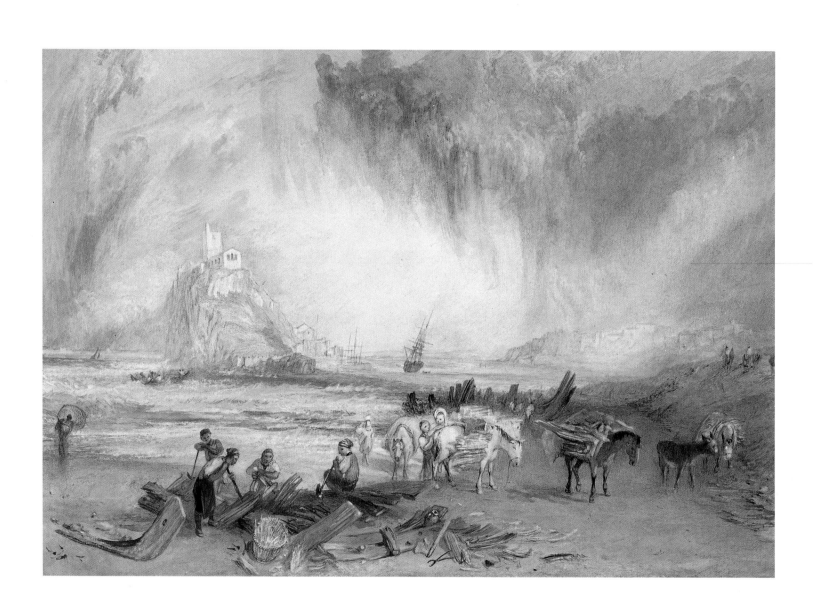

St Michael's Mount, Cornwall c.1836 watercolour University Art Gallery, Liverpool (cat. no. 77)

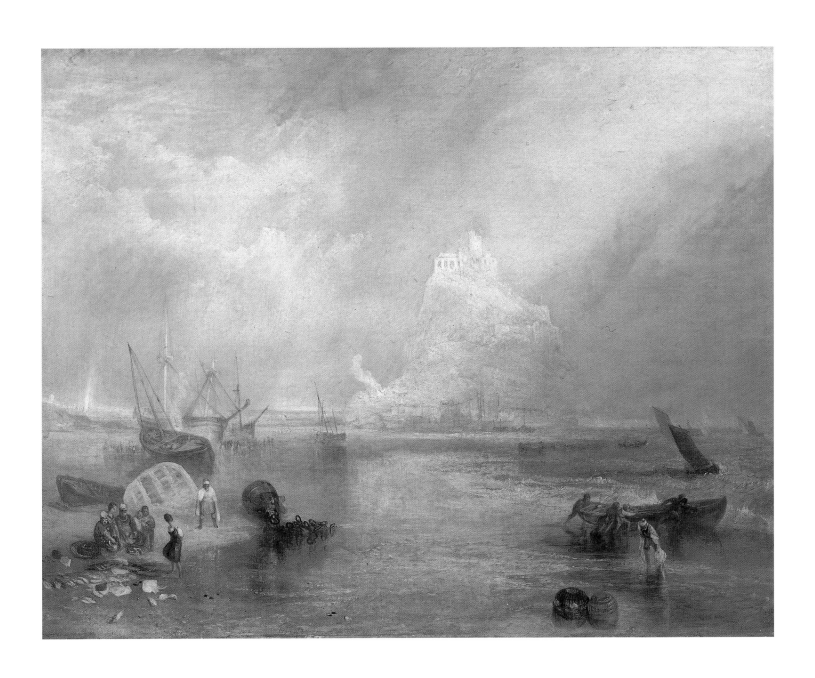

St Michael's Mount, Cornwall R.A. 1834 oil on canvas Victoria and Albert Museum, London (cat. no. 17)

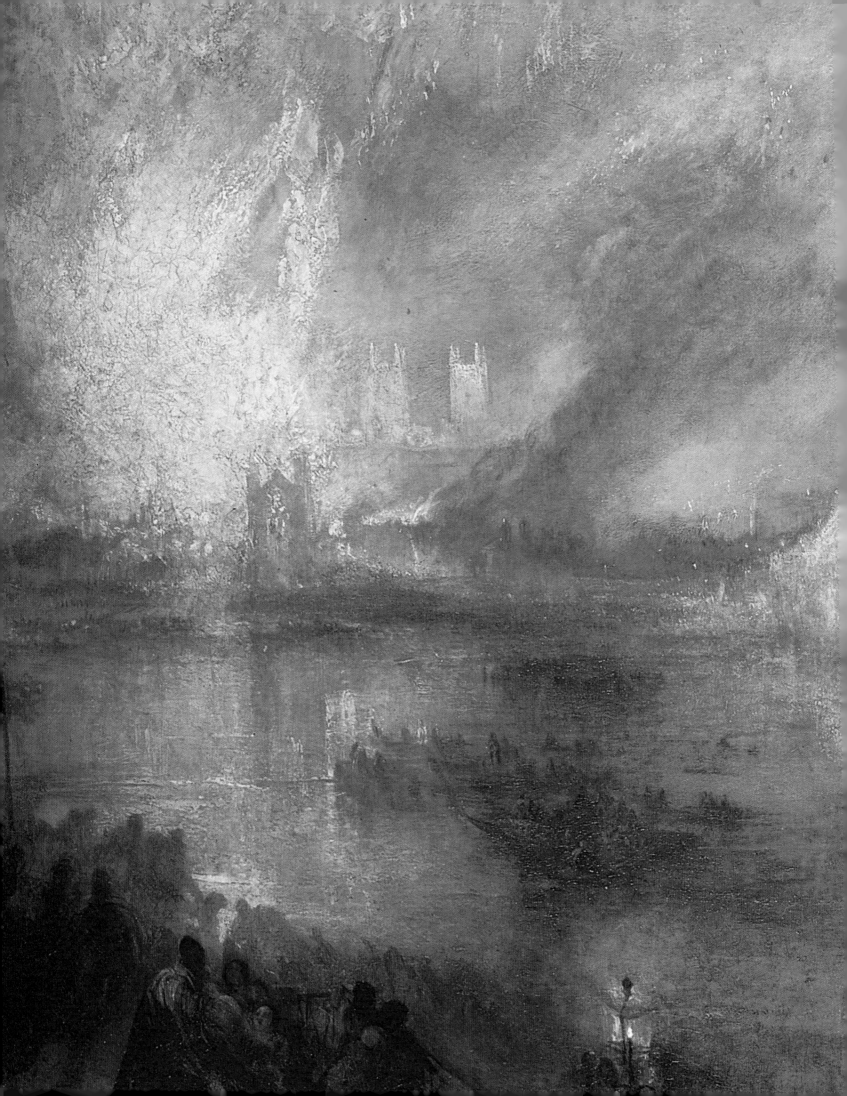

The Burning of the Houses of Parliament

Evelyn Joll

The Burning of the Houses of Lords and Commons, 16th October, 1834 1835
oil on canvas
Philadelphia Museum of Art
John Howard McFadden Collection
(cat. no. 19)
details left and above

Napoleon required of his commanders that they should above all be *lucky*, by which he meant that they should possess the knack of being in the right place at the right time. Turner certainly displayed this kind of luck on a number of occasions during his career: for instance, when only seventeen in 1792, he exhibited a watercolour at the Royal Academy of *The Pantheon, the Morning after the Fire* (British Museum, London; W 27), an eyewitness account of the scene in Oxford Street which testifies to his early interest in contemporary events, especially those connected with a disaster. But the supreme example of Turner's luck in this respect was his presence in London on the night of 16–17 October 1834, when the Houses of Parliament caught fire. If one were allowed to choose any artist to record the event, one would unhesitatingly opt for Turner.[1]

The two paintings of the burning of the Houses of Parliament (illus. pp. 88,89), exhibited by Turner in 1835, are among his very greatest works. In *The Romantic Rebellion*, Kenneth Clark wrote: 'Both his versions of this historic event are now in American museums [Philadelphia and Cleveland] and are among the very few works of art which I would have felt justified in forcibly retaining in England.'[2] The version now in Cleveland was indeed originally earmarked by Turner to form part of his bequest of his finished pictures to the nation.

The group of buildings that formed the Palace of Westminster were not only very old but were chiefly built of timber covered with plaster. The distinguished architect, John Soane, had warned in 1828 that 'such an extensive assemblage of combustible material' constituted a serious fire hazard. Although a number of architects were consulted about rectifying matters, nothing was done beyond refurbishing the Exchequer Offices, including the office known as the tally-room. It was this that led to the fire.

'Tallies', usually made of hazelwood, were notched sticks on which Exchequer accounts were recorded from the twelfth century until 1826. The sticks were then split lengthwise so that both the payer and the Exchequer retained a record; the larger piece went to the payer while the smaller, known as the foil, remained with the Exchequer. In the past these foils had been burnt in the fireplace of the tally-room, but this method was no longer available due to the refurbishment. By 1834 two cartloads of foils had accumulated and it was planned to dispose of them by burning out of doors. But the objection that this would cause a great bonfire and might lead to interference from the police caused the plan to be abandoned. It was decided instead to burn them in the stoves of the House of Lords. Two men, Joshua Cross and Patrick Furlong, were ordered to bring the foils from the Exchequer to the House of Lords. They did so on the evening of 15 October. The men returned at 6.30 the next morning to begin burning the foils, having been cautioned to do so carefully and damp them occasionally as the wood, being at least eight years old, was tinder-dry. Not surprisingly the two men found this a slow and tedious job and were soon to disregard their instructions: Richard Reynolds, who looked after the furnaces in the House of Lords, saw Cross shovelling the foils into the fires as fast as he could which created 'an astonishing blaze'.

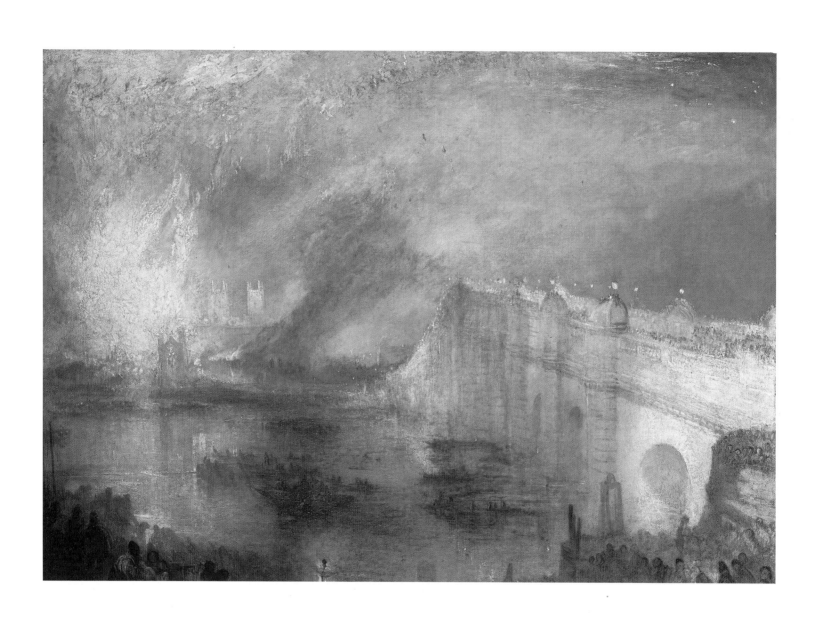

The Burning of the Houses of Lords and Commons, 16th October, 1834 1835 oil on canvas Philadelphia Museum of Art John Howard McFadden Collection (cat. no. 19)

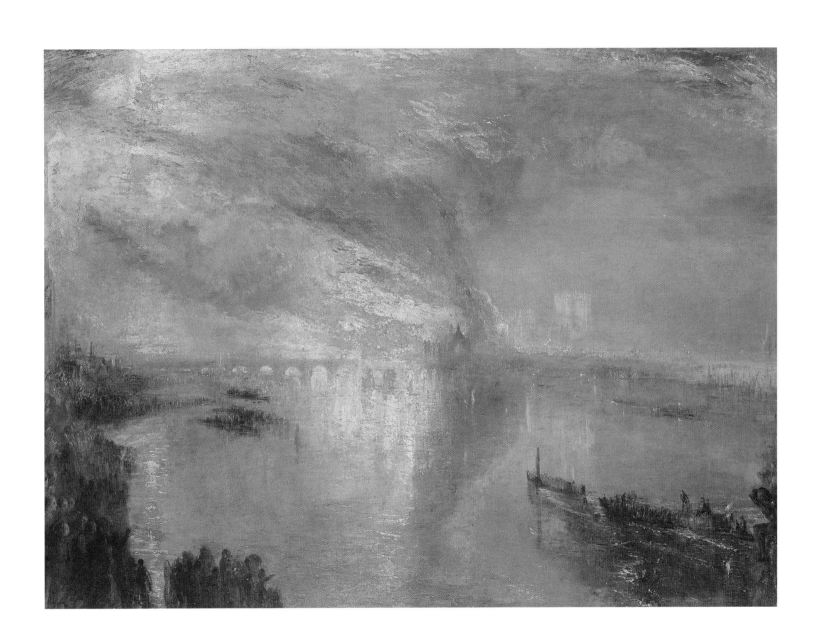

The Burning of the Houses of Lords and Commons, October 16, 1834 R.A. 1835 oil on canvas Cleveland Museum of Art Bequest of John L. Severance (cat. no. 20)

During the afternoon, at about 4 o'clock, two visitors from the country were shown around the House of Lords by the housekeeper, Mrs Wright. One of the visitors, John Snell, at once felt the heat coming through the floor of the chamber and was 'much grieved that there was so much smoke in the House I could not see the tapestry, and I went over to put up my hand to convince myself it was tapestry ...'[3] It was noticed that the temperature in the House of Lords had now reached 60°F; nevertheless, Mrs Wright locked up the House at 5 o'clock without reporting the matter. Cross and Furlong subsequently claimed that they also had left the building by 5 o'clock. It was only about an hour later that the building caught fire and spread so rapidly that by 7 o'clock the entire House of Lords was ablaze.

The news of the fire spread as fast as the flames, and crowds soon collected in such force that the approaches to Parliament Street and Westminster Bridge became entirely blocked, causing many to take to boats in order to watch the fire.

The spectacle was indeed a dazzling one in every sense: great pillars of flame and smoke, sparks flying, accompanied by the crash of falling timbers and the sound of splintering glass, while the bells of St Margaret's Westminster tolled mournfully. Lawrence Gowing has compared Turner's representation of the scene, in the version now in Philadelphia, to grand opera where 'the spectators gape at the spectacle before them'[4] — at the bottom right of the picture, the onlookers within the circular parapet of Westminster Bridge (much exaggerated in height by Turner) do look as if they are in a box at the theatre. This theatrical element in Turner's picture echoes a report in *The Gentleman's Magazine*: '[A]bout half-past nine an immense column of flame burst forth through the roof of the House of Lords ... and so struck were the bystanders with the grandeur of the sight at this moment, that they involuntarily (and from no bad feeling) clapped their hands as though they had been present at the closing scene of a dramatic spectacle.'

Meanwhile St Stephen's Chapel, where the House of Commons sat, was also ablaze; its east end appears in the very centre of the flames in the Philadelphia picture, with the twin towers of Westminster Abbey beyond to the right.

Accounts of the fire differ as to the direction of the wind, making it difficult to decide whether Turner has shown the position of the flames accurately or whether he altered this aspect to heighten the drama. *The Times* reported that the wind blew to the northeast at first — therefore towards Westminster Bridge, as shown in the Philadelphia picture. Other reports claim that the wind was due south to begin with and then veered to the west. In view of the fact that Westminister Hall seemed certain to catch fire at one point, *The Times* account seems more plausible. But all reports agree that a lucky change in the wind came just in time to save it. Westminster Hall was the oldest building in the Palace, begun by William Rufus in 1097. It was originally used as the meeting place for the King's Council — from which Parliament itself developed. The fears for this historic building were so great that the reporter from *The Gentleman's Magazine* wrote that, on seeing its gable apparently alight: 'I felt as if a link would be burst asunder in my national existence.'

Where was Turner during this momentous night? In the Turner Bequest there are two sketchbooks labelled 'Burning of the Houses of Parliament'. The smaller one (TB CCLXXXIV) contains a few rough pencil studies, each 10.1 x 15.2 cm, which have been proposed as eyewitness sketches of the fire, the kind of rapid notations Turner could have made on the spot even among jostling crowds. However, their identification with the fire is far from proven. Boats on a beach may be an alternative interpretation of these rough notations, but we cannot entirely rule out that some may relate to a fire.

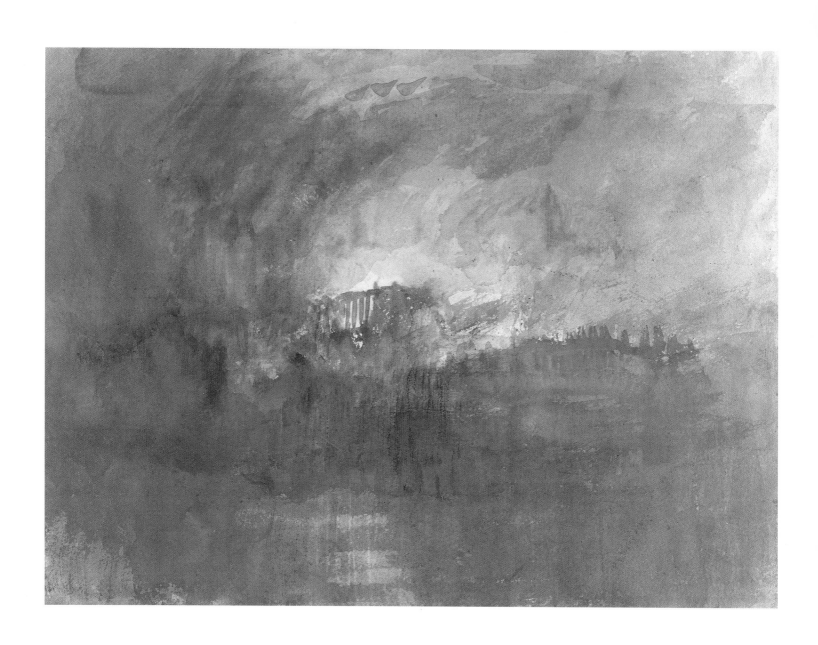

Colour study: The Burning of the Houses of Parliament 1834 watercolour Tate Gallery, London Bequeathed by the artist, 1856 (cat. no. 70)

Colour study: The Burning of the Houses of Parliament 1834 watercolour Tate Gallery, London Bequeathed by the artist, 1856 (cat. no. 71)

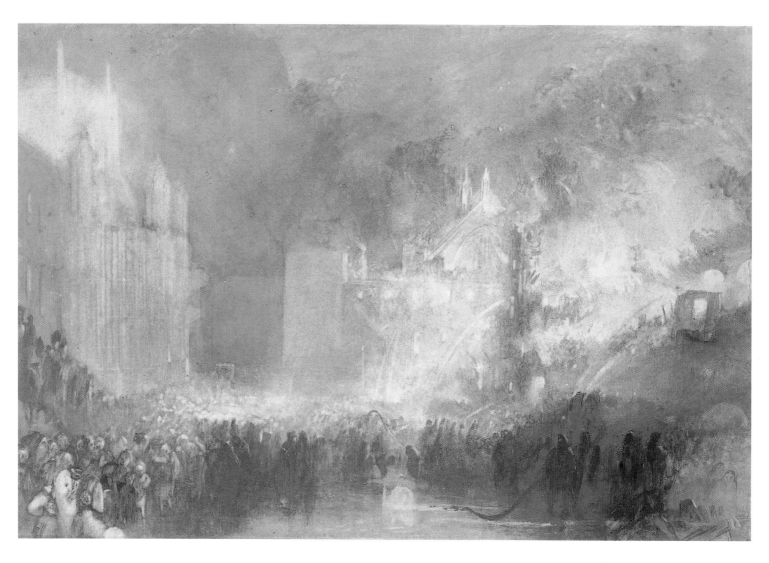

The other, larger sketchbook (TB CCLXXXIII) consists of nine watercolour studies of a fire, each 23.2 x 32.6 cm, but this book is also the subject of controversy as none of the sheets contains any distinguishable architectural feature which can be connected with the Houses of Parliament with absolute confidence. Nonetheless, in view of the two oils, it seems unnecessarily cautious to doubt that these studies refer to the fire on the night of 16 October. There then arises the question of when they were done. Some writers, Lawrence Gowing for example, have suggested that they convey such a sense of contact with the event that Turner must have done them on the spot while watching from the bank. I followed this view in the catalogue raisonné of Turner's oils (rev. edn 1984). Other writers, such as Andrew Wilton, have contended that it would have been almost impossible, even for Turner, to use watercolour in this way under the conditions prevailing that night. Looking at the sketches, one feels confident that if they were not made on the spot, then they must have been painted within a very few days, perhaps even hours after the fire.

At one time the on-the-spot argument seemed to gain force because some of the pages of the sketchbook are blotted as though Turner, in his haste to record the scene, had turned them over while still wet. But it was then pointed out that the same effect might just as well be due to the sketchbook's immersion when the cellars of the Tate Gallery were flooded in 1928.

On the assumption that these sketches do relate to the fire, Richard Dorment has proposed a chronology for them[5] which indicates that Turner began watching the fire from close to Westminister Bridge, the viewpoint of the Philadelphia picture, but then moved downstream, still on the south bank, to near Waterloo Bridge, from where the Cleveland version was planned, probably in the early hours of the morning of 17 October. It would seem that Turner was at the scene from soon after the fire began until dawn the next day.

The two sketches in the exhibition (illus. pp. 92,93), in which fire merges with both sky and water, are images of the most vivid brilliance — they are pages 1 and 6 in the sketchbook. It seems likely that the pages were not painted in order from 1 to 9, but that Turner dodged about in the book. Both sketches relate to the Philadelphia picture and, following Dorment's hypothesis, pages 1, 2 and 7 are the earliest views, probably taken from a spot just to the left of Westminster Bridge looking directly across the river towards the Palace of Westminister. Dorment believes that pages 5 and 6 were perhaps taken from further back, showing the parapet of the bridge stretching to the left crowded with spectators. Pages 3, 8 and 9 show the river from Waterloo Bridge when the fire had abated slightly, the viewpoint of the Cleveland picture, although in it Turner depicts the fire burning as fiercely as ever.

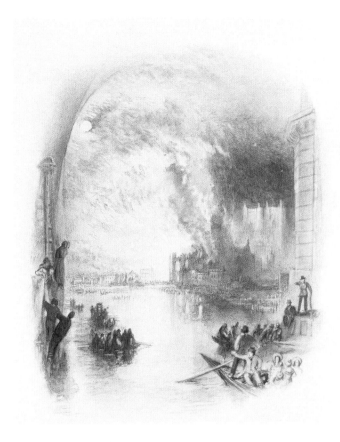

Destruction of Both Houses
of Parliament by Fire, October 16, 1834
c.1835
watercolour
14.0 x 11.5 cm (5-1/2 x 4-1/2")
vignette
Museum of Outdoor Arts,
Englewood, Colorado

Later Turner painted a more finished watercolour (illus. p. 94) showing the fire-fighters attempting to bring the blaze under control in Palace Yard, which means that he must have crossed Westminster Bridge at some point in order to witness this scene. During the night he was also seen in a boat on the Thames with fellow Academician Clarkson Stanfield, and students from the Royal Academy. It was this trip that led to a vignette of the fire as shown from the river through the arches of Westminster Bridge. This was later engraved in 1836 in the *Keepsake* to illustrate a poem by the editor, the Hon. Mrs Norton, entitled 'The Burning of the Houses of Lords and Commons'.

In 1835 Turner exhibited his two paintings of the fire: the first, now in Philadelphia, was shown at the British Institution in February; and the painting now in Cleveland was exhibited at the Royal Academy in May. In fact the Philadelphia version was to a very large extent painted at the British Institution during the Varnishing Days as is recorded by the minor Norfolk artist E.V. Rippingille.

> Turner was there, and at work before I came, having set-to at the earliest hour allowed. Indeed it
> was quite necessary to make the best of his time, as the picture when sent in was a mere dab of
> several colours, and 'without form and void', like chaos before the creation ... for the three hours
> I was there — and I understood it had been the same since he began work in the morning —
> he never ceased to work, or even once looked or turned from the wall on which his picture hung.
> All lookers-on were amused by the figure Turner exhibited in himself, and the process he was
> pursuing with his picture ... Presently the work was finished: Turner gathered his tools together,
> put them into and shut up the box, and then, with his face still turned to the wall, and at the same
> distance from it, went sideling off, without speaking a word to anybody, and when he came
> to the staircase, in the centre of the room, hurried down as fast as he could. All looked with a
> half-wondering smile, and [Daniel] Maclise, who stood near, remarked, 'There, that's masterly,
> he does not stop to look at his work; he knows it is done, and he is off'.

S.W. Parrott *c*.1813-1878
Turner on Varnishing Day *c*.1846
oil on panel
25.5 x 23.0 cm (10 x 9")
Ruskin Gallery, Sheffield
Collection of the Guild of St George

The Herefordshire painter, John Scarlett Davis, also reported this scene although he described a less respectful audience: 'He finished it on the walls the last two days before the Gallery opened to the public. I am told it was good fun to see the great man whacking away with about fifty stupid apes standing round him, and I understand he was cursedly annoyed — the fools kept peeping into his colour box and examining all his brushes and colours.' He later continued: 'I have heard it spoken of as a failure — a devil of a lot of chrome.' This seems a very harsh verdict for, although Turner's fondness for yellow was well known (leading to some not very good jokes by the critics along the lines of: 'Mr Turner's exhibits show him to be afflicted with the jaundice again this year'), to paint a fire *without* using a lot of chrome would seem impossible.

The accuracy of Rippingille's observation is confirmed by the small panel, *Turner on Varnishing Day* by S.W. Parrott probably painted in 1846, which shows Turner with his nose almost touching his canvas.

In view of Turner's well-documented refusal to allow anyone to watch him at work, his practice on Varnishing Days seems contradictory, but he clearly made an exception for his fellow Academicians — and, by this date in his career, he must have realised that his methods were impossible to imitate. John Gage has shown that Turner's performances on Varnishing Days were compared by his contemporaries to the violinist Paganini who was at this period (1831–34) astonishing English audiences with his virtuoso playing.[6]

EXTERIOR OF THE LATE HOUSES OF PARLIAMENT.
TAKEN FROM PALACE-YARD.

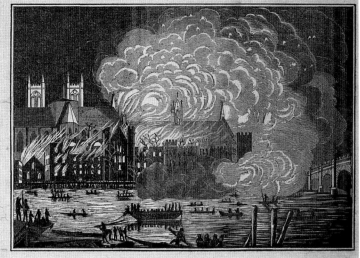

VIEW OF THE FIRE.
TAKEN FROM THE SURREY SIDE OF THE RIVER, ABOVE WESTMINSTER BRIDGE.—OCTOBER 16, 1834.

INTERIOR OF THE HOUSE OF LORDS.

The sketch from which the above engraving has been made was taken at the opening of the last session of parliament. The view is supposed to be taken from below the bar, at which the Speaker and members of the Commons were received. The King is seated on the throne, and the peers are in their full robes, as customary on such occasions. On the right of the throne are the episcopal benches; and on the same side of the house, facing the table and the woolsack, are those which the ministers and their chief supporters occupied. On the left of the throne are the opposition benches. A number of cross benches, not introduced into this view, were ranged below the table, and extended quite down to the strangers' bar. This noble apartment was hung with tapestry, representing some of the most signal naval victories of Great Britain, including the invasion by the Spanish armada, all of which have been consumed. This print, from the necessity which existed for completing our arrangements at a certain hour, it has been found impossible to render such as we could have wished. It will, however, suffice to give a general idea of the character of the building.

INTERIOR OF THE HOUSE OF COMMONS.

The above engraving is taken from below the bar, the house in debate. In front of the chair is the table, with the clerks of parliament, to which all bills, returns to orders, and petitions are brought up. The benches on the right of the chair are called the "Treasury Benches;" those on the left the "Opposition;" the front one at either side being occupied by the leaders of the respective parties. The figure standing at the table is supposed to be in possession of the house, and the member on the opposite side, with the hat off, is supposed to be replying to some question. During the last few years the members have generally ticketed the places they intended to occupy; but, previous to the last session, cavities were made as depositories for cards, a plan that met with general approbation. On the front treasury bench sat, during the last session, Lord Althorp, Lord J. Russell, Lord Palmerston, Mr. Secretary Rice, Mr. E. Ellice, Mr. C. Wood, and, (until their secession from the administration) Sir James Graham and Mr. Stanley, who subsequently took their station on what are called the "Neutral Benches," on the same side, but below the range of the table. The front bench, on the opposite side, presented a singular array of talent and conflicting political partisans. There sat Sir Robert Peel, within a short distance of the Speaker's chair, and almost in immediate contiguity were Messrs. O'Connell and Cobbett, the latter always remarkable by his pepper and salt coat, with drab inexpressibles and continuations to match. Mr. Hume has for several years kept the same place, close to the second pillar on the second row, at the opposition side, though disclaiming connection with either party. Mr. A. Baring, Sir R. Inglis, Mr. C. W. Wynn, Mr. D. W. Harvey, and Mr. Shell, generally occupied seats on the neutral benches at the same side of the house, and nearer to the bar.

FURTHER PARTICULARS.

Mr. Cooper's STATEMENT.—The following letter from Dudley, dated Sunday night, Oct. 26, throws a great degree of doubt on the statement which Mr. Cooper made before the Privy Council. If the writer be rightly informed,

THE LATE FIRE.
INVESTIGATION BEFORE THE PRIVY COUNCIL.

TUESDAY.—The gentleman who was sent down specially to Dudley, by order of the lords of the Privy Council, arrived in town yesterday, and had a long interview with Mr. Secretary Rice, who, in the absence of Lord Duncannon, superintends the official business of the home department. Summonses were afterwards issued for their lordships to assemble to-morrow.

WEDNESDAY.—On the breaking up of the King's council at St. James's, the privy counsellors immediately repaired to the Cockpit. The Speaker of the House of Commons, who was attired in his state robes, was the first who arrived. A considerable time however elapsed before their lordships assembled, and the investigation was resumed.—Mr. Cooper, the gentleman whose evidence has excited so much attention, accompanied by an intimate friend, was in attendance. In conversation Mr. Cooper repeated that he was perfectly confident of the truth of the statement he had made when before the council, and he was fully prepared again to substantiate on oath every syllable that he then uttered.—After their lordships had assembled, they remained for a considerable time in deliberation, when Mr. Riddle, a commercial traveller connected with a highly respectable house in Dudley, and who was spending the evening of the Thursday in question at the Bush Inn, was first called in. He perfectly recollected that a gentleman answering the description of Mr. Cooper was at the Bush Inn on the evening of the day mentioned, but he did not recollect that any conversation on the subject of the late fire occurred on that evening.—The landlord of the Bush Inn was next examined by the Lord Chancellor.—Sarah Taylor, the waitress, could not take upon herself to swear that such a conversation did or did not take place on that evening. She had no recollection of hearing the news herself.—Thomas Mocchin, the individual whose name has been so often mentioned in the papers, and who, it will be recollected, addressed a letter to his brother, who resides in Berwick-street, Soho, stating that on his journey to Birmingham, on Thursday evening, he heard the news of the fire, was also examined. This witness, who was specially brought to town for the purpose, we understood, positively persisted in the statement contained in his letter.—On Mr. Cooper entering the room, Mr. Riddle immediately recognised him as spending the evening in question at the Bush Inn. The Lord Chancellor then put questions to the following effect:—Mr. Cooper, do you recollect this gentleman (pointing to Mr. Riddle)?—Yes, my lord, I do; I have a recollection of seeing him before.—Have you any doubt that this is one of the gentlemen with whom you spent the evening of the Thursday on which the fire occurred, at the Bush Inn, Dudley?—I have not the least doubt but it was in that place and at that time I saw this gentleman.—Now, Mr. Cooper, perhaps you will be able to recollect what sort of a person it was who brought the news of the burning the two houses?—I cannot exactly describe him.—Was he a black man or a white man?—I do not exactly understand your lordship's question. He certainly was not what is called a black man; that is, not a man of colour.—No, no; I don't mean exactly whether he was a white man or a negro—I mean, was he of a dark complexion; did he wear a black stock, or any thing dark or particular about his dress; or was he of a dark or light complexion?—My lord, I did not pay any particular attention to his person or appearance.—Then, do you still persist in the accuracy of your former statement, as to the time when you heard of the fire?—I do, my lord; and I am confident I cannot be mistaken.—This was the whole of the evidence adduced, and the witnesses were then ordered to withdraw.—It has been stated in the daily papers that Mr. Cooper a few days before had received a letter by the twopenny-post, addressed to his partner, Mr. Hall, of which the following is a copy:—

"Mr. Hall.—You would, probably, like to take a very active part in the discovery of the origin of the late fire which destroyed the houses where the enemies of liberty used to meet for the support of oppression, the depredation of the poor, and to deprive them of every privilege that belongs to mankind; but their career is short. Fires shall not cease their ravage—SHALL NOT, I SAY!!! Great deeds are on the eve of taking place, which shall make them quake in their concealment. Not one of them shall dare to show his face.—Take this hint, and remain strictly neutral till it is shown to you what you are to do, or tremble for the consequences.—From an innumerable force of the Friends of Liberty.
"A TRUE REFORMER.

"Dated Head-quarters, Oct. 22."

This, it was added, Mr. C. transmitted to Lord Melbourne, having himself retained a copy. It was this day also submitted to the council by his lordship, and it would appear that it created a considerable sensation in the council, who immediately resolved to adjourn till Saturday.—At a late hour in the evening summonses for the reassembling of the council on that day were issued; contrary to usual custom, these summonses were enclosed in sealed envelopes. All the Cabinet Ministers, the Speaker of the House of Commons, the Lord Chief Justices of the King's Bench and Common Pleas, and a vast number of other distinguished legal and other authorities, are summoned to attend on Saturday.

Mr. Cooper, in the evidence he gave before the Privy Council, on Wednesday, mentioned to their lordships the important fact of his having, when engaged sixteen years ago in laying down the flues in the House of Commons, according to the plan for which the Marquis de Chabannes obtained a patent, suggested to several persons his fears that they would not answer the desired purpose, or, if they did, that he felt some apprehension that they might be productive of danger. The reply which he received from some individual who was engaged in the works was, "We'll, if they are dangerous, never mind, for I have often heard Mr. —— (mentioning the name of an eminent architect) say that he would give 500l., or 1,000l., to see the House of Commons burned down, or destroyed." He (Mr. Cooper) naturally felt a good deal of astonishment at such an assertion, and inquired what possible object the eminent individual alluded to could have in wishing such a catastrophe. The person who made the observation replied, "It has for years been the grand object of Mr. ——'s ambition to have an opportunity of submitting a plan for the erection of such a building for the Commons House of Parliament to assemble in that would not only be a credit to the national architecture, and convenient to the members, but would likewise tend to immortalise his own reputation." Had it not been for the late conflagration, Mr. Cooper added, in all probability their conversation would never again have been recalled to his memory; but although sixteen years had elapsed, the moment that event occurred he immediately recollected it; the words, in fact, flashed across his mind in a moment. Upon this point we understand their lordships, especially the Lord Chancellor, questioned Mr. Cooper at considerable length. He, however, was confident as to the fact of such a circumstance having taken place, of which he now had the most perfect recollection. We understand that their lordships directed the short-hand writers not to mention the name of the architect alluded to in their notes, and consequently, although we are in possession of the gentleman's name, we refrain from giving it. The doubt thus naturally exist as to the correctness of Mr. Cooper's statement as to the time of his hearing of the fact of the fire, as we understand, induced him to institute every inquiry in his power, and he feels most sanguine that he shall, before many days elapse, be able to produce other evidence that will convince every body, as much as he is himself convinced, that he is not mistaken as to the fire being talked about upwards of one hundred miles from London on the very evening it occurred.

Mr. C. did not hear of the houses of parliament being burned down until 10 o'clock the following morning. The writer says—"I have this day instituted the strictest inquiry upon the subject, and the result is, that there can be no doubt but Mr. Cooper is, to say the least of it, labouring under the most strange and unaccountable delusion. It is true that Mr. Cooper was present in the commercial room of the Bush Hotel between the hours of eight and ten o'clock on the night in question, but that appears to be about the only truth to which he deposed. I have the authority of Mr. Cartwright, the landlord of the Bush; Mr. Riddle, a commercial gentleman of Dudley; and Sarah Taylor, the waitress, for stating the following facts:—Mr. Riddle was, indeed, examined before the magistrates (Mr. Thomas Bager and Mr. Mollineux) yesterday; and his deposition, together with that of the girl Taylor, was subsequently transmitted to the lords of the Privy Council. Mr. Riddle deposed to this effect:—On the Thursday in question he (Mr. Riddle) arrived by Eaves's coach, from Birmingham, at the Bush Hotel, in Dudley, about eight o'clock. On his arrival he ordered his supper, and stayed in the room for about an hour. He then absented himself, having to visit the Dudley Arms Hotel, for about half an hour. On his return to the commercial room at the Bush, a gentleman whom Mr. Cartwright, the landlord, says was Mr. Cooper, had just arrived by the Tally-ho from Birmingham. The coach was then standing at the door. This was about a quarter before 10 o'clock. Mr. Cooper ordered his tea immediately; and in the course of about an hour he retired to bed. During the whole of this time Mr. Riddle was in the room, and he declares, and so he has sworn, that not a single word of conversation relative to any fire in London or any where else took place between any of the parties. The next morning Mr. Riddle breakfasted about eight o'clock with two other gentlemen. When he had finished he again went up to the Dudley Arms Hotel. This was about half-past nine on Friday morning. Mr. Smith, the landlord, met him in the hall and said, " Have you heard of the Houses of Lords and Commons being on fire?" He replied that he had not. If so, it is clear that the conversation reported by Mr. Cooper could not have occurred the previous night. The intelligence arrived by the mail that morning. After a few minutes' conversation with Mr. Smith, Mr. Riddle returned to the Bush, where there were four or five breakfasting in the commercial-room. There can be no doubt that it was on this occasion Mr. Cooper must have first heard of the fire, being about a quarter before 10 o'clock on Friday morning, instead of about a quarter before 10 o'clock on Thursday night.—A gentleman representing the house of Harford and Co. of Bristol, was in the room during the whole evening, and can corroborate the statement given by Mr. Riddle.—Mr. Cooper's testimony is laughed at universally, both in Birmingham and Dudley.

COMMITTEE-ROOMS.—One of the most important points for consideration in the erection of the new houses of parliament will be the providing suitable accommodation for committees. It has been long known that the most important portion of the business of the legislature is transacted by committees; indeed, we may say that in almost every question that comes before the houses of parliament, all the minute details, and generally even the more important points are settled in committee, and during some portions of the session as many as from 20 to 30 daily assemble, appointed by the House of Commons only. It is not, however, generally known, how frequently the labours of 'hon' gentlemen are protracted to an almost indefinite period. At this particular time it may, therefore, be interesting to mention a statement which we remember being made by Mr. Harrison last session, before the Monaghan election committee a few days previously to that inquiry terminating. The committee had sat upwards of 30 days, and some of the members began to manifest something like impatience at the tediousness of the proceedings. Mr. Harrison said that that inquiry was short compared with many others that had taken place within his recollection, and in many of which he was professionally engaged. For instance, the petition presented again the return of the sitting members at the well-known and great contest for the county o Middlesex occupied no less than 170 days; others he remembered which occupied 70, and he had heard of others which consumed even a longer time. In one of these the committee, after the most laborious investigation on one day, adjourned for the purpose of considering their report, when the next morning the King dissolved parliament, and by that step rendered their labours altogether useless. The committees appointed on election matters, however by no means take the first place as regards the time consumed. There are others equally as (possibly of more) public importance, which occupy as many, if not a greater number of days, as the voluminous reports of evidence which from time to time are published abundantly testify. In the old buildings, it is but just to say that many of the apartments appropriated to that purpose furnished good accommodation, especially those attached to the House of Commons. Those of the Lords, however, were not so convenient.

The last number of the New Monthly contains a rather clever article on the subject of the late fire, from which we make the following extracts:—

"Praise to economy, exulted the Globe the other day, the antiquated machinery of the Exchequer has ceased to exist,—the old tallies will make capital firewood. So far, very well; but out spoke the Spirit of Economy again in the shape of the Court of Bankruptcy. We want another room—that in which you have lodged your firewood is the very thing for us; carry off the tallies, and let us have it. Forth came an order, then, from the Board of Works, to burn the tallies at once. Mark what followed. A curious old got knaw, hearing the fate that awaited these venerable bits of wood, applied to purchase them. The Herald is unkind enough to whisper that he had something like a sordid motive in this; that it was not altogether out of generous sympathy for the reverses of official antics; that, in fact, he had acted on some private intimation ' that persons curious in such matters would like to purchase bundles of them for museums and collections.' By this as it may, this application was refused. Mark, still, the tallies stindies that herald in great events. The worthy Mr. Milne, of the Board of Works, having issued further directions for the removal of the devoted tallies into some especial burning place, an inferior officer took on himself to consider thereupon how much more economical it would be to burn them on the spot. Economy again ! On the spot accordingly they were burned, and with them—the two Houses of Parliament! Economy has cost the country three hundred thousand pounds."

"The night, as on the night of the great fire of 1666, was a fine one, with a sharp wind and a very brilliant moon. At some distance from Whitehall, the struggle between the two lights in the sky had a very strange and emphatic effect. On the scene itself, however, the moon was vanquished, and 'paled her ineffectual fire !' Along the whole frontage of buildings which enclosed the Parliament Houses glared a huge sheet of lurid flame. Occasionally the wind, shifting on uncertain points, rolled it back, then brought it again dashing forwards towards the Abbey, while, in returning, caught as it were among the inimitable fret-work and tracery of the chapel of Henry the Seventh, it imprinted an instant with a sort of playful tinge before the wind dashed it again upon the office of destruction. Then the Abbey looked for some instants over the scene in dark and frowning quiet, but soon to its highest pinnacles the wayward light again played over it."

"The loss from this calamity is stated at three hundred thousand pounds in the matter of buildings alone. The actual loss of private property is also great. But do the losses terminate here? We fear not. Everywhere an ominous advertisement in the papers stating that many papers have been lost from the Augmentation-office. Are not fines and recoveries deposited there? How many of these are missing? How many estates may lie in consequences unsettled?"

RUINS OF THE HOUSE OF LORDS.

RUINS OF THE HOUSE OF COMMONS.

The Cleveland picture records the state of the fire several hours later than is shown in the Philadelphia version. It includes, in the lower right, the arrival of a floating fire pump, the proud possession of the Sun Fire Insurance Office (on its side the sun emblem appears between the words SUN and FIRE). But the boat was unable to prove its worth as, on its way to the fire earlier in the evening, it had gone aground due to the very low tide. When it finally arrived it was too late to be of any real use, although it was reported in *The Times* that 'its effect on the burning embers was said to be prodigious' — the paper's correspondent by this time having left the scene of the fire in order to write his account.

Turner surely would have appreciated the irony of this incident, seeing it as another example of man's helplessness in the face of the hostile elements of both fire and water. But, as Gage has pointed out,[7] Turner was concerned to make a serious comment here, for the rapid way the fire was able to spread showed how little coordination existed between the separate fire-fighting crews belonging to the private insurance companies. This lack of cohesive effort led to a needless increase in damage.

Although the fire is further away in the Cleveland version, it is, paradoxically, the more threatening. The vast plume of flames rushing across the sky towards the spectator is so menacing with its effect of scorching heat that one is tempted to retreat a pace when first confronted by the painting. But, at the same time, the moon is reflected in the river on the left, providing the juxtaposition of cool and warm colours that Turner was to employ on other occasions, most notably four years later in *The Fighting Temeraire, tugged to her Last Berth to be broken up, 1838* (illus. p. 195), exhibited at the Royal Academy in 1839.

The two pictures, recording a scene still fresh in the minds of many visitors to the exhibitions, received, as one would expect, a good deal of attention from the critics. The Philadelphia version was generally criticised on the grounds that the sky was too light a blue for a night scene, but Turner seems to have been accurate here for *The Times* reported that the 'light reflected from the flames of the fire, as it shone on the Abbey and the buildings in the vicinity, had a most extraordinary effect, and every place in the neighbourhood was visible, so that a person could have been enabled to read as in the day time'. The *Spectator* critic found faults in the picture but admitted that 'it transcends its neighbours as the sun eclipses the moon and the stars'.

The Cleveland picture also had a mixed reception, the *Morning Herald* being the most abusive: 'We seriously think the Academy ought now and then, at least, to throw a wet blanket or some such damper over this fire King or his works; perhaps a better mode would be to exclude the latter altogether, when they are carried to the absurd pitch which they have now arrived at ...' In the perception of the *Spectator*'s critic: 'The sheet of flame that is carried across the sky and is reflected in the water is a stroke of art that none but a master could dare. It looks too flaring now ... we should like to see it a year hence. Turner paints for posterity, and allows for the effect of time as Robin Hood when he shot allowed for the wind ...'

On the whole, the critics admitted that Turner had captured the wonder and confusion of the scene as no other artist could have done. What's more, both paintings were sold quickly: the Philadelphia version was bought during the British Institution exhibition by Chambers Hall, and the Cleveland picture was acquired from Turner himself by John Garth Marshall of Leeds, whose grandson later recalled the details of the purchase:

> This picture was painted in the year 1835, and in that year my grandfather, Mr James Garth Marshall, took his son, Mr Victor A.E. Marshall (my father) to Turner's studio. My grandfather asked Turner what his price was and he said he could have anything in his studio for £350. My grandfather then turned to my father and said, 'Which do you like best?'

and he pointed to the picture now in my possession. But Turner said: 'Well, young man, that is the one you cannot have, as I have decided to give that one to the nation,' — but my grandfather, who was a hard-headed Yorkshireman, said: 'No, Mr Turner, you gave me the offer of anything in your studio at a price and I must hold you to it.' And so the picture came into the family and it has never been out of my family from that date … I, myself have received one offer from a local furniture dealer of £27, frame included![8]

It is not surprising that Turner, having sold one version of the 'burning' so quickly, should have wished the second to remain as part of his bequest to the nation; so he must have regretted having failed to turn it face to the wall when Mr Marshall came to his studio.

After the fire, there was general rejoicing that Westminster Hall and Abbey had been saved, but people seemed to care little about the destruction of the other buildings. Carlyle, for instance, wrote to his brother observing that 'a man *sorry* I did not anywhere see'; while others openly expressed their regret that the Lords and Commons had not been in session at the time. It was of course a time of political unrest; the Poor Law Amendment Act of 1834 had just been passed which laid down that no able-bodied man would get assistance unless he entered a workhouse. This was universally unpopular and led to the disgraceful conditions in the workhouses so vividly described three years later by Dickens in *Oliver Twist*.

The general opinion seemed to be that, as the antiquated Parliament buildings had gone up in smoke, perhaps their replacements might lead to the reappraisal and possibly also the reform of equally outmoded parliamentary institutions.

In 1835 a competition was announced inviting plans for rebuilding the Palace of Westminster. Ninety-seven architects entered and Charles Barry was chosen; he was assisted in matters of decoration by the young and versatile Augustus Welby Pugin. But the project was subject to many delays and construction was very slow. Eventually the House of Lords was ready for use in 1847, but the Commons Chamber was not completed until 1852. By then, memories of the fire were fast fading and Turner was dead. Fortunately for us, however, Turner's two great masterpieces — and the word in its strictest sense is justified in both cases — ensure that we still have a matchless record of that historic night.

Notes

1. There are two principal sources of information about Turner's two 'burning' pictures: Richard Dorment's meticulous and masterly entry in his catalogue of *British Painting in the Philadelphia Museum of Art*, Philadelphia: Philadelphia Museum of Art, 1986, pp. 396–405, and the exhibition catalogue *Dreadful Fire! Burning of the Houses of Parliament*, Cleveland: Cleveland Museum of Art, 1984, when both versions were shown at the Cleveland Museum of Art in 1984 to mark the 150th anniversary of the fire. The excellent Cleveland catalogue, which is particularly informative on the events leading up to the fire, was researched and written by Katherine Solender of the Education Department at the Cleveland Museum. I believe that the Cleveland exhibition was only the second time that the paintings had been seen together, the first being at Lawrence Gowing's exhibition, *Turner: Imagination and reality*, in 1966 at the Museum of Modern Art, New York.
2. Kenneth Clark, *The Romantic Rebellion*, London: John Murray: Sotheby Parke Bernet, 1973, p. 256.
3. Katherine Solender, 1984, p. 31.
4. Lawrence Gowing, 1966, p. 33.
5. Richard Dorment, 1986, pp. 396–405.
6. John Gage, *Colour in Turner: Poetry and truth*, London: Studio Vista, 1969, p. 169.
7. John Gage, *J.M.W. Turner: 'A Wonderful Range of Mind'*, New Haven: Yale University Press, 1987, p. 233.
8. Katherine Solender, 1984, p. 62.

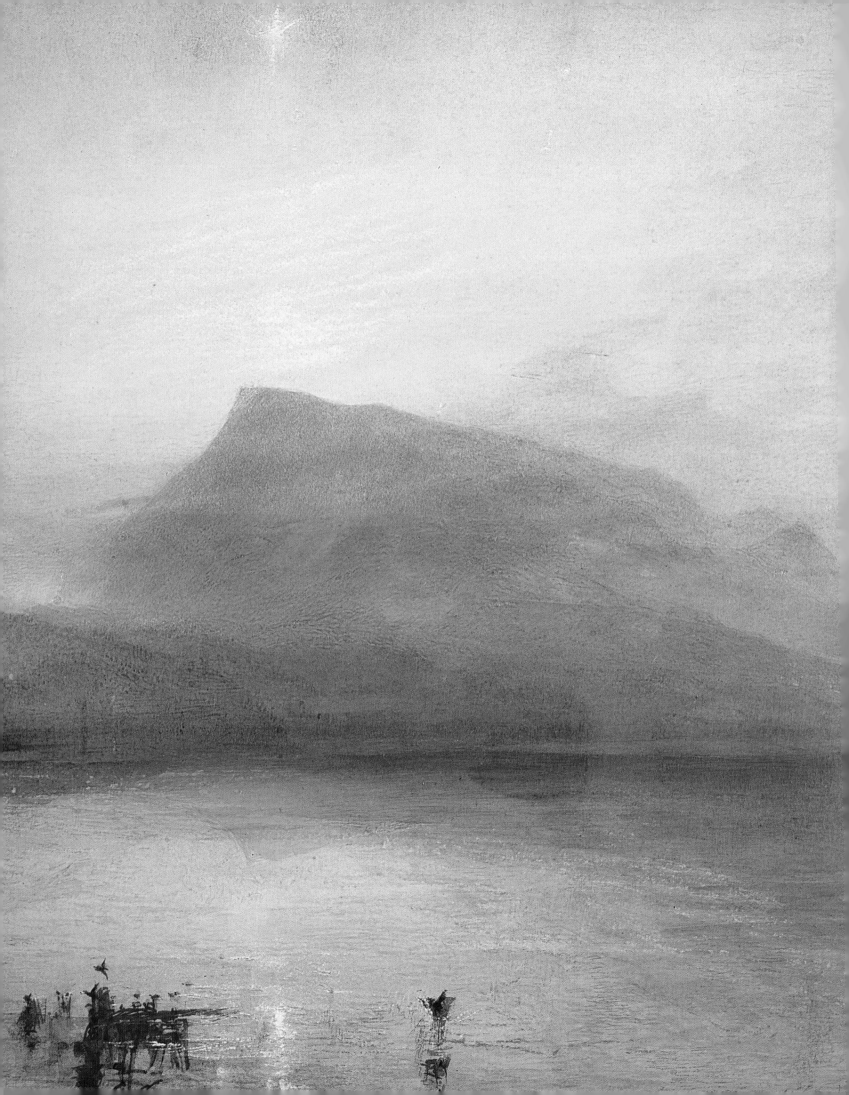

Turner:
A Watershed in Watercolour

John Gage

Turner's '*The Blue Rigi* ' (illus. p. 102) and its companion, the slightly larger '*The Red Rigi* ' (illus. p. 103), are among the most strikingly beautiful of his late works. We are impressed at once by the vast stretch of tranquil water, variegated largely by colour, and the monumentality of the mountain, seen probably from the artist's waterfront hotel at Lucerne. In the cool morning version, the Rigi is a single mass of blue, modulated only by the skeins of clearing mist. At evening, the blue twilight is slowly advancing up the mountain, but still leaves it capped with the most delicate and indescribable of sunset pinks. Turner clearly loved this subject, and in the 1840s he returned to draw and paint it again and again. In the context of nineteenth-century painting, we might be inclined to link his acute analysis of exactly the same motif under differing lights — there is also a third finished image, '*The Dark Rigi* ' (private collection; W 1532), in this set — with Cézanne's Mont St Victoire or Monet's haystacks or, closer to Turner's own day, with the contrasting landscape studies of Pierre Henri de Valenciennes,[1] were it not that Turner the Romantic animated his foregrounds with the signs of activity so typical of the Swiss lakes at these times of day. Witness the birds and their predators, the lumbermen and fishermen, even the tourists on their way to or from this most popular of Swiss peaks. He thus showed, in this latest phase of his work as a watercolourist, his continued engagement with the abundant humanity of the *Picturesque Views on the Southern Coast* or the *Picturesque Views in England and Wales* (so well represented in this exhibition) and even of the earliest watercolours of the 1790s. Turner has also enriched these Rigi subjects with the implication of sound: the hunter's gun shattering the morning silence, or the splash of the catch, perhaps, being washed at evening. Such incidents show his concern to play on several senses, and remove him from the immediate ancestry of formalism.[2]

'The Blue Rigi' 1842
watercolour
Private Collection (cat. no. 89)
detail left and above

The late Swiss watercolours are remarkable first of all for their originality of conception and for their aesthetic distinction; but they also represented a new departure in the way Turner marketed his work and, more importantly, in the way he conceived of it. John Ruskin, his greatest admirer and interpreter who, sooner or later, acquired eight of the fifteen watercolours in the sets of 1842 and 1843 (four of the eight are in the present exhibition) gave a detailed account of how the painter brought to his dealer, Thomas Griffith, a group of fifteen watercolour 'sample' sketches based on studies in Switzerland in 1841, from which ten might be selected to be elaborated into finished works. Four subjects, including '*The Blue Rigi* ' and '*The Red Rigi* ', he had already worked up as finished versions of the sketches; Ruskin called them 'specimens or *signs*', 'to manifest what their quality would be, and honestly "show his hand" (as Raphael to Dürer) at his sixty-five years of age, — whether it shook or not, or had otherwise lost its cunning'.[3]

According to Ruskin, Griffith remarked to Turner that the sample drawings were 'a little different from your usual style'. And the first potential purchaser the dealer approached, the coach-maker and manufacturer of patent medicine, Benjamin Godfrey Windus, a long-standing collector of Turner watercolours, also felt that 'the style was changed, he did not quite like it', and refrained from commissioning a completed subject until 1845. Recently discovered letters from Turner to Windus, written in March 1842, suggest that the painter was proposing to complete a series of twenty watercolours, and the collector's coolness must have come as something of a shock.[4]

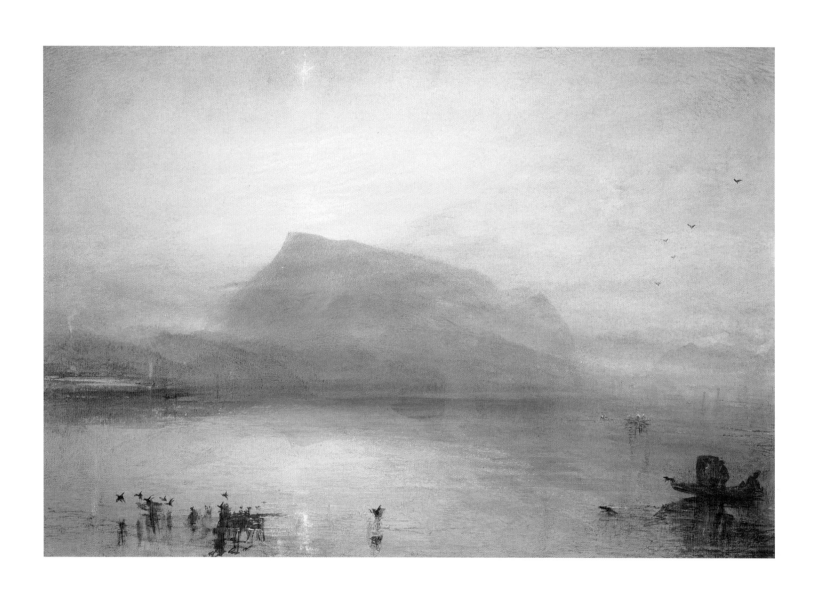

'The Blue Rigi' 1842 watercolour Private Collection (cat. no. 89)

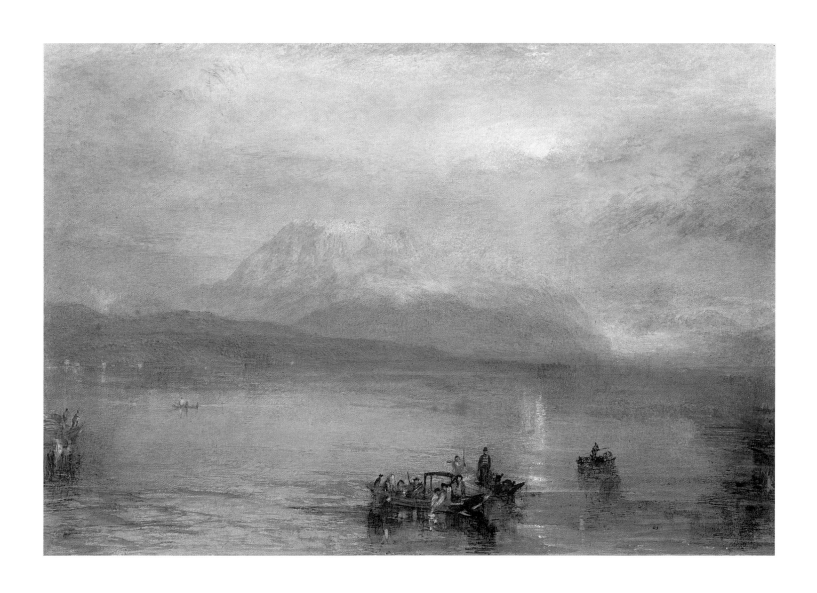

'The Red Rigi' 1842 watercolour National Gallery of Victoria, Melbourne Felton Bequest, 1947 (cat. no. 88)

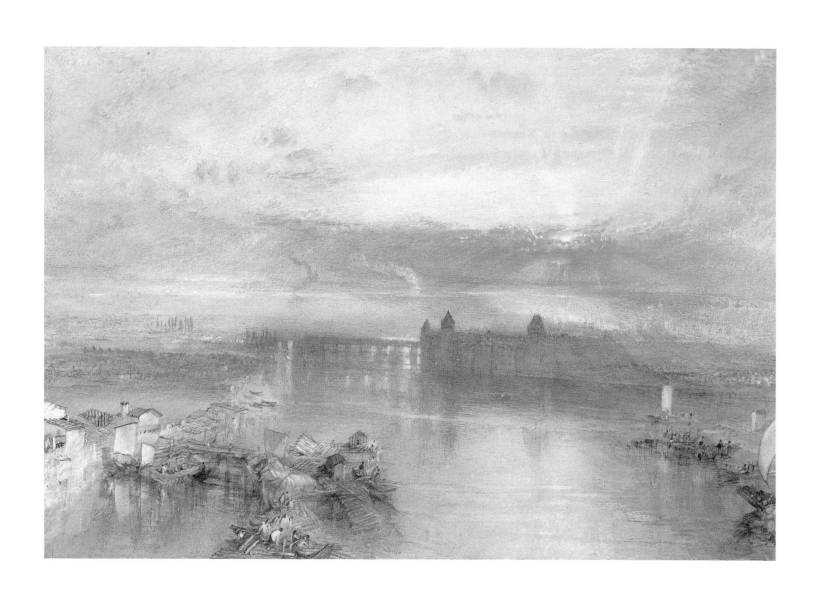

Constance 1842 watercolour York City Art Gallery Purchased with the aid of the Victoria and Albert Museum and the National Art Collections Fund, 1984 (cat. no. 91)

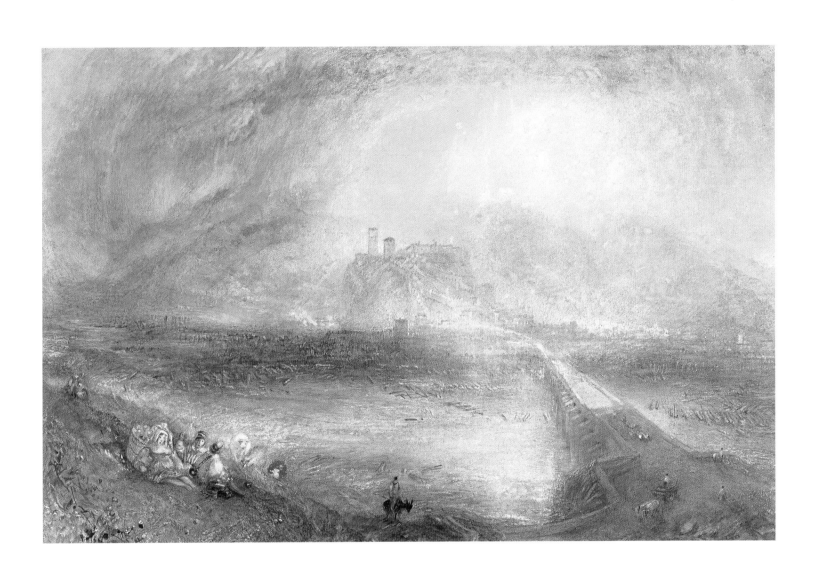

Bellinzona from the Road to Locarno 1843 watercolour City of Aberdeen Art Gallery and Museums Collections (cat. no. 95)

In the end, five of the finished watercolours, including 'The Red Rigi', went to Hugh Andrew Johnstone Munro of Novar, a Scottish laird, an amateur painter, an old friend of Turner's who had travelled and sketched with him in the Alps in 1836, and one of the most important collectors both of old masters and modern British painting at that time. Munro had already acquired more than one hundred Turner watercolours.5 Of the remaining five executed Swiss drawings, two were bought for Ruskin by his father, and two, including 'The Blue Rigi' and Brunnen on the Lake of Lucerne (illus. p. 130), went to the whaling entrepreneur and collector Elhanan Bicknell, who had been an admirer of Turner's work for a number of years. Griffith took the Constance (illus. p. 104) in lieu of his commission, and later passed it on to Ruskin. When Turner offered his dealer another ten Swiss subjects in the same way in 1843, only five commissions could be negotiated, including Bellinzona from the Road to Locarno (illus. p. 105), which went to Munro of Novar, and Goldau (illus. p. 137) and The Pass of St Gotthard, near Faido (illus. p. 138) which both went to Ruskin.

Ruskin's rather casual comparison between Turner's dealings with Griffith and Raphael's with Dürer nevertheless embodies a profound truth: the painter's 'hand' is everywhere in evidence in these watercolours, both at the level of Turner's thoroughly individual handling of his materials — the elaborate yet economical hatching and stippling combined with transparent washes — and in his overall principles of colouristic design. Even more significant was Turner's equally 'Renaissance' procedure of submitting to potential patrons what was in effect a series of *modelli* to serve as the basis of fully-fledged commissions; for this preparatory stage, unusual in the context of watercolour, at last brought this humble medium into the highest reaches of art. Not that the finished watercolours were simply enlargements of the 'samples': the study for 'The Red Rigi', for example, is far more compressed spatially and more strident colouristically than in its final form, and such discrepancies are characteristic of the whole group. Turner's novelty of approach may be better appreciated if we look briefly at the status of watercolour in England during the Romantic period, and at Turner's influence on how this medium came eventually to be seen.

A National Medium

Watercolour was regarded in the Romantic period — and has continued to be regarded — as a quintessentially British development. Surveying the state of painting in Rome in 1816, the Scottish landscapist Hugh 'Grecian' Williams, an admirer of Turner, with whom he collaborated in later years, suggested that 'in the beautiful art of painting in watercolours, Britain stands supreme, or rather, she may be said to have appropriated it exclusively ...'6 And the even more partial compiler of the Water-Colour Society's 1821 exhibition catalogue prefaced it with the uncompromising view that: 'Painting in Water Colours may justly be regarded as a new art, and, in its present application, the invention of British Artists ...'7

Yet the chief platform for the British art establishment, the Royal Academy, of which Turner was a lifelong and devoted member, remained largely diffident about the medium; and although it always showed some watercolours in its smaller exhibition galleries, it would not admit exclusively watercolour painters into its ranks. Turner for example, while he had been trained as a watercolourist, could only aspire to academic honours as an oil painter. From 1796 he regularly showed oils at the Academy exhibitions and began to limit the number of his exhibited watercolours until, after 1800, he showed very few indeed.

One of the problems was that watercolour traditionally had been associated almost exclusively with topographical landscape, which was among the least highly-regarded branches of visual art — what Henry Fuseli, Professor of Painting at the Royal Academy in Turner's day, called 'the tame delineation of a given spot'. Watercolour was also the medium most used for teaching amateurs, and the Academicians

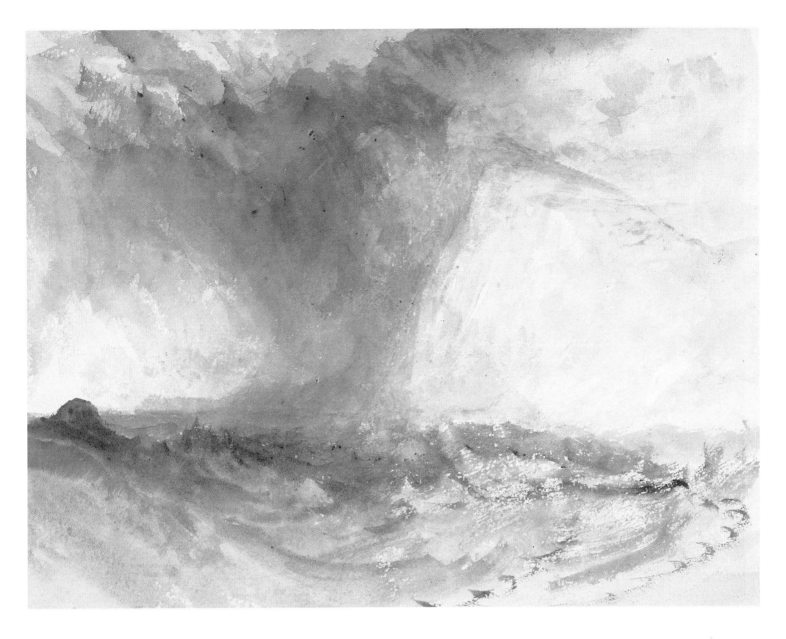

were intensely jealous of their professional status. Turner himself, as a young man, occasionally taught watercolour drawing — among others, to the Rev. Robert Nixon, the father of a later Bishop of Tasmania who seems to have been the first to bring Turner paintings and watercolours into Australia, including it seems *Shakespeare Cliff, Dover*, now in the Fitzwilliam Museum, Cambridge.[8] But, partly because teaching paid so poorly, Turner never did so for long. The Midlands painter Joseph Wright of Derby echoed a very general opinion when he remarked in 1795: 'Paper and camel hair pencils [i.e. brushes] are better adapted to the amusement of ladies than the pursuit of an artist.'[9] In his youth, John Constable, an accomplished watercolourist but also a painter who nursed thoroughly academic ambitions, refused the offer of a position as drawing master at the Royal Military College because 'it would have been a death blow to all my prospects of perfection in the Art I love'. His friend, Archdeacon Fisher, understood his feelings when he wrote to him in the twenties that the very successful John Varley was with the Fisher family at Salisbury, 'teaching drawing to the young ladies. Principles he says are the thing, "the warm grey", "the cold greys" and the "round touch".'[10] Turner for his part was always sceptical of principles, and one of the earliest accounts of his method attributed to him 'no settled process but [he] drives the colours abt. till He has expressed the idea in his mind'.[11]

Shakespeare Cliff, Dover
*c.*1825
watercolour
The Syndics of the Fitzwilliam
Museum, Cambridge (cat. no. 58)

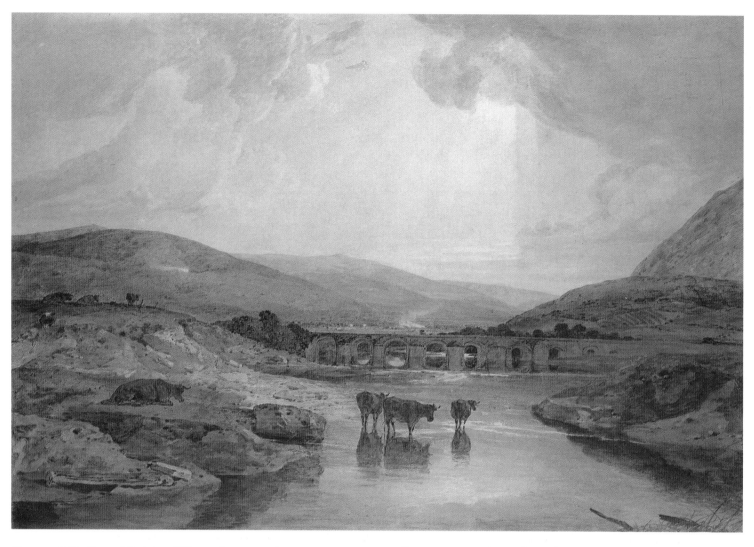

Abergavenny Bridge, Monmouthshire,
clearing up after a Showery Day
R.A. 1799
watercolour
Victoria and Albert Museum, London
(cat. no. 40)

Watercolour was thus, as an amateur medium, very much implicated in questions of class and gender. It was associated not only with females, who were generally discouraged from membership of the Royal Academy, but also with gentility. One of Turner's most gifted pupils, for example, was Julia Bennett, later Lady Willoughby Gordon, to whom he seems to have given lessons, unusually, over a period of some thirty years.[12] The Society of Arts, from which the Royal Academy grew in 1768, did indeed encourage watercolour, although it signalled the importance of amateurs by introducing a class restricted to the children of the gentry and aristocracy. In 1790 the Society offered:

> Honorary Premiums for Drawings for the best drawings by sons or grandsons, daughters or granddaughters, of peers or peeresses of Great Britain or Ireland ... N.B. Persons professing any branch of the polite arts, or the sons and daughters of such persons, will not be admitted candidates in these classes.[13]

Watercolour was thus deeply involved in the vigorous art politics of the Romantic period in England.

It was in the face of this professional snobbery that a group of watercolour specialists, led by one of Turner's closest friends, W.F. Wells, founded the Society of Painters in Water-Colour in 1804. Their chief inspiration had come, however, from the increasingly impressive displays of watercolours in the Royal Academy summer exhibitions. An early member of the Society, Thomas Uwins, in 1833 recalled 'the time when the council-room of the Royal Academy was devoted to the exhibition of paintings in water-colours'.

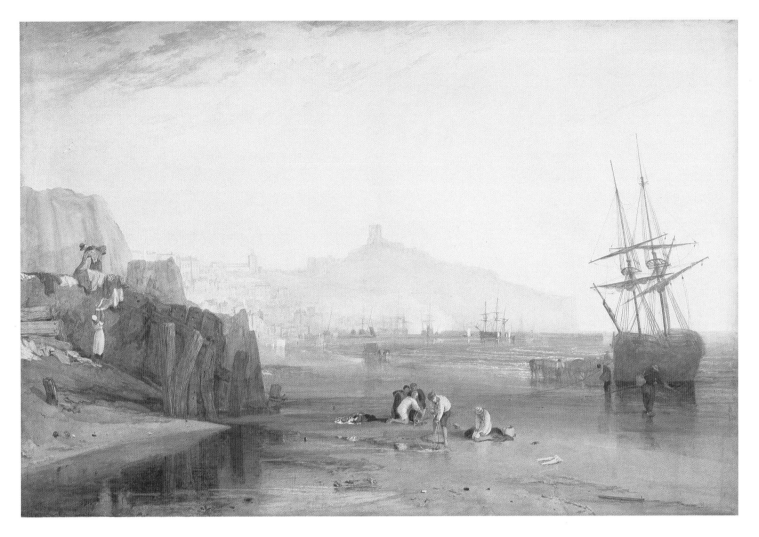

Scarborough Town and Castle:
Morning:Boys catching Crabs R.A. 1811
watercolour
Private Collection
(cat. no. 43)

Here were to be seen the rich and masterly sketches of [William] Hamilton, the fascinating compositions of [Richard] Westall, the beautiful landscapes of [Thomas] Girtin, [Augustus Wall] Callcott and [Ramsay Richard] Reinagle, and the splendid creations of Turner — the mightiest enchanter who has ever wielded the magic power of art in any age or country. At this time the council-room, instead of being what the present arrangement makes it, a place of retirement from the bustle of the other departments, was itself the great point of attraction. Here crowds first collected, and here they lingered longest, because it was here the imagination was addressed through the means of an art which added the charm of novelty to excellence. It was the fascination of this room that first led to the idea of forming an exhibition entirely of pictures in water-colours.[14]

The organisation of the Water-Colour Society also remained very close to that of the Royal Academy — it did not, for example, elect any female member until 1809[15] — and its exclusiveness provoked the founding of a second watercolour group, the New Society of Painters in Miniature and Water-Colours (later called The Associated Artists) in 1807. The President of the Royal Academy, Benjamin West, was one of several Academicians who began to feel that academic strictures against the medium should be relaxed. In August 1810 he set up a committee to review the state of the Academy and gave his opinion that:

> it wd be proper ... to rescind the law which prevents Artists who make drawings such as those by Westall & Heaphy from becoming Members of the Academy ... The law ... was made against inferior works done on paper, but the works now produced are of a quality not then known.[16]

109

But of course Richard Westall, an Academician for more than a decade, and the brilliant genre painter Thomas Heaphy were both specialists not in landscape, but in the more prestigious figure painting.

Both watercolour societies flourished until about 1809, when public interest began to wane and an attempt was made to revive it by including oils as well as watercolour in their exhibitions. Clearly, watercolour was still not a medium to be taken very seriously, and Turner, although he had close friends in both societies, never showed with either, nor gave them any sort of support.

Watercolour Exhibitions

Turner's work in watercolour, however, was at the centre of a revived public interest in the medium in the 1820s. One of his most important patrons, Walter Fawkes, of Farnley Hall in Yorkshire, opened his London house in 1819 and the following year for the public display of his large collection of watercolours, notably a room of some sixty Turners, and another with a mixed collection of works by more than a dozen members of the specialist societies. In the opinion of a contemporary critic: 'Mr Walter Fawkes's fine collection of drawings did more to stamp the character of water-colour art upon general attention than any other effort within our recollection.'[17]

It may well have been the renewed interest in the medium stimulated by Fawkes's exhibitions which persuaded the Society of Painters in Water-Colours to restrict its scope to works in that medium again in 1821, after an interval of nearly ten years, for, as its catalogue stated: 'Those who are acquainted with the splendid collection of Walter Fawkes Esq., that liberal and judicious patron of the Fine Arts, and of this art in particular, must be sensible of these modern improvements ...'

The Society's galleries in Bond Street, where the top-lighting of the main room was diffused through a thin white cloth hung like a false ceiling, may have impressed Turner, since this was a device similar to one he used in his own private gallery in Queen Anne Street, which was rebuilt in its final form between 1819 and 1822.[18]

The most impressive single section of Fawkes's collection was a series of some fifty watercolours of views on the river Rhine that Turner had painted specifically for him and without any thought of publication. A number of individual watercolours on display included *A First Rate taking in Stores* (illus. p. 118), which had been painted very swiftly by Turner on a visit to Farnley in 1818. Others among Fawkes's Turners were connected with the illustrated publications that continued to employ the painter in this medium throughout the 1810s and 1820s, such as *High Force, Fall of the Tees, Yorkshire* (illus p. 61), which is a version of the subject engraved for Whitaker's *History of Richmondshire* (1819–23), for which Turner also painted *Weathercote Cave* (illus. p. 59).

Most of Turner's watercolours of this date were in fact made with engraving in mind, for publications such as W.B Cooke's *Picturesque Views on the Southern Coast of England*, for Whitaker, or for the most important series of all, Charles Heath's *Picturesque Views in England and Wales*, which began in 1824, and was to have included one hundred and twenty plates. Just as the most important late eighteenth-century topographical collection, Thomas Hearne's *Antiquities of Great Britain* (1807) — which had been so important for Turner's early formation — had been partly advertised through the public exhibition of the watercolours,[19] so Cooke and Heath sought to attract subscriptions in the 1820s by showing a wide range of Turner's drawings side by side with their engraved reproductions. Cooke's first exhibition at his refurbished London shop, in 1821, had included only engravings, but at a second one the following year *Weymouth, Dorsetshire* (illus. p. 67), *Lyme Regis, Dorsetshire: A Squall* (illus. p. 70), *Teignmouth, Devonshire* (illus. p. 69) and *Tor Bay, from Brixham* (illus. p. 68) were all on show, and other exhibitions of Turner's watercolours for engraving were held in 1823 and 1824.

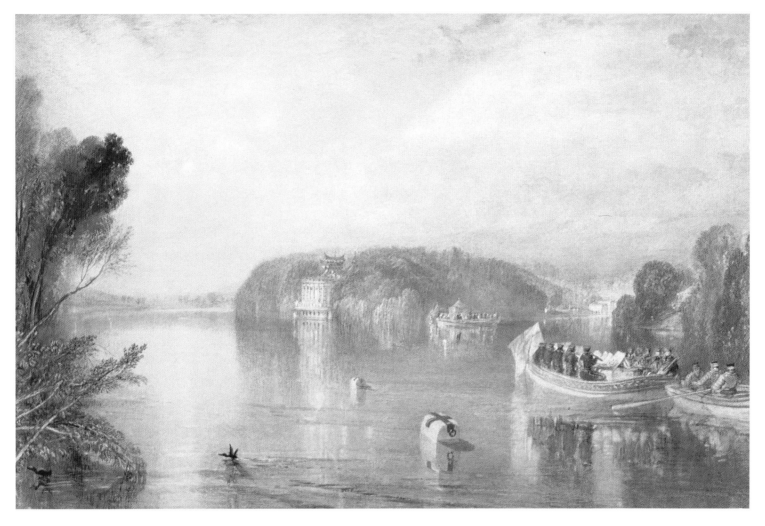

Virginia Water c.1829
watercolour
Private Collection
(cat. no. 62)

Heath showed forty-one watercolours, including *Virginia Water, Alnwick Castle,* (illus. p. 77) and *Holy Island, Northumberland* (illus. p. 112), some beside their engravings, at the Egyptian Hall in Piccadilly in 1829. There was, unusually, no charge for admission; the exhibition was widely reviewed, and the critic for *The Athenaeum* made the claim, by now conventional, that 'safely ... may it be affirmed that excellence in water-colour drawing is exclusively British, when such an exhibition as this exists ...'[20]

Another critic, alluding to a contemporary controversy about the plausibility of Turner's colouring, showed how important it already seemed to be to see his work in groups:

> Although several among the number are too much surcharged with glaring tints, viz. bright-blue clouds, gamboge grass, deep purple water, and rose-pink castles, others again exhibit all the chaste tone, or sparkling light of real nature. As unelaborated drawings, they exhibit astonishing effect with their freedom.[21]

A handful of these watercolours was also shown at Birmingham in the same year, and a few years later Heath introduced a number of the more recent ones at the London Artists' and Amateurs' Conversazione. His shaky finances, however, led to his passing the largest share in the *England and Wales* publication to the print firm of Moon, Boys and Graves, who in 1833 mounted an extraordinary display of sixty-six of the watercolours, and arranged a conversazione at its conclusion where, among the 'two hundred artists and literati', Turner himself appeared: 'his coarse, stout person, heavy look and homely manners contrasting strangely with the marvellous beauty and grace of the surrounding creations of his pencil.'[22] Eight of the watercolours in the present exhibition were first seen at this 1833 show.

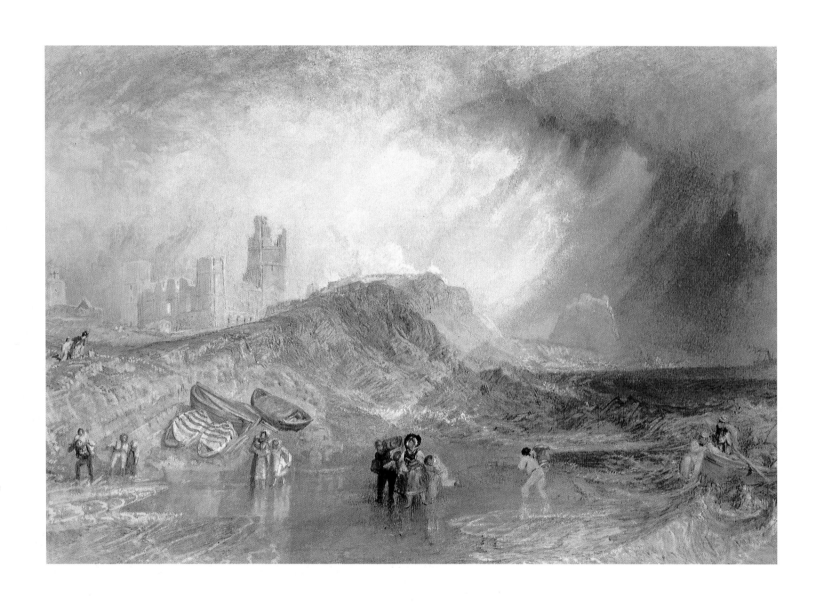

Holy Island, Northumberland c.1829 watercolour Victoria and Albert Museum, London (cat. no. 64)

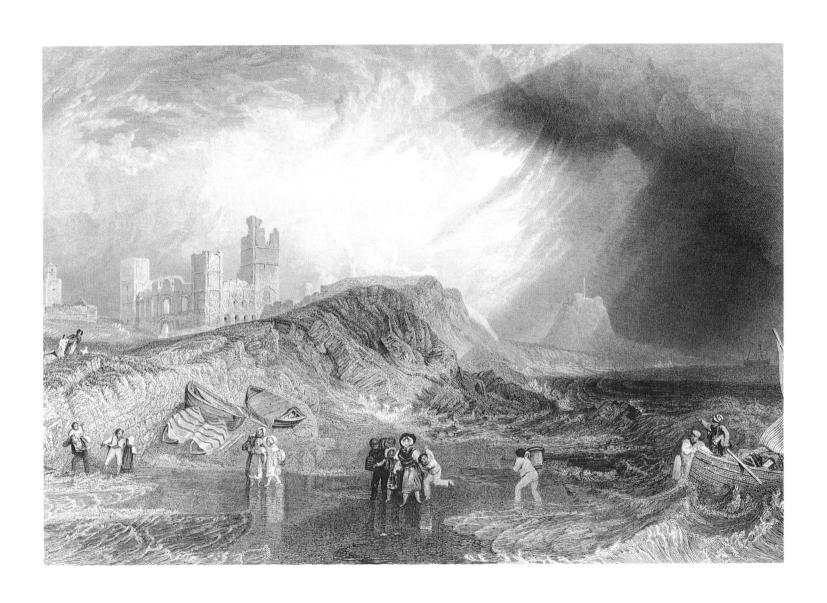

W. **Tombleson** engraver, after **J.M.W. Turner** *Holy Island, Northumberland* 1830 from *Picturesque Views in England and Wales* engraving Art Gallery of New South Wales, Sydney
Gift of Mrs Arthur Acland Allen, 1940 (cat. no. 116)

John Scarlett Davis 1804–1845
The Library at Tottenham,
the Seat of B.G. Windus, Esq. 1835
watercolour
29.2 x 55.8 cm (11-1/2 x 22")
British Museum. London

Okehampton Castle, Devonshire
(illus. p. 115) can be seen hanging
in the top row of pictures on the right
just before the door; Alnwick Castle,
Northumberland *(illus. p. 77)*
is below it, leaning on a chair.

So Turner's watercolours were becoming widely known and widely sought-after. One of that very small circle of collectors who commissioned the Swiss drawings of the early 1840s, B.G. Windus, began to make purchases from these earlier series almost as soon as they were available. Windus had lent *Weymouth* and *Whiting Fishing off Margate, Sunrise* (illus. p. 117) to Cooke's exhibitions of 1822 and 1823, and he acquired fourteen of the watercolours shown by Heath in 1829 and lent most of these, plus a further four, to Moon, Boys and Graves in 1833. Thirty *England and Wales* watercolours were also lent in 1833 by Thomas Griffith, who had bought heavily from Heath's exhibition four years earlier. Through Griffith's dealings many of these watercolours soon passed to Windus, Ruskin or Munro of Novar.

Windus is crucial to the history of Turner's reputation as a watercolourist, not simply because at one time or another he owned more than two hundred of his works in this medium, but also because, like Fawkes, but over a far longer period, he made them widely accessible, every Tuesday opening his house in Tottenham to the public — or at least 'a select portion' of it. Windus was often in attendance himself. 'We are glad to record', wrote a visitor in 1844, 'our sense of the patient kindness with which he accompanied a stranger during the inspection of upwards of two hundred of Turner's finest productions.'[23] Some seventy watercolours, mainly *England and Wales* subjects, were framed in gold and hung in the library, a rather looser hang than was usual in public exhibitions of watercolours at this time, but very much in the style of heavy frames on a warm and darkish ground, favoured by Fawkes and indeed by Turner himself.[24] And yet, paradoxically, there is very little evidence that after the early years of the century Turner ever showed his own watercolours in this way, even in his private galleries. He was never the Academician more than in giving his serious attention to oils; and it is this old-fashioned emphasis which makes the attitudes implicit in the commissioning of the Swiss watercolours in the 1840s even more remarkable.

Okehampton Castle, Devonshire c.1826
watercolour
National Gallery of Victoria, Melbourne
Felton Bequest, 1905 (cat. no. 59)

Oil and Water

One of the most significant technical controversies of the Romantic period in England was precisely the debate about the relationship between the mediums of watercolour and oil. In 1806 the Royal Institution, which had been founded in London in 1799 as a public laboratory and platform for the most recent developments in arts and sciences, mounted a series of lectures by the miniaturist William Marshall Craig, 'On the Practice of Drawing and Painting in Water Colours', in which Craig argued that watercolour was a far older and more permanent medium than oil and would 'become, finally, the current process of the painter's art'.[25] He had already published a drawing manual in 1793, and one feature of his discussion which particularly incensed the Royal Academicians was his belief that amateurs could aspire to excellence in this medium. The figure painter Robert Smirke, R.A. reported that Craig 'encouraged Amateurs to practice in Water Colour & by the example of Mr. Abott of Exeter [John White Abbott] who had produced in the Exhibitions pictures universally admired, invited them to acquire fame which might easily be obtained ... [Mary Smirke] was disgusted at his presumption and folly, but what He said caused many claps of approbation from the ignorant auditors.'[26]

Oil painters were also sceptical of Craig's claims for the permanence of watercolour, which he contrasted with the yellowing of oils over time and the consequent unbalancing of colour harmonies; and he argued that damp could be combated by varnishing watercolours with isinglass dissolved in spirit of wine.[27]

On the other hand, Craig did not discuss fading — the problem that became such a contentious issue in the production of watercolours later in the century. It was perhaps only with the exhibition of watercolours of the 1790s and 1800s that prolonged exposure to light was in question, since earlier watercolour drawings had usually been kept in portfolios; and only in the 1820s do commentators seem to have begun to point seriously to the impermanence of the medium.[28]

The size and quality of papers was also crucial to the prestige of the watercolour, and it was during this period that specialised artists' papers began to be manufactured in substantial quantities. Craig noted that the largest available sheet was Antiquarian (137 cm wide), but that it could be joined and mounted on panel or canvas to make larger surfaces.[29] Turner's largest known watercolour, the *Lake of Geneva*, now at Yale, does not by any means reach Antiquarian proportions.[30]

Craig's most significant claim was, perhaps, that watercolour used a pure white ground,
> by which every colour may be preserved with great, even with dazzling brightness while, on the other hand, we have the power to make our tints as broken and subdued as our contemporary rivals [in oils].[31]

White grounds and transparent glazes were certainly not peculiar to watercolour; they had been used from time to time by oil painters since the Renaissance, and in the eighteenth century by an artist to whom Craig several times referred in his lectures, Joseph Wright of Derby. Wright's devotion to the expression of light, for example in subjects of volcanic eruption, was well known.[32] Craig also advocated a procedure in watercolour which he attributed to the father of the medium, Paul Sandby (1725–1809), but which also had its parallel in the oil methods of Wright, namely the blocking-in of the tonal structure of a composition in a neutral grey before adding the local colours.[33] This continued to be a standard way of working up a watercolour drawing well into the nineteenth century. One of its most notable practitioners was John Glover, a leading member of the Society of Painters in Water-Colour who, through his pupil and Turner's intimate friend James Holworthy, was close to Turner in the 1810s. He emigrated to Van Diemen's Land (Tasmania) in the 1830s. Glover had hoped to arrange a joint exhibition with Turner in 1820, but was rudely rebuffed.[34]

As a younger man Turner had himself used the traditional method of monochrome underpainting in watercolour from time to time;[35] but it was never his only practice, and by the late 1810s the notion of anything like a standardised procedure had entirely vanished from his work. *A First Rate taking in Stores*, for example, was completed at Farnley Hall in a single morning, in the presence of Walter Fawkes's son.
> [Turner] began by pouring wet paint on to the paper till it was saturated, he tore, he scratched, he scrabbled at it in a kind of frenzy and the whole thing was chaos — but gradually and as if by magic the lovely ship, with all its exquisite minutia, came into being and by luncheon time the drawing was taken down in triumph.[36]

The spontaneous technique of painting was expanded and refined in the following decades, and by the 1840s Turner had developed an astonishing virtuosity. The Victorian watercolourist William Leighton Leitch reported on the basis of his own observations that
> each of the matchless drawings which were painted for Mr Windus of Tottenham, was executed there in a day. Turner's method was to float-in his broken colours while the paper was wet ... he stretched the paper on boards, and, after plunging them in water, he dropped the colours onto the paper while it was wet, making *marblings* and gradations throughout the work. His completing process was marvellously rapid, for he indicated his masses and incidents, took out half-lights, scraped out high lights, and dragged, hatched and stippled until the design was finished. This swiftness, grounded on the scale practice in early life, enabled Turner to preserve the purity and luminosity of his work, and to paint at a prodigiously rapid rate ... [37]

Whiting Fishing off Margate, Sunrise 1822 watercolour Private Collection (cat. no. 54)

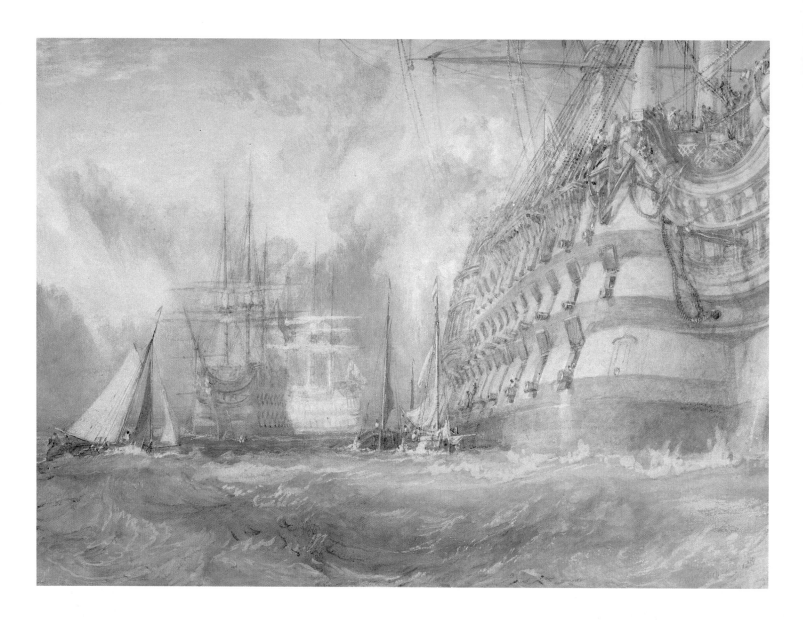

These performances — the musical analogy with 'scale practice' is significant — were precisely analogous to Turner's Varnishing Day activities in oil painting, when a barely-defined lay-in would be finished on the walls of the exhibition room at the Royal Academy.[38] Although there is little evidence for the traditional view that Turner employed watercolour in this finishing process,[39] in his work the interchangeability of techniques and materials between the two mediums was unusually spontaneous. From his first recorded oil of *c.*1793, which was described as 'in just the manner one might suppose a water-colour artist would paint', to the white-primed canvases and delicate surface drawing of the final decades, Turner exemplified similar interests in all his highly inventive procedures. As he noted against a passage on the use of light or metallic grounds in his copy of Goethe's *Theory of Colours* (1840): 'thus paper as the acting-ground in Water Colours, White in Oil Colours'.[40]

Warm and Cool

Craig was one of the first theorists of colour to give some attention to the notion of colour-temperature, at a time when the psycho-physiology of colour was coming to have an increasing impact on the practice of painting — in the work of Robert Waring Darwin, Benjamin Thomson, Count Rumford (a key figure in the foundation of the Royal Institution) and, in the 1820s, the French chemist Michel Eugène Chevreul.

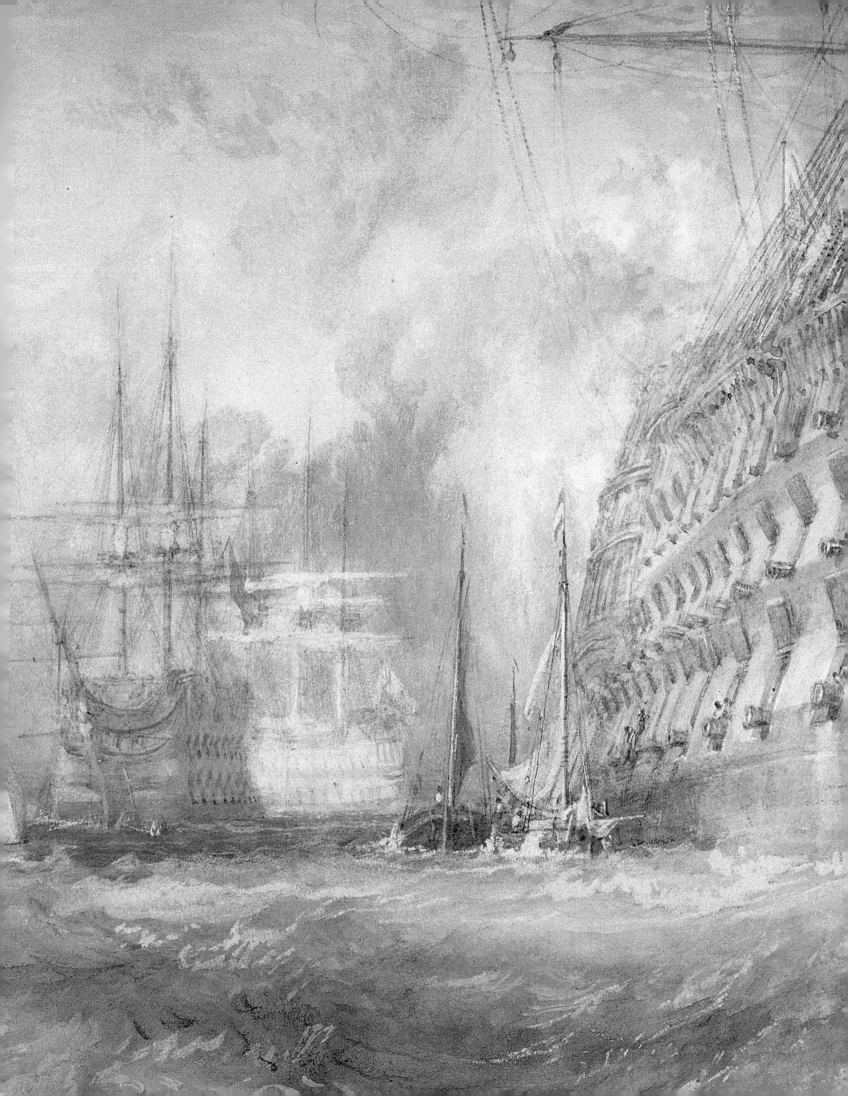

While the scientist divided the scale of prismatic colours into primary and secondary ('primitive and compound') hues, said Craig, 'they are divided by the painter, into warm and cold':

> The warm colours are understood to attract, and seemingly to approach the eye; the cold colours, on the other hand, are considered as having a tendency to give the appearance of receding.[41]

Although Turner, at this stage of his theoretical work as Professor of Perspective at the Royal Academy, was far more concerned with the structural role of the light and dark content of hues, in his Academy lecture series of 1818 he did begin to introduce considerations of temperature into a discussion of colour. There is some reason to think that he may have been stimulated to do so by Craig, whose most recent series of lectures had been given at the Royal Institution in the spring of the previous year.[42] Certainly, by the mid-1820s, the division of the spectrum into warm and cool colours had become an important principle for Turner — although his argument still remains obscure[43] — and towards the end of that decade he began to experiment more clearly with the division of his pictorial space into clearly-defined areas along these lines, particularly in watercolour, where the developing use of a broadly washed underpainting, or 'colour-beginning' allowed him a very abstracted view of colour balance. *Holy Island, Northumberland* and *Pembroke Castle, Wales* (illus. p. 78), from the *England and Wales* series, are impressive examples of this process at work. By the mid-1830s Turner had extended the process to oils, such as the two versions of the burning of the Houses of Parliament (illus. pp. 88,89), that paradigm of the mingling of fire and water. By the end of the decade this had become such a prominent feature of his colour organisation that theorists began to identify it specifically with him. Frank Howard wrote in 1838 that 'Turner's Principle' was to substitute contrasts of colour (hue) for contrasts of tone (value) and to raise the overall tonality of his paintings so that 'the only distinction between the lights and shadows is to be found in the difference of tint, — the shadows being blue or purple, and the lights a warm yellow, or fleshy colour'.[44] Howard added that this new breadth of light was more likely to be found in watercolour than in oil painting. Thus a new generation of drawing masters was distilling principles from Turner's novel practice.

Although it must remain doubtful whether Turner's concern for tonal coherence was ever completely relaxed in favour of a purely hue-based structure, nonetheless his practice of working compositions up on a matrix of colour-areas, a practice which reached a peak with the *England and Wales* watercolours, encouraged him to leave more and more of these broad swathes of enveloping colour evident in the finished works; and in the watercolour *Goldau* of 1843, where the cool greys and purples of the foreground are backed by an incandescent sky, Turner's 'principle' of warm and cool reaches a new pitch of abstraction and daring.

Water, the Image of the Mind

Turner's thoroughly unconventional attitude towards the status of watercolour, and his capacity to develop watercolour methods in his oil painting, are so striking that it would be surprising if they were not related to views on the nature and role of water itself. Mediums and materials were fascinating to Turner, and his relish for experimentation testifies not only to his devotion towards the arch-experimenter of the eighteenth century, Sir Joshua Reynolds, but also to his interest in the rapidly developing technology of art in his own day, a technology especially directed at improving the materials of watercolour. But Turner became involved with the properties of water in many different contexts.

As an experienced fisherman and a reader of Izaak Walton's classic, *The Compleat Angler* (1653), he would have learned that water was named by Moses as the first element, 'the eldest daughter of the Creation';[45] and it was of course in this role that it played a part in the several versions of the biblical Deluge which Turner painted both early and late in his career.

Turner also shared the view of another distinguished amateur angler, the chemist Sir Humphry Davy, that a river offered a complete analogy for the course of the intellectual life.

> In its origin — its thundering and foam, when it carries down clay from the bank, and becomes impure, it resembles the youthful mind, affected by dangerous passions. And the influence of a lake, in calming and clearing the turbid water, may be compared to the effect of reason in more mature life, when the tranquil, deep, cool and unimpassioned mind is freed from its fever, its troubles, bubbles, noise and foam. And, above all, the sources of a river, — which may be considered as belonging to the atmosphere, — and its termination in the ocean, may be regarded as imaging the divine origin of the human mind, and its being ultimately returned to, and lost in, the Infinite and Eternal Intelligence from which it originally sprung.[46]

As Turner wrote at the head of a version of his Academy lecture on 'Reflexes' (i.e. the perspective of reflections):

> Water, the image of the mind,
> Clears as it runs, and as it runs, refines.[47]

Yarmouth Roads c.1840
watercolour
National Museums and Galleries
on Merseyside: Lady Lever Art Gallery,
Port Sunlight (cat. no. 83)

Longships Lighthouse, Land's End *c.*1835 watercolour J. Paul Getty Museum, Malibu, California (cat. no. 74)

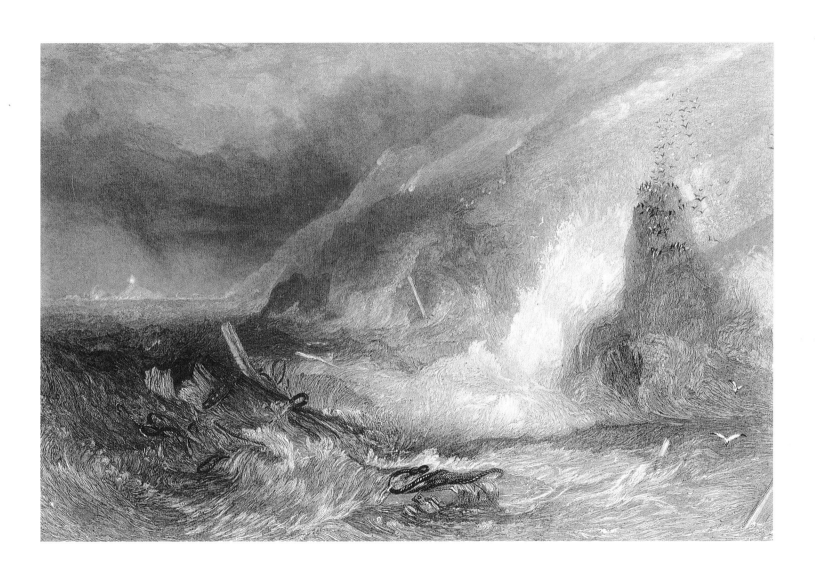

W.R. Smith engraver, after J.M.W. Turner *Longships Lighthouse, Land's End* 1839 from *Picturesque Views in England and Wales* engraving Art Gallery of New South Wales, Sydney
Gift of Mrs Arthur Acland Allen, 1940 (cat. no. 118)

It was indeed his appointment in 1807 as Professor of Perspective at the Academy that induced Turner to make his most thoroughgoing investigation of the properties of water. The perspective rules for constructing reflections, both from solid shining or transparent bodies, and from water, are extraordinarily complex; thus, said Turner in his first lecture series of 1811, they had been generally neglected, although they were 'absolutely requisite', and he hoped to 'rouse a more minute investigation which may, in the end, discover positive axioms for reflexes'.[48]

His starting point for the examination of reflections from water was Joseph Priestley's *Familiar Introduction to the Theory and Practice of Perspective* (1770); but he may also have been stimulated by witnessing, or hearing reported, John George Wood's lectures on perspective construction given at the Royal Institution from 1807.[49] The earlier theorists, such as Priestley, had treated water essentially as if it were a mirror, and this, thought Turner, was clearly implausible.

> Water has hitherto been said to be the same as polished bodies. Generally it may be considered as such, but abstractly [it is] quite different: first, from colour; secondly, from motion; and thirdly, its reflections, which admit of such endless variety incomprehensible contrarities and exhibit such phenomena, that it imperiously demands more attention than the dismissal it has generally received: 'Water, like other transparent bodies may be treated the same, it being like a mirror.' True, it is a mirror, but of nature's choicest work. Do we ever trace the double tones and prismatic reflected ray of the glass, or do we see the liquid melting reflection, or the gentle breeze that on the surface of the water sleeps?[50]

In an early draft for this lecture Turner referred particularly to distinctions in colour.

> Water often appears dark under a reflected sky, but the mirror under the same sky would be lighter, for it should be recollected that a glass repells [sic] only, while water has the double property of absorbing the rays of light and reflecting and refracting.[51]

In a note to the 1811 version which incorporated some garbled reminiscences of poetry, he listed a great variety of characteristics in water in a way that is remarkably close to Sir Humphry Davy's poetic analogy quoted above.

> Quantity, division, clear or turbid, all present such ever pleasing and perpetual changes whether from the Mountain Stream struggling impediments or spreading its wandring stream in the unruffled Lake undistorted possessor [?] or
>
>> as the Western wave
>> whose broad cerulean mirror
>> gave back in beamy visage calm and bright
>> to the sky
>> with splendour undiminished
>> And each cloud glowing unempurpled gold (azure purple)
>> High shone, gleaming around his throne
>> Or lashed into foam and spray painted to the imagination the overwhelming majesty
>> and power of the ocean, as Dr Night Thoughts Glean [?]
>> Thou dreadful and tumultuous home of death,
>> where most he dominates.[52]

Here is an anthology of the powers and effects of water which Turner recreated so abundantly.

Turner's concern with water was thus characteristically comprehensive; it embraced considerations ranging from the purely technical to the metaphysical, and each demand for understanding was addressed by him with his usual vigour. The consequences of these investigations may be felt in virtually every work in this exhibition, from the placid Venetian lagoon or the lake of Lucerne in '*The Red Rigi*' to the devastating power of sea and weather in *Longships Lighthouse, Land's End* (illus. p.122). What has perhaps been little

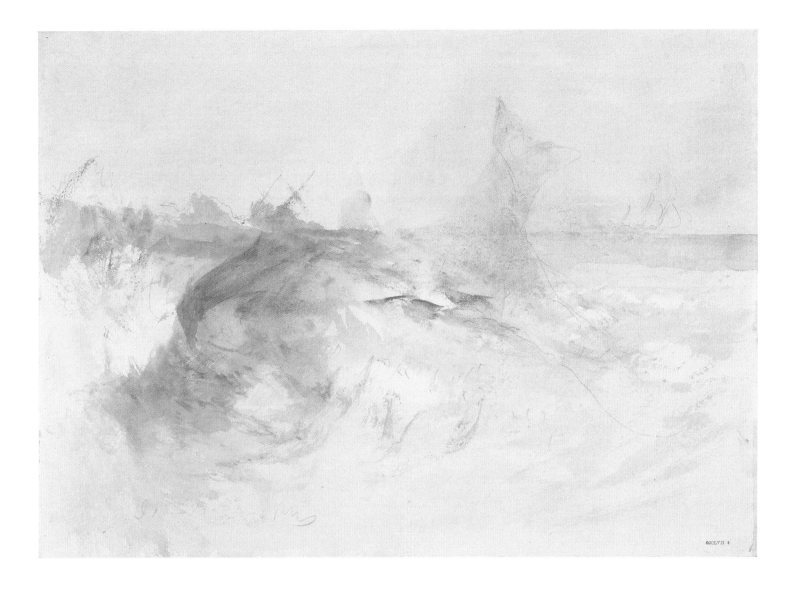

A Harpooned Whale 1845
watercolour Tate Gallery, London
Bequeathed by the artist, 1856
(cat. no. 97)

appreciated hitherto is how much these interests chimed with the other imaginative minds of English Romanticism. How, for example, the teasing ambiguities of sea and ship in the *Yarmouth Roads* (illus. p. 121), or the elision of waves and gulls in *Lyme Regis, Dorsetshire: A Squall* or *Longships Lighthouse* depend on the same order of curiosity as that expressed by Samuel Taylor Coleridge in the notebook of a visit to Malta in 1804.

> A brisk Gale, and the spots of foam that peopled the *alive* Sea most interestingly combined with the numbers of white Sea-Gulls; so that repeatedly it seemed, as if the foam-spots had taken Life and Wing & flown up. The white precisely same-colour Birds rose up so close by the ever perishing white wave head, that the eye was unable to detect the illusion which the mind delighted indulging — [53]

Coleridge is, as so often, turning the interpretation of birds and moving water into a riddle, a test of mental agility of precisely the sort offered by Turner's representations. But, as the poet also makes clear, riddling is pleasurable, of the same order of pleasure that Turner's contemporaries, and generations of admirers after him, found in comparing their experience of his drawings and paintings with their experience of the visual world at large. Turner's conceptions of nature were stamped with the most wide-ranging preoccupations of his generation; but he alone, and above all in watercolour, could find techniques for giving them an appropriately various visual form.

Notes

1. On Valenciennes, see P.R. Radisich, 'Eighteenth-century *plein-air* Painting and the Sketches of Pierre Henri de Valenciennes', *Art Bulletin*, 1982, 64, pp. 98–104.

2. Eric Shanes has pointed to this synaesthetic element in '*The Blue Rigi*' in *Turner Studies*, 1990, vol. 10. no. 1, p. 59, and A.G.H. Bachrach noticed a similar incident to that found in '*The Red Rigi*' in Turner's oil of the becalmed *Dort Packet-Boat*, (1818, Yale Center for British Art, New Haven, Paul Mellon Collection), and its precedents in van Goyen and Cuyp, in 'Turner, Ruisdael and the Dutch', *Turner Studies*, 1981, vol. 1, no. 1, p. 26.

3. Edward Tyas Cook and Alexander Wedderburn (eds), *The Works of John Ruskin*, 39 vols, London: George Allen, 1903–12, vol. 13, pp. 475–485 (hereafter, Ruskin, *Works*). The fullest overview of the history of the late Swiss watercolours is now Ian Warrell, *Through Switzerland with Turner: Ruskin's first selection from the Turner Bequest*, London: Tate Gallery, 1995, pp. 149–154. This catalogue illustrates several 'sample' studies beside the finished drawings. Ruskin's reference to Raphael and Dürer is to a red chalk drawing of two men *c.*1515 in the Albertina, Vienna, inscribed by Dürer to explain that it was sent by Raphael to him 'to show his hand', see P. Joannides, *The Drawings of Raphael*, Oxford: Phaidon, 1983, no. 371, plate 37.

4. S. Whittingham, 'Windus, Turner and Ruskin: New documents', *J.M.W. Turner, R.A.*, no. 2, 1993, pp. 69–116.

5. For Turner and Munro, see John Gage (ed.), *Collected Correspondence of J.M.W. Turner, with an Early Diary and a Memoir by George Jones*, Oxford: Clarendon Press, 1980, pp. 272–273.

6. Hugh W. Williams, *Travels in Italy, Greece and the Ionian Islands*, Edinburgh: A. Constable and Co., 1820, vol. 1, p. 333. Williams was, in 1807, a founder-member of the New Society of Painters in Miniature and Water-Colours.

7. J. Bayard, *Works of Splendor and Imagination: The exhibition watercolor 1770–1870*, New Haven: Yale Center for British Art, 1981, p. 7. This is the fundamental study of the subject.

8. See A.J. Finberg, *The Life of J.M.W. Turner, R.A.*, 2nd edn rev., London: Oxford University Press, 1961, p. 46. The Tate Gallery has recently acquired a letter from the Rev. Robert Nixon to Turner, written in 1798, including a wash drawing for correction, with Turner's corrections and response. I am grateful to David Blayney Brown for showing me his notes on this letter. For Nixon's son, see John Gage, *J.M.W. Turner: 'A Wonderful Range of Mind'*, New Haven: Yale University Press, 1987, p. 247, n. 16.

9. W. Bemrose, *The Life and Works of Joseph Wright, A.R.A.*, London: Bemrose and Sons, 1885, p. 95.

10. For Constable's teaching post, see R.B. Beckett (ed.), *John Constable's Correspondence*, vol. 2, Ipswich: Suffolk Records Society, 1964, p. 31; vol. 6, 1968, pp. 6–7; also K. Garlick, A. Macintyre, Kathryn Cave (eds), *The Diary of Joseph Farington*, 16 vols, New Haven: Yale University Press, 1978–84, vol. 5, p. 1779, 20 May 1802, (hereafter, *Farington*). For Fisher's comments on Varley, see R.B. Beckett (ed.), vol. 6, 1968, p. 145. Varley's *Treatise on the Principles of Landscape Design, with General Observation and Instructions to Young Artists* was first published between 1816 and 1821: see P. Bicknell and J. Munro, *Gilpin to Ruskin: Drawing masters and their manuals, 1800–1860*, Cambridge: Fitzwilliam Museum, 1988, pp. 28–29.

11. *Farington*, vol. 4, p. 1303, 17 November 1799; see also vol. 4, p. 1255, 21 July 1799.

12. John Gage, 1987, pp. 157–158.

13. Michael Clarke, *The Tempting Prospect: A social history of English watercolours*, London: British Museum Publications, 1981, p. 111. The Society did offer drawing premiums to intending professional artists as well, and Turner himself was awarded one in 1793.

14. S. Uwins, *A Memoir of Thomas Uwins, R.A.*, vol. 1, London: Longmans, Brown, Green, Longmans and Roberts, 1858, (facsimile rep. 1978, Wakefield: E.P. Publishing) pp. 30-31.

15. Michael Clarke, 1981, p. 81.

16. *Farington*, vol. 10, p. 3715, 23 August 1810.

17. M. Hardie, *Water-colour Painting in Britain*, vol. 2, London: Batsford, 1967, p. 119n, see also pp. 36–37.

18. For the Water-Colour Society's gallery, J. Bayard, 1981, p. 28. For Turner's second gallery, with its awning of herring-net and tissue-paper, John Gage, *Colour in Turner: Poetry and truth*, London: Studio Vista, 1969, p. 162.

19. D. Morris, *Thomas Hearne and his Landscape*, London: Reaktion, 1989, p. 29.

20. *The Athenaeum*, 10 June 1829, p. 363. The fundamental study of this series is Eric Shanes, *Turner's Picturesque Views in England and Wales, 1825–1838*, London: Chatto and Windus, 1979.

21. *The Atlas*, 7 June 1829, p. 381, also *Literary Chronicle*, Eric Shanes, 1979, p. 12.

22. Ibid., p. 14.

23. Ruskin, *Works*, vol. 3, p. 235n.; see in general S. Whittingham, 'The Turner Collector: B.G. Windus', *Turner Studies*, 1988, vol. 8, no. 2, p. 29.

24. John Gage, 1969, p. 163; John Gage, 1980, Letter 84; for Fawkes, see MS note in C.F. Bell, *The Exhibited Works of J.M.W. Turner*, London: Victoria and Albert Museum, 1901, pp. 168–169. For gold frames at the watercolour exhibitions, see J. Bayard, 1981, pp. 26–29. It is notable that Munro of Novar, who also opened his collection very readily to visitors, kept his Turner drawings in portfolios (*Art Union*, 9, 1847, pp. 253–255).

25. William Marshall Craig, *Course of Lectures on Drawing, Painting and Engraving, Considered as Branches of Elegant Education, Delivered in the Salon of the Royal Institution in Successive Seasons and Read Subsequently at the Russell Institution*, London: Longman, Hurst, Rees, Orme, and Brown, 1821, p. 121.

26. *Farington*, vol. 7, p. 2686, February 1806, see also vol. 7, p. 2692, 15 March 1806, and vol. 7, p. 2777, 3 June 1806.

27. William Marshall Craig, 1821, p. 126–127. On p. 241 Craig mentions two London suppliers of this varnish, but it is not clear how soon before 1821 it began to be marketed. For varnishing watercolours, see M.B. Cohn, *Wash and Gouache: A study of the development of the materials of watercolor*, Cambridge, Mass.: Fogg Art Museum, 1977, pp. 59–60.

28. J. Bayard, 1981, p. 18; M.B. Cohn, 1977, pp. 61–64.

29. William Marshall Craig, 1821, p. 126; see also Peter Bower, *Turner's Papers: A study of the manufacture, selection and use of his drawing papers 1787–1820*, London: Tate Gallery, 1990, p. 110.

30. *Lake of Geneva with Mont Blanc*, (c.1803, Yale Center for British Art, New Haven, Paul Mellon Collection).

31. William Marshall Craig, 1821, pp. 125,426.

32. For Craig's uncomplimentary remarks on Wright, see ibid., pp. 95f.,160f. For Wright's use of thin glazes over a white ground, see R. Jones, 'Wright of Derby's techniques of painting', in Judy Egerton, *Wright of Derby*, London: Tate Gallery, 1990, pp. 263,267.

33. William Marshall Craig, 1821, pp. 15f.,426. For Wright's monochrome underpaintings, see R. Jones, 1990, pp. 267,269–270. These underpaintings have a parallel in Wright's many monochrome pen and wash drawings, well represented and illustrated in the 1990 exhibition catalogue, London: Tate Gallery.

34. For Glover's method, see *Farington*, vol. 9, p. 3263, 20 April 1808; see also John Gage, 1969, pp. 38,246. On Turner's relations with Glover, see Andrew Sayers's essay, this catalogue pp. 202–215.

35. John Gage, 1969, p. 28.
36. *Turner, 1775–1851*, London: Royal Academy of Arts, 1974, pp. 83–84, no. 194.
37. B. Webber, *James Orrock, R.I.*, 1903, pp. 60–61. The drawings executed at Tottenham for Windus generally have been thought to be *England and Wales* subjects, not all of which were specifically painted for Heath; but equally they may have been the Swiss, German and Italian subjects of *c.*1840–45. Leitch certainly exaggerates their number.
38. The fullest discussion is still John Gage, 1969, ch. 10, but see also J. Townsend, *Turner's Painting Techniques*, London: Tate Gallery, 1993, p. 5.
39. See John Gage, 1987, pp. 93–94; J. Townsend, 1993, pp. 58–59 shows that the media for 'finishing' were invariably oils.
40. For the earliest oil, see John Gage, 1969, p. 229, n. 53; for the note to Goethe, see John Gage, 'Turner's Annotated Books: "Goethe's Theory of Colours"', *Turner Studies*, 1984, vol. 4, no. 2, p. 42. For the sovereign role of white in Turner's practice, see J. Townsend, 1993, pp. 45–46.
41. William Marshall Craig, 1821, pp. 171ff. The earlier discussion of warm and cool colours by Reynolds had been confined to the argument that the tonality of paintings should be predominantly warm, since there are two 'warm' primaries (red and yellow) and only one 'cool' (blue). The idea of warm and cool colours in painting does not seem to pre-date the eighteenth century.
42. See M. Berman (introduction), *Minutes of the Meetings of the Managers of the Royal Institution*, 2 December 1816, vol. 6, p. 131, (hereafter, *Minutes*). In his Lecture VI, of January 1818, Turner used Craig's characterisation of red as an 'attractive' colour and blue as 'distance' (see John Gage, 1969, p. 206) just after he had attacked Gerard Lairesse's symbolic values for colours, which were also discussed by Craig shortly after his account of warm and cool (see William Marshall Craig, 1821, p. 173). It is, incidentally, perhaps a sign of Turner's weakness as a lecturer that the reporter of *The Morning Herald*, which gave a long resumé of his lecture on 28 January 1818, thought that he was endorsing Lairesse's scheme. Craig's concluding essay in his edition of Lairesse's *Art of Painting* (1817) also included a formulation of white as the compound of the colours in light and black of the mixture of pigments, which is close to Turner's Lecture VI (see William Marshall Craig (ed.), Lairesse, 1817, vol. 2, p. 282; John Gage, 1969, p. 206); and, more interestingly, on red as either a light or a dark colour according to its function in the picture, a notion which Turner passed on to the engraver Edward Goodall a few years later (see John Gage, 1969, p. 52).
43. John Gage, 1969, pp. 114–17,210.
44. Frank Howard, *Colour as a Means of Art*, London: Joseph Thomas, 1838, pp. 76–77, see also pp. 51,53–54.
45. Izaak Walton, *The Compleat Angler* , 1653, pt 1, ch. 1. For this book in Turner's travelling library, see Walter Thornbury, *The Life and Correspondence of J.M.W. Turner, R.A.*, rev. edn, London: Chatto and Windus, 1877, p. 364.
46. Humphry Davy, *Salmonia, or Days of Fly Fishing* (1828), 4th edn, London: J. Murray, 1851, pp. 16ff. For possible contacts between Turner and Davy, see John Gage, 1987, p. 254 n. 44. Turner's own much earlier draft of a poem on the river as an allegory of human life, but in a pastoral idiom close to Turner's paintings of around 1806, has been discussed by Andrew Wilton and Rosalind Mallord Turner, *Painting and Poetry: Turner's Verse Book and his Work of 1804–1812*, London: Tate Gallery, 1990, pp. 44–45.
47. John Gage, 1969, p. 40. Here I considered this draft in a private collection to be a later version than those in the British Library, but Maurice Davies, *Turner as Professor: The artist and linear perspective*, London: Tate Gallery, 1992, p. 105, n. 26, has shown that it is likely to be earlier than 1811.
48. Ibid., p. 50.
49. Joseph Priestley, *A Familiar Introduction to the Theory and Practice of Perspective*, London: Printed for J. Johnson and J. Payne, 1770, p. 87; John George Wood, *Lectures on the Principles and Practice of Perspective as Delivered at the Royal Institution*, 2nd edn, London: T. Cadell and W. Davies, 1809, pp. 85ff. Wood began his series in 1806, but the lecture on perspective construction (Lecture VII) does not seem to have been included until the following year (see M. Berman, *Minutes*, 16 March 1807, p. 239; 30 March 1807, p. 243). Craig included a lecture on water in which, for the study of reflections, he recommended Wood's course (see William Marshall Craig, 1821, pp. 304ff).
50. Maurice Davies, 1992, pp. 51–52. The inset quotation may be based on Joseph Priestley, 1770, p. 87.
51. MS of Turner's Lecture V, private collection, n.p.
52. British Library Add. MS 46151, H. ff.11–12. The reference is to Edward Young, *Night Thoughts*, Night VIII, lines 168–170, a copy of which was in Turner's travelling library (see Walter Thornbury, 1877, p. 364). The passage in Young reads:
 Ocean! thou dreadful and tumultuous home
 Of dangers, at eternal war with man!
 Death's capital, where most he domineers ...' (1778 edn, VI, pp. 10–11).
53. Kathleen Coburn (ed.), *The Notebooks of Samuel Taylor Coleridge*, London: Routledge and Kegan Paul, 1957–, vol. 2, part 1, 1962, no. 2345 (December 1804).

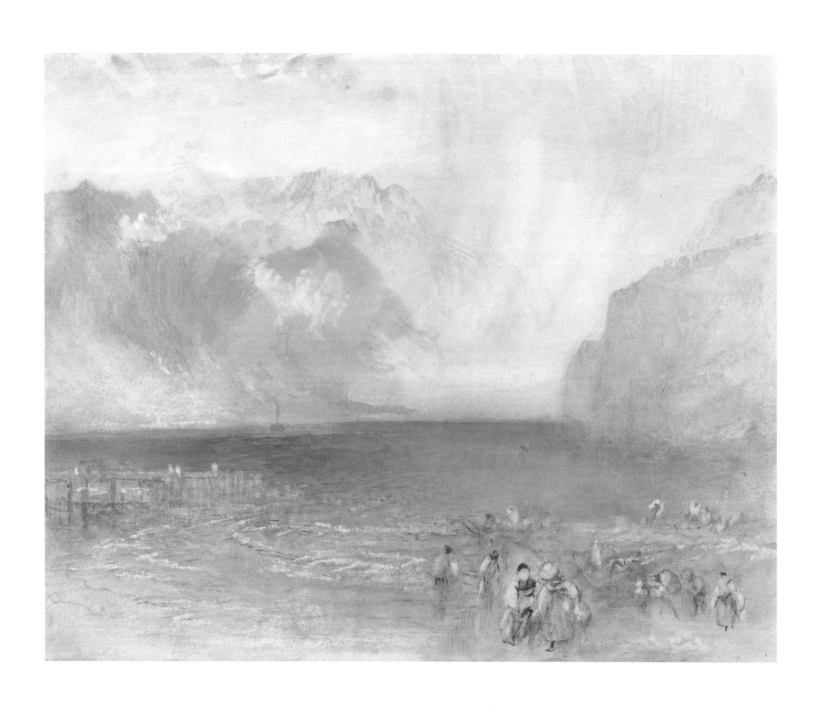

The First Steamer on Lake Lucerne c.1841 watercolour University College, London College Art Collections (cat. no. 84) *detail right*

The Late Swiss Watercolours

Irena Zdanowicz

Returning home from a sketching tour of Switzerland in the late Autumn of 1841, Turner, then aged sixty-four, decided upon an unusual plan of creating a series of finished watercolours based on the sketches he had produced there.[1] His idea for selling the finished works was also unorthodox, reflecting perhaps his awareness that they were different enough from work he had so far produced to warrant concern about how they should be sold.[2] A more pragmatic reason, given his financial shrewdness and his plans to endow a charity for artists, may have been his wish to finance several large and expensive engravings without dipping into his accumulated capital.[3]

When Turner approached his dealer, Thomas Griffith, with fifteen sketches from which he hoped to obtain commissions for finished watercolours, he had taken the precaution of completing four to demonstrate the degree to which the unfinished 'sample' studies might be worked up. Based on what Griffith told him, John Ruskin later wrote a memorable account of this first meeting:

> Says Mr Turner to Mr Griffith: 'What do you think you can get for such things as these?'
> Says Mr Griffith to Mr Turner: 'Well, perhaps, commission included, eighty guineas each?'
> Says Mr Turner to Mr Griffith: 'Ain't they worth more?'
> Says Mr Griffith to Mr Turner: (after looking curiously into the execution which, you will please note, is rather what some perhaps might call hazy) 'They're a little different from your usual style' — (Turner silent, Griffith does not push the point) — 'but — but — yes, they are worth more, but I could not get more ...'[4]

The 'hazy' effect of the finished works, noted by Ruskin, was in fact meticulously and laboriously executed and took so long to achieve that Turner abandoned his original plan to produce twenty finished watercolours, reducing the number by half.[5] Ruskin, who was about to embark on writing his first volume of *Modern Painters* — a partisan and eloquent account of Turner's work composed in the face of growing criticism of the hazy, painterly effects of his late paintings, first published in 1843 — considered these works to be the wonderful climax of Turner's art in watercolour, a view that has been upheld to the present day.

Of the collectors whom Griffith gathered together, Hugh Andrew Johnstone Munro of Novar, Turner's Scottish friend and patron of many years, chose five works, among them the finished watercolour, '*The Red Rigi*' (illus. p. 103); Elhanen Bicknell, owner of a whaling fleet and one of the newer breed of merchant collectors, selected two including another finished specimen, '*The Blue Rigi*' (illus. p. 102). Bicknell also took *Brunnen on the Lake of Lucerne* (illus. p. 130) which he commissioned on the basis of its sample study. Benjamin Godfrey Windus, owner of a splendid collection of Turner's watercolours, including many of the *Picturesque Views in England and Wales*, had been first on the scene, but declined, annoyed with the commissioning procedure and not liking Turner's change of style.[6] Ruskin eventually selected views of Lucerne and Coblenz (the only German scene in the series) from the sample studies. A buyer for the tenth view, *Constance* (illus. p. 104), could not be found and Turner gave it to Griffith as part of his fee. Later, Ruskin was able to persuade Griffith to relinquish it, describing the day he brought it home as one of the happiest in his life.[7]

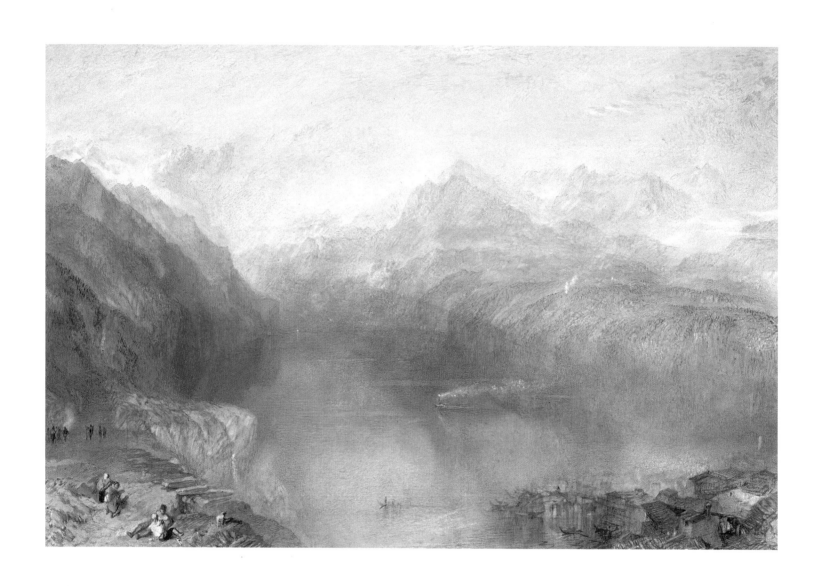

Brunnen on the Lake of Lucerne 1842 watercolour Private Collection (cat. no. 90)

C. **Turner** engraver, after **J.MW. Turner**
Little Devil's Bridge
from *Liber Studiorum,*
part IV. 29 March 1809
etching and mezzotint
National Gallery of Victoria, Melbourne
Felton Bequest, 1949
(cat. no. 105)

This initial awkwardness in disposing of the watercolours and their equivocal reception amongst Turner's most loyal collectors may have disappointed the artist, but it did not deter him from continuing to work according to the procedures he had established. Inspired by the Swiss landscape, he returned to the Alps for the next three years — 1842, 1843 and 1844 — revisiting favourite places, yet each time exploring new terrain. Switzerland drew out of him a great series of views depicting its mountains, valleys, lakes and towns. The watery expanse of the lakes and the suspended mists of the atmosphere created shimmering, expansive visions of colour in which water merges with shore, and mountain tops dissolve in light and clouds. Human activity is accommodated naturally in most of the scenes, merging with the fabric of the lakeside towns in richly textured evocations of city life, or inhabiting the wilder, less familiar spaces. These Swiss views of the 1840s, done in Turner's maturity, were very different from those made earlier in his career.

Turner had been an assiduous and systematic traveller from his youth, going on sketching tours in Britain or on the Continent every summer. He had originally gone to Switzerland in 1802, as soon as the Treaty of Amiens made travel across Europe possible and safe, and only a few months after he had been elected a Royal Academician. While most of his fellow artists and connoisseurs elected to head for Paris, Turner aimed for the Alps. His first Swiss landscapes focused on the grandeur and bleakness of the mountains, staples of the Sublime, and are monochromatic in tonal tendency. He often sketched on paper prepared with grey wash, using these drawings mainly as reference material for his other work.

He depicted glaciers and treacherously steep mountain paths linked by improbably suspended arched bridges, towering mountains and waterfalls whose spray mingled with the mountain mists creating a sense of giddy heights and sheer descents. Stopping in Paris on his way back from this first trip he told Joseph Farington that 'the trees in Switzerland are bad for a painter — fragments and precipices very romantic, and strikingly grand. The country, on the whole surpasses Wales; and Scotland too, though Ben [Arthur?] may vie with it.'[8]

Turner's earlier sketching tours of Scotland and Wales had served as a preparation for the spectacular grandeur of Swiss scenery and he was familiar with the watercolours of John Robert Cozens which were among those he was set to copy at Dr Thomas Monro's academy in the 1790s.[9] Cozens's grand and brooding, yet delicately drawn portrayals of alpine scenery were made en route to Italy during his 1776 tour there in the company of the connoisseur and collector, Richard Payne Knight. They are notable in being the first such views painted by an English artist which transcend topographical exactitude, conveying visually those feelings of overwhelming scale, awe and fear that were previously only recorded in literature or in tourists' written accounts. They are the most significant precursors of Turner's first Swiss landscapes of the early 1800s. The experience of Turner's alpine tour of 1802 was synthesised graphically in a number of the early plates of mountain scenery he produced for the *Liber Studiorum* (illus. p. 131). It reached its culmination a decade later in the painting, *Snow Storm: Hannibal and his Army crossing the Alps* (illus. p. 23), in which the classical subject is portrayed in Sublime mode, invested with the power and veracity of Turner's experience and his close observation of alpine terrain and atmosphere.[10]

Although he continued to travel abroad regularly, Turner did not return to Switzerland until 1836, when, in the company of Munro of Novar, he set off for the Alps, travelling via France and returning through the Valley of Aosta. He sketched continuously but, as Munro later recalled, colour did not come out till they reached Switzerland.[11] Numerous sketchbooks were filled, including those with broadly-mapped colour studies, but this tour did not result in any finished watercolours.

By 1838 Turner's work on the *Picturesque Views in England and Wales* series had come to an end and, being used to the discipline of creating watercolours to order, he may have felt that he needed another project. In 1841 he decided to go to Switzerland for the third time. The work stemming from his three Swiss sketching tours of the 1840s is characterised by a systematic approach to creating finished watercolours, of working on several levels of resolution before making the final version. Those works that were elaborated to a relatively high degree of definition or colour, like *The First Steamer on Lake Lucerne* (illus. p. 128), however acceptable as finished works they may seem to our eyes, were not meant as such, but were done as colour or compositional preparations, 'left in their chance state when done from nature'.[12] Turner worked compulsively, and with a professionalism born of a lifetime's practice.

A glimpse of him at work outdoors on one of his late Swiss tours comes to us from the photographer, William Lake Price, who remembered seeing him on a steamer on Lake Como: 'Turner held in his hand a tiny book, some two to three inches square, in which he continuously and rapidly noted down one after another ... *changing* combinations of mountain, water, trees &c., until soon *twenty* or more had been stored away in an hour and a half's passage.'[13] Similarly, the watercolourist William Callow, while feasting his eyes on the views of Venice from a gondola, had caught sight of Turner in another, sketching intently, putting his own inactivity momentarily to shame.[14] Ruskin provides this description: 'Turner used to walk about a town with a roll of thin paper in his pocket, and made a few scratches upon a sheet or two of it, which were so much shorthand indication of all he wished to remember. When he got to his inn in the evening, he completed his pencilling rapidly, and added as much as was needed to record his plan of the picture.'[15]

'*The Red Rigi*': *sample study* c.1841–42
watercolour
Tate Gallery, London
Bequeathed by the artist, 1856
(cat. no. 86)

The practice of constant observation, the exercise of his phenomenal memory and his formidable artistic talent are abundantly evident in the four series of Swiss watercolours that he completed between 1841 and *c.*1850, numbering over twenty highly finished works and numerous studies. Amongst these, the group of drawings of Mount Rigi, situated across the lake from Lucerne, which Turner watched and drew repeatedly from the window of his hotel, the Hôtel du Cygne, are of special interest and merit. Two of the four finished specimens from the first set of 1841–42 were devoted to it: '*The Blue Rigi*' depicting the mountain in the cool colours of morning, and '*The Red Rigi*' showing it in the warm glow of sunset. A third, '*The Dark Rigi*' (private collection: W 1532), which portrays the subject looming as a dark shadowy shape just before the first light of dawn, was commissioned by Munro of Novar from one of the samples. Such repeated portrayals of a subject from the same viewpoint, in different light and at different times of day has often been seen as prophetic of later nineteenth-century practice, exemplified by Monet's haystacks. In another context, the repetitive, mesmeric focus on a single looming object has been likened to the story of the obsessive hunt for the great whale in Moby Dick.[16] Clearly, from the number of renderings he made of it, the Rigi's soaring hump and its reflection in the deep waters of the lake held a great fascination for Turner.

The sample studies for the Rigis are sufficiently definite in terms of composition and colour to allow us to identify them fairly confidently with the corresponding finished versions. However, the differences between sample and finished watercolour also demonstrate the extent to which the studies were *aides memoires* for works which, ultimately, were very different in detail and execution. The genesis of '*The Red Rigi*' provides a good example of this. Its sample study (illus. p. 133) fixes the broad outlines of the composition which is dominated by the mountain whose shape is mirrored in the lake, while the moon casts a vertical beam of light across the water. The principal boat is positioned directly beneath the mountain, echoing in miniature both its actual and its reflected shape. Summarily painted, the boat's function is nevertheless clear: it immediately establishes a sense of scale, initiating a clearly receding perspective that extends to the little boat in the middle left distance.

While the features of the landscape are unchanged in the finished work, the sense of atmosphere, of light and space are structured quite differently. Here the highly-wrought stippling and hatching technique enables one colour to merge ineffably with another, creating an appearance of alternating areas of atmospheric density and translucence that suggest immeasurable levels of distance and depth. From the base of the mountain colour changes from a dark blue, through delicate iridescent tones of blue and violet that climb to the lower slopes and glow with pink at the top. The uppermost ridges are defined with feathery brushstrokes of light yellow that fan out in all directions, suggesting the refracting, dissolving light of the peaks. The rendering of the water, and the disposition of areas of darkness and light also contribute to the construction of depth. The broad ripples in the left corner, as they arc towards the centre, provide lines of recessive space, while the line of the buildings on the far shore glinting with the last light of day expand the sense of open space. Rather than the two boats of the study, as many as six are dotted across the lake. Towards the right, a single boatman is an inspired rendering, in dry brush, of a motif whose clarity disintegrates as it recedes into the distance. A picture so meticulously crafted could never be done in front of the subject. All depictions of the Rigi represent fleeting appearances that are as much remembered as observed and given pictorial embodiment by the contemplative power of memory.

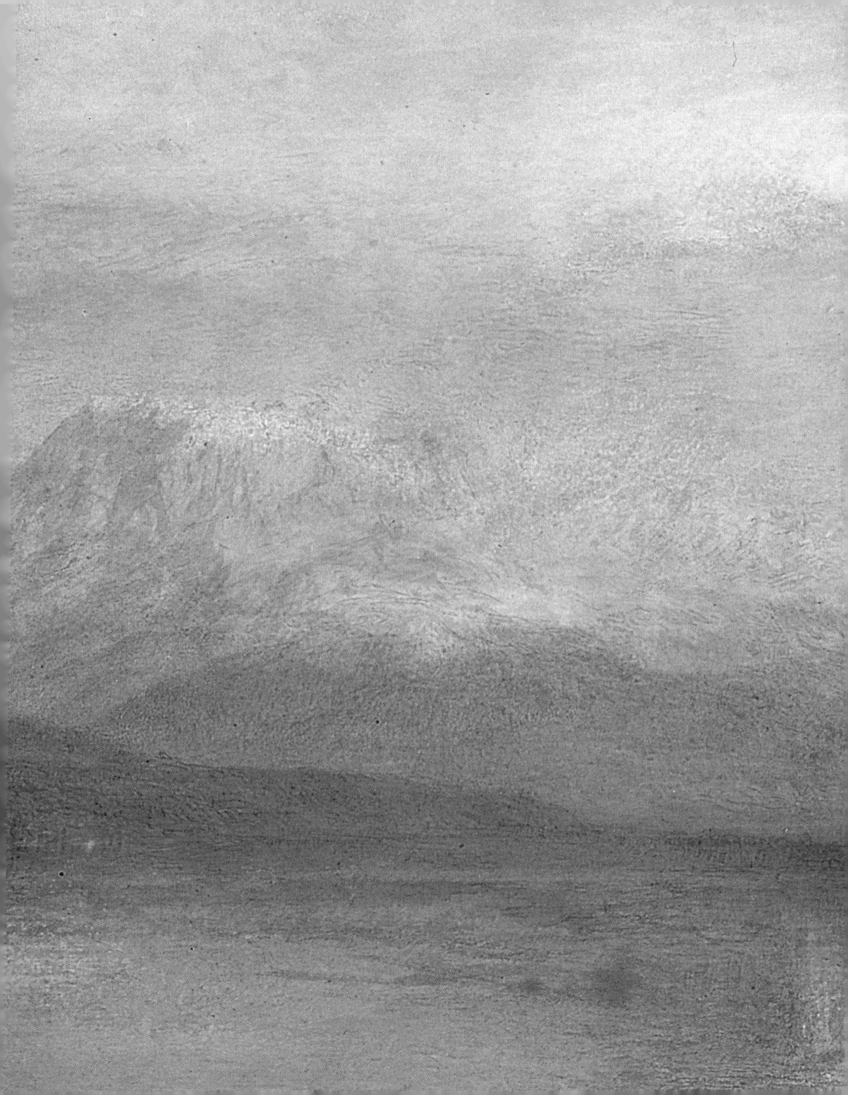

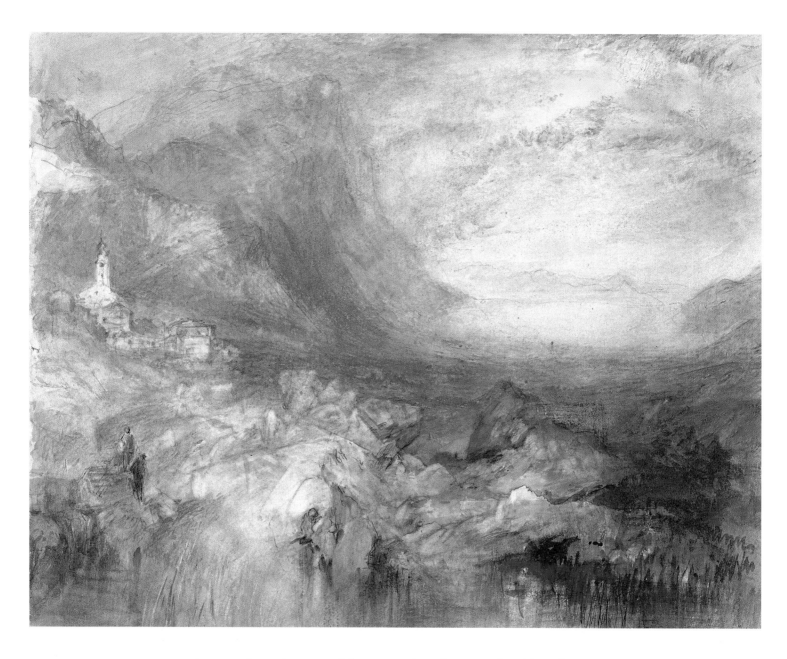

Goldau, with the Lake of Zug in the Distance: sample study c.1842–43
watercolour
Tate Gallery, London
Bequeathed by the artist, 1856
(cat. no. 92)

An even clearer instance of this approach is the view of *Goldau* (illus. p. 137). Whereas the prevailing mood of the late Swiss watercolours is one of contemplative calm in the face of an immense and serene nature, the dramatic portrayal of Goldau in colours of searing intensity shows nature's other, more frightening aspect. This is one of six finished works made in 1843, following Turner's 1842 tour of Switzerland; it was commissioned by Ruskin from a sample study (above). The village of Goldau on Lake Zug had been the place of a great catastrophe earlier in the century. In 1806, four years after Turner's first visit to the Alps, the village which he had passed through was destroyed by an avalanche of rocks in which nearly five hundred people were killed. The incident became famous and was recorded in travel guides to Switzerland and commemorated in Byron's epic poem, *Manfred* (1817). Murray's *Handbook for Travellers in Switzerland*, first published in 1838 and consulted by Turner, described the disaster in the following way: '[T]he whole surface of the mountain seemed to glide down, but so slowly, as to afford time to the inhabitants [of the neighbouring towns] to go away ... [They] were first roused by loud and grating sounds like thunder; they looked towards the spot from where it came, and beheld the valley shrouded in a cloud of dust — when it had cleared away they found the face of nature changed'.[17]

136

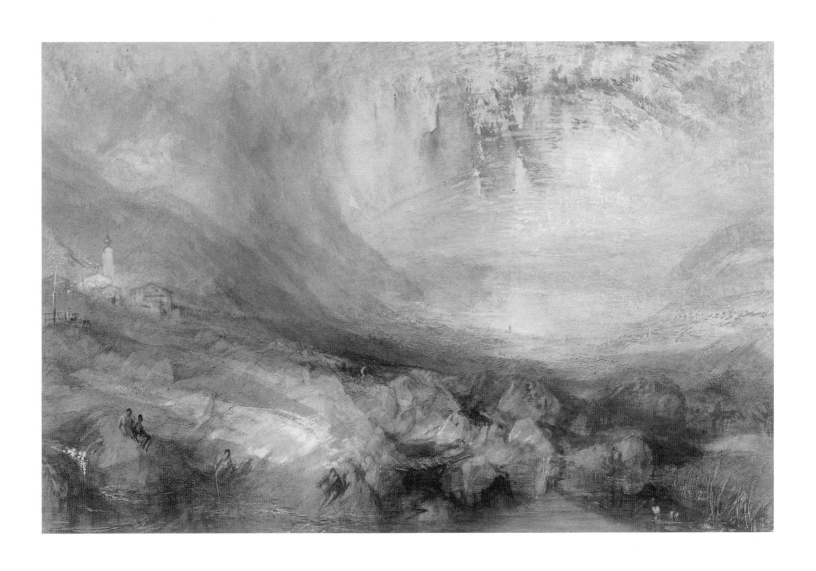

Goldau 1843 watercolour Private Collection (cat. no. 93)

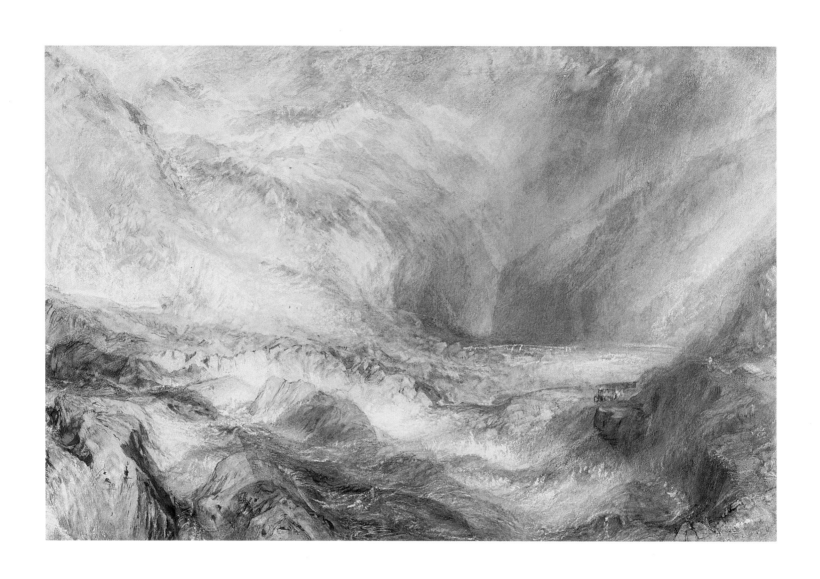

The Pass of St Gotthard, near Faido 1843 watercolour The Pierpont Morgan Library, New York The Thaw Collection (cat. no. 94)

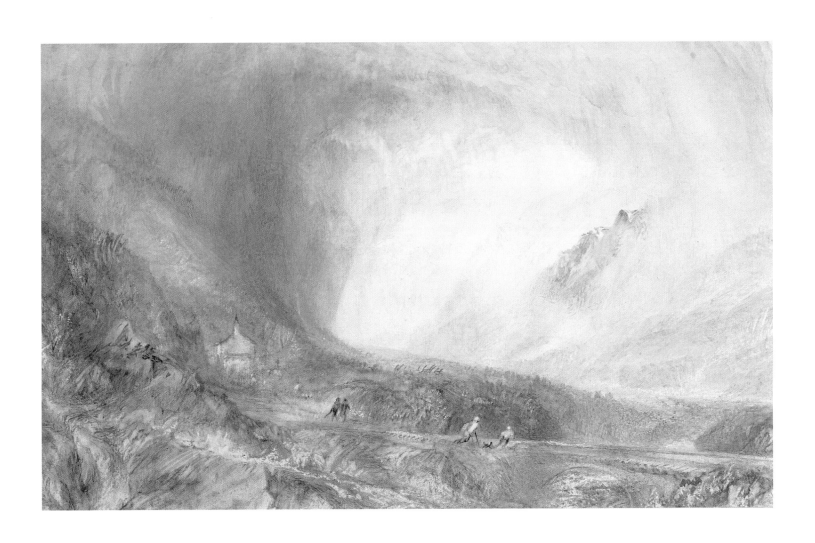

Storm in the St Gotthard Pass. The First Bridge above Altdorf 1845 watercolour Whitworth Art Gallery, Manchester (cat. no. 96)

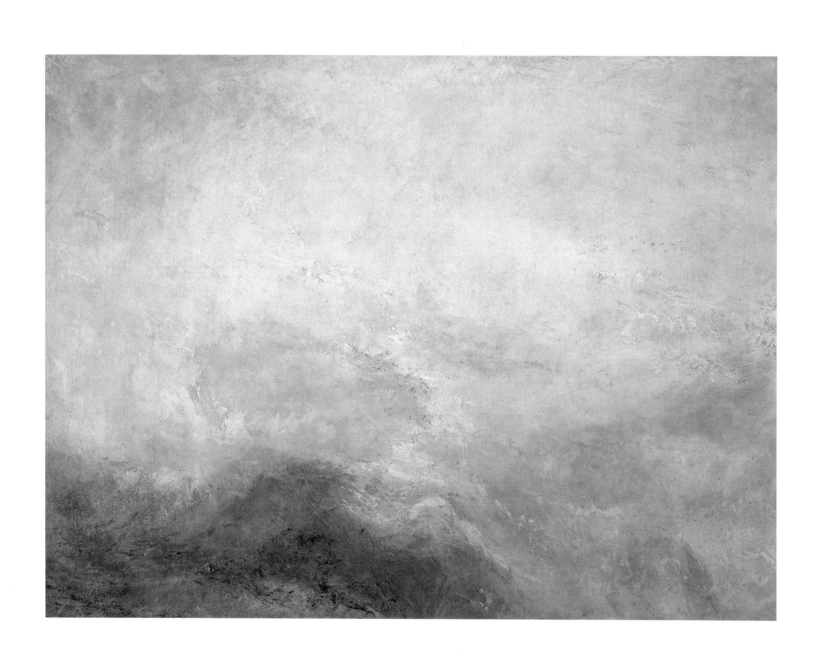

Val d'Aosta c.1845 oil on canvas National Gallery of Victoria, Melbourne Purchased with the assistance of the National Gallery Society of Victoria, 1973 (cat. no. 33)

The differences between the study for *Goldau* and the finished watercolour might almost be accounted for in terms Murray's description, as representations of the scene before and after the catastrophe. The study establishes the main outlines of the design, with the addition of cool yellow and blue washes, and with a bleached view into the empty distance. There is no hint of the changes that were to be wrought, especially (though not entirely) through colour. The molten reds and yellows that define the emotional pitch of the finished work — showing the place with 'the face of nature changed' — are amongst the most dramatic in Turner's oeuvre. The broad, flat and jagged application of paint in the sky, so different from the fluid use of colour elsewhere in the series, approximates to Turner's use of the palette knife in oil paintings of the period. While Ruskin considered the 1842 watercolours to be the most 'finished and faultless' of Turner's late works, the 1843 set was the 'truest and mightiest', done with 'absolute truth of passion, and truth of memory, and sincerity of endeavour'.[18] He connected this fiery view with others in Turner's oeuvre depicting the death of multitudes, such as the *Slavers throwing overboard the Dead and Dying — Typhon coming on* of 1840 (Museum of Fine Arts, Boston; BJ 385).[19]

When Ruskin visited Switzerland in 1861 to check the locations that Turner had drawn, he found that the finished drawings generally resembled the places more closely than did the sketches.[20] He was particularly struck by this when he reached the St Gotthard Pass, a view of which he had commissioned from a study made after Turner's final alpine tour of 1844. On first seeing the study for *Storm in the St Gotthard Pass. The First Bridge above Altdorf* of 1845 (illus. p. 139), he told Turner that he liked it because of the pines; he was to find them mischievously removed by Turner in the finished work. Nevertheless, writing to his father from Switzerland in 1861, Ruskin was forced to admit that: 'In many respects, I find that the realised drawing was always liker the place than the sketch; though in this instance the pines were cut down; the bridge is really carefully drawn in the finished drawing; and being an ugly one disappointed me — the sketch having suggested one far more picturesque.'[21]

The connection recently made between this subject and the exploits of the legendary Swiss hero, William Tell, identifies the village of Altdorf as the place where Tell shot an arrow through an apple balanced on his son's head, and where he subsequently met a heroic death trying to save a drowning child.[22] Not surprisingly, points of reference to the legend have been found in a number of the other Swiss watercolours, including *Brunnen*, 1842, where the white spot on the far shore signifies one of a number of chapels dedicated to William Tell.[23] The story of the mythic hero of the fight for Swiss independence against Austria would have reverberated poignantly given the internal unrest that beset the Swiss Confederation in the 1840s. It eventually boiled over, culminating in the civil war of 1847 (the Sonderbund War). Turner was keenly aware of the disturbed state of the country, referring to it in a letter of 1843 as 'a cauldron of squabbling political or religious'.[24] For this reason he did his best to dissuade Ruskin from going there in 1845.[25] However, none of this, is apparent in the tranquil grandeur of his views of Switzerland, a country for which, according to Andrew Wilton, he had 'an enduring affinity irradiated with the glow of Byronic reminiscence'.[26]

Notes

1. Turner's Swiss watercolours of the 1840s are discussed in all the standard Turner literature. The present account has drawn on this, but is particularly indebted to the following references: John Russell and Andrew Wilton, *Turner in Switzerland*, Dubendorf: De Clivo Press, 1976; Andrew Wilton, *Turner Abroad: France, Italy, Germany, Switzerland*, London: British Museum Publications, 1982; Andrew Wilton, *Turner in his Time*, London: Thames and Hudson, 1987; Robert Upstone, *Turner: The final yars: Watercolours 1840–1851*, London: Tate Gallery, 1993; Ian Warrell, *Through Switzerland with Turner: Ruskin's first selection from the Turner Bequest* London: Tate Gallery, 1995.

2. For further information on Turner's unusual method of marketing these watercolours, see John Gage's essay, 'Turner: A watershed in watercolour', in this catalogue at pp. 100–127.

3. A.J. Finberg, *The Life of J.M.W. Turner, R.A.*, 2nd edn rev., London: Oxford University Press, 1961, p. 389.

4. John Ruskin's earliest published reference to the first series of Swiss watercolours of 1841–42 occurs in the first volume of *Modern Painters* (1843). His main first-hand account of the circumstances of the commissions (written thirty years after the events) is contained in the Epilogue to *Notes by Mr Ruskin on his drawings by the late J.M.W. Turner, R.A., Exhibited at the Fine Art Society's Galleries*, [London], 1878, published in Edward Tyas Cook and Alexander Wedderburn (eds), *The Works of John Ruskin*, 39 vols, London: George Allen, 1903–12, vol. 13, p. 479 (hereafter, Ruskin, *Works*).

5. See Turner's letter to Windus of 18 March 1842, published as letter no. T.14 in S. Wittingham, 'Windus, Turner and Ruskin: New documents', *J.M.W. Turner, R.A.*, no. 2, 1993, p. 97. I am grateful to Ian Warrell for obtaining a copy of this article for me.

6. Ibid.

7. Ruskin, *Works*, vol. 13, p. 483.

8. Andrew Wilton 1987, p. 62.

9. For Cozens, see Andrew Wilton, *The Art of Alexander and John Robert Cozens*, New Haven: Yale Center for British Art, 1980, and Kim Sloan, *Alexander and John Robert Cozens: The poetry of landscape*, New Haven: Yale University Press in association with the Art Gallery of Ontario, 1986. A recent reassessment of J.R. Cozens's alpine scenery in the wider context of the development of eighteenth-century attitudes to mountainous landscape appears in Simon Schama, *Landscape and Memory*, London: Harper Collins 1995, ch. 8, especially pp. 459–462,472-478.

10. J.R. Cozens also portrayed Hannibal's alpine crossing in a celebrated painting (now lost) which Turner saw: *A Landscape with Hannibal in his March over the Alps, Showing to His Army the Fertile Plains of Italy*, submitted to the Royal Academy in 1776.

11. A.J. Finberg, 1961, p. 360.

12. Letter no. T.14, S. Wittingham, 1993, p. 97. Because of their specific purpose, the sample studies were retained by Turner, with the exception of the study for *Brunnen on the Lake of Lucerne* (illus. this catalogue p. 130), commissioned by Elhanen Bicknell, and given to Thomas Griffith's daughter.

13. Andrew Wilton 1987, pp. 226–227.

14. Robert Upstone 1993, p. 12.

15. Ruskin, *Works*, vol. 13, p. 190.

16. Robert K. Wallace, *Melville and Turner: Spheres of love and fright*, Athens: University of Georgia Press, 1992, pp. 482–483.

17. Andrew Wilton 1982, pp. 68–69.

18. Ruskin, *Works*, vol. 13, p. 485.

19. John Ruskin, *Modern Painters*, Sunnyside, Orpington, Kent: George Allen, 1888, vol. 4, p. 322.

20. Ian Warrell 1995, pp. 80–81.

21. Ibid., p. 82.

22. Ian Warrell 1995, no. 39, pp. 80–82.

23. John Russell and Andrew Wilton, 1976, pp. 102–103.

24. A.J. Finberg, 1961, p. 402.

25. Ibid, p. 411.

26. Andrew Wilton 1982, p. 25.

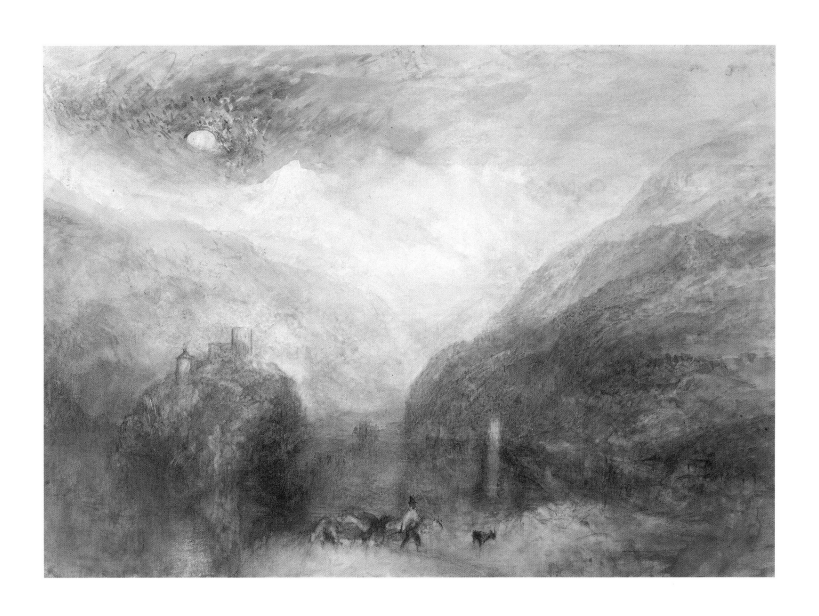

The Lauerzersee with Schwytz and the Mythen *c*.1845–51 watercolour Victoria and Albert Museum, London (cat. no. 99)

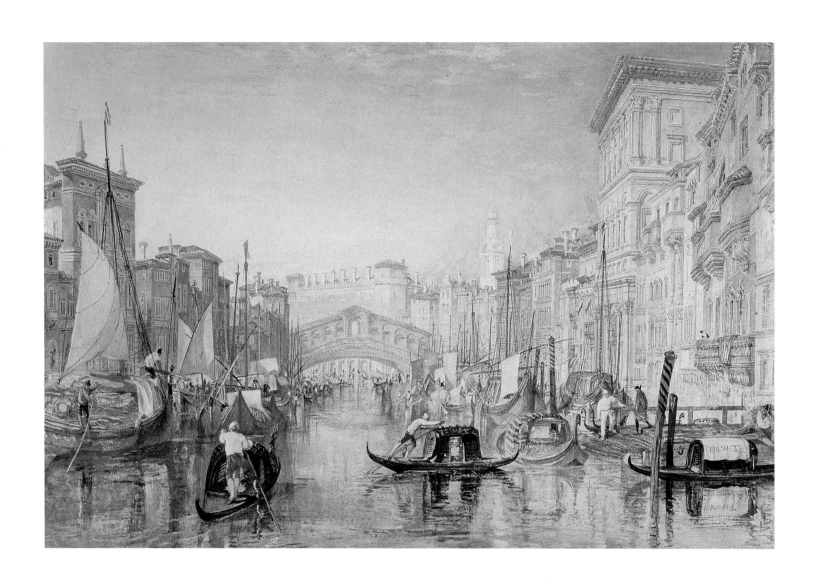

Venice: The Rialto *c.*1820 watercolour Indianapolis Museum of Art, Indiana Gift in memory of Dr and Mrs Hugo O. Pantzer by their children (cat. no. 53) *detail right*

Venetian Journey

Margaret Plant

Venice is a commodity city now, visited swiftly every year by numbers in the millions. Exotically sited on the sea, its architecture looks old and authentic; its long history can be appreciated without effort; the fragility of the island city menaced by the sea and pollution gives it a particular poignancy. The network of canals and narrow footpaths, and the splendid open space of the Piazza San Marco have made it the *mise-en-scène* of films and fashion photography. As a painter of Venice, Turner is at the beginning of this process of commodification.[1] The detail of the Republic's history begins to become vaporous and to disappear; indeed its loss may be the particular subject of Turner's paintings.

The famous architecture begins to lose its precision — its delineation as Gothic, Byzantine or Palladian. It fuses, glows, reflects in the water, existing as much in the reflection as in substance. The remorseless consumption of the city by the picturesque is announced. History washes over the stones, preparing for the twentieth century's erosion. Grown men prepare to find their mother surrogate in Venice.

Venice as Nature

In *Remembrance of Things Past*, Marcel Proust takes the narrator along the Grand Canal with his mother, and communicates his sense of Venice *as landscape* :

> ... we watched the double line of palaces between which we passed reflect the light and angle of the sun upon their pink flanks, and alter with them, seeming not so much private habitations and historic buildings as a chain of marble cliffs at the foot of which one goes out in the evening in a boat to watch the sunset. Seen thus, the buildings arranged along either bank of the canal made one think of objects of nature ... [2]

It is not surprising to find Turner's name invoked as part of Proust's experience, for it was Turner who first turned the palaces into cliffs of marble.[3] In 1908, Octave Mirbeau was to claim that Monet had gone to Venice to restore it to nature with the example of Turner before him.[4]

The 'marble cliffs' are not only extraordinary in being right on the water, but in their colour too: in the juxtapositions of brick, Istrian stone and marble. Turner anticipates Ruskin's eloquent realisation that Venetian architecture is above all colouristic. For Ruskin, the marbles of the Basilica of San Marco epitomised that use of colour; for Turner, who rarely painted San Marco, much preferring sea-based viewpoints, the colour is a consequence of the total atmosphere. Ruskin saw that colour bestowed by time; the patina was almost as precious as the stones themselves.[5] Anxiously assessing their own monuments, the Venetians themselves came to see their city as 'art, history, archaeology and nature'.[6]

All Turner's Venice paintings come from the latter part of his career. In 1819 he visited for the first time, travelling via the Alps, finding in the line of lakes, mountains and sky perfect elements for composition and atmosphere.[7] Lake Como was a prelude to Venice, to painting its sheets of water and sky. Venice's lagoon and the Grand Canal offered the constant presence of water, offset not by mountains, but buildings. The pencil drawings from this visit, executed along the Grand Canal and in the Basin of St Mark's, study skyline and architectural formation with even-handed precision.

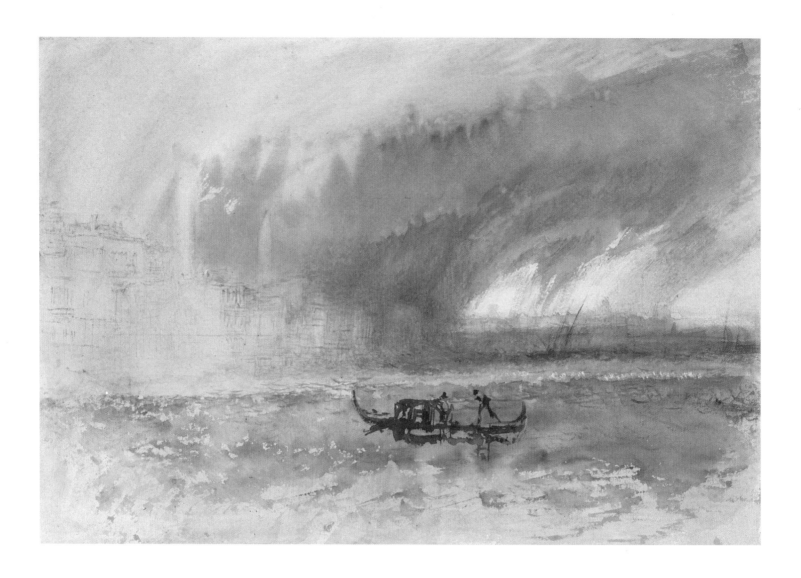

Venice: A Storm 1840
watercolour
British Museum, London
(cat. no. 80)

The watercolours relinquish that detail as the liquid paint washes over blocks of buildings along the water — water and sky have the most attention; the buildings form but a dividing line between them.

The effects of light and local colour give the sketches from 1814 to 1840 an observational precision. Elsewhere, Turner sticking his head out of the train window or lashing himself to a ship's mast in a storm are instances of a splendid empirical urge with respect to the observation of weather. In the early morning, well-known buildings such as Palladio's Zitelle appear as a block of blue, without further detail. An 1840 watercolour (above) annotates the crossing of the lagoon in a storm. A gondola appears as a tiny craft, the gondolier leaning forward sharply on his oar, the boat making pace on the shallow waters. The vessel is a professional barque, perfectly adapted to its function, moving with a sense of urgency and mastery across the choppy lagoon.

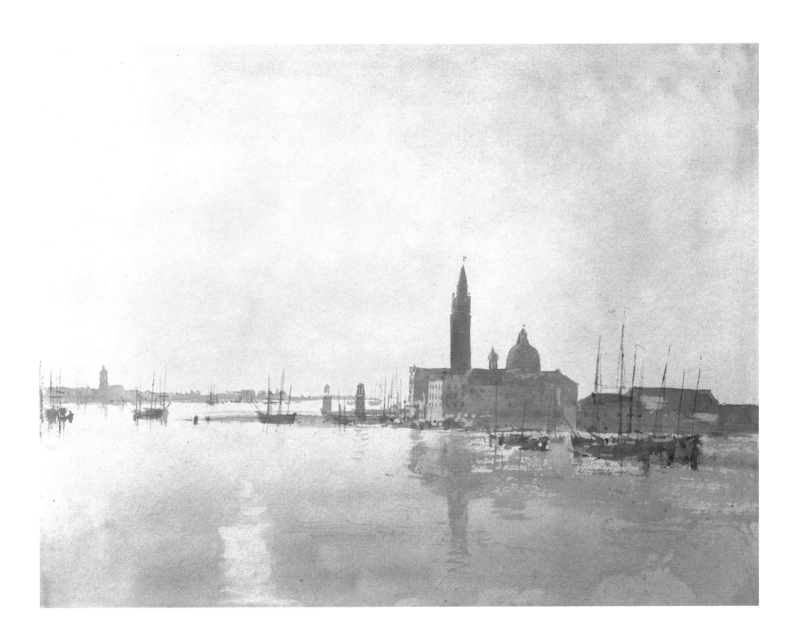

Venice: San Giorgio Maggiore from the Dogana 1819 watercolour Tate Gallery, London Bequeathed by the artist, 1856 (cat. no. 52)

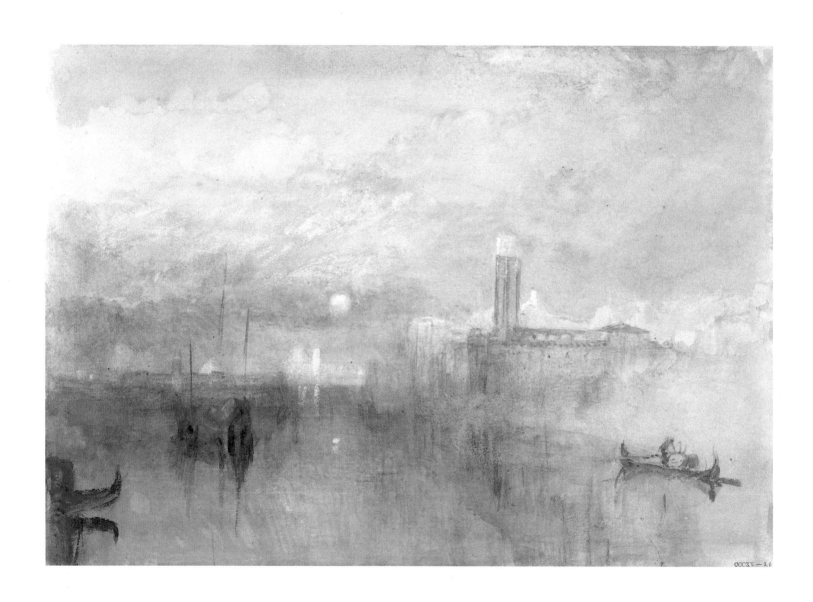

Venice: Moonrise, the Giudecca and the Zitelle in the Distance c.1840 watercolour Tate Gallery, London Bequeathed by the artist, 1856 (cat. no. 79)

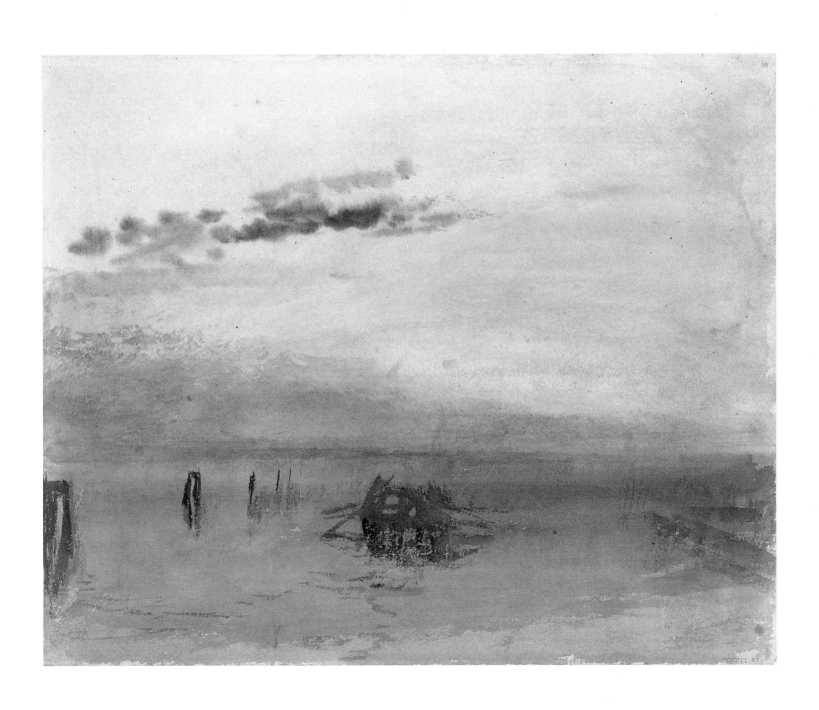

Venice: Looking across the Lagoon 1840 watercolour Tate Gallery, London Bequeathed by the artist, 1856 (cat. no. 81)

Local Venetian painting has its parallels with Turner's view of Venice as nature and weather, and its tradition of painting night festivals and fireworks. Called 'the modern Canaletto', Venetian-born Ippolito Caffi was resident for many years in Rome, undertaking picturesque tours in Constantinople, Cairo and Jerusalem as well as in Europe. Forsaking conventional summer, he painted his native city in many weathers and light conditions, piling up the snow on the coils of Santa Maria della Salute in 1838, painting the eclipse of the sun in 1842, and the night festival and fireworks at San Pietro di Castello, as Canaletto did before him.[8] (left) On the days of thanksgiving for delivery from the plague, on the feast days connected with the churches of the Redentore and

Ippolito Caffi
Serenata innanzi alla Piazzetta 1858
oil on canvas
Galleria Internazionale d'Arte Moderna
di Ca' Pesaro, Venice

Santa Maria della Salute, Venice continued to hold its night fireworks. Turner made watercolour studies of the fireworks as well as lightning over the Piazzetta.

The English Venice
But Turner's Venice is an outsider's Venice, an English view. The one-time Republic had long been a political and maritime model for the British Empire. More than other foreign nations, England had absorbed the Golden Age view of the Perfect Republic propounded by Contarini in the *De magistratibus et republica venetorum*, known in English in the translation and commentary by Lewkenor.[9] It was a primary source for Shakespeare's Venetian plays and it still echoed in English poetry written after the Republic's fall in 1797: in Wordsworth's *Ode on the Extinction of the Venetian Republic*, Shelley's *Lines written in the Euganean Hills*, the fourth canto of Byron's *Childe Harold's Pilgrimage*, and Ruskin's readiness to compare the marine empires of Venice and England.[10] These post-1797 writers specifically compared the Venice of Contarini/Lewkenor with contemporary Venice under Austria. They felt the demise of the Republic keenly.

Yet Turner does not subscribe in an emphatic way to the view of Venice as subjugated and doomed — as Shelley put it, writing to Thomas Love Peacock: 'Venice which was once a tyrant is now a worst thing, a slave'; and Lady Eastlake later protesting that it was 'melancholy and disgusting'.[11] Turner himself appended verses to his paintings which indicate his acceptance of the current mores with relation to Venice, and yet much of the evidence of the paint is otherwise. His Venice would appear to be still Republican. When he paints across the water towards San Giorgio Maggiore, he does not show the new harbour with its lighthouses, built during French rule in 1813 to mark the harbour for free trade, although he observed it carefully in on-site drawings.[12] In *Bridge of Sighs, Ducal Palace and Custom-house, Venice: Canaletti painting* (illus. p. 152), he avoids showing the new royal gardens created on the site of the demolished granary next to Sansovino's mint. There are details of the Austrian occupation only in studies: in the vignette of the Ducal Palace prepared to illustrate Samuel Rogers's *Italy: A Poem*, with the red and white flag of Austria on the Doge's official barge, the *Bucintoro*; and an Austrian sentry box in a watercolour of the Piazzetta.[13]

Was Turner's Venice profoundly inspired by Byron?[14] Ruskin, admiring them both, thought so, and most Turner scholars give considerable weight to Byron's influence. But there is little discernible impact in the 1819 watercolours which conjure up an innocent Venice, washed by mists and beset by reflections.

Canaletto 1697–1768
*Venice: The Bacino di S. Marco
on Ascension Day* c.1732
oil on canvas
77.0 x 126.0 cm (30-1/4 x 49-1/2")
The Royal Collection Trust,
Windsor Castle, Berkshire

The rich history of Venice which infuses Byron's poetry and plays, and Venice's abundant architectural legacy so inspirational for Ruskin's *The Stones of Venice* (1851–53), are less than Turner's Venice-as-nature. Turner shows little interest in Doge Foscari or Marino Faliero, the subjects of Byron's historical dramas.

Turner's brief sojourns in Venice — some six weeks in all, in three visits — cannot be compared with Byron's residential familiarity. Byron had some mastery of the Venetian dialect, frequented the local salons and excelled in his intimate domestic arrangements, as is well known. The 'melancholy' of the city is often remarked upon in his letters. Byron, who had come to Venice in 1816, was schooled by a saddened ex-patriciate in acceptance of Venetian decadence and loss of power. But, at the same time, in the Albrizzi salon, he must have witnessed the urge on the part of some ex-patricians to memorialise their culture. It was then neo-Classical: still immured in Palladio and idolising Canova. Byron dedicated a poem to Canova's bust of Helen which he admired at the salon of Isabella Teotochi Albrizzi.[15] The most important Venetian publication of these years was the work of Giustina Renier Michiel, niece of the penultimate Doge, whose classic study of the origins of Venetian festivals was first published in 1817, the same year as Byron's fourth canto for *Childe Harold*.[16] Michiel's study shows that the festivals were still part of living memory.

Turner and Canaletto
Turner was in Venice for the second time only after he had exhibited his first major oil painting on a Venetian theme, the *Bridge of Sighs, Ducal Palace and Custom-house, Venice: Canaletti painting*, shown at the Royal Academy, London, in 1833.[17]

151

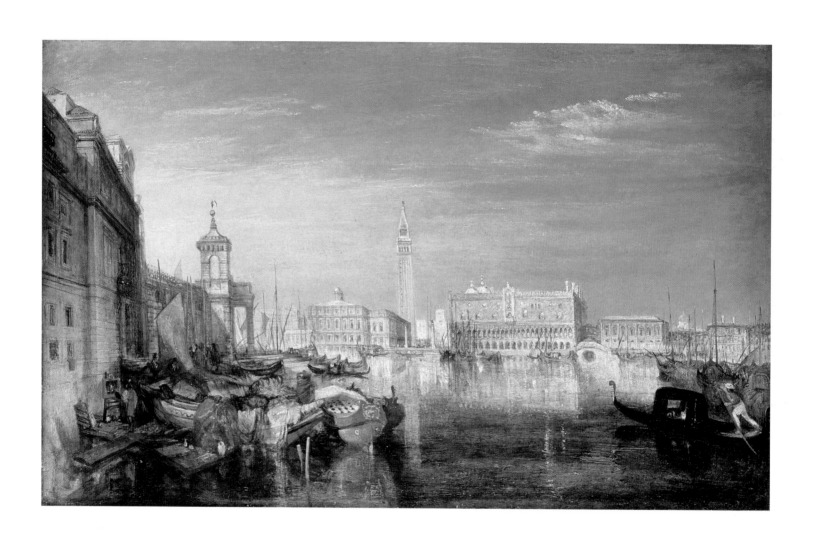

Bridge of Sighs, Ducal Palace and Custom-house, Venice: Canaletti painting R.A. 1833 oil on panel 51.0 x 82.5cm (20-1/4 x 32-1/2") Tate Gallery, London (BJ 349)

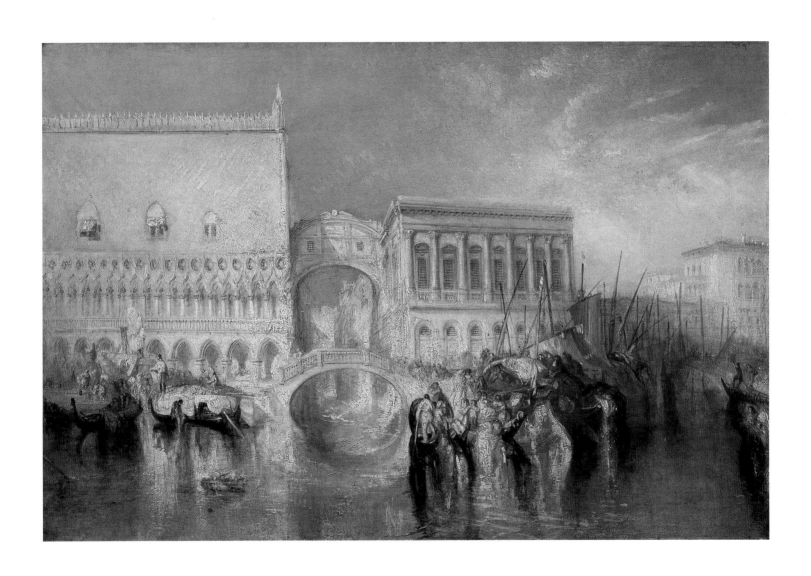

Venice, the Bridge of Sighs R.A. 1840 oil on canvas 61.0 x 91.5 cm (24 x 36") Tate Gallery, London Bequeathed by the artist, 1856 (BJ 383)

In seeking to explain Turner's burgeoning interest in Venice as a subject for Academy paintings in the 1830s, historians have noted his admiration for Richard Bonington who had died in 1828 and his competitiveness towards Stanfield Clark who had exhibited a large Venice painting in the Royal Academy. The impact of the poetry of Samuel Rogers, particularly his *Italy: A Poem* for which Turner had prepared two illustrations in 1828, was perhaps of more involving importance.

Painted many years after an actual visit, *Canaletti painting* would appear to be a memory painting. On an obvious level, it is a homage to the *veduta* painting of the previous century, and the visual aspect of Venice, still as potent for Turner as it had been for Canaletto. There is no visual evidence of moral censure. No allusion is made to the end of the Republic: rather, the Republican past washes over the present and irradiates it.

The detail of this painting must have been furnished from the 1819 drawings and watercolours and from other work circulating: the countless engravings, James Hakewill's 'picturesque' views, fashionable diorama and the pantomimes, as well as Canaletto's work, well known in England.[18] In this, Turner's first large-scale Venetian work, the light is magical and celebratory: the cream-yellow crust of paint confers harmony and unity, dramatised by the shadowed openings of loggia and arcade. Moored off the Dogana, where Canaletto is shown painting, is a beguiling shadowy clutter of boats heaped with oriental rugs and hangings that recall the Venice that was once the hinge of Europe, its most eastern point. It is hard to impute decadence to this view. The loss of the plenitude of Canaletto's day is by implication only. A similar tribute to Venetian painting must have been intended in the *Depositing of John Bellini's Three Pictures in La Chiesa Redentore, Venice* (private collection; BJ 393), exhibited in 1841.[19] A letter from Turner seeking the correct spelling of 'Redentore' is indicative of his less-than-firm grip on the subject, and the generalised references overall in the Venetian paintings.[20]

In Turner's shift of focus from the great buildings of Venice to the city as ambience, registered in terms of sky, lagoon and the unity of architecture on the water-line, he is closer to Francesco Guardi than to Canaletto. While Canaletto's work was well known in England from the mid-eighteenth century, Guardi's was less so but more of his paintings were circulating in the second decade of the nineteenth century.[21] It is the spatial likeness that is compelling, amounting to a revolution on the lagoon: the openness on the water and the dominance of sky effect a powerful suction of the elements towards the horizon — Venice is becoming nature.

Turner was moving dramatically offshore, altering the balance and focus of foreground and distance, sky and water, coalescing past and present: this is evident in the painting with Canaletto as its subject. Despite the homage, the differences amount to an epistemological shift. Canaletto's paintings were fabricated with the instruments of the Enlightenment, both literally and metaphorically: organised literally by the *camera obscura*; metaphorically, in terms of the representation of a rational society in environmental and societal concord, with the precise deportment of human estates from bird sellers to senators. In seeking to document changes in vision from the eighteenth to the nineteenth century, Jonathan Crary argues for a paradigmatic shift from the model of the *camera obscura* to the model of 'the process of perception itself becoming a primary object of vision'; Turner is the main exponent.[22] The eradication of (Venetian) history is the consequence of the ascendancy of the process of perception as subject.

The Journey
Turner's Venice appears quite different to the projects of the many English painters in Venice in the 1820s and 1830s, such as Richard Parkes Bonington, William Etty, Clarkson Stanfield and Samuel Prout. They hold Venice in sharp focus; for Turner focus yields to unstable atmospheres, doubling reflections

and refracted colour. It is not Canaletto's model of the Venetian caprice or the ranging views of the city that form Turner's itinerary; like a tourist, he virtually limits himself to the Grand Canal, the area of the Basin of St Mark's and, in later works, the outer lagoon. A journeying on amniotic waters suggests itself: a view of Venice that had some preparatory literary treatment before Turner, and certainly afterwards. If one seeks literary affinities, and Turner's interest in literature impels them, then they are appropriately found in journey literature. It is not so much the accounts of what has been seen and visited, but the effects of journeying, and to Venice in particular. That the journey is water-borne is obvious; it also partakes of time and memory.

With the exception of the remarkable *Juliet and her Nurse* (private collection, Buenos Aires; BJ 365), Turner's major oil paintings of Venice are painted from the water. The fluidity in them is borne of the water, but it is also metaphorical in time, visually determined by interweave and light that effects the interpenetration of past and present. To argue this is to depart from a reading that is grounded in one aspect of Byron: that is, Venice ruined by the conjunction of palace and prison. Nor is Ruskin's view of the immorality of the city endorsed by Turner. One wants to restore the positive readings which exist in the detail of Byron's writing where, in contrast with the present, he conjures up the Venice of the enchanter's wand. This gives space to a Venice in the nineteenth century which is not bound to the discourse of particular morality and the British Empire, but is subjectivised to the point where it is lodged in the subconscious. The dream element works toward an ahistorical present transmitted through the wraith-like delicacy of buildings and the dioramic of water, smokey accents of gondolas in the foreground — and the floating rubbish.

Rather than insisting on references to tyranny, imprisonment and loss of liberty, Turner finds mysterious aureoles and shadows inscribed by under-arches of bridges — devices that illuminate, not castigate. In his Academy painting *Venice, the Bridge of Sighs* (illus. p. 153) exhibited in 1840, he appends the well known lines of Byron about the palace and the prison. The Bridge of Sighs had become over-emblematic in Turner's day; it summed up the fashionable view of the behaviour of the Republic as repressive.[23] A more literal rendering in the Byronic mode was William Etty's *Bridge of Sighs*, (York City Art Gallery) with that bridge in sharp focus and, below, the potent detail of the prisoner's body being transferred to a boat at the foot of the prison. It is surely to strain likeness to see Turner's watercolour *The Bridge of Sighs: Night* (illus. p. 156) as a version of Etty's macabre painting, which is so attentive to the letter of Byron.[24] Turner's stars are fully out; it is a magical night, any real detail of the transferral of the body, if it is there at all, is blurred into insignificance.

In *Venice, the Bridge of Sighs*, the focus is not on one bridge, but on the emphatic doubling of two bridges; the Ponte della Paglia is played off in front of the Ponte dei Sospiri so that the two become, with their reflections, deep ovals of light.[25] The Ponte della Paglia is in fact more prominent than the Bridge of Sighs. The canal beneath the bridges is an entry point to the internal recesses of the city which Turner observes from the distant water, as an outsider.[26] The water sustains the city's ample trafficking, animated and doubled with reflections; it bears a crowd of gondolas and sailboats, and Turner's inevitable flotsam and jetsam, man's mark upon the waters.

Other works are panoramically framed to augment the sense of flux and movement proper to a city on the water. Such paintings create a mobile viewer prepared for movement and change, ready for slow, inevitable journeys. Turner's many harbour scenes, particularly the classic subjects, anticipate journeys on the full ocean. To be earthbound would be to jeopardise the essential element for the journey and for detachment from reality and the mariner's outsider status.

The Bridge of Sighs: Night *c.*1833 watercolour and bodycolour on brown paper 22.7 x 13.3 cm (9 x 5-1/4") Tate Gallery, London (TB CCCXIX-5)

In insisting on painting the city from the water, Turner shows his indifference to the many Venetian endeavours in the nineteenth century to subjugate that element, to build bridges to the mainland and from island to island, to bring the railroad right to the heart of the city up to Santa Maria della Salute or San Giorgio Maggiore; to fill in canals to create thoroughfares, even to the point where some mooted that the Grand Canal should be filled in to become a modern road.[27] Much of the urban planning energy in nineteenth-century Venice went in these directions, while Turner painted an anachronistic water-borne city.

'As in a dream'

Among the late Venetian subjects are the journeys on the water, coming and going from the ball, and festive scenes with processions of boats, painted around 1845. These late oil paintings carry memories of hedonism and carnival. In fact, the Venetian love of water-borne revelry had not ended with the Republic; there are many testimonies to the Venetian spirit, the regattas and music on the waters for such an interpretation to hold. In the 1820s Stendhal, in his study of the music of Rossini, wrote of sheer Venetian happiness.[28] In 1833, George Sand wrote of the nightingales and the music on the water in a Venice that was for her 'the perfect city for unending songs'.[29] By this time the economy had shown some recovery even if, for all its efforts to modernise and re-energise its commerce, Venice remained for the outsider the obverse of the new world of the Industrial Revolution.[30] Lovers of old Venice came to criticise even the small degree to which industry penetrated in the second half of the nineteenth century. For Turner, the city is written in the past — not imaged in a spirit of nostalgia, but through a dialectic of remembering — the present yields to the past and its richness, present-day detail and its sounds are muffled.

An English literary tradition is seduced by such voyages on the water. Ann Radcliffe never visited Venice, but it is clear from any number of testimonies that Venice may be known without a visit. In *The Mysteries of Udolpho*, published in 1794, her leading character, Emily, sets forth on a journey where the images admitted to the eye are 'imperfect'; distant music is heard: 'Emily gazed and listened and thought herself in a fairy scene.'[31] We anticipate the many moonlight scenes and serenades on the water, and, in due course, the anger vented upon Venice by the Futurists in 1910, fed up with venal Venetian moonlight.

The dream journey was compellingly announced in English literature by William Beckford in his *Dreams, Waking Thoughts, and Incidents*, letters written on a European journey in 1780–82.[32] Turner painted at Beckford's country estate, Fonthill, in 1799; he might have read Beckford's account, or discussed the travels with him, especially as the letters were addressed to Beckford's painter–tutor, J.R. Cozens. For Beckford, travel could provoke hallucinogenic states; he confessed and commended a 'visionary way of gazing' in advance of Turner: 'A frequent mist hovers before my eyes, and through its medium, I see objects so faint and hazy, that both their colours and forms are apt to delude me.'[33] The letters from Venice are amongst the most spirited: his entrance is suitably rhapsodic, he wanders in San Marco savouring its oddity; he relishes the many nations in evidence; he admires Palladio; he refreshes himself swimming off the Lido. On his first day he is wakened at half past five and watches from his window the nobility buying fruit at the Rialto as they come home from their all-night revels.

Samuel Rogers was a participant in the Venetian dream journey; perhaps he was inspired by Beckford whom he, too, had visited at Fonthill. Rogers's *Italy: A Poem* was among the most famous utterances of its time. It was first published anonymously in 1822, in Rogers's name in 1824, and in the illustrated version to which Turner contributed in 1830.[34] But Turner was very specific in his interest: it was in the delineation of the city, and not the many historical characters which Rogers treated in his poem.[35]

While Rogers directed the illustrations in this way, he probably did so with particular appreciation of Turner's talents and interests.[36] The opening lines of Rogers's Venice section:

> There is a glorious City in the Sea.
> The Sea is in the broad, the narrow streets,
> Ebbing and flowing; and the salt sea-weed
> Clings to the marble of her palaces ...

were as famous in their time as Byron's beginning of the fourth canto of *Childe Harold*. In 1828, Turner prepared his two sensuous illustrations to the poem using the vignette format; the motifs hover on the page, the moonlight beats its path into the depths through the arch of the Rialto Bridge; the *Bucintoro* is poised to sail again. Rogers's floating, dreaming journey is explicitly quoted by Turner in lines appended to his painting *Approach to Venice* (National Gallery of Art, Washington DC; BJ 412), exhibited in 1844:

> The path lies o'er the sea invisible,
> And from the land we went
> As to a floating city, steering in,
> And gliding up her streets as in a dream
> So smoothly, silently.[37]

The dream journey occurs again in the magical report given by Charles Dickens in his *Pictures from Italy*.[38] Turner was present at the dinner given in 1844 to farewell Dickens on his departure: perhaps he played some imaginative role in the author's preparation, for Dickens was regularly at the Royal Academy and certainly knew Turner's paintings.[39]

Approaching Venice, Dickens's narrator comes from the mainland 'towards a great light upon a sea'. He passes the burial island of San Michele, a cemetery in the sea — which Turner paints in his *Campo Santo, Venice* (illus. p. 190), exhibited at the Academy in 1842 — and comes to the Grand Canal which appears as 'a phantom street'. Bridges 'perplex' the dream, as indeed do the circular forms of bridges doubled by their reflections in Turner's paintings. Structures are 'of ponderous construction and great strength' on the one hand; on the other, they catch up some Turnerian spirit: they are 'as light to the eye as garlands of hoar-frost or gossamer'. On falling asleep, the narrator feels as if he is still on the water; awakeness feels as a state still in dream ('Dream' is addressed with a capital letter); the Piazza San Marco, which is solid, paved earth, feels water-borne. With his interest in prisons, Dickens was then eager to see those aspects of the Ducal Palace which confirmed 'the extinction of Hope' and 'the heraldry of Murder'.

Dickens (like Turner we might suppose) thought that Shakespeare's 'spirit was abroad upon the water somewhere: stealing through the city'. A similar conviction in 1836 must have provoked Turner's evanescent transferral of *Juliet and her Nurse* improbably to the rooftops of the Procuratie Nuove above the Piazza San Marco. The view is dazzling, down onto the crowded Piazza, and across the Bacino lit up by fireworks. Dickens wrote of the arcade awash with 'cheerful light ... the life and animation of the city all centred here'. [40]

About a century later, under the mantle of fashionable psycho-analysis, Adrian Stokes declared that 'Venice is the potent symbol of the mother'. He writes this breathlessly: 'As we ride the canals we move within her circulation. All we have said of Venetian architecture reflects the same symbolism.'[41] There is little novelty in Stokes's characterisation of Venice as a female city: the trope was well exploited in the Republic. But a shift occurs from the Republican personification of the Virgin, as emblem, to this surrogate mother needed by post-Republican sons.

The Sun of Venice going to Sea R.A. 1843 oil on canvas 61.5 x 92.0 cm (24-1/4 x 36-1/4") Tate Gallery, London Bequeathed by the artist, 1856 (BJ 402)

It may be of interest to remember the difficulties of Turner's youth, watching his mother suffering from schizophrenia and eventually institutionalised.[42] The fluid female element of water has been seen to have its potency for Ruskin, in the biographical circumstances of his life.[43] Ruskin's intoxication with water, he directly acknowledged, was inspired by Turner.[44] There may have been a deeper propinquity.

Stokes's reading of Venice is doubtless informed by his study of Turner.[45] He declares that 'the first character of Venetian building is sheerness and height', and Turner frequently exaggerates the verticality of the Campanile and heightens the drums of Palladian and Longhenian domes. Stokes everywhere observes counters to the expression of architectural weight; Turner floats solid architecture on the water and undermines it with reflections. To Stokes, as if recalling Turner's Venice, 'the black gondola appears an organic connexion with its light surroundings'.[46] Driving towards a synoptic view of the city, Stokes attends to the work of dissolution in process: 'So deeply laid are the imaginative foundations of Venice, to such an extent has stone abrogated the meaning of soil in our minds, that decay ... takes the form of metamorphosis, and even of renewal.'[47]

Adrian Stokes wrote specifically on Turner in his *Painting and the Inner World* (1963).[48] Stressing Turner's 'connectiveness' and 'indistinctiveness', he equates his fluctuant elements with the aqueous nature of paint itself, doubling the metaphors. Stokes sexualises the reading of the sketches: from the 'simple zoned beginnings' there comes a bearing down from the top area; in others, 'a reverse surge from the lower section' occurs and mating takes place along the line of the horizon. We can suppose that the openings of canals between cliffs of buildings are the seductive invitations to further voyages: a passage is offered through the lines of the perspective staked in the reflections of the distant moon or the path of the setting sun.

Returning to *Remembrance of Things Past*, one might recall that Proust's longing for his mother and the lost Albertine vie in his mind and are intermingled with the intrigue and charms of Venice when at last he finds himself there. Venice is only known as part of Proust's longing. Once again Turner stands in as progenitor, for longing is implicated in Proust's blurring of past and present, in his desire for a golden city. Such desire is predicated on absence, absence of the historic continuity of the city that leads to Turner's incomplete depiction of the festival of the Doge, with the Doge in the state barge poised to wed the sea in the wrong place — in the Bacino, rather than the traditional area of the Lido.[49] More evocative than the detailed depiction of the event made by Canaletto — Canaletto's series of paintings of Dogal ceremonies were known to Turner — the suffusion of light and seductiveness of the scene is born of a need to imagine and to image the obsolete festival.[50]

Insisting on Turner's Venice as one of amphibious fascination; edging the work away from contemporary interpretations of melancholy and decline; insisting on the city's poetry — or a sense of accumulated and mellowed history, however generalised — gives substance to contemporaneous critical response to Turner in his time which used the words 'evanescent', 'poetic' and 'beautiful', approbations no longer germane to this century's unsentimental vocabulary.

Was Venice an allegorical subject for Turner, as were other matters pertaining to seas and shipping, or to conflagrations of seats of governance? Two of Turner's Venetian boat paintings are sited on open waters, in the upper reaches of the Bacino and the northern reaches of the lagoon. Sail, rather than gondola, takes over; there is space to anticipate the ship's journey running from day to night. *The Sun of Venice going to Sea* (illus. p. 159) has as its subject a *barozza* fishing boat with a painted sail, characteristic of the Chioggia-based fishing fleet which remained active on the lagoon for many decades thereafter and could be seen moored near the public gardens, as contemporary photographs show.[51]

160

Venice with the Salute *c.*1840–45 oil on canvas Tate Gallery, London Bequeathed by the artist, 1856 (cat. no. 28)

Allusion is made *verbally* to the setting of the sun, but one needs to be careful that this is not taken too literally as a specific historical allusion to Venice; it may well attest generally to the human condition: as the night, the day. Most telling in terms of the great journey of the soul is the representation of a double-rigged sailing craft in the vicinity of the modern cemetery of the Campo Santo, the island cemetery still gathering together its references to crossing by water, and Lethe.[52] Here is a post-Republic setting, but one that few would read as such. In *Procession of Boats with Distant Smoke, Venice* of about 1845 (Tate Gallery, London; BJ 505), the activity on the lagoon waters is blurred, the boats appear lethargic and heavily weighted; the city is but spectral on the horizon. Is the smoke that of Venice's own industrial exercises, not seen by many, although it was there, or is it the smoke of a passing ship that will render the gondola not obsolete, but a sentimental conveyor of tourists and honeymooners?[53]

In the smaller oil paintings of the mid-1840s — those works that hang in the magical last room of the Clore Gallery — the city of Venice is much less the subject than the lagoon and the space of colour and light, with the few boat-borne revellers making their way to and fro at dawn or dusk. Such waters again bespeak a feminised body, altering by night and day, hosting a fluid journey which is allied with a metaphoric subconscious. The journey is now more allegorical than historical, and to insist on this is to reduce Turner's own intentionalism at work when he appends Byronic lines, and to broaden the literary and historical base for his inspiration. It is also to see him as prophetic of our modern-day psyche and the fragmentary condition that pertains to knowledge and certainty a century and a half later. The seeds of a larger ruin are sown and they are more potent and longlasting than the end of the Republic and the restrictions of Austrian rule. Turner predicts Venetian façadism: the Venice that is now a cardboard destination for its millions of tourists.

Notes

1. There is a specific literature on Turner and Venice: A.J. Finberg, *In Venice with Turner*, London: The Cotswald Gallery, 1930; George Hardy, 'Turner in Venice', *Art Bulletin*, vol. 53, 1971, pp. 84–87; Lindsay Stainton, *Turner's Venice*, London: British Museum Publications, 1985; John Gage, 'Turner in Venice', in J.C. Eade (ed.), *Projecting the Landscape*, Canberra: Humanities Research Centre, Australian National University, 1987, pp. 72–77.

2. Marcel Proust, *Remembrance of Things Past*, C.K. Scott Moncrieff and Terence Kilmartin (trans.); and Andreas Major (trans.), London: Chatto and Windus, 1981, vol. 3, p. 643. Peter Collier points out that Turner is acknowledged to be one of the major figures behind Proust's Elstir, because of his interest in 'the metaphorical transposition of land and water', *Proust and Venice*, Cambridge: Cambridge University Press, 1986, p. 46.

3. *Remembrance of Things Past*, C.K. Scott Moncrieff and Terence Kilmartin (trans.); and Andreas Major (trans.), 1981, p. 667. Ruskin doubtless facilitated Proust's appreciation of Turner.

4. 'Claude Monet est allé à Venise et l'a restituée à la nature': Octave Mirbeau, 'Les "Venises" de Claude Monet', *L'Art moderne*, 2 Juin 1912, cited in Philippe Piguet, *Monet et Venise*, Paris: Herscher, 1986, p. 113.

5. Harold I. Shapiro (ed.), *Ruskin in Italy: Letters to his parents 1845*, Oxford: Clarendon Press, 1972, p. 201.

6. *Valore dei Monumenti: L'Avvenire dei monumenti in Venezia*, Venice: Fontana, 1882. Reference to Ruskin is made on p. 7.

7. For the chronology of Turner's visits to Venice, see George Hardy, 1971, pp. 84ff. Turner's sketches at this point were preparatory to engraved albums of picturesque views. See Cecilia Powell, 'Topography, Imagination and Travel: Turner's relationship with James Hakewill', *Art History*, vol. 5, no. 4, 1982, pp. 408–425.

8. See in general Mary Pittaluga, *Ippolito Caffi, 1809–1866*, Vicenza: Neri Pozza, 1971. For this sequence of paintings, pp.46ff. Caffi had also specialised in night festival paintings in Rome. Turner's night studies in watercolour on brown paper are currently assigned to the Venetian visit thought to have taken place in late 1833, although the British Musum has favoured attributing them to the 1840 visit; see Andrew Wilton, *Turner in the British Museum: Drawings and watercolours*, London: British Museum Publications, 1975, p. 144.

9. See for example Zera S. Fink, *The Classical Republicans: An essay in the recovery of a pattern of thought in seventeenth century England*, Evanston: Northwestern University Press, 1945, esp. ch. 2, 'The Most Serene Republic', and ch. 3, 'Immortal Government: Oceana', pp. 28–89.

10. These works are collected in Marilla Battilana, *The English Writers in Venice, Scrittori Inglesi e Venezia, 1350–1950*, Dario Calimani (trans.), Venice: La Stamperia di Venezia, 1981.

11. Roger Ingpen (ed.), *The Letters of Percy Bysshe Shelley*, London: Sir Isaac Pitman, 1912, p. 629; in her memoirs (1852), Lady Eastlake testifies to the English ambivalence with regard to beauty and corruption in Venice: *Venice Discovered*, London: Wildenstein Gallery, 1972, p. 30.

12. The Venetian drawings are comprehensively illustrated in A.J. Finberg, 1930.

13. David Blayney Brown, *Turner and Byron*, London: Tate Gallery, 1992, p. 127.

14. On the indisputable influence of Byron on Turner overall: ibid., passim.

15. These observations are based on Byron's letters of 1816–17: L.A. Marchand (ed.), Byron, George Gordon, Baron, *Letters and Journals*, London: J. Murray, 1973–82, vol. 5, 1976, 'So Late into the Night': 1816–17'.

16. Giustina Renier Michiel, *Le Origine delle Feste Veneziane*, 5 vols, Milan, Venezia: Dalla Tipografia di Alvisopoli, 1817–27.

17. See the entry in Martin Butlin and Evelyn Joll, *The Paintings of J.M.W. Turner*, 2 vols, rev. edn, New Haven and London: Yale University Press for the Paul Mellon Center for Studies in British Art and the Tate Gallery, 1984, vol. 1, pp. 200–201.

18. Jonathan Crary treats the nineteenth-century diorama and the panorama in his *Techniques of the Observer: On vision and modernity in the nineteenth century*, Cambridge, Mass.: MIT Press, 1991, see for example pp. 112–113, but he does not implicate Turner in the panoramic vision. Turner's lateral spread and his encircling viewpoints seem to be deliberate techniques of positioning that might be directly linked to such contemporary formats. Venice was frequently featured in dioramas. Clarkson Stanfield was involved, see *The Spectacular Career of Clarkson Stanfield 1793–1867: Seaman, scene-painter, Royal Academician*, Newcastle upon Tyne: Tyne and Wear County Council Museums, 1979, see pp. 92ff for 'Stanfield's Grand Diorama' as it appeared on the stage in Drury Lane in the pantomime *Harlequin and Little Thumb*, 1831.

19. Martin Butlin and Evelyn Joll, 1984, p. 219.

20. John Gage (ed.), *Collected Correspondence of J. M. W. Turner, with an Early Diary and a Memoir by George Jones*, Oxford: Clarendon Press, 1980, p. 182.

21. For the interest in Guardi in England, see Frances Haskell, 'Francesco Guardi as *Vedutista* and some of his patrons', *Journal of the Warburg and Courtauld Institutes*, vol. 23, 1960, pp. 266ff.

22. Jonathan Crary, 1991, ch. 5, 'Visionary Abstraction', pp. 137ff, which focus on Turner.

23. The Ponte dei Sospiri (the Bridge of Sighs) was completed in 1600, see Gianpietro Zucchetta, *Venezia Ponte per Ponte*, Venice: Stamperia di Venezia, vol. 11, 1912.

24. Lindsay Stainton, 1985, p. 49. William Etty was specifically interested in the prisons: ibid.

25. Martin Butlin and Evelyn Joll, 1984, p. 235. For the Ponte della Paglia, see Gianpietro Zucchetta, 1912, pp. 164–172.

26. A number of the works in watercolour on brown paper, usually dated from the 1833 visit, are positioned in the Piazza and the Piazzetta: for example, *St Mark's from the Piazzetta*; *The Piazzetta at Night*; *The Interior of St Mark's*. On the dating, see note 8 above.

27. For these plans, see *Le Venezie Possibili: Da Palladio a Le Corbusier*, Milan: Electa, 1985. The Futurists notoriously wanted to fill in the Grand Canal.

28. Stendhal, *Life of Rossini*, (first published 1823), Richard W. Coe (trans.), London: John Calder, 1956.

29. George Sand, *Lettres d'un Voyageur*, (first published in book form in 1837), Sacha Rabinovitch and Patricia Thomson (trans.), Harmondsworth: Penguin, 1987, p. 107.

30. Kent Roberts Greenfield, 'Commerce and New Enterprise at Venice, 1830–1848', *The Journal of Modern History*, vol. 11, 1939, pp. 313–333.

31. Ann Radcliffe, *The Mysteries of Udolpho*, (first published in 1794) Oxford University Press, 1966, p. 174ff.

32. William Beckford of Fonthill, *Dreams, Waking Thoughts, and Incidents*, Robert J. Gemmett (ed.), Rutherford, NJ: Fairleigh Dickinson University Press, 1972. Beckford's expurgated version appeared as *Italy: With sketches of Spain and Portugal* in 1834. The Venice letters commence p. 110.

33. Ibid.

34. J.R. Hale (ed.), *The Italian Journey of Samuel Rogers*, (with an account of Rogers's life and travel in Italy in 1814–1822), London: Faber and Faber, 1966, pp. 107ff. On the work that Turner did for Rogers, see Adele M. Holcomb, 'A Neglected Classical Phase of Turner's Art: His vignettes to Rogers' *Italy*', *Journal of the Warburg and Courtauld Institutes*, vol. 32, 1969, pp. 405–410, for Venice, especially p. 408, and 'Turner and Rogers' Italy Revisited', *Studies in Romanticism*, vol. 27, 1988, pp. 63–95.

35. However Jerrold Ziff makes very plausible suggestions with respect to Rogers's further influence on Turner's Venice works in his review of Martin Butlin and Evelyn Joll, 'The Paintings of J.M.W. Turner', *The Art Bulletin*, vol. 62, 1980, p.170.

36. Adele Holcomb, 1969, p. 408.

37. Martin Butlin and Evelyn Joll, 1984, pp. 259–260.

38. Charles Dickens, 'An Italian Dream', *American Notes for General Circulation and Pictures from Italy*, introduction by Peter Ackroyd, London: Mandarin, 1991, pp. 350ff. All of Dickens's other chapters are given place names, for example, 'Through Bologna and Ferrara'.

39. For the dinner, Jack Lindsay, *J.M.W. Turner: His life and work*, Manchester: Granada, 1975, p. 257. Note Dickens in 1847 writing to the Hon. Mrs Richard Watson, ' ... we will go and see some of Turner's recent pictures', M. House, Graham Storey et al (eds), *The Letters of Charles Dickens*, Oxford: Clarendon Press, 1965–, vol. 5, 1847–49, Graham Storey and K.J. Fielding (eds), 1981, p. 12.

40. Martin Butlin and Evelyn Joll, 1984, pp. 215–216. But see Jerrold Ziff's suggestion that this may well refer to Rogers, note 35 above.

41. Adrian Stokes, *The Critical Writings of Adrian Stokes*, London: Thames and Hudson, 1978, vol. 2, p. 93.

42. Of course, Adrian Stokes makes reference to Turner's mother: ibid., vol. 3, p. 244.

43. See Denis Cosgrove, 'The Myth and the Stones of Venice: An historical geography of a symbolic landscape', *Journal of Historical Geography*, vol. 2, 1982, p. 164.

44. Edward Tyas Cook and Alexander Wedderburn (eds), *The Works of John Ruskin*, 39 vols, London: George Allen, 1902–12, vol. 3, 'Of Water as Painted By Turner', pp. 537–572.

45. Adrian Stokes, 1978, vol. 3, 'The art of Turner 1775–1851', 'Painting and the Inner World', pp. 236–259.

46. Ibid., vol. 2, p. 90.

47. Ibid., p. 93.

48. See note 45 above.

49. Martin Butlin and Evelyn Joll, 1984, p. 296.

50. John Gage notes that Turner would have seen Canaletto's suite of Dogal Processions at Stourhead, see 'Turner and Stourhead: The making of a classicist?', *Art Quarterly*, vol. 37, 1974, p. 83–84.

51. Ibid., pp. 250–252.

52. Ibid., p. 246. A similar double-sailed vessel features without allegorical intent (surely) in *Returning from the Ball, (St Martha)*, exhibited 1846, see Martin Butlin and Evelyn Joll, 1984, illus. p. 429. The cemetery was a Napoleonic initiative, decreed in 1807, see Giandomenico Romanelli, *Venezia Ottocento, L'Architettura, L'Urbanistica*, Venice: Albrizzi, 1988, pp. 229–236.

53. Martin Butlin and Evelyn Joll, 1984, p. 297.

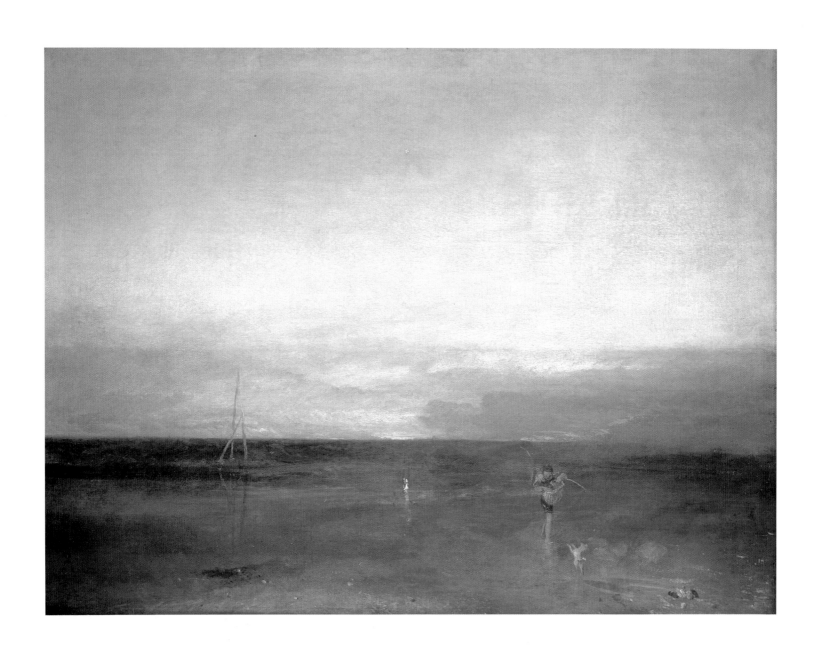

The Evening Star *c.*1830 oil on canvas National Gallery, London Bequeathed by the artist, 1856 (cat. no. 14) *detail right*

Turner's Last Journey

John Golding

Virtually every critic of Turner's work has commented on the important role played by travel in the development of his art; Andrew Wilton has described the sketches he executed during the course of his wandering as 'the very life-blood of his art'.[1] The place names of the watercolours included in the present exhibition in themselves take us on a visual journey around much of Britain: to Wales, to Dorset, to Northumberland and Yorkshire, and along the Kentish coast that Turner loved. They also take us several times to Venice — after London, the city that was ultimately most important to the evolution of Turner's art. Turner had stayed in Venice on his first trip to Italy in 1819, a voyage that marked perhaps the most important single turning point in his long and outstandingly productive career. Although he painted little on this visit, he brought back some wonderfully fresh and immediate watercolours which convey a sense of wonder and delight at the new country he had just discovered for himself; and he produced some two thousand drawings which were to supply him with information for years to come. The late Venetian watercolours and oils distil memories of his last trip to the city in 1840. In his old age, Venice had come to haunt him.

Throughout the 1820s foreign travel became a regular part of Turner's life. He returned to Italy in 1829 and, with the death of his father in the same year, he experienced an even greater freedom to roam around Britain and abroad, looking for new matter to enrich his visual repertoire, and with a view to finding new subjects which might be saleable and attract new purchasers and patrons. The final watercolours in this exhibition find Turner in Switzerland. In his latter years that majestic landscape had come to tower in his imagination as the supreme manifestation of the Romantic Sublime. These are amongst his grandest and most elegiac essays in the medium, and Turner himself saw them as a high point in his art. His last visit to the Continent was in 1844; but he continued to visit it in memory until his death in 1851.

Many of Turner's first watercolours were executed to exploit the market for topographical and antiquarian views. These were mostly worked up from rougher, calligraphic drawings executed on the spot, often in the evenings on his return to his temporary lodgings, while memories of his subjects and the atmosphere in which they had been bathed remained fresh in his mind. This method of work, which already involved visual distillation and recall, also enabled him to impose on his subjects any additional pictorial flavour that he felt they merited; the remoteness and picturesqueness of certain views, for example, could be rendered more hauntingly; or the feeling of modernity and change that was overtaking other sites could be emphasised and underlined. These working methods also helped him to develop his truly astounding visual memory that was to become legendary and a source of admiration, also of envy, among many of his contemporaries.

Some early watercolours were shown at the Royal Academy in 1790, although works in that medium were subsequently only rarely put on public display. The two studies of *Dunstanborough Castle from the South* (illus. pp. 38,39), executed in 1797, provide insights into his early handling of the medium. The sketch in black, grey and white is the more atmospheric of the two; in what is presumably the slightly later version, the pictorial space is handled less convincingly and the touches of colour which have been added

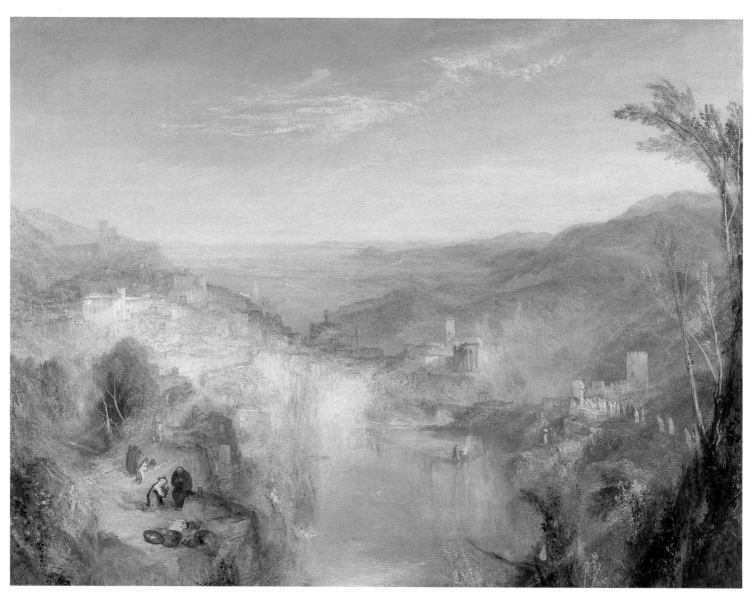

Modern Italy — The Pifferari R.A. 1838
oil on canvas
Glasgow Museums: Art Gallery
and Museum, Kelvingrove (cat. no. 22)

read almost as detail or as informational matter. Turner matured rapidly as a topographic draftsman but found mastery of colour a slower process. In both sketches a few quick pencil marks have provided the starting point and, prophetically, in view of his later unorthodox technical procedures, Turner has incorporated creases in the paper into his compositions. A finished watercolour worked up from the sketches a year or two later, *Dunstanborough Castle c.* 1798–1800 (illus. p. 43) retains a sense of freshness and vitality but inevitably there is a loss of immediacy; bodycolour (gouache) has been added to the watercolour to give a sense of greater density and Turner has scratched back into it, a procedure that was to become a hallmark of his later production in both watercolours and oils.

Turner increasingly came to distinguish between more finished watercolours, which were for sale, and the fresher, rougher variety, which were for himself — a distinction he had formulated by 1806. Henceforth, the more private watercolours, the ones kept for his own perusal, are almost always in advance of his oils; many in their boldness and freedom foreshadow the great visionary oils of the late period. But all the early watercolours show an ever deepening appreciation of the changing moods of nature and a new, almost reverential feeling for atmosphere. The delicate watercolours he produced in Venice in 1819 (illus. p. 147) exemplify this new feeling for atmosphere; a soft, liquid light drenches the entire pictorial surface.

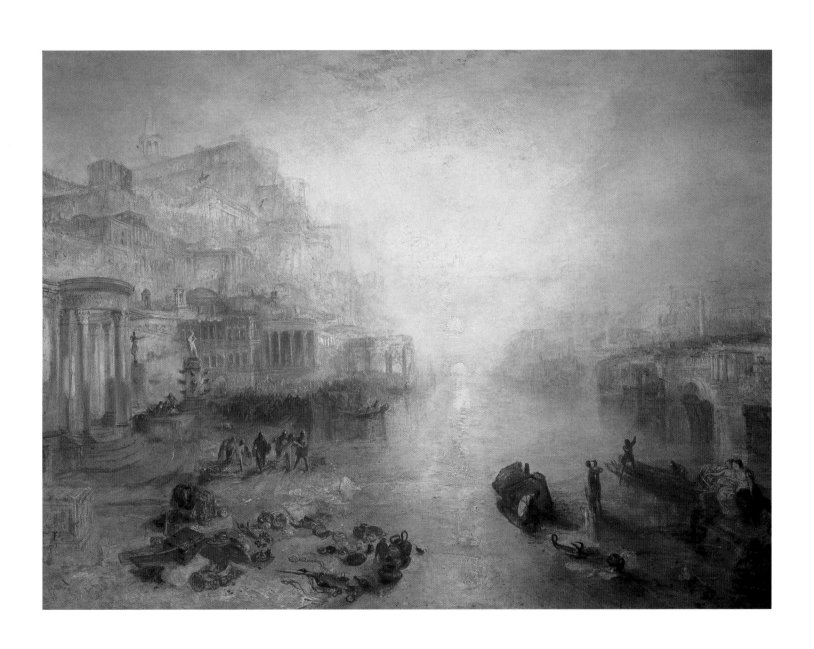

*Ancient Italy — **Ovid banished from Rome*** R.A. 1838 oil on canvas Private Collection (cat. no. 23)

The watercolours were records of Turner's travels, although many of them are the products of remembrance. But if Turner's travels were undertaken to find inspiration in new visual surroundings, they were also in a very real sense acts of communion with other art. Graham Reynolds has spoken of the way in which Turner painted in imitation of others, not just to learn from them, but also in rivalry and as if to gain possession and mastery over them.[2] The early watercolours show that Turner appreciated the very special Englishness of Gainsborough, J.R. Cozens and Richard Wilson; and in some of the Claudian work of Wilson he must already have felt himself in communion with the landscape and art of Italy. In 1802 the Peace of Amiens allowed him to travel abroad for the first time and, after paying his respects to the Alps, he found his way to the Louvre in Paris — its own vast holdings now temporarily augmented by plundered masterpieces. There he was drawn primarily to the Italians; but he also found confirmation of the greatness of Poussin (although he had reservations about Poussin's use of local colour); and because of his now obsessional interest in the properties of light he recognised in Claude his true exemplar. When he subsequently made his way to Italy it was to confirm his feelings about the way in which Claude in particular had made use of the Italian light, and to verify for himself Renaissance Italy's debt to the classical world. Against a sketch of some countryside near Loreto he jotted down: 'The first bit of Claude'. Similarly his wanderings in the Low Countries were made in order to seek out the visual roots of artists like Willem van de Velde, Jan van de Capelle and Jacob Ruysdael. Turner was to pay tribute to Ruysdael and also Jan van Goyen in the titles of two works of his high maturity.

The colouristic and atmospheric lessons of Venice can be felt, indirectly, in the sumptuous colour that characterises his superb watercolour sketches of the burning of the Houses of Parliament of 1834 (illus. pp. 92,93). Here the paper support itself plays a part in the atmospheric totality; and Turner's ability to exploit or incorporate the luminosity of his paper supports — often tinted or coloured — was from the start masterly. Like the Venice visit, the destruction of this architectural landmark on the banks of Turner's beloved Thames marked a pivotal turning point in his career; in front of his very eyes a familiar piece of cityscape was turned into an apocalyptic vision of terrifying yet Sublime grandeur. Although Turner is alleged to have executed colour sketches on the site, something rare in his art, these particular watercolours give the impression of being distillations; and their hot, bold colours anticipate the oils of the final decades.

These sketches demonstrate, too, a phenomenon that is rarely remarked upon: Turner's ability to use red, a colour which normally tends to advance towards the spectator, recessively. Blue is perhaps the colour we associate with the British watercolour tradition up to Turner; but Turner increasingly was using his beautiful clear blues as colour accents and, far from receding, as they so often do in both art and in nature, they tend to cling to the surface — when they recede, it is because we force them to do so through visual association. If yellow is the colour we associate with Turner's later production, red was to become second to it in dominating his palette. It is his use of a range of reds married to the yellows

Storm off the East Coast c.1835 watercolour Sheffield City Art Galleries, Yorkshire (cat. no. 76)

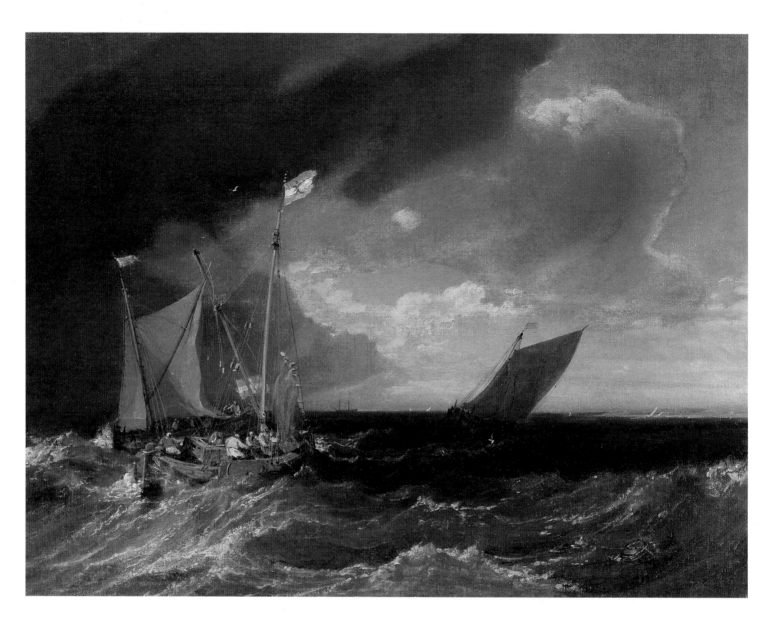

Seascape with a Squall coming up
*c.*1803–04
oil on canvas
Tokyo Fuji Art Museum
(cat. no. 7)

that gives the yellows their glow and shimmer, or by contrast can make them look cool and silvery. Turner disliked purple, the complementary colour to yellow, because he saw it as yellow's enemy. And it is remarkable that, as one of the greatest landscapists of all time, he had little love of green, the colour of nature's renewal.

The story of the evolution of Turner's art can be viewed in many ways, but it is perhaps most simply and truthfully told by tracing the way in which light and colour eventually appear to become confounded in his mind. It is in the oils that we can slowly but clearly see this happening. A comparison between the two oil paintings of Dunstanborough Castle (illus. pp. 36,41) is as instructive as the comparison between the two preparatory sketches on paper. In the larger work, exhibited in 1798, the light in the sky is soft and pearly; but, despite the hazy highlights, the work is characterised by a neutral, overall tonality. In the smaller and more dramatic picture, probably of the same date, the light in the sky is fiery and can be associated with a specific colour, yellow; and it is picked up again in the active brushwork in the sea at the base of the hill — a premonition of things to come. But for the first three decades of his active life as a painter Turner uses light in a naturalistic and basically traditional way. The light effects in *Seascape with a Squall coming up* of *c.*1803–04, for example, are reminiscent of those to be found in countless Dutch marines.

170

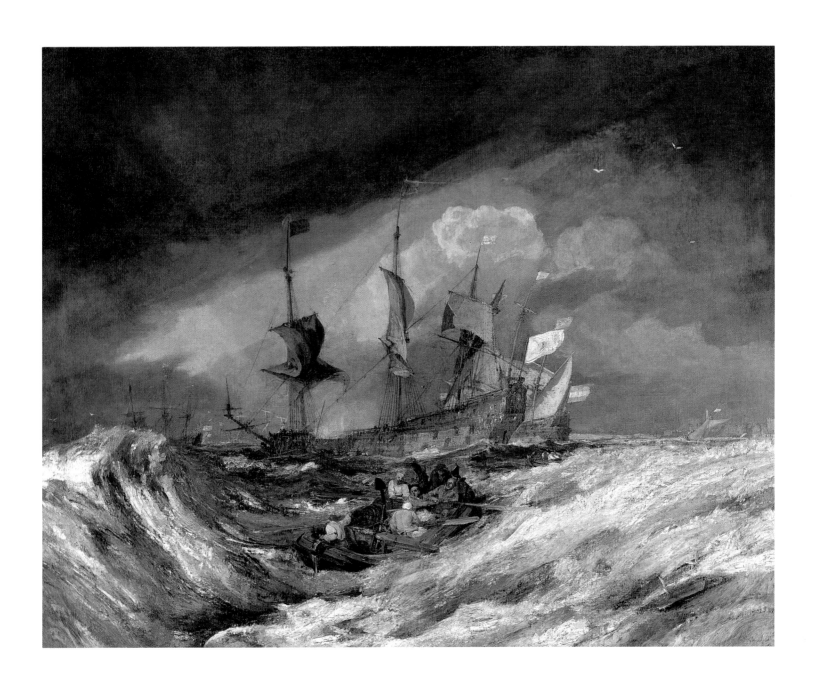

Boats carrying out Anchors and Cables to Dutch Men of War, in 1665 R.A. 1804 oil on canvas Corcoran Gallery of Art, Washington DC William A. Clark Collection (cat. no. 8)

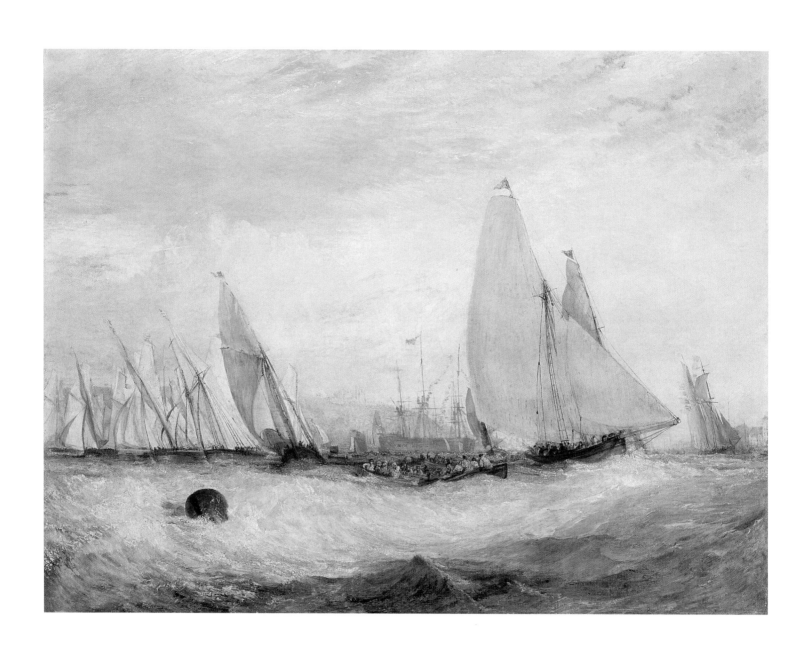

East Cowes Castle, the Seat of J. Nash, Esq.; the Regatta beating to Windward R.A. 1828 oil on canvas Indianapolis Museum of Art, Indiana Gift of Mr and Mrs Nicholas Noyes (cat. no. 12)

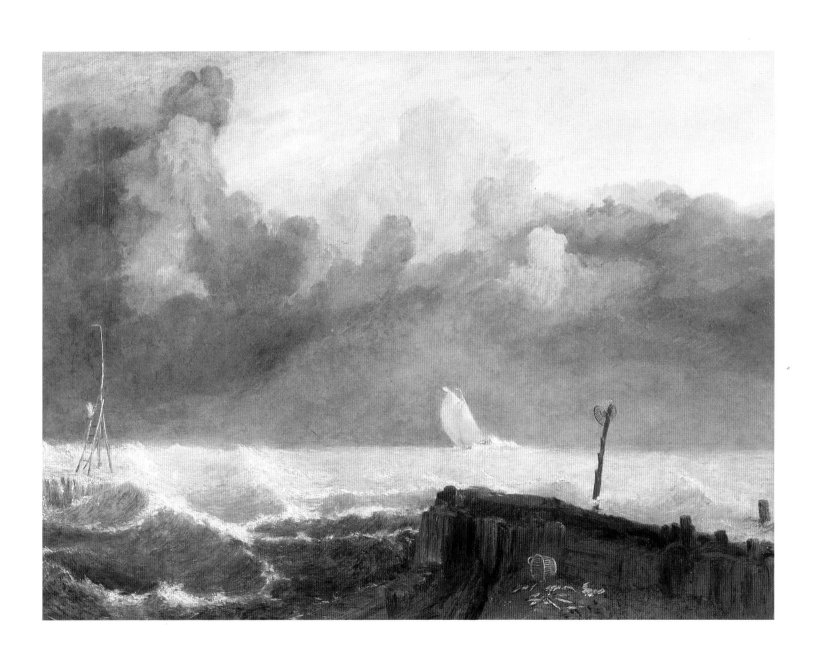

Port Ruysdael R.A. 1827 oil on canvas Yale Center for British Art, New Haven Paul Mellon Collection (cat. no. 11)

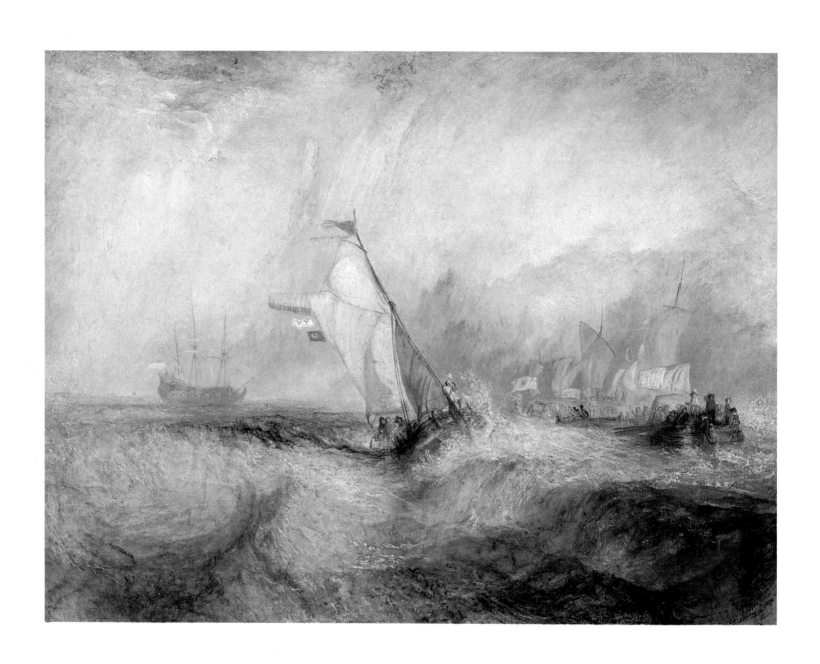

Van Tromp, going about to please his Masters, Ships a Sea, getting a Good Wetting R.A. 1844 oil on canvas J. Paul Getty Museum, Malibu, California (cat. no. 26)

Walton Bridges (illus. p. 63) reminds one yet again of Turner's admiration for Wilson's handling of light and, in turn, of Wilson's love for Italianate paintings. A comparison between *Seascape with a Squall coming up* and *East Cowes Castle, the Seat of J. Nash Esq.; the Regatta beating to Windward* (illus. p. 172), painted some twenty-five years later, demonstrates that if Turner's touch and palette were getting lighter and clearer he was still acknowledging a debt to the same Dutch tradition.

Works such as *The Evening Star* (illus. p. 164), painted about 1830, and *Calais Sands, Low Water, Poissards collecting Bait* (illus. p. 176), exhibited at the Royal Academy in that year, mark an important transition in Turner's art. *The Evening Star* is one of the calmest, emptiest pictures Turner ever painted. Its absolute stillness is broken only by a small leaping dog, a minuscule note of activity that the viewer becomes aware of only after prolonged study of the picture. The evening star of the title is itself another subliminal note; while the ghost of a boat, to the right of the composition, painted out, confirms Turner's intention to concentrate on the lonely magnitude of sea and sky. Traditionally regarded as unfinished, the painting has about it a perfection that suggests Turner was satisfied with the canvas as he left it — and during the last decades of his life, colleagues and critics were united in seeing many of the works he chose to exhibit publicly as unfinished. Turner himself must have faced a dilemma because he was surely aware of the fact that his works often made totally satisfying wholes before they reached the degree of elaboration that would make them acceptable for public exhibition. *Calais Sands* is in a sense a companion picture; here the wet sand extends virtually to the horizon, while the setting sun (obscured by cloud in *The Evening Star*) unrolls below it a carpet of coloured light, echoed in reverse perspective in the sky above. The multiple small figures do not lessen the deep sense of loneliness — they reinforce it.

The compositional simplicity and reductiveness of works such as these suggest that Turner saw them as a watershed, possibly even as a kind of 'tabula rasa' in his career. A study of the works of the 1820s reveals that Turner was becoming increasingly interested in paint for paint's sake. But it is in the works executed after 1830 that paint, colour and light come together to produce Turner's last and final manner. His technique had been becoming increasingly unorthodox for some time. And, despite his secrecy about his painting methods, stories concerning his work practices were already rife during his lifetime: the bucket of chrome yellow he liked to keep at his side and into which he dipped his hands; his use of a palette knife not only to lay on paint but also to scrape back and through it; the final touches of scumbled pigment applied on the Academy's Varnishing Day to challenge and often annihilate other pictures amongst which his own were placed. More importantly, by the 1830s he had ceased to emulate the changing light effects in nature. Rather, he was recreating them, paralleling them in effects of paint or, to put it differently, paint itself now substitutes for naturalistic effects earlier created by it. It is this obsession with pigment and colour as generators of light that gives his late works their particular modernity, a modernity that has been a source of inspiration to painters ever since.

Turner continued to be inspired by his travels to the end of his life; the titles of some of the late works in this exhibition, of watercolours and oils alike, testify to this. And his travels continued to keep him in touch with the artists of the past who had given him sustenance in earlier years. There are reminiscences of Claude, for example, in *Ancient Italy — Ovid banished from Rome* (illus. p. 167), exhibited at the Royal Academy in 1830, and of Claudian light even in such a visionary and totally original work as *Sunrise with Sea Monsters* of *c*.1845 (illus. p. 181). There are still echoes of Dutch marines in *Rough Sea* of *c*.1840–45 (illus. p. 180) and even stronger ones, not surprisingly, in *Van Tromp, going about to please his Masters, Ships a Sea, getting a Good Wetting* of 1844 (illus. p. 174).

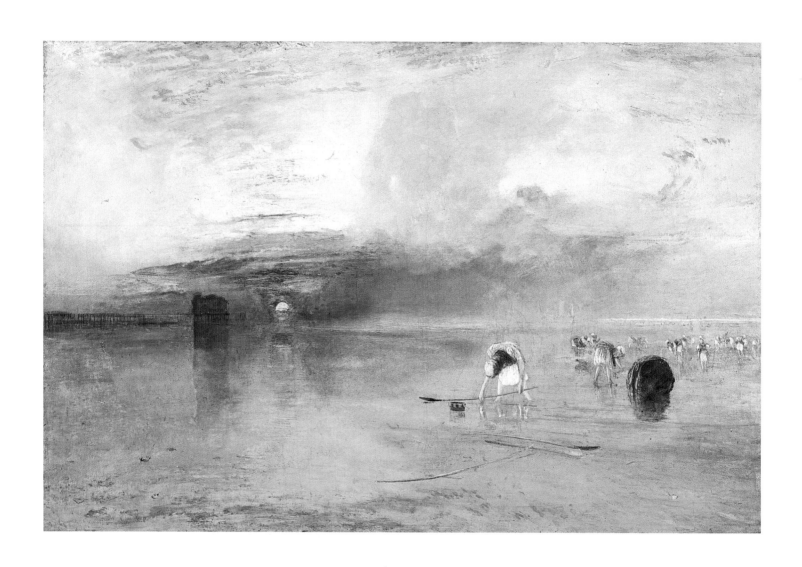

Calais Sands, Low Water, Poissards collecting Bait R.A. 1830 oil on canvas Bury Art Gallery and Museum, Lancashire (cat. no. 13)

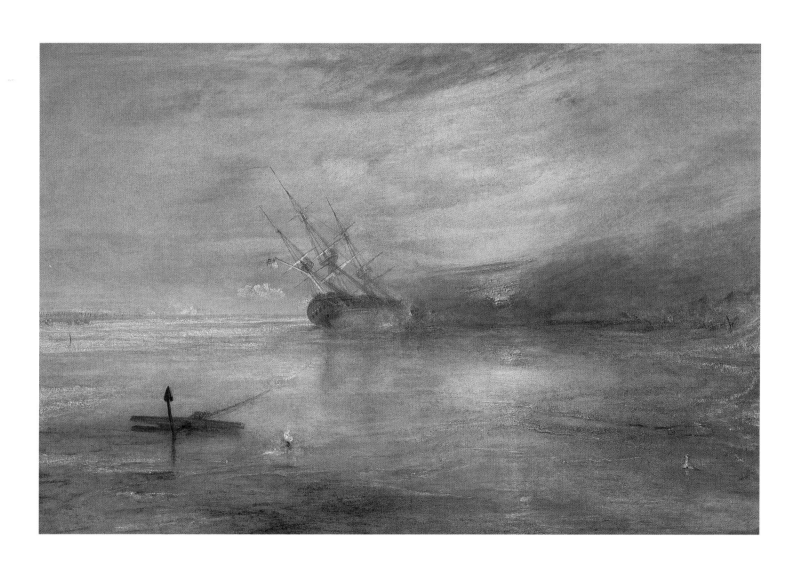

Fort Vimieux R.A. 1831 oil on canvas Private Collection (cat. no. 15)

But Turner's travels were becoming increasingly travels in memory. Nothing could confirm this more vividly than his obsession during the 1840s with Venice, the city where he had experienced revelation over twenty years before. Some of his late depictions of Venice are amongst the most particularised of all the late works; this is true for example of *Campo Santo, Venice* (illus. p. 190), probably executed soon after his return in 1840 from a final visit to the city that so inspired him, and described by Ruskin as 'the most perfect of all the late Venices', and 'the second most lovely picture he ever painted of Venice'.3 But as the late Venice series progresses, the pictures become increasingly dreamlike and evanescent. *Venice with the Salute* of *c*.1840–45 (illus. p. 161), for example, achieves a degree of abstraction rare in nineteenth-century art and anticipates some of Monet's boldest innovations.

But it seems to me that Turner's last journey was basically down into his own psyche; and I sense that it was ultimately bound up with the fact that light, colour and pigment had become confounded in his mind. As the very act of painting came for him to take on a symbolic, affirmative significance, he continued to look for new ways of applying paint to canvas and paper and, in the process of doing so, for ways of forging new pictorial meanings and resonances. One gets the sensation that, by the end of his life, he had reached into every single crevice of his inner being in order to put it at the service of his art. I believe that as his handling of paint grew increasingly free and personalised, he was unconsciously looking for new aspects not only of his talent, but also of his very being that could be exploited to extend the boundaries of his art. This desire to serve art through self-exploration lends his late work a moral dimension, and this perhaps explains his ultimate dedication to Rembrandt, one of the most moralistic and psychologically truthful of all artists, but one about whom Turner had originally felt reservations.

During the 1830s Turner had been obliterating distinctions between the forms of nature and the abstract forces of nature that condition the way we perceive them. Now his subjects often seem to be born out of colour and out of the very handling of paint. For some time he had been experimenting with J.R. Cozens's 'new method' of generating or discovering landscapes from random blots and stains of paint. After Turner's death, when the vast proportion of his output that had remained in this studio was being catalogued, a whole new category of art described as 'colour beginnings' was invented to describe these virtually abstract lay-ins of colour that were designed to suggest or provoke a subject.

There are certain features that characterise the late work, in addition to the freedom and variety of technique. The vortexes that had been a feature of Turner's compositions from his earliest beginnings — there is even an implied vortex at the centre of *Fishermen at Sea* (illus. p. 15) exhibited in 1796 — became increasingly pronounced. The mastery with which Turner can tunnel the viewer's eye inwards while simultaneously spinning it outwards in a centrifugal fashion is exemplified, for example, in one of his undisputed masterpieces, *Snow Storm — Steam Boat off a Harbour's Mouth making Signals in Shallow Water, and going by the Lead* of 1842 (illus. p. 33). Canvases with a pronounced horizontal emphasis persist, and some of Turner's most original and felicitous compositions had been produced on these — one thinks at once of the Petworth pictures of *c*.1829. But he was now also experimenting with squarer formats, sometimes with their corners sliced off, possibly because the resulting octagons contained the vortexes more tightly and hence fortified their impact.

Most importantly, Turner's handling of light had subtly altered. In the work up to the 1830s light is generally seen to emanate from behind the picture surface. Henceforth, and as he made increasing use of scumbled marks and patches of colour — particularly of yellow and white — light seems to project itself from the picture surface. The advance of the picture surface towards the viewer, so fundamental to much twentieth-century painting, was in a sense initiated by Turner. 'We must consider every part [of a painting] as receiving or emitting rays to every surrounding surface', Turner declared; and: 'Light is therefore colour and shadow the privation of it.'4

Water has always lain at the heart of Turner's subject matter. He associated rivers, but above all the sea, with travel. And as he travelled towards the end of his life as a painter he found in water — once again above all in the ocean — a multiplicity of meanings: a source of wonder and of terror, a feeling of being cradled and soothed by water, but also and of being threatened by it. Turner had always been aware of the dangers of travel by water; and Ruskin for one came to feel that he associated the sea with death. As the drama of Turner's art became increasingly internalised, the constant shimmer and pulse of water and of the shifting and scudding skies above it are at times compounded into a single flux of pictorial movement; this is true of many of the Venetian paintings and of works such as *Seascape: Folkstone* of *c*.1845 (illus. p. 185).

Towards the very end of Turner's life, his colour tends to pale and fade as if it, too, were reaching the end of a journey. But it remains present, by implication, as light, and the luminosity of Turner's art remained undimmed. Light had been the true subject of Turner's art all along. In the late work it reaches the same degree of abstraction as the paint effects that convey it. To this extent it becomes what might be described as a light of the spirit. And because of this, and despite his love of drama and the fundamental pessimism of his vision, he remains, ultimately, a supremely optimistic artist.

Notes

1. Andrew Wilton, *Turner in his Time*, London: Thames and Hudson, 1987, p. 63.
2. Graham Reynolds, *Turner*, London: Thames and Hudson, 1969, p. 8.
3. Quoted in Martin Butlin and Evelyn Joll, *The Paintings of J.M.W. Turner*, 2 vols, rev. edn, New Haven: Yale University Press for the Paul Mellon Center for Studies in British Art and the Tate Gallery, 1984, p. 246.
4. Quoted in Lawrence Gowing, *Turner: Imagination and reality*, New York: Museum of Modern Art, 1966, pp. 21, 24.

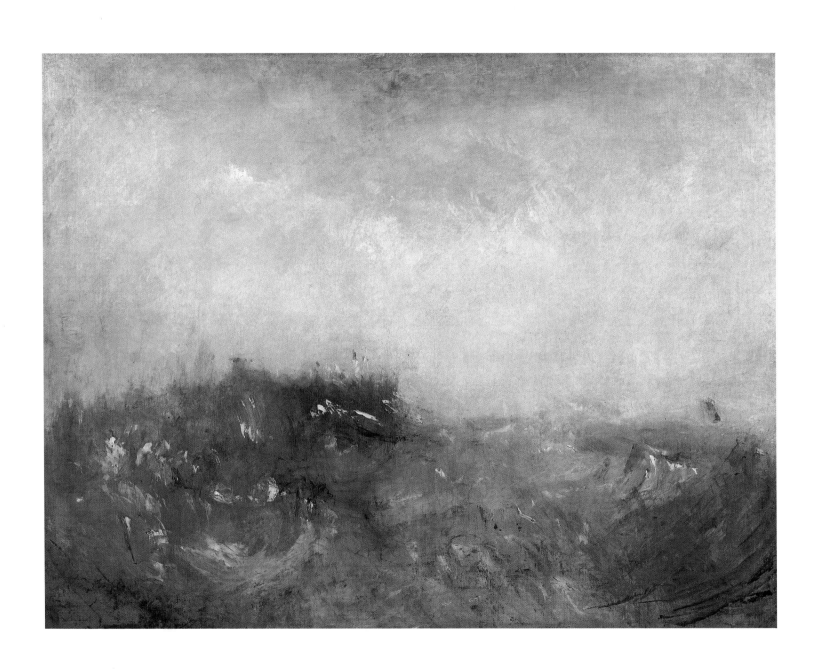

Rough Sea c.1840–45 oil on canvas Tate Gallery, London Bequeathed by the artist, 1856 (cat. no. 27)

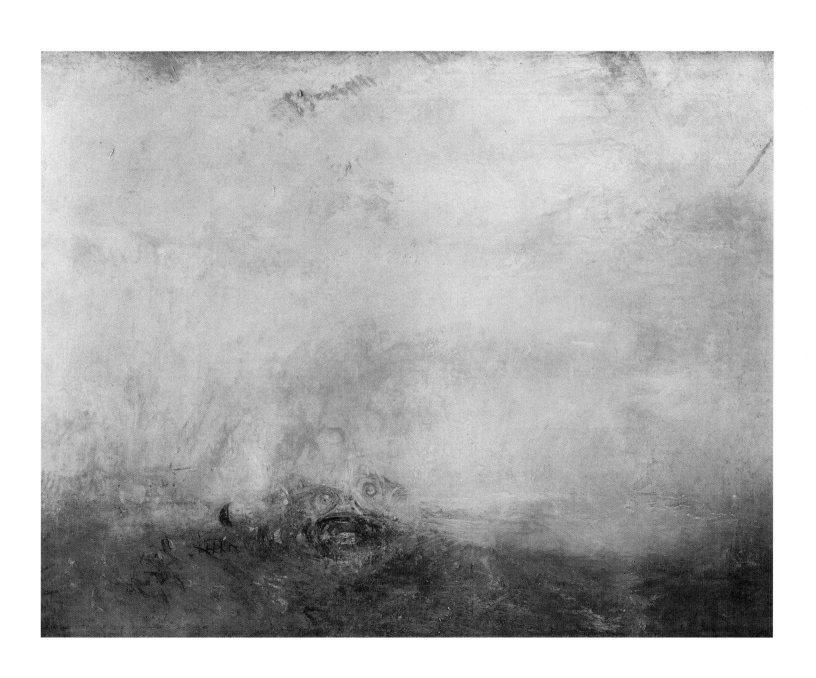

Sunrise with Sea Monsters *c.*1845 oil on canvas Tate Gallery, London Bequeathed by the artist, 1856 (cat. no. 30)

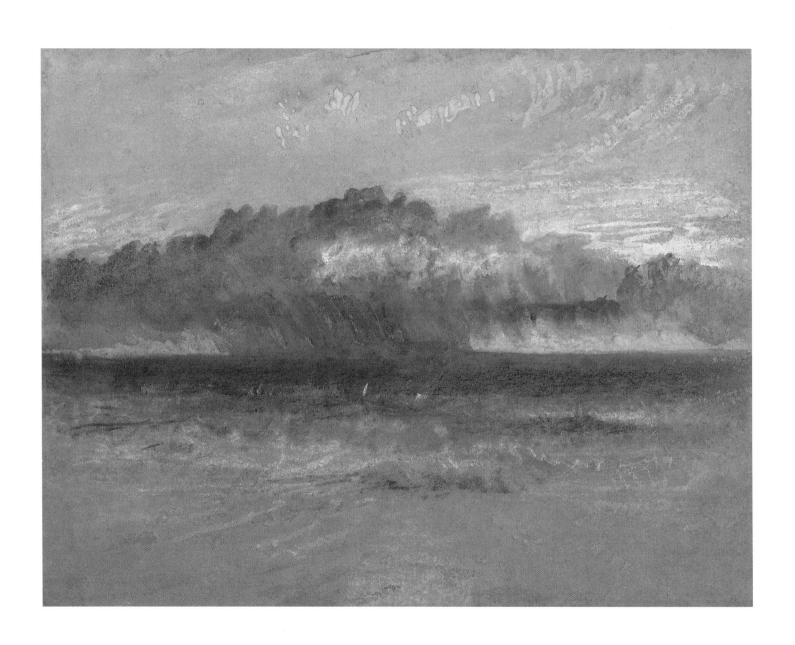

A Storm on Margate Sands 1830s watercolour Courtauld Institute Galleries, London Stephen Courtauld Bequest (cat. no. 69)

Storm Clouds, looking out to Sea 1845 watercolour Tate Gallery, London Bequeathed by the artist, 1856 (cat. no. 98)

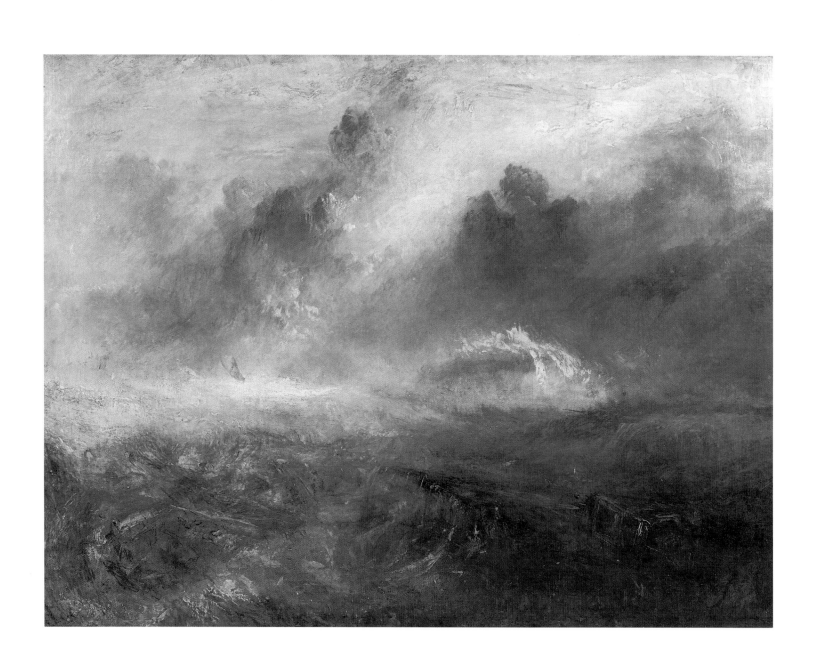

Rough Sea with Wreckage c.1830–35 oil on canvas Tate Gallery, London Bequeathed by the artist, 1856 (cat. no. 21)

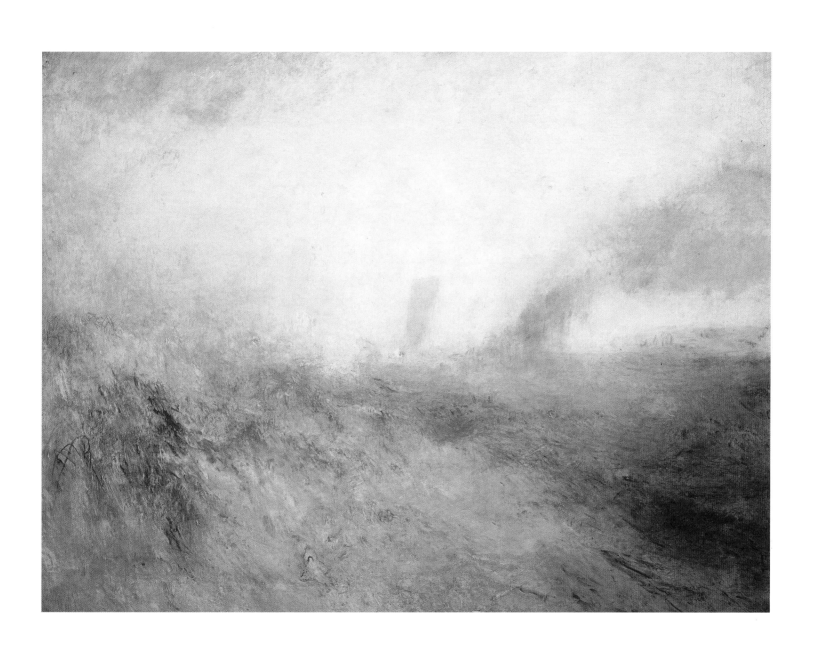

Seascape: Folkestone c.1845 oil on canvas Private Collection (cat. no. 29)

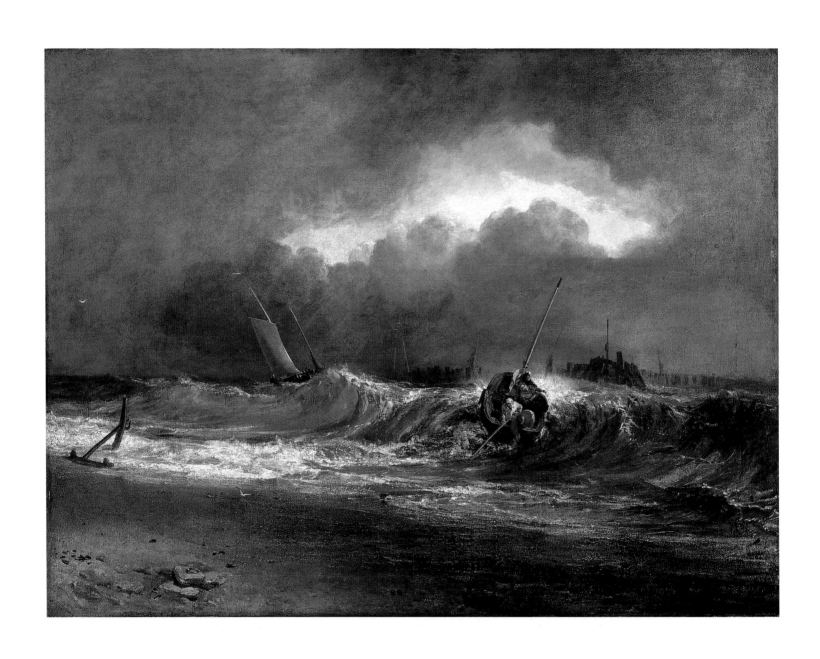

Fishermen upon a Lee Shore, in Squally Weather R.A. 1802 oil on canvas Southampton City

Being There

Michael Lloyd

Turner in a small boat is the setting for one of the most vivid first-hand accounts of the artist. It was written by a journalist, Cyrus Redding, in recollection of a day's excursion probably made in 1813, when artist and journalist sailed from Plymouth eastwards along the coast to Bur Island in Bigbury Bay. 'Our excuse was to eat hot lobsters', wrote Redding, 'fresh from the water to the kettle.'

> The sea was boisterous, the morning unpropitious ... The sea had that dirty puddled appearance which often precedes a hard gale ... running out from the land the sea rose higher, until off Stokes Point, it became stormy ... The artist enjoyed the scene. He sat in the stern sheets intently watching the sea, and not at all affected by the motion ... In this way we made Bur Island ... At last we got round under the lee of the island, and contrived to get on shore. All this time Turner was silent, watching the tumultuous scene ... absorbed in contemplation, not uttering a syllable. While the shell-fish were preparing, Turner, with a pencil, clambered nearly to the summit of the island, and seemed writing rather than drawing. How he succeeded, owing to the violence of the wind, I do not know. He, probably, observed something in the sea aspect which he had not before noted.[1]

'The description fits perfectly', writes Andrew Wilton: The self-contained indifference to discomfort, the rapt attention to natural effects, the concentration; and the act of drawing as if writing — an entirely natural and instinctive use of the pencil to record what he sees: all this is Turner to the life.'[2]

In the remarkable diary which he kept on his first sketching trip to Wales in the summer of 1792, Turner, aged seventeen, speaks for himself; as the days go by, the entries become increasingly short, matter-of-fact, rendered superfluous on future trips it might be supposed by sketchbook and pencil. On Thursday 9 August 1792, he made his way from Bangor to Caernarvon by boat:

> Had a very rough and tedious passage — up the Menai the wind blowing hard against the tide — did not reach Caernarvon till dusk. But tho weather was hazy on the water, the view of the Caernarvon hills beautiful — seem to be from the rays of the setting sun impregnated with gold and silver. [Next day] Friday — Went on the water made 2 views ...[3]

Contemporary sightings of Turner often find him in boats sketching, apparently preferring the water-borne view; on a steamer on Lake Como, a gondola in Venice, ferries on the Rhine or Danube, a common fishing smack making slow headway against the steep choppy seas of the Menai Strait.[4]

The sightings may be years apart, but the portrait of the artist that emerges is the same — not solitary exactly, but distantly self-absorbed, looking and drawing. These accounts do nothing to disparage the less reliable, more famous images of the artist lashed to a ship's mast in a storm or leaning with his head out of the window of a speeding train. Turner's wonder of the world is deservedly legendary.

Artists had always drawn from nature, and Turner's artistic origins lie in the eighteenth-century topographical tradition which encouraged this practice more than most. Turner is different nonetheless; more than 19,000 miscellaneous drawings and sketchbooks found in his studio at his death speak of a lifetime working eye to hand that has no precedent in the history of art.

Turner abroad in the world ready with pencil and sketchbook is an enduring image of the artist. No less famously there is Turner the 'visionary' — the painter of *Snow Storm — Hannibal and his Army crossing the Alps*, which he exhibited at the Royal Academy 1815 (illus. p. 23), or *Ulysses deriding Polyphemus — Homer's Odyssey*, exhibited at the Royal Academy in 1829, (National Gallery, London; BJ 330); Turner the legendary magician of Varnishing Days, miraculously transforming indistinct colour lay-ins into masterpieces on the walls of the British Institution and the Royal Academy. The most extensive eyewitness account of one of these performances — likened by Turner's contemporaries to the virtuoso playing of the violinist, Paganini, who astounded London audiences in the early 1830s[5] — applies to the painting of *The Burning of the Houses of Lords and Commons, 16th October, 1834* (illus. p. 88) at the British Institution in February 1835. It was written by the Norfolk artist, E.V. Rippingille:

> Turner was there, and at work before I came, having set-to at the earliest hour allowed. Indeed it was quite necessary to make the best of his time, as the picture when sent in was a mere dab of several colours, and 'without form and void', like chaos before the creation. 'The managers knew that a picture would be sent there, and would not have hesitated, knowing to whom it belonged, to have received and hung up a bare canvas, than which this was but little better.' Such a magician, performing his incantations in public, was an object of interest and attraction. [William 'Little'] Etty was working by his side [on his picture *The Lute Player*] and every now and then a word and a quiet laugh emanated and passed between the two great painters. Little Etty stepped back every now and then to look at the effect of his picture, lolling his head on one side and half closing his eyes, and sometimes speaking to some one near him, after the approved manner of painters: but not so Turner; for the three hours I was there — and I understood it had been the same since he began in the morning — he never ceased to work, or even once looked or turned from the wall on which his picture hung. All lookers-on were amused by the figure Turner exhibited in himself, and the process he was pursuing with his picture. A small box of colours, a few very small brushes, and a vial or two, were at his feet, very inconveniently placed; but his short figure, stooping, enabled him to reach what he wanted very readily. Leaning forward and sideways over to the right, the left-hand metal button of his blue coat rose six inches higher than the right, and his head buried in his shoulders and held down, presented an aspect curious to all beholders, who whispered their remarks to each other, and quietly laughed to themselves. In one part of the mysterious proceedings Turner, who worked almost entirely with his palette knife, was observed to be rolling and spreading a lump of half-transparent stuff over his picture, the size of a finger in length and thickness. As [Augustus Wall] Callcott was looking on I ventured to say to him, 'What is that he is plastering his picture with?' to which inquiry it was replied, 'I should be sorry to be the man to ask him.' ... Presently the work was finished: Turner gathered his tools together, put them into and shut up the box, and then, with his face still turned to the wall, and at the same distance from it, went sidling off, without speaking a word to anybody, and when he came to the staircase, in the centre of the room, hurried down as fast as he could. All looked with a half-wondering smile, and [Daniel] Maclise, who stood near, remarked, 'There, that's masterly, he does not stop to look at his work; he *knows* it is done, and he is off.'[6]

Turner the visionary and Turner of the no less 'magnificent empirical urge', as Margaret Plant aptly puts it in her essay in this catalogue, are of course the same artist and most Turner historians would locate the source of much of his achievement in effecting what Wilton once described as 'an unexpected *rapprochement* between historical painting and topography which was crucial to both strands in his art'.[7] Taking particular works from this exhibition by way of example, the results of this 'unexpected *rapprochement*' may be no less surprising.

While Turner's virtuoso performances in oil painting might be witnessed by his fellow artists on Varnishing Days, accounts of his making of watercolours are rarer. *A First Rate taking in Stores* (illus. p. 118) is a marvellous exception; its creation in November 1818 at Farnley Hall in Yorkshire — the home of Walter Fawkes, a great friend and Turner's most substantial supporter during the first half of his career — has come down to us in the family memoir:

> One morning at breakfast Walter Fawkes said to [Turner], 'I want you to make me a drawing of the ordinary dimensions that will give some idea of the size of a man of war.' The idea hit Turner's fancy, for with a chuckle he said to Walter Fawkes' eldest son, then a boy of about 15, 'Come along Hawkey, and we will see what we can do for Papa', and the boy sat by his side the whole morning and witnessed the evolution of 'The First-Rate Taking in Stores'. His description of the way Turner went to work was very extraordinary; he began by pouring wet paint on to the paper till it was saturated, he tore, he scratched, he scrabbled at it in a kind of frenzy and the whole thing was chaos but gradually and as if by magic the lovely ship, with all its exquisite minutia, came into being and by luncheon time the drawing was taken down in triumph.[8]

This account gives us more than a description of Turner's extraordinary technique in painting his watercolours; it also usefully confuses neat distinctions between the topographic and the visionary in Turner's approach. The watercolour is produced in response to a straightforward topographic brief — to show the size of a man-of-war. Turner created the watercolour from memory and imagination however, miles from the sea, from a memory well stocked with the accumulated knowledge of years of observing and drawing the ships of the line. And the subject, the scale of these ships, is realised with imaginative artifice worthy of Piranesi,[9] the looming vastness apparently defeating 'a drawing of the ordinary dimensions', and the diminishing size of the tiers of gun portals lending a mountainous perspective to the side of the ship. True to scale no doubt, the scale of this man-of-war is rendered awe-inspiring nonetheless, conjoining dictates of topography and the Sublime.

The few watercolours that Turner made during his first trip to Venice in 1819, such as *Venice: San Giorgio Maggiore from the Dogana* (illus. p. 147), have been seen to signal a turning point in his career. 'In them', Wilton has written, 'we encounter a new luminosity, a willingness to allow the white paper to speak for itself, that lend a completely fresh character to his style. This does not constitute a great leap of technical progress, for Turner had long possessed the capacity to work in this way; now for the first time he found scenes that required such a response ...'[10] It is Turner's direct visual response to the airy liquidity of Venetian light that effects the change in his style, and these watercolours unusually seem to have been made outside, before the view he was recording. Normally he preferred the fast, precise notations of pencil while working out-of-doors; and when another Englishman offered to join him on a day's outing of watercolour painting during his 1819 Italian tour, Turner, it is reported, 'grunted for answer that it would take up too much time to colour in the open-air — he could make 15 or 16 pencil sketches to one coloured'.[11]

The distinctiveness of the Venetian watercolours may be appreciated by comparison with the large, finished watercolour of *Venice: The Rialto* (illus. p. 144) which Turner made after his return to London. Although based on a pencil drawing made in Venice in 1819, *The Rialto* is in many ways closer to a similar view which he made just before his visit to Italy using James Hakewill's *'camera obscura'* outline pencil drawings of Italian views. The glorious theatre of *The Rialto,* contrived with the aid of the mechanical eye of the *camera obscura*, is far removed from the airy openness and light-filled atmosphere of the watercolours made on the spot in Venice — the radical result of natural vision.

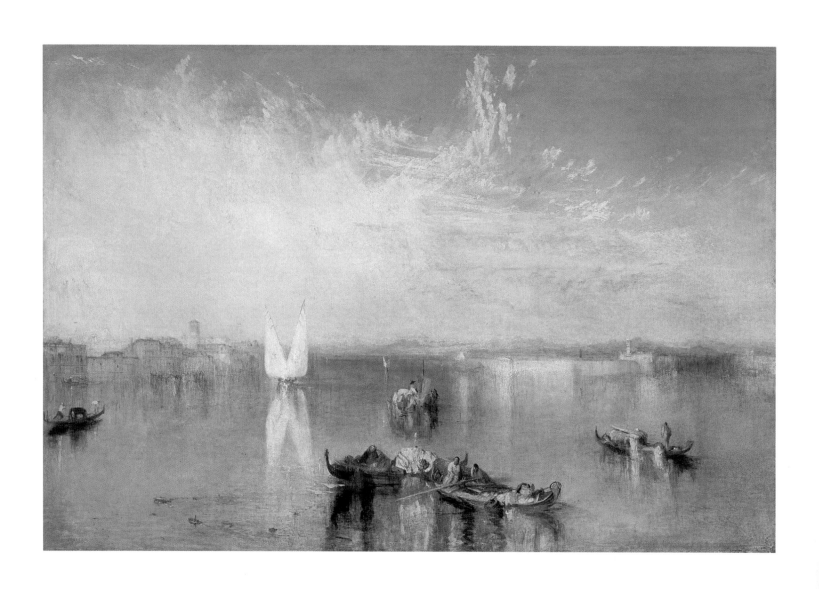

Campo Santo, Venice R.A. 1842 oil on canvas Toledo Museum of Art Gift of Edward Drummond Libbey (cat. no. 24) *detail opposite*

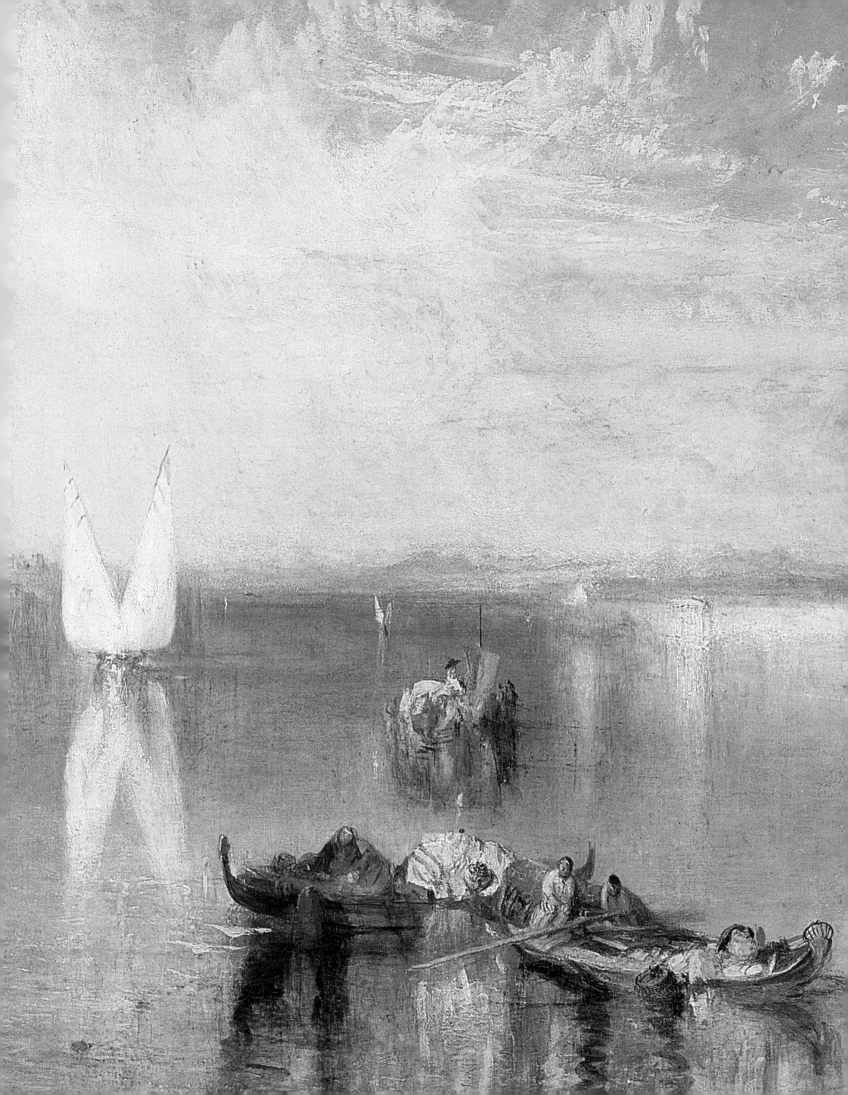

In her essay, 'Venetian Journey', in this catalogue, Margaret Plant points out that in his paintings of Venice, Turner generally follows the visual lead of his 1819 watercolours. Venice is pictured from the water, Turner's fascination with the effects of light and atmosphere deflecting the conventional view of Venice as historical artefact.

Of course, like any well-informed English visitor, Turner subscribed to the fashionable view of Venice's decline, culminating in the fall of the Republic to Napoleon in 1797. Some historians have argued that his paintings virtually narrate this view. *Campo Santo, Venice* (illus. p. 190) is cited as a prime example, with the island cemetery established by Napoleon in the background on the right, and the foreground littered with 'humble fishing vessels and floating garbage'.[12] Perhaps, but the painted image speaks immediately and forcefully of another, visual experience. Melancholy allusions pale before this emphatic celebration of sea and sky and the languor of the sun-drenched lagoon, or so his contemporaries thought; '... a most brilliant, airy, beautiful picture', wrote William Makepeace Thackeray on seeing *Campo Santo* first exhibited at the Royal Academy in 1842.[13] John Ruskin, Turner's greatest and most eloquent champion, and author of *The Stones of Venice* (1851–53), a central document in the English story of the glorious decline of that city, thought it simply 'the most perfect of all the late Venices'.[14]

As for the floating garbage in the foreground of *Campo Santo*, this is quintessential Turner. The flotsam and jetsam of human passage turns up in the foreground of many of his paintings and watercolours, generally increasing in proportion to the spectacular nature of the scenery presented. It suggests something other than Turner's undoubted grasp of current intellectual theories, something perhaps more Dickensian than Byronic — a matter-of-fact and unpatronising fascination with ordinary lives in the spectacularly beautiful world of nature. Incidentally, Turner, at nearly seventy years of age, was present at the dinner given to farewell Dickens on his first visit to Italy: '[H]e enjoyed himself in a quiet silent way', observed a friend, 'less perhaps at the speeches than at the changing lights on the river.'[15]

At the Royal Academy exhibition of 1842, along with the beautiful, becalmed lagoon of *Campo Santo*, Turner exhibited his greatest painting of tempest at sea, *Snow Storm — Steam Boat off a Harbour's Mouth making Signals in Shallow Water, and going by the Lead. The Author was in this Storm on the Night the Ariel left Harwich* (illus. p. 33). This painting has been seen as the ultimate portrayal of the wild, magnificent sea and storm-tossed boat of Romanticism, especially favoured in the literature of the English Romantic tradition. Ruskin acclaimed it 'one of the very grandest statements of sea — motion, mist, and light, that has ever been put on canvas, even by Turner', adding disconsolately, but in a way that could only enhance its Romantic allure: 'Of course it was not understood; his finest works never are...'[16] The stature of the painting within Romanticism is further enhanced by legend, a story encouraged by Turner himself, that in order to observe the storm at first hand he had sailors lash him to the mast. Jonathan Raban comments: 'The story (which has been generally doubted) has the essential rightness of fiction. It portrays the artist as a heroically manly figure whose devotion, both to the artistic endeavour and to nature, is touched with religious self-sacrifice. Turner, making himself a hostage to the wind and sea, becomes the solitary outcast hero of Romantic iconography — he becomes the Ancient Mariner and Childe Harold.'[17]

The painting itself however, its title, even the circumstances that led Turner to claim he was in the storm — which he almost certainly wasn't — suggest a more complicated and interesting reading. The ship at the centre of the maelstrom is not, after all, the vulnerable storm-tossed sailing vessel of Romantic preference, but a modern steamer, so incongruous in this context that Ruskin failed to mention it at all. And while the steamer is obviously taking a battering, the title tells us that it is not helplessly at the mercy of the elements, but is proceeding cautiously, 'going by the lead', that is, taking soundings to negotiate a safe passage

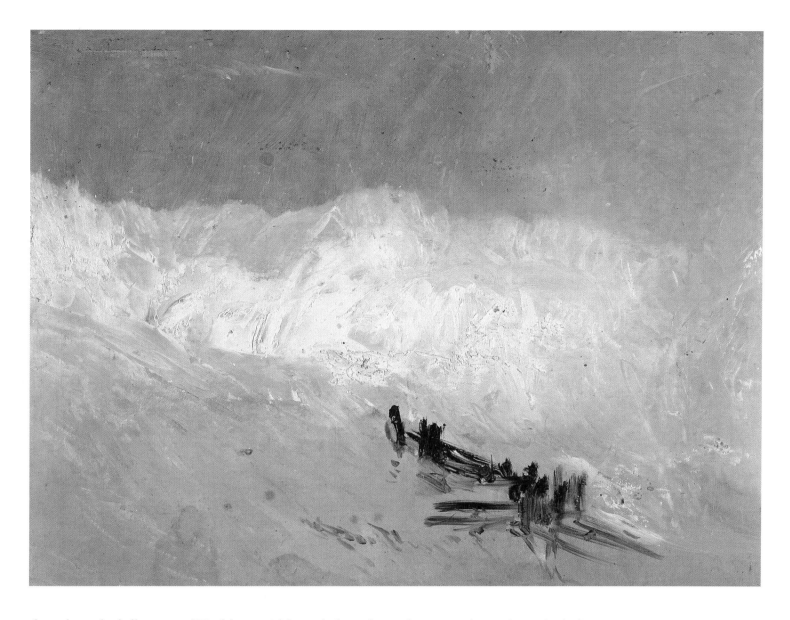

through rough, shallow water. 'His elaborate title', concludes Wilton in his essay in this catalogue, 'including the precise nautical activities the ship is engaged in ... the name of the vessel and her port of origin, reinforces the clear intention to be thoroughly realistic: "true to nature".'

Shore Scene with Waves and Breakwater
*c.*1835
oil on millboard
Tate Gallery, London
Bequeathed by the artist, 1856
(cat. no. 34)

It would seem to have been Turner's frustration at the lack of understanding of his thoroughly realistic intentions, rather than any desire to play the archetypal Romantic hero — completely out of character, in any case — that led him to invent the story that he was in the storm. The reaction to the painting when first exhibited was not sympathetic, one critic famously dismissing it as a mass of 'soapsuds and whitewash'. Evidently the criticism rankled: 'soapsuds and whitewash!', Turner was heard muttering to himself. 'What would they have? I wonder what they think the sea's like? I wish they'd been in it.'[18] Turner told his friend, the Rev. William Kingsley: 'I did not paint it to be understood, but I wished to show what such a scene was like; I got the sailors to lash me to the mast to observe it; I was lashed for four hours, and I did not expect to escape, but I felt bound to record it if I did.'[19]

The unlikelihood of the story only enhances Turner's extraordinary achievement of building into the painting itself, the perspective of a direct witness. As Wilton points out in his essay, the composition breaks with the usual 'old-masterly order of Turner's pictorial structures':

'In this canvas, all the lines are broken, tentative, diverging from any horizontal or vertical. The minimal chromatic range ... combines with this structure to produce a sense of dislocation, or rather of non-location — of being in a chaotic void.' We are inside the vortex. In this, the grandest of visionary statements, it is the legacy of the topographer that produces an epic manifestation of the Sublime. We should not doubt that for Turner the astonishing reality of the natural world may surpass all imaginings. Picturing that truth however, Turner was on uncharted ground.

The ferocious circumstances of *Snow Storm — Steam Boat off a Harbour's Mouth* have always cast into doubt the mast-lashed claim of the sixty-seven year old artist, but no one until very recently questioned the stories — which in this case did not originate with Turner himself — that he had directly witnessed the scene he painted in *The Fighting Temeraire, tugged to her Last Berth to be broken up, 1838* (illus. p. 195), exhibited at the Royal Academy in 1839.[20] Judy Egerton has shown that this is in fact unlikely — Turner may even have been abroad at the time — and in any case the *Temeraire* would not have appeared as it does in Turner's painting, fully rigged, with sails furled as if fresh from her heroic role at the Battle of Trafalgar, but a demasted hulk stripped to the minimum for her ultimate fate in the breaker's yard at Rotherhithe. The reaction to this solid scholarship has been quite sensational. No mere 'documentary account of something seen', the painting is now celebrated as a vindication of Turner's 'imaginative, visionary powers'. This lapse into the old polarities of Turner the topographer and Turner the visionary is surprising.

'Turner did not need to witness the subjects he painted', writes Egerton. 'His greatest paintings are works of the imagination rather than reality. He did not witness "Dido building Carthage", "Ulysses deriding Polythemus" or "Hannibal crossing the Alps"'.[21] Certainly on the basis of these paintings and much else besides, Turner's old-masterly aspirations and visionary credentials are beyond dispute. But to draw *The Fighting Temeraire* into the orbit of these earlier paintings is to be alerted also to its remarkable differences.

However imaginatively transformed, the actual subject of *The Fighting Temeraire* is ordinary, workaday. It is not a subject from classical mythology, nor a momentous event from history, ancient or modern. The towing of the hulk of the *Temeraire* to the breaker's yard was hardly even newsworthy.[22] Decades before, Turner had included the *Temeraire* in his huge canvas *The Battle of Trafalgar* of 1822–24 (National Maritime Museum, Greenwich; BJ 252), a history painting in the classic mode, composed complete in the artist's mind from contemporary reports. As with his other paintings of momentous contemporary events — of the 'Battle of the Nile' (exhibited at the Royal Academy in 1799 and now lost), or the 'Field of Waterloo' (exhibited at the Royal Academy in 1818, now in the Tate Gallery, London; BJ 138) — the public response to the heartfelt, patriotic theatre of these paintings was lukewarm; and generally remains so today.

On the other hand, from the moment *The Fighting Temeraire* was first exhibited at the Royal Academy in 1839, the response was overwhelmingly enthusiastic. The critic of the *Spectator* saw it as 'a grand image of the last days of one of Britain's bulwarks', while Thackeray, writing as Michel Angelo Titmarsh for *Fraser's Magazine*, likened the effect of the painting to a performance of the national anthem: 'a magnificent national ode' he called it.[23] If *The Fighting Temeraire* is in fact 'wholly a creature of the artist's imagination', as Egerton's assiduous research has recently suggested to some critics, it must also be conceded that the power of the painting has not been affected by the fact that it hasn't seemed so. On the contrary, Thackeray prefaced his colourful interpretation of the painting by pointing out that 'Turner makes you see and think of a great deal more than the objects before you'; there was no disparity between the apparent ordinariness of the scene depicted and the imaginative intervention of the artist.[24]

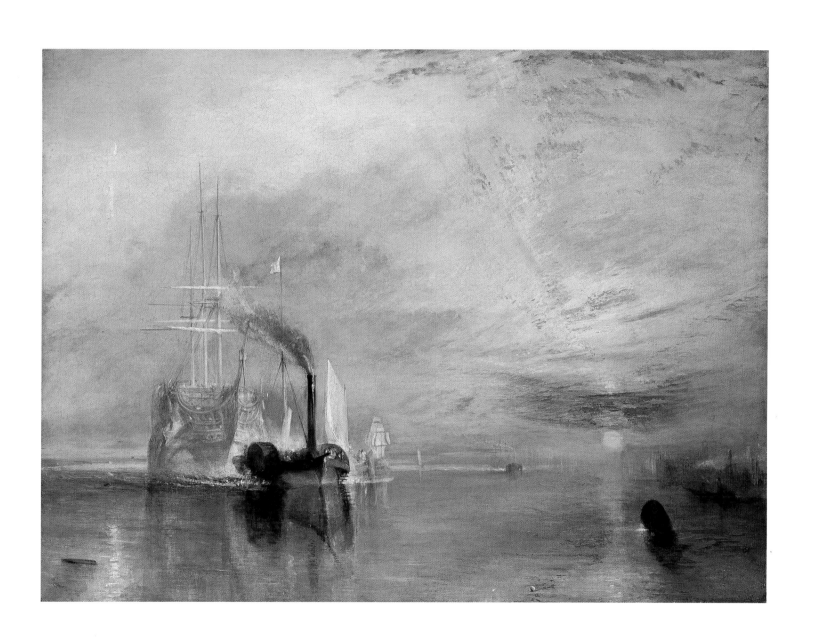

The Fighting Temeraire, tugged to her Last Berth to be broken up, 1838 R.A. 1839 oil on canvas 91.0 x 122.0 cm (35-1/4 x 48") National Gallery, London (BJ 377)

Ship in a Storm c.1840–45 oil on millboard Tate Gallery, London Bequeathed by the artist, 1856 (cat. no. 35)

Yellow Sky ? *c*.1840–45 oil on millboard Tate Gallery, London Bequeathed by the artist, 1856 (cat. no. 36)

It might be suggested rather, that the force of the artist's vision has gained in suggestive power and credibility by retaining the semblance of everyday, empirical fact. As the critic of the *Spectator* wrote, introducing his own enthusiastic response to the painting, this is 'real nature, and its poetry is intelligible'.[25]

The Fighting Temeraire is more than an expression of Turner's undoubted imaginative powers in the old master mode of, say, *Ulysses deriding Polythemus — Homer's Odyssey*, it is a new kind of history painting, a radical artistic invention. Modern, not so much because it includes an image of a steam powered tug boat, but because it addresses a modern historical self-consciousness, pragmatic at heart and conditioned by constant commentary (exemplified by the advent of daily newspapers — another phenomenon of Turner's times) to espy in daily events the portent of significant change. And surely change itself, however interpreted, is the essential subject of *The Fighting Temeraire*, as radically modern a subject as the portrayal of headlong, mechanical locomotion in *Rain, Steam, and Speed — The Great Western Railway* (illus. p. 48).

In 1984, while carrying out research for the catalogue of an exhibition organised by the Cleveland Museum of Art which brought together (150 years after the actual event) Turner's two brilliant paintings of the burning of the Houses of Parliament (illus. pp. 88,89), Katherine Solender made a remarkable discovery.[26] When Turner first came to paint this extraordinary spectacle of the urban Sublime — largely, as has already been mentioned, in a virtuoso performance on the walls of the British Institution in February 1835 — he did not follow the watercolour studies that he had made as a result of his direct experience of the scene. He was certainly there on the night of the fire, but the view of the fire presented by Turner in the painting now in the Philadelphia Museum of Art follows rather more closely the newspaper descriptions of the scene, particularly the account published in *The Times*. The implications of Solender's discovery are not at all clear although generally accepted, and perhaps inform Wilton's memorable description of Turner's paintings of the 'Dreadful Fire!' as 'journalism, topography and grand opera rolled into one' — a truly remarkable *rapprochement*.[27]

Turner's second painting of the burning of the Houses of Parliament, first exhibited at the Royal Academy in May 1835 and now in the Cleveland Museum of Art, is closer to a group of freely sketched watercolours (illus. pp. 92,93), done on the spot or very soon afterwards, and often likened in their immediate 'coloured' response and significance to the 1819 Venetian watercolours. As Evelyn Joll suggests in his essay in this catalogue, the Cleveland painting is also perhaps the more spectacular. In this panoramic vista the great arc of thickly painted flames sweeping across the sky is magnified to a grander scale by its reflections in the river below — the nasty smear of red firelight on the water contrasting with the dancing reflections of moonlight, warm and cool.

Firelight and moonlight and their reflections on water had fascinated Turner in his first exhibited oil painting, *Fishermen at Sea* (illus. p. 15). The view of the burning of the Houses of Parliament, as reconfigured in the Cleveland painting, is calculated to make the most of these light effects; and it may have been this opportunity, as much as the ongoing commentary on the implications of the fire in the newspapers and hence its continuing topicality, that prompted Turner to take the unusual step of painting this second version. As John Golding points out elsewhere in this volume, light itself was the central subject of Turner's art; light, I think, not as a proto Impressionist agent of seeing, but rather as the climactic expression of the visible world, the essence of Turner's Sublime. Submitted to the Royal Academy in 1835, with the Cleveland version of the burning of the Houses of Parliament, the great *Keelmen heaving in Coals by Moonlight* (illus. p. 28) similarly explores effects of firelight and moonlight, and their reflections on water. Wilton observes in his essay that, in this painting, 'Turner's vivid response to a modern industrial scene is placed securely in a historical perspective by his organisation of the subject as though it were a harbour scene by Claude.' Turner's place in the tradition of the old masters is thus re-affirmed, once again.

Recalling the rapt silence of the man in the stern of a small boat in rough weather, it could also be seen in another way. Turner needed all his imaginative and technical powers, and all the lessons of the old masters, to translate into art his enduring astonishment and wonder at the world about him. This radical stance also made him a pivotal example for the art to come.

More immediately, such a stance might bring us closer to understanding some of those areas of Turner's work which remain problematic, such as the so-called 'late unfinished seapieces', some of which, *The Evening Star* for instance (illus. p. 164), are neither especially late nor obviously unfinished. It is surprising how many Turner scholars love *The Evening Star* and yet how rarely it is discussed at any length in the literature. It is understandable that Turner would not have braved such an unconventional 'empty' picture at the Royal Academy. It is equally clear from the painting itself that the pungent loveliness of this twilight sky, with its infinitely subtle pearly modulations of colour, was fully subject enough for this artist.

Notes

1. Andrew Wilton, *Turner in his Time*, New York: Harry N. Abrams, 1987, p. 104.
2. Ibid.
3. John Gage (ed.), *Collected Correspondence of J.M.W. Turner, with an Early Diary and a Memoir by George Jones*, Oxford: Clarendon Press, 1980, p. 17.
4. Some of these accounts are worth quoting here: In 1840, the watercolourist, William Callow, crossed paths with Turner in Venice: 'One evening while I was enjoying a cigar in a gondola I saw in another one Turner sketching San Giorgio, brilliantly lit up by the setting sun. I felt quite ashamed of myself idling away the time whilst he was hard at work so late.' (Robert Upstone, *Turner: The final years: Watercolours 1840-1851*, London: Tate Gallery, 1993, p. 12). Probably in 1843, the pioneer photographer, William Lake Price, sighted Turner on a steamer on Lake Como: 'Turner held in his hand a tiny book, some two or three inches square, in which he continuously and rapidly noted down one after another of the changing combinations of mountain, water, trees, etc., which appeared on the passage, until some twenty or more had been stored away in an hour-and-a-half's passage.' (Andrew Wilton, 1987, p. 227). It is interesting to note in this regard that one obvious difference between the studies (illus. p. 133) and the final worked up watercolours of '*The Red Rigi*' 1842 (illus. p.103) and '*The Blue Rigi*' 1842 (illus. p. 102) is that the studies have no foreground incidents, shallows or shoreline — just an open expanse of water, like the water-borne views of Venice in the 1819 watercolours.
5. John Gage, *Colour in Turner: Poetry and truth*, London: Studio Vista, 1969, p. 169.
6. E.V. Rippingille, 'Personal Recollections of Great Artists', *The Art-Journal*, new series, vol. 6, p. 99. See Evelyn Joll's essay, 'The Burning of the Houses of Parliament', in this catalogue pp. 86–99.
7. Andrew Wilton's introduction to Eric Shanes, *Turner's Picturesque Views in England and Wales, 1825–1838*, London: Chatto and Windus, 1979, p. 5.
8. John Gage, *J.M.W. Turner: 'A Wonderful Range of Mind'*, New Haven: Yale University Press, 1987, pp. 159–160.
9. For Turner's acquaintance with the work of Piranesi, see Andrew Wilton's essay in this catalogue, 'Past and Present: Turner and his brother artists', pp. 12–35, also John Gage, 'Turner and Stourhead: The making of a classicist?', *Art Quarterly*, vol. 37, 1974, pp. 59–87.
10. Andrew Wilton, *Turner Abroad: France, Italy, Germany, Switzerland*, London: British Museum Publications, 1982, p. 40.
11. Cecilia Powell, *Turner in the South: Rome, Naples, Florence*, New Haven: Yale University Press, 1987, p. 50.
12. John Gage, 1987, p. 54.
13. Martin Butlin and Evelyn Joll, *The Paintings of J.M.W. Turner, R.A.* 2 vols, rev. edn, New Haven: Yale University Press for the Paul Mellon Center for Studies in British Art and the Tate Gallery, 1984, p. 246.
14. Ibid.
15. Jack Lindsay, *J.M.W. Turner: His life and work*, Greenwich, Conn.: New York Graphic Society, 1966, p. 194.
16. Edward Tyas Cook and Alexander Wedderburn (eds), *The Works of John Ruskin*, 39 vols, London: George Allen, 1903–12, vol. 3, p. 571 (hereafter, Ruskin, *Works*).
17. Jonathan Raban (ed.), *The Oxford Book of the Sea*, Oxford and New York: Oxford University Press, 1992, pp. 15–16.
18. Ruskin, *Works*, vol. 29, p. 584.
19. Martin Butlin and Evelyn Joll, 1984, p. 247.
20. Alas, and not for want of trying, *The Fighting Temeraire* is not in this exhibition. However, it needs to be discussed here, for the painting raises so many interesting questions, highlighted by the exemplary focus exhibition on the painting, in the 'Making and Meaning' series at the National Gallery, London (8 July – 1 October 1995), curated by Judy Egerton. The following references to Judy Egerton relate to the catalogue she produced for the exhibition, published by National Gallery Publications. Judy Egerton, *Turner: The Fighting Temeraire*, London: The National Gallery, 1995.
21. Ibid., p. 77.
22. News of the tow was recorded after the event in the *Shipping and Mercantile Gazette* (see Judy Egerton, 1995, p. 40, note 78, and p. 45, note 99), and a week later on page 6 of *The Times* (see ibid., p. 42, note 88).
23. Critical response quoted in Martin Butlin and Evelyn Joll, 1984, p. 230.
24. Thackeray is quoted, ibid., p. 230.
25. Ibid.
26. See Katherine Solender, *Dreadful Fire! Burning of the Houses of Parliament*, Cleveland: Cleveland Museum of Art, 1984.
27. Andrew Wilton, 'Painting in London in the Early Nineteenth Century', in Celina Fox (ed.), *London — World City 1800–1840*, New Haven: Yale University Press in association with the Museum of London, 1992, p. 182.

Inverary Pier, Loch Fyne: Morning c.1845 oil on canvas Yale Center for British Art, New Haven Paul Mellon Collection (cat. no. 32)

Landscape with a River and a Bay in the Distance c.1845 oil on canvas Musée du Louvre, Paris (cat. no. 31)

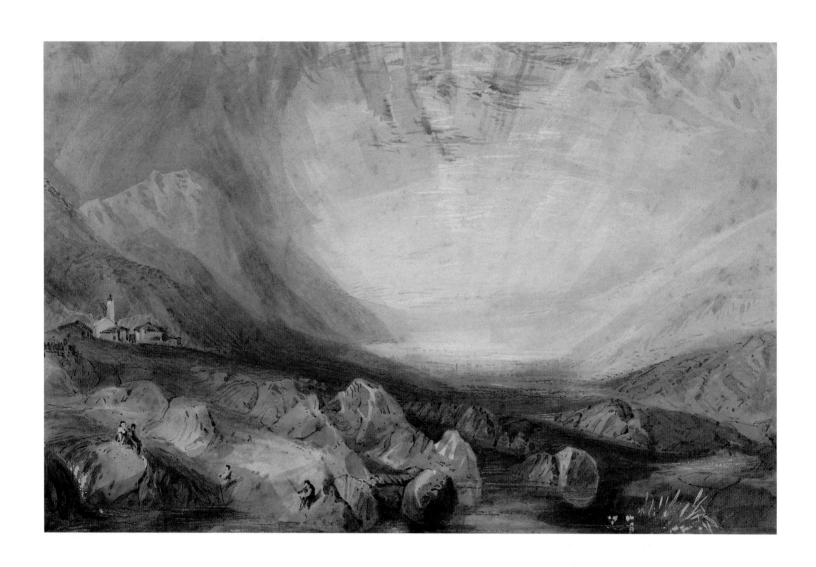

Conrad Martens 1801–1878 *Goldau — copy after Turner* sepia on paper 19.2 x 29.4 cm (7-1/2 x 11-1/2) Dixson Galleries, State Library of New South Wales, Sydney

Turner and the Origins of Landscape Painting in Australia

Andrew Sayers

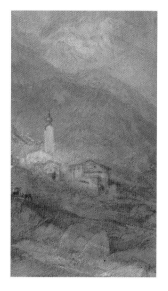

In November of 1830 Turner wrote to his friend James Holworthy making a passing reference to the emigration to Australia of the painter John Glover: 'I understand he is off ... to New South Wales, and has taken a vanload of pictures.'[1] The emigration which excited Turner's interest had taken place in September of that year and Glover was to arrive in Australia in February 1831. After a year in Hobart he settled in a remote part of northern Tasmania (then Van Diemen's Land) and there spent the rest of his life.

Glover's arrival in Australia marks an appropriate point to begin an examination of an Australian awareness of Turner because since the 1790s, Glover, like Turner, had been vying for the attention of the London art public. He was a close contemporary of Turner, but not an exact contemporary. Glover was Turner's senior by some eight years, though their deaths are closer in time, Glover's in 1849, Turner's in 1851.

Despite their contemporaneity, Glover and Turner were very different artists. The essential difference can be described in the broadest terms as a difference of centuries. Glover was still an eighteenth-century painter well into the 1830s; Turner uniquely developed the traditions of the eighteenth century into the new world of the nineteenth. The years around the turn of the century were a watershed for both artists. Glover looked back into the previous century, unable to achieve success in the rich medium of oils and avoiding contemporary subjects; Turner looked forward into the new century, enthusiastically embracing its possibilities. Glover's world, wherever it happened to be, was imbued with the honey-coloured light of an arcadian nostalgia; Turner's was a modern world lit up by coal fires and burning buildings.

The differences between the approach of Glover and that of Turner around the turn of the century are captured in Joseph Farington's record of opinions relating to their works in 1805. Comparing the work of Glover at the Exhibition of Painters in Watercolours with the works of Turner in his private gallery, Farington's colleague John Hoppner preferred Glover to Turner. Hoppner found Turner's exhibition 'rank, crude' and 'disordered'. Farington demurred, describing Glover's watercolours as 'too artificial, too equally detailed and finished' and lacking in feeling or mastery.[2] It was Farington's view that found an increasing number of adherents as the century progressed.

When Glover died in the idyllic splendour of his Tasmanian farm, Patterdale, his enthusiastic obituarist, relying on information provided by the family, claimed that during the early part of his career Glover had been a rival of Turner.[3] The notion of rivalry has been repeated often ever since, but the evidence does not support it.[4] Indeed, the lack of any real rivalry throws light on the different nature of Glover's art, particularly at the moment of his arrival in Australia.

The art of Glover and Turner shared a common root in the topographical watercolour; each began their professional careers making watercolour drawings of antiquities and gentlemen's seats. Despite this apprenticeship in the 'tinted drawing', both artists aspired to paint in oils. It was an aspiration which led Turner to spectacular achievements. In Glover's case it led to an amount of criticism.

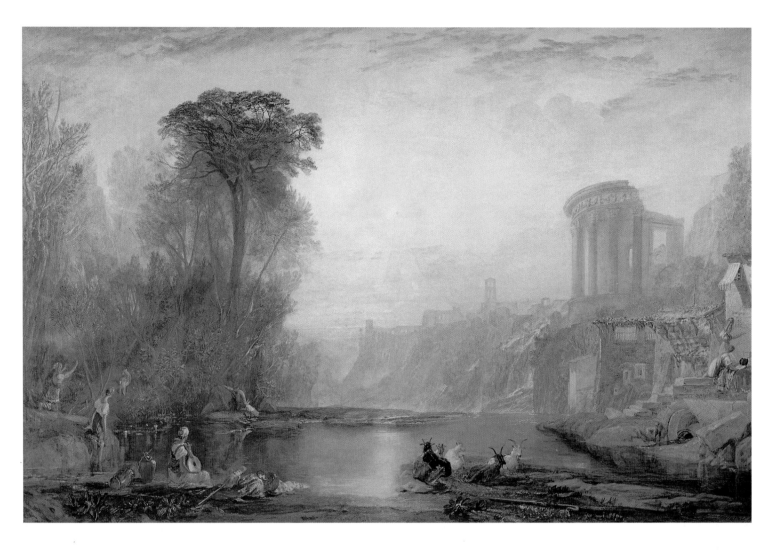

Landscape: Composition of Tivoli
R.A. 1818
watercolour
Private Collection
(cat. no. 49)

Glover, 'tumbling into oil', was reckoned to have misrecognised his appropriate metier.[5] There is no doubt that Glover's work had a certain popularity, but his patrons were, as far as can be determined, regional collectors with tastes for the old master pictures.[6] And his work was not regarded highly by those who mattered to the artist; when he sought election as an Associate of the Royal Academy in 1818, Glover failed to obtain a single vote even in the opening ballot.[7]

It appears that by the 1820s Glover had abandoned hope of having 'A.R.A', let alone 'R.A.', appended to his name. He was more concerned to be compared with Claude than with his immediate peers. In the exhibition of his own paintings which opened on 24 April 1820 at 16 Old Bond Street, two days before the Royal Academy's Annual Exhibition, Glover included a work by Claude which he had bought, reportedly, at great expense. By including Claude in his exhibition, Glover's intention may have been to draw attention to the classical character of his own art and to acknowledge his reverence for Claude. But the juxtaposition invited a comparison which was not favourable to Glover, one reviewer commenting: '[W]e cannot ... praise Mr. Glover's discrimination in having placed by the side of his own work an exquisite little production of that celebrated master [Claude], which abounds in beauty ... and which consequently renders Mr. Glover's deficiency in this respect infinitely more apparent.'[8]

Glover's inclusion of a work by Claude suggests a comparison with Turner's desire to see his own work hung side by side with Claude's. John Lewis Roget was the first to draw attention to this parallel.[9] In his discussion of Glover's art, Roget noted Turner's will of 1829, in which he bequeathed to the

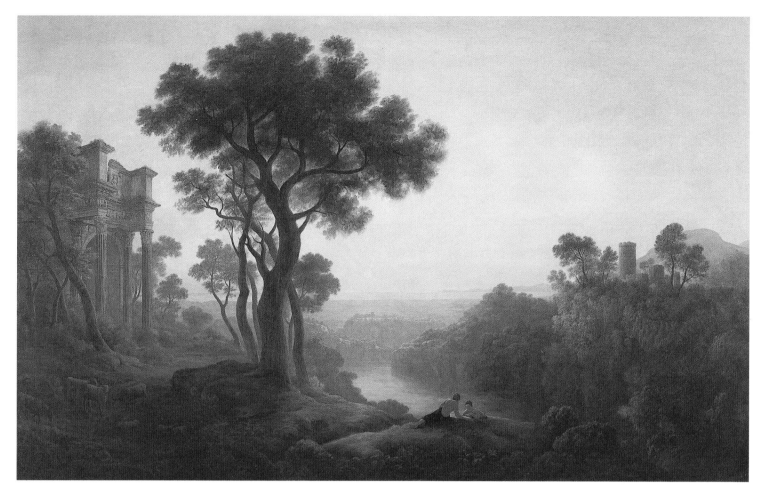

John Glover 1767–1849
Classical Landscape
oil on canvas
149.2 x 240.0 cm (58-3/4 x 94-1/2")
Art Gallery of New South Wales, Sydney

National Gallery his most ambitiously Claudian works, *Dido building Carthage: or the Rise of the Carthaginian Empire* (illus. p. 21) and *The Decline of the Carthaginian Empire* (Tate Gallery, London; BJ 135), stipulating that they should be hung with two works by Claude in the National Gallery collection. Apart from noting the parallel, Roget falls short of suggesting that Glover's experiment had inspired Turner's wish to present his own works adjacent to those of the French master. Indeed, it is more likely, as has been suggested, that Turner's decision was prompted by an 1817 review of his *The Decline of the Carthaginian Empire* which raised the question: '[W]hen shall we see a National Gallery where the works of the old masters and the select pictures of the British School may be placed by the side of each other in fair competition ...?'[10]

Roget makes a further connection between Glover and Turner, recounting the tradition that 'before stocking his Bond Street gallery' in 1820 Glover 'had actually been so bold as to ask the great painter to join him in the speculation', but that Turner refused, saying: 'If you are so confident try it yourself.'[11] This story is probably apocryphal, and Turner's supposed reply suggests that he had doubts about the notion of a private gallery, whereas he was well aware of the possibilities or otherwise of such an enterprise, having set up his own private gallery in 1804.

Both Glover and Turner revered Claude and painted deliberately Claudian works. Both, at various times, were referred to (along with a number of other artists) as 'the English Claude'.[12] However the attitude of each painter to the earlier landscapist was by no means the same. As Michael Kitson remarked in his study of Turner and Claude: '[F]or the most part [Turner's] use of Claude's art was neither superficial nor misjudged ... on the contrary, it was ingenious and highly creative.

In many ways Turner went beyond his source. He pressed Claude's style into the mould of his own developing pictorial language, and his finest 'imitations' are often those in which he departed furthest in the literal sense from his original.'13

The same could not be said of Glover, at least during his English years. Glover's use of Claude would become highly original only after he reached Australia and found Claudian delicacy in the Tasmanian bush.14 Glover's achievement as a painter was to discover qualities which no other observers had noticed in the Australian landscape. Where others had found monotony, Glover found the challenge of a new landscape art: 'There is a trilling and graceful play in the landscape of this country which is more difficult to do justice to than to the landscapes of England.'15

The pervasiveness of the taste for Claude creates difficulties for us if we are to attempt to find a Turnerian influence in Australian art in the early part of the century. Where we see a sun setting over water as the central element of a work, or classical devices framing a landscape, are we looking at the influence of Claude, or of Turner? Or are we seeing a Claudian motif that had been given relevance and currency by Turner? In the case of Australian art, the question is more apparent than real because, until the arrival of Conrad Martens in 1835, Glover was the sole landscape artist working in Australia who aimed to transcend the all-pervasive topographical motivation that gave birth to the majority of early landscape views. And Glover remained, after 1835 (when he sent sixty-seven works back to London for exhibition), something of a figure isolated from any art world, European or, for that matter, Australian.

—————

The career of Conrad Martens, between his arrival in Australia in 1835 and his death in 1878, exemplified, in an Australian setting, the significant transformation of landscape vision of the first half of the nineteenth century. I refer here to the shift from topographical exactitude to a landscape manipulated to achieve a sense of magnitude, a shift in which Turner's example was central. When Martens arrived in Sydney, having sailed from South America where he had left HMS *Beagle*, he entered an English colonial society which had only recently gained a confidence in its own existence and which was ready to celebrate that confidence through the arts. Unlike the topographers and travel artists who had preceded him in Sydney, Martens had the technical skill and the vision to portray the properties and houses of the colonial gentry with an effective breadth. From the moment of taking up his brush in Sydney, his work was popular and in demand.16

Some of the reasons for Martens's success can be found in a work such as his watercolour *View from Sandy Bay* of 1836 (illus. p. 207). The first thing we notice is that the work is not primarily topographical — at least in the sense in which previous views of Sydney Harbour had been — but celebratory. Details of distant buildings and sailing ships are lost in the glare of the sun. It is a watercolour which delights in the beauty of Sydney Harbour, rather than simply describing the landscape. It is a view which obviously owes much to Claude and to Turner, but it also owes much to the example of Martens's teacher, Copley Fielding. Before his emigration Martens had studied with Fielding and many of the watercolourist's techniques can be seen in Martens's treatment of water and in his broad, washy skies.

His central position in Sydney landscape painting — a position he maintained for three decades — was due first to Martens's determination to give a sense of atmosphere and scale to his subjects and secondly to the suavity of his watercolour technique. In both of these elements he owed a debt to Turner, but the precise nature of that debt is by no means easy to discern. Certainly by 1856, when Martens delivered his 'Lecture upon Landscape Painting', he was full of admiration and praise for Turner and was ready to recognise him, along with Claude, as the highest authority on landscape painting.17

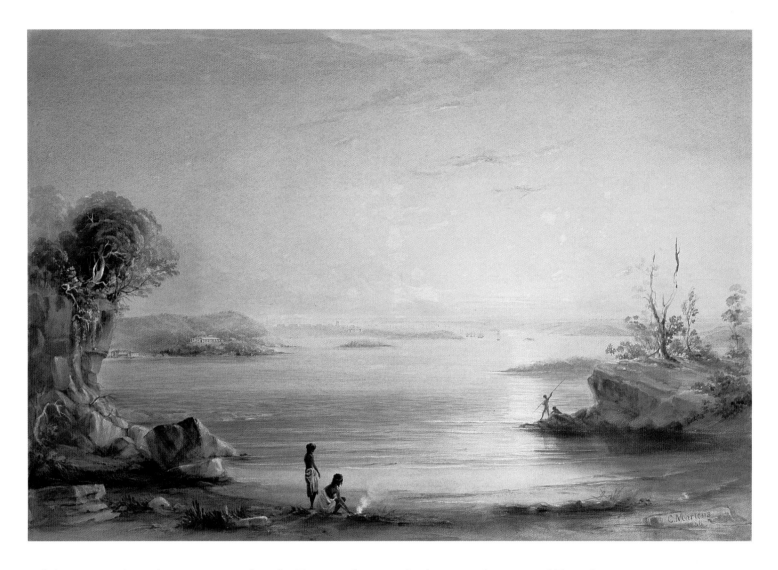

Conrad Martens 1801–1878
View from Sandy Bay 1836
pencil and watercolour
46.1 x 66.4 cm (18-1/4 x 26-1/4")
National Gallery of Victoria, Melbourne
Felton Bequest, 1950

While Martens claimed an important place for Turner in his own development, the power of Turner's work seems to have been something of a late discovery for him. His pre-Australian works actually show very little evidence of any Turnerian influence; most of Martens's English drawings owe more to Thomas Girtin and the Rev. William Gilpin than to Turner.[18] The only English work in which Turner is definitely present is a thumbnail sketch in one of Martens's sketchbooks of the early 1830s of Turner's *Van Tromp returning after the Battle off the Dogger Bank* (Tate Gallery, London; BJ 351), which had been exhibited in the Royal Academy of 1833.[19] Perhaps it is a measure of the impression made by that seascape that a Martens oil of Tahiti, painted after his arrival in Australia, carries a strong echo of the mood and composition of the Turner painting.[20]

Although in the 1830s there are certain Claudian qualities in Martens's watercolours, and a belief in 'effect' — both of which can be traced back to Turnerian attitudes — it was not until the 1850s that his work began to show a specifically Turnerian influence. This was the result, in large measure, of Martens's reading during the late 1840s and 1850s which included much on Turner. In his notebooks, Martens copied extensive quotations from John Burnet's *Turner and his Works* which was published in 1852, the year after Turner's death, and from Ruskin's *Modern Painters*.[21] His own copy of the first volume of *Modern Painters* (1843) still exists,[22] with Martens's marginal notes, but he must have read subsequent volumes because his sepia copy after Turner's 1843 watercolour *Goldau* (illus. p. 137) can only have been made from the plate illustrating the work in *Modern Painters*, volume four, which appeared in 1856.[23]

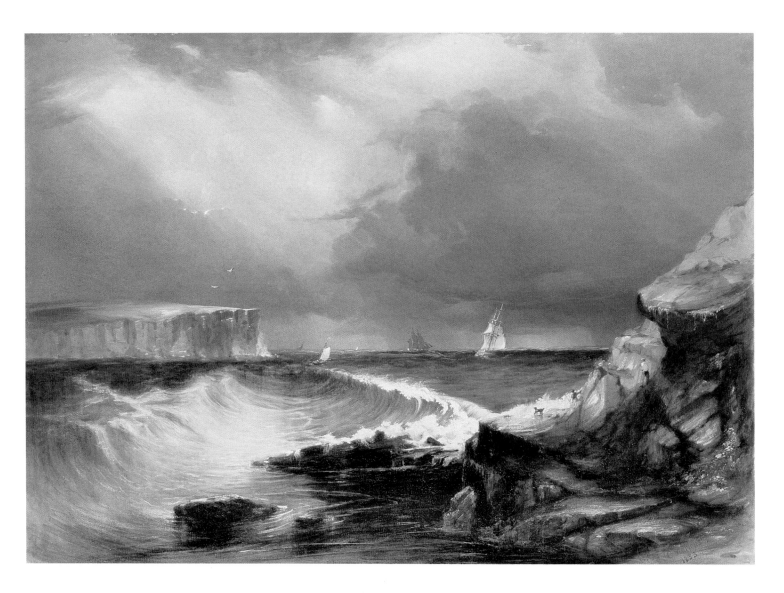

Conrad Martens 1801–1878
View of the Heads, Port Jackson 1853
watercolour, gouache on paper
54.2 x 76.4 cm (21-1/4 x 30")
Art Gallery of New South Wales, Sydney

Martens's notations on Ruskin are interesting because they show some impatience with the critic's flights of fancy and the apparent inconsistencies of his reasoning.[24] The school-masterish Martens was certainly not in awe of Ruskin, but he paid close attention to that writer's formulations on aerial perspective, light and shade and chiaroscuro. Always on the lookout for adaptable formulae, Martens marked passages in *Modern Painters* which have some practical picture-making application. For example, the list of Turner's works in which different times of day are represented has been noted for study.[25]

Several of Martens's watercolours of the 1850s possess a dense, dark quality, and this surely comes out of his reading of Ruskin and Burnet. His stormy watercolour *View of the Heads, Port Jackson* of 1853 may have been inspired by a reading of Burnet who extolled Turner as a master of the seapiece, particularly 'when the tempest-tossed waves threaten to "swallow navigation up"'.[26] *View of the Heads, Port Jackson* can be seen, in any case, as an example of Martens renewing and revitalising his practice in the 1850s to accommodate an aesthetic of landscape drama which owed its existence in large part to Turner. When Martens came to paint the Apsley Falls in the early 1850s (and again in 1873) they are distinctly Turnerian falls; never has the Apsley looked so like Schaffhausen. When he painted the grand *Funeral Procession for Admiral King* in 1856 (State Library of New South Wales, Sydney), it is again Turnerian in its density and richness; and never have whaleboats so resembled gondolas.[27]

Martens's 1856 'A Lecture upon Landscape Painting' can be seen in the context of this new dramatic intensity in his work. In the lecture his concern was to demonstrate that the art of landscape painting lies 'not in that of imitating individual objects, but the art of imitating an effect which nature has produced with means far beyond anything we have at hand'. The principal means at the disposal of the artist, Martens suggests, is 'breadth of light and shade' which is 'the making of the picture; all the others are but studies and sketches'. To support this observation, he drew a telling distinction between topographical illustration, on the one hand, and the work of Turner on the other. He contrasted lithographs after David Roberts (which Martens considered as topographical illustrations) with the *Liber Studiorum*. In the *Liber*, he said, 'will be found breadth, grandeur, and a total absence of all petty details and yet notwithstanding these high qualities it is from the general simplicity of the subjects, particularly well suited for, and easily understood by, the young student'.[28]

'Breadth' and 'grandeur' are the recurring ideas in Martens's art and were the bywords of his approach. He claimed in the lecture that one of his first practical lessons was 'carefully comparing the drawings of Turner with the scenes which he represented'. This was a lesson which taught him not only the importance of the scale of objects in a work, but a fundamental respect for the delicacies of aerial perspective. Lionel Lindsay, the author of the first monograph on Martens, was undoubtedly correct in his observation that in his *View of Sydney Harbour from above Tivoli*, a large watercolour of 1864 which Lindsay considered to be his masterpiece, Martens 'rested ... upon a far-off memory of Turner, as Turner had stayed himself upon Claude'.[29]

After his arrival in Australia Martens's opportunities to look at Turner's works at first hand were limited. Indeed he had to rely on 'far-off memory' as well as on prints and book illustrations for his studies. Opportunities for Australians to engage with Turner's paintings and drawings were almost non-existent for a full century after European settlement. The exception to this was in Tasmania, the nineteenth century's 'Athens of the South'. The people of Hobart were able to see a number of Turner paintings and drawings publicly exhibited on at least two occasions, in the 1840s and 1850s. These works were the property of Francis Russell Nixon, the first Bishop of Tasmania, who was in Hobart from 1843 until February 1862, and a member of a circle of enthusiastic amateur artists.

Bishop Nixon owned two Turner oils, three Turner watercolours and a number of prints after Turner. The paintings and drawings were exhibited by the bishop in an exhibition, held in the Legislative Council Chambers in Hobart in January 1845, where, quite naturally, they attracted considerable notice. The paintings were listed in the exhibition catalogue as *Landscape* and *View of Snowdon, North Wales*; the watercolours as *View on the Dee*, *Ruins of Sir Gregory Page Turner's House, Blackheath* and *Shakespeare's Cliff, Dover* (all, whereabouts unknown).[30] *View on the Dee* and *Shakespeare's Cliff* were both described as 'early drawings'. The bishop had acquired the works through his father, the Rev. Robert Nixon of Foot's Cray, Kent, an early supporter of the young Turner.[31]

The catalogue to the 1845 exhibition included an annotation regarding the Snowdon painting that it was believed to be 'the first production in oils of that distinguished artist'. Certainly it was an early painting, as the contemporary descriptions attest. Perhaps it was this work which Turner's first biographer Thornbury was thinking of when he included the perpetually mystifying piece of information in his 1862 life of Turner that the painter made his first oil painting at Foot's Cray for Reverend Nixon.[32]

Both of Hobart's newspapers ran long notices on the 1845 exhibition. The *Hobart Town Advertiser* described the Snowdon painting in the following terms:

> If this be, what the catalogue indicates it to be and what we have no reason to doubt it really is —
> Turner's first production in oils, then is it [sic] in truth an extraordinary specimen of youthful
> talent, as well as a curiosity in art itself. It represents a waggon with its passengers, halting at
> early dawn, at the door of a Welsh alehouse. The clear sharp outline of Old Snowdon cutting
> against the grey morning sky is happily given. It would be unreasonable to look for much artistical
> effect in the attempt of a boy of some 16 or 17 years of age to embody in oils that which
> he had already mastered in watercolours. He was feeling his way; but he seems to have guessed
> with almost intuitive accuracy. The figures are more carefully drawn, than has been Turner's wont
> in later years; and the grouping evinces thought as well as manual dexterity.[33]

This critique demonstrates some awareness of the shape and development of Turner's art and career. Beyond this it is difficult to know what impact the Turner works had on the Hobart audience in 1845. After all, Anna Maria Nixon, the bishop's wife, had written in 1844: 'No one here seems to care a straw for the arts, or even for reading ...'; and, following the exhibition: 'alas, the Hobartians have proved themselves very unworthy of such an intellectual treat ...'[34] However there was one group for whom the opportunity to see Turner's works would have been instructive — the vigorous Hobart sketching circle of the 1840s which briefly flourished as one of the most interesting of all artists' groups in nineteenth-century Australia and whose works provided the bulk of a further exhibition mounted in Hobart in 1846.[35]

The principal figure in the Hobart visual arts community was the Bristol watercolourist John Skinner Prout. He arrived in Hobart in 1844 from Sydney, where he had been living since 1840, and in 1848 he was to return to England. After his return Prout wrote a notice on the state of the fine arts in Australia which was published in the *Art Union*.[36] Prout perceived a general improvement in art activity in the colonies and greater refinement of taste over the eight years of his stay. The 1845 and 1846 Hobart exhibitions in which he played a significant organisational part, he considered, had made some impact on taste, although 'a great number of trashy prints are still sent out from England, and meet with purchasers', he wrote. '[Y]et ... engravings from Wilkie, Landseer, and Turner, are much more frequently to be seen than they were, and ... the lithographic works of Haghe, Frederick Tayler, Harding, Nash, &c., &c., are taking their places on the drawing-room tables of the colonists.'[37]

In addition to raising the tone of Australian taste by organising the Hobart exhibitions and delivering lectures on practical aspects of painting, Prout was at the centre of the group of enthusiastic amateur sketchers. This group included Bishop Nixon, Charles Stanley, the Secretary to the Governor, Peter Fraser, the Colonial Treasurer, and the Colonial Architect, William Porden Kay (nephew of the William Porden for whom the young Turner had made architectural drawings).[38] In addition Francis Simpkinson (de Wesselow) was numbered among these 'thorough lovers of Nature and genuine disciples of Art'.[39] Numerous women also took lessons from Prout.[40]

Turner was probably less important for the Hobart sketchers around Prout than for, say, Conrad Martens in Sydney. The entire program of the group was to treat the pursuit of art as a social activity, and outdoor sketching was central to the enjoyment of making pictures. Whereas Martens had believed that an outdoor sketch was simply a 'means to an end', Prout's artists happily exhibited the results of a half-holiday sketching expedition as finished works. They cared little for the opinions of an older generation of artists such as the Colonial Auditor G.T.W.B. Boyes who had trained under J.C. Schetky and who looked with disdain upon the quick sketches of Prout's circle.[41]

Some of Prout's circle were members of the so-called Hobart Town Sketching Club. This group was clearly modelled upon the Bristol sketching societies with which the young Prout had been involved.[42] It is unfortunate that we can no longer identify any of the works produced at the evening meetings of the club. Six such works were included in the 1846 Hobart exhibition and four of their titles are given simply as set pieces from Shelley. If we are to judge from the example of Prout's small-scale imaginary sketches — such as his highly Turnerian pair of views of a shipwreck now in the National Gallery of Australia, Canberra — Turner may well have been an important part of the pictorial imagination of this generation of artists.

John Skinner Prout 1805–1876
Tom Thumb's Lagoon c.1847
gouache
23.5 x 37.9 cm (9-1/4 x 15")
National Library of Australia, Canberra

Prout's later finished works are rich in colour and tone, particularly those that he worked up in the 1860s from the field sketches he had taken in Australia in the 1840s. These works include a panoply of Turnerian techniques. Whereas Martens had made an alpine cascade of a modest New South Wales river, Prout, in his watercolour view of *Tom Thumb's Lagoon*, found a Rigi in Mount Kiera. And whereas Glover had thought of the Tasmanian landscape in terms of Claude and Gaspar Dughet, Prout, on a sketching tour into the interior was led to compare the landscape, more modestly, to that of 'some of our wild Devonshire rivers' and parts of North Wales.[43]

Bishop Nixon's Turners were exhibited once more, in the 1858 Art Treasures Exhibition held in Hobart, before they returned with him to England in 1862.[44] Thereafter Australian audiences at large were denied the opportunity to see Turner paintings until 1888. The Melbourne Centennial Exhibition of 1888 included three important Turner paintings *Dunstanborough Castle, N.E. Coast of Northumberland. Sunrise after a Squally Night* (illus. p. 36), *Conway Castle, North Wales* (collection Duke of Westminster, UK; BJ 141)) and *The Mouth of the Thames* (destroyed; BJ 67), all lent by the Duke of Westminster. However there was a sense of disappointment with these works; in the company such 'modern' dazzlers as Holman Hunt's *The Shadow of the Cross* (City Art Gallery, Manchester), they seemed dull.

In his extensive writings on the 1888 exhibition, James Smith, an ardent Ruskinian and important taste-maker in nineteenth-century Melbourne, took little notice of the three Turners. He noted that the paintings 'will be a disappointment to those who know the works of this great artist by repute only, and who may have expected to find in them those luminous qualities, that glitter of light and glow of colour, with which he knew how to suffuse his works in so marvellous a manner'.[45] Smith criticised Turner's liberal use of 'the brown amber of rich asphaltum' which had caused the colours to sink and the paintings to become 'dingy and discoloured'. Smith's disappointment was probably the result of the evidence of the paintings not quite matching Ruskin's glowing evocation of Turner in the pages of *Modern Painters*.

Given the frequency with which Turner was cited as the greatest British landscape painter, it is perhaps mysterious that his example is not more conspicuous in Australian art of the nineteenth century. The fact remains, however, that the figure Turner presented was not so much the figure of an artist who could be followed, but of an exemplar of modern artistic genius. James Smith pointed this out to his readers in 1888. Turner's lack of followers was explained by Smith as a sign of 'a certain sturdy independence of perception, conception, method of interpretation and technical treatment' — an independence which he extolled as the fundamental quality of British art.[46]

211

Public perceptions of Turner in the latter half of the century became inextricably linked in Australia with the advocacy of Ruskin. Gradually, as the century entered its later decades, Ruskin came to be seen as more than simply an interpreter of the visual arts; in the minds of many he became a prophet and a seer,[47] and his theoretical writings on architecture were more widely available in Australian libraries than *Modern Painters*.[48]

The subject of Ruskin's reception in Australia is, in itself, worthy of extensive study, and is touched on in David Brown's essay in this catalogue. In the context of this discussion of perceptions of Turner in Australia it is interesting to note the work of another prominent Ruskinian — a man in a very different position from the journalist James Smith — the bank manager James Macdonald Larnach. Larnach had a passion for books, history and ethnography and was devoted to the art of Turner. In addition to publishing the first study of the *Liber Studiorum* to appear anywhere in the world — in Sydney in 1865 — he also published a pamphlet containing the text of a lecture on Ruskin that he gave to the Scots Church Literary Association in 1883.[49] In the lecture — sermon would be a more apt description — Larnach presented a picture of Ruskin as an 'art critic, political economist and humanitarian', with heavy emphasis on the latter two spheres of activity. The lecture contains Larnach's hearty endorsement of Ruskin's view of Turner's genius. In his discussion of *Modern Painters*, which he described as having 'no parallel in any age or country', Larnach summed up Ruskin's five-volume work with some acuity. 'In it', Larnach said, '[Ruskin] proved abundantly that, though one or two other painters had painted isolated facts better, Turner had beaten most of them in detail and all in universality.'

It is not possible to know the extent of Larnach's audience for his Ruskin lecture, or the impact of his presentation. Was anyone prompted by Larnach's descriptions of Turner's 'unparalleled genius' to look again at the works of the artist outside of the Ruskinian matrix? As for Larnach himself, he undoubtedly would have become a more widely recognised cultural commentator had he not died in 1887 at the age of forty-nine in the midst of his life's work — a study of the origins of the Australian Aborigines.[50]

A decade after Larnach's lecture on Ruskin, the painter Frederick McCubbin, Instructor of Drawing at the National Gallery of Victoria School, Melbourne, advised students to take Ruskin in smaller and more measured doses.[51] McCubbin was a practical painter who urged his students to keep their reading in a proper balance with their true work — looking and drawing and painting. To an extent McCubbin followed his own advice; he considered Ruskin to be a beautiful writer but of no practical help.[52] In McCubbin's own case it was not until he experienced the work of Turner at first-hand that the earlier master became a real and powerful presence in his art, rather than a vaguely apprehended ideal. In 1894 when he delivered the lecture, McCubbin had not been overseas and his notions of British art were neither original nor precise. Like James Smith before him he viewed Turner as a personification of the 'variety of style and individuality of expression' which was the strength of British art. He saw Turner as the originator of Impressionism, a style which, he admitted, French artists had assimilated and developed.

When McCubbin visited England in 1907 he had been prepared, through looking at the plates in the 1903 *Studio* book, *The Genius of J.M.W. Turner, R.A.,* to be receptive to Turner's work and he had been painting works which he described as 'Turnerian'.[53] While he found merit in much of the art he saw in London, he reserved his most abundant praise for Turner. After a visit to study the Turner Bequest paintings displayed in the Tate Gallery, McCubbin wrote: '[T]hey are mostly unfinished but they are divine — such dreams of colour — a dozen of them are like pearls — no theatrical effect but mist and cloud and sea and land drenched in light — [There is] no other master like him. They glow with a tender brilliancy ... these gems with their opal colour — you feel how he gloried in these tender visions of light and air.'[54] McCubbin found the experience of Turner's paintings to be both a revelation and yet strangely familiar; *St Benedetto, looking towards Fusina* (in 1907 hanging in the National Gallery, London — now in the Tate Gallery, London; BJ 406) he described as 'exactly as we thought it would look and so near to us'.[55]

Frederick McCubbin 1855–1917
Princes Bridge 1908
oil on canvas
61.5 x 92.5 cm (24-1/4 x 36-1/2")
National Gallery of Victoria, Melbourne
Purchased with the assistance of a special
grant from the Government of Victoria,
1979

McCubbin's admiration of Turner was an indication of personal artistic temperament; he always preferred pearly colour schemes and misty atmospheric effects. But McCubbin's enthusiasm was symptomatic of a new appreciation of Turner in the early years of the twentieth century. It was an enthusiam which McCubbin shared with his fellow Heidelberg School painter Arthur Streeton. It is interesting to compare McCubbin's reaction with that of Arthur Streeton several years earlier. Streeton had written to Tom Roberts from London in June 1899: 'Oh [Turner] is wonderfull [sic] master — as a landscape painter embraces I should say more qualities than any other — Oh the variety — the *variety* tremendous range ... Oh the transition of colour & value — the Castle & Cloud & the imagination — I think it will help me immensely'.56 For Streeton the example of Turner was perhaps more in his choice of subjects than in his technique; the phrase 'Castle and Cloud' sums up Streeton's preoccupations in his English years. A comment Streeton made (again to Tom Roberts) in 1908 reveals the traps of Turner-worship. Anticipating a painting trip to Bamborough Castle, Streeton described it as 'a grand subject overlooking the sea. It was painted by Turner & for once I am glad I haven't seen Turner's picture. I feel quite free — '.57

When McCubbin remarked that Turner's Venice seemed 'near to us' he was voicing a view which was widely felt. A half-century after Turner's death, his works, particularly the late paintings, could be seen again as modern paintings; his activities as a painter and his interests in the life of his times could be seen as those of a truly modern artist.

Notes

1. Turner to James Holworthy, 7 November 1830. John Gage (ed.), *Collected Correspondence of J.M.W. Turner, with an Early Dairy and a Memoir by George Jones*, Oxford: Clarendon Press, 1980, pp. 139–40.

2. Joseph Farington, diary entry for 13 May 1805, quoted in A.J. Finberg, *The Life of J.M.W. Turner, R.A.*, 2nd edn rev., London: Oxford University Press, 1961, p. 117.

3. *Examiner*, Launceston, 5 January 1850, pp. 2–3: 'Hitherto [Glover] had made water colours his chief study, but he soon began to practice [sic] in oil, and so satisfying was the result that he became a rival to Turner — at that time the best landscape painter in Europe.' *The Gentlemen's Magazine* (vol. 34, July 1850, p. 97) based its obituary notice on the *Examiner* obituary, modifying the reference to: 'he was considered the rival of Turner'. *The Art Journal*, 1850, p. 216, also based its obituary of Glover on the Launceston piece, omitting any reference to Turner.

4. John McPhee in *The Art of John Glover*, South Melbourne: Macmillan, 1980, p. 16 'quotes' Turner as saying 'the critics were more interested in John Martin showing at Egyptian Hall or J. Glover, called the English Claude, at 16 Old Bond Street'. This is not in fact a quote from Turner but Jack Lindsay's precis of a paragraph of A.J. Finberg, (1961), p. 274. It is worthwhile, I think, to dismiss the notion of rivalry at the outset, by examining the relative positions of Glover and Turner in the English art world of the first half of the nineteenth century. Some professional rivalry possibly existed between the two artists, but the fact remains that Glover was never considered by his contemporaries to be the equal of Turner. Glover had his circle of admirers and devoted patrons, some of whom were prepared to declare his work superior to Turner's, but outside of that group his work was considered second-string. Glover was prolific; his paintings and watercolours were abundantly to be seen in exhibitions, but admiration was invariably tempered with criticism. A typical assessment is found in *The Times* review of Glover's own gallery in the summer of 1821. The writer praised Glover for the fidelity of his approach but concluded that, on balance, he 'seems to want that comprehensive faculty, that intuitive power of genius, which, ever superior to its subject knows how to infuse into the most trifling scenes that mysterious charm of imagination which vibrates in sympathy with our inmost affections ...' (*The Times*, London, 14 June 1821, p. 3).
 In his lifetime the words applied to Glover were 'talent' and 'ability'; never 'genius'.

5. The phrase 'Glover has tumbled into oil' was Martin Shee's, reported by Maurice Henry Grant, *A Chronological History of the Old English Landscape Painters (in oil): From the sixteenth century to the nineteenth century*, 1957–61, Leigh-on-Sea: F. Lewis, vol. 5, 1959, p. 394. It is interesting to note that the idea persisted until well into the last years of Glover's life; Lady Franklin, arriving in Tasmania in 1837 seems to have made up her mind to despise the artist, acerbically commenting that if Glover's Tasmanian works 'are no better than those I saw exhibited of his in London before our departure, they are not worth much ... In fact when Glover left off water colour he abandoned his proper vocation', (letter from Lady Jane Franklin, Hobart, to her father, 12 October 1841, Franklin Papers Scott Polar Research Institute, Cambridge).

6. Glover's patronage is a subject which deserves considerable research. His most conspicuous patrons included Lord Northwick, whose taste was for Italian paintings. Closely allied with Northwick was Sir Thomas Phillipps, who acquired many of his paintings from Northwick's collection in 1859 and, some years later, acquired Northwick's Thirlestaine House itself. Phillipps was noted for his bibliomania, but his tastes in painting were neither progressive nor mainstream. The majority of paintings in Phillipps's 'Glover Gallery' in Thirlestaine House were not acquired until after Glover's death. Neither Northwick nor Phillipps possessed paintings by Turner.

7. Joseph Farington reported the voting in his diary entry of 11 November 1818. Kathryn Cave (ed.), *The Diary of Joseph Farington*, New Haven: Yale University Press for the Paul Mellon Center for Studies in British Art, 1984, vol. 15, pp. 5283–5284. There were thirty-eight candidates of whom nine received votes in the first ballot; in the second ballot Washington Allston was elected.

8. *The Times*, London, 14 June 1821, p. 3.

9. John Lewis Roget, *A History of the 'Old Water-Colour' Society*, 2 vols, London: Longmans, Green and Co., 1891, vol. 1, p. 405.

10. Michael Wilson, *Second Sight: Claude, The Embarkation of the Queen of Sheba; Turner, Dido building Carthage*, London: National Gallery, 1980, p. 3.

11. John Lewis Roget, 1891, p. 405.

12. Trevor Fawcett, *The Rise of English Provincial Art: Artists, patrons and institutions outside London 1800–1830*, Oxford: Clarendon Press, 1974, p. 89, quotes a Leeds newspaper report which described Turner as the 'English Claude'. See also Deborah Howard, 'Claude Lorrain and English Art', in Michael Kitson, *The Art of Claude Lorrain*, London: Arts Council, 1969, p. 9.

13. Michael Kitson, 'Turner and Claude', *Turner Studies*, vol. 2, no. 2, 1983, pp. 2–15

14. On arriving in Tasmania in February 1831, John Glover's son described in a letter to his sister the 'blazing sun and glowing landscape' and remarked upon how the country around the Tamar River was, in the massing of the bush on the wooded hills, 'very like the management of Gaspar Poussin's landscapes, a good school for the chiaroscuro'. J.R. Glover to Mary Bowles, 20 February, 1831. Mitchell Library, State Library of New South Wales.

15. Glover's handwritten note, originally attached to the reverse of *View of Mills Plains, Van Diemen's Land* (Art Gallery of South Australia, Adelaide), undated catalogue of the collection of Sir Thomas Phillipps, Thirlestaine House, Cheltenham (not dated, but after 1866).

16. Tim Bonyhady, *Images in Opposition: Australian landscape painting, 1801–1890*, Melbourne: Oxford University Press, 1985, pp. 10–11.

17. Conrad Martens, 'A Lecture upon Landscape Painting', 1856, reprinted in Bernard Smith (ed.), *Documents on Art and Taste in Australia: The colonial period 1770–1914*, Melbourne: Oxford University Press, 1975, pp. 96–111.

18. Many of these drawings are in the Mitchell and Dixson collections of the State Library of New South Wales. See Elizabeth Ellis, *Conrad Martens: Life and art*, Sydney: State Library of New South Wales Press, 1994, pp. 95–99.

19. The sketchbook is in a private collection, but is recorded on microfilm in the State Library of New South Wales (FM4/7693).

20. *Tahiti*, oil on canvas, 1840. Dixson Galleries, State Library of New South Wales, ZDG 160. Reproduced in Elizabeth Ellis, 1994, p. 155.

21. Martens's notebook is in the Mitchell Library, State Library of New South Wales, MS142.

22. National Library of Australia, Canberra.

23. Dixson Galleries, State Library of New South Wales, ZDG D11, f. 7.

24. Martens's annotated copies of John Ruskin, *Modern Painters*, vol. 1, 2nd edn, London: Smith, Elder and Co., 1846, and John Ruskin, *The Elements of Drawing*, 1857. National Library of Australia, Canberra.

25. Ibid.

26. John Burnet, *Turner and his Works*, London: Bogue, 1852, p. 75.

27. *Apsley Falls*, watercolour, 1873 is in the collection of the National Gallery of Victoria, Melbourne, P166 31/1 and is reproduced in Caroline Clemente, *Australian Watercolours 1802–1926 in the Collection of the National Gallery of Victoria*, Melbourne: National Gallery of Victoria, 1991, p. 55; *The Funeral Procession for Admiral King*, watercolour, 1856, is in the Mitchell Library, State Library of New South Wales, ML994 and is reproduced in Elizabeth Ellis, 1994, p. 80.

28. Martens's 'Lecture' etc., see note 17 above.

29. Lionel Lindsay, *Conrad Martens: The man and his art*, Sydney: Angus and Robertson, 1920, p. 32.

30. *Catalogue of Paintings, Water-Colour Drawings and Engravings Exhibited in the Legislative Council Chambers, Hobart Town*, Hobart, 6 January – 15 February 1845.

31. For Turner and the Rev. Robert Nixon ,see Walter Thornbury, *The Life and Correspondence of J.M.W. Turner, R.A.* rev. edn, London: Chatto and Windus, 1877, pp. 45–46; A.J. Finberg, 1961, pp. 17, 46–47; Lionel Cust, 'J.M.W. Turner — An episode in early life', *Burlington Magazine*, vol. 21, 1912, pp. 109–110.

32. Walter Thornbury, 1877. For further discussion of the issue see Martin Butlin and Evelyn Joll, *The Paintings of J.M.W. Turner*, 2 vols, rev. edn, New Haven: Yale University Press for the Paul Mellon Center for Studies in British Art and the Tate Gallery, 1984, p. 20. and Andrew Wilton, *The Life and Work of J.M.W. Turner*, London: Academy Editions, 1979, p. 255.

33. *Hobart Town Advertiser*, 14 February 1845.

34. Anna Maria Nixon to her father, 5 July 1844 and 12 February 1845, reprinted in Norah Nixon (ed.), *The Pioneer Bishop in Van Diemen's Land 1843–1863; Letters and Memories of Francis Russell Nixon, D.D. First Bishop of Tasmania*, Hobart: Walch and Sons, 1953, pp. 27 and 45.

35. This second exhibition, held in R.V. Hood's New Exhibition Rooms between 24 May and 17 July 1846 did not include any works by Turner. Nonetheless, Bishop Nixon sent the catalogue of this and the 1845 exhibitions to London and they formed the basis of a column in the *Art Union*, 1 January 1847, p. 96.

36. *Art Union*, London, 1 November 1848. p. 332.

37. Ibid.

38. Andrew Wilton, 1979, p. 24.

39. Prout's description of his travelling companions on his journey into the interior of Tasmania. See note 43 below.

40. Andrew Sayers, *Drawing in Australia: Drawings, water-colours, pastels and collages from the 1770s to the 1980s*, Melbourne and Canberra: Oxford University Press for the National Gallery of Australia, 1989, p. 54.

41. Ibid.

42. The most extensive discussion of the activities of the Bristol sketching societies and Prout's involvement with them is found in N. Neal Solly, *Memoir of the Life of William James Müller*, London: Chapman and Hall, 1875. Solly also emphasises the role played in Bristol by the amateur artist and commentator, the Rev. John Eagles, whose public criticism of Turner led to Ruskin's defence of Turner, John Ruskin, *Modern Painters*, vol. 1, London: Smith, Elder and Co., 1843.

43. John Skinner Prout, 'The Sketcher in Tasmania', *Once a Week*, London, 1 March 1862, pp. 275–280; 8 March 1862, pp. 304–308.

44. Nixon left Australia in 1862 and expected to return; however ill-health prevented his coming back to Tasmania. As the contents of the sale of his house, Bishopstowe, in Hobart in 1863 lists no paintings of any importance, there is no doubt that Nixon had the Turners, and his prized Guido Reni *St Sebastian*, brought back to England.

45. *Australasian*, Melbourne, Exhibition Supplement, 18 August 1888, p. 2.

46. 'The British School of Painting', *Argus*, Melbourne, Exhibition Supplement, 9 August 1888, p. 11

47. See for example the report of a sermon preached in Adelaide on 'Ruskin as a Prophet' by the Rev. F. Hastings in the North Adelaide Congregational Church, *Advertiser*, Adelaide, 12 July 1892, p. 9.

48. This conclusion is based on a scanning of catalogues of nineteenth-century public libraries in Australia. Copies of John Ruskin's *The Seven Lamps of Architecture, Sesame and Lilies* and *The Elements of Drawing* easily outnumber the rare occurrences of *Modern Painters*.

49. James Macdonald Larnach, *John Ruskin. A lecture delivered before the Scots Church Literary Association, Melbourne, August 15th, 1883*, Melbourne 1883.

50. Obituary of James Macdonald Larnach, *Transactions and Proceedings of the Royal Geographical Society of Australasia (Victorian Branch)*, vols 3 and 4, Melbourne, May 1887, n.p.

51. Frederick McCubbin, 'The training of an Artist', a lecture delivered to the Royal Victorian Institute of Architects, 29 May 1894. Reprinted with an introduction by Humphrey McQueen, *Art Monthly Australia*, 79, May 1995, pp. 13–16.

52. 'Notes by Frederick McCubbin', *c*.1910–11. Reprinted in Andrew Mackenzie, *Frederick McCubbin 1855–1917: 'The Proff' and his art*, Lilydale: Mannagum Press, 1990, pp. 9–18.

53. McCubbin wrote to Tom Roberts on 14 June 1904: 'That book on Turner's work issued by The Studio is a great treat. One is never tired of looking through the lovely drawings and paintings', Andrew Mackenzie, 1990, p. 235. See also McCubbin's letter to Roberts of 8 January 1906, in which he talks of his painting a 'Turnerian gem', ibid., p. 243.

54. Letter of McCubbin to Tom Roberts, 19 July 1907, ibid., p. 259.

55. Letter of McCubbin to Annie McCubbin, 11 July 1907, ibid., p. 257.

56. Ann Galbally and Anne Gray (eds), *Letters from Smike: The letters of Arthur Streeton 1890–1943*, Melbourne: Oxford University Press, 1989, p. 80.

57. Ibid., p. 114.

Liber Studiorum

The *Liber Studiorum* was Turner's most important venture into printmaking. As suggested by the title which may be translated as 'Book of Studies', the purpose was essentially didactic. According to an early advertisement, 'it is intended in this publication to attempt a description of the various styles of landscape, viz the historic, mountainous, pastoral, marine and architectural'.

Originally planned to comprise one hundred engravings, only seventy-one were actually issued, appearing in fourteen instalments between 1807 and 1819. Each instalment contained examples of the different categories of landscape, abbreviated on the prints as: 'H' for Historical, 'M' for Mountains, 'P' for Pastoral, 'M' for Marine, 'A' for Architectural and 'EP' which has been variously interpreted as denoting Elevated Pastoral or Epic Pastoral. The *Liber Studiorum* is the clearest expression of Turner's efforts to elevate the status of landscape art as a subject of serious study and hence, serious art.

Turner was intimately involved in all phases of the production of the plates for printing the *Liber Studiorum*. His initial step was to execute a preliminary drawing in pen and wash as a guide for the engraver. In some cases these designs were based on existing paintings and drawings, others were specifically invented for the series. Turner himself etched the outline of the design onto the plate, and then the composition was worked up in mezzotint by a professional engraver. Turner's supervision of the engraver was exacting and quarrels often led to new engravers being engaged. Charles Turner (no relation to the artist) was responsible for engraving the first twenty plates of the *Liber*, but fell out with Turner over the fees. Turner's experimental artistic nature and technical skills were such that he actually mezzotinted eleven of the *Liber* plates himself, and some of these contain the richest tonal modulations and most skilful rendering of passages of light and shade in the whole series.

It is interesting to note that the first history of the *Liber Studiorum* was written by a Sydney bank manager, James Macdonald Lanarch, and was published in Sydney in 1865.

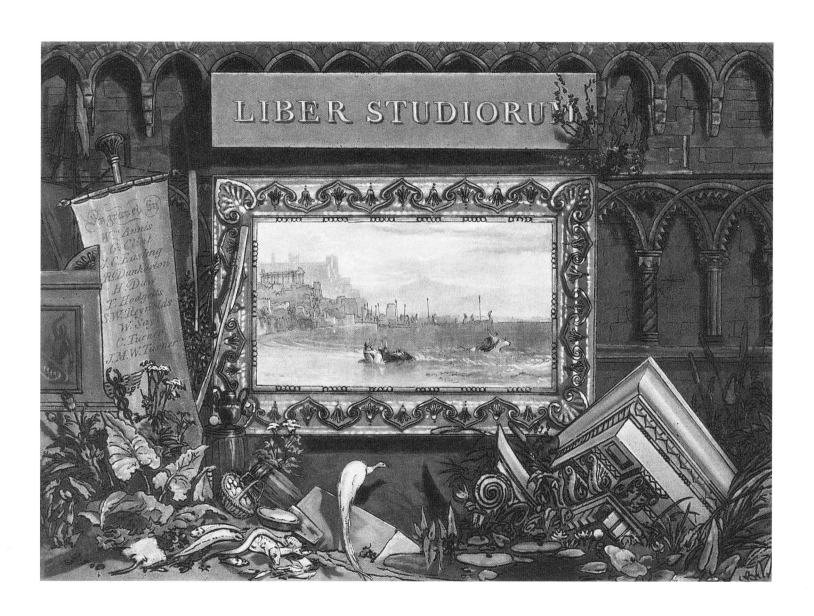

J.C. Easling engraver, after **J.M.W. Turner** *Frontispiece* from *Liber Studiorum*, part X, 23 May 1812 etching and mezzotint National Gallery of Victoria, Melbourne Felton Bequest, 1949 (cat. no. 112)

C. Turner engraver, after **J.M.W. Turner** *London from Greenwich* from *Liber Studiorum,* part V, 1 January 1811 etching and mezzotint National Gallery of Victoria, Melbourne Felton Bequest, 1949 (cat. no. 107)

J.M.W. Turner *Crypt of Kirkstall Abbey* from *Liber Studiorum,* part VIII, 11 February 1812 etching and mezzotint National Gallery of Victoria, Melbourne Felton Bequest, 1949 (cat. no. 110)

C. Turner engraver, after **J.M.W. Turner** *The Straw Yard* from *Liber Studiorum,* part II, 20 February 1808 etching and mezzotint National Gallery of Victoria, Melbourne Felton Bequest, 1949 (cat. no. 102)

R. Dunkarton engraver, after **J.M.W. Turner** *Young Anglers* from *Liber Studiorum,* part VII, 1 June 1811 etching and mezzotint National Gallery of Victoria Felton Bequest, 1949 (cat. no. 108)

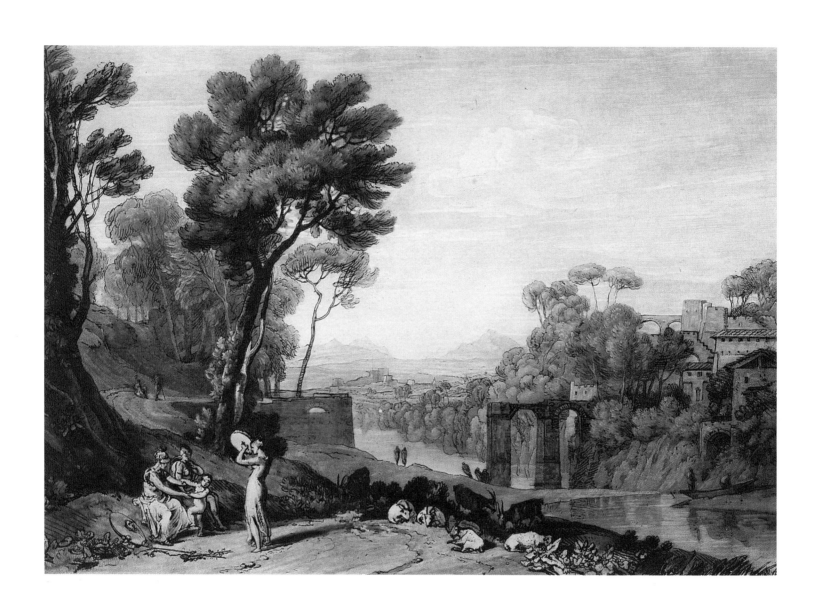

C. Turner engraver, after **J.M.W. Turner** *The Woman and Tambourine* from *Liber Studiorum,* part I, 11 June 1807 etching and mezzotint National Gallery of Victoria, Melbourne Felton Bequest, 1949 (cat. no. 100)

J.C. Easling engraver, after **J.M.W. Turner** *St Catherine's Hill near Guildford* from *Liber Studiorum*, part VII, 1 June 1811 etching and mezzotint National Gallery of Victoria, Melbourne
Felton Bequest, 1949 (cat. no. 109)

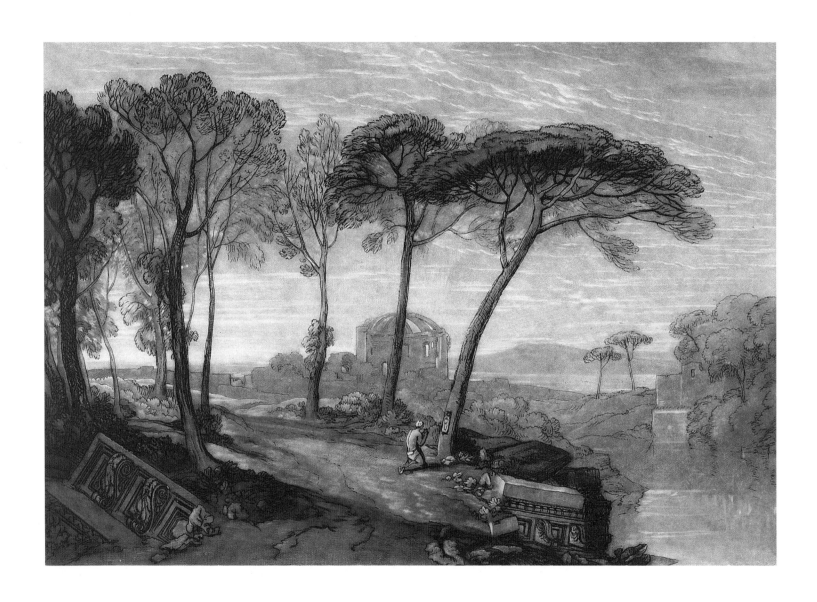

C. Turner engraver, after **J.M.W. Turner** *The Temple of Minerva Medica* from *Liber Studiorum,* part V, 1 January 1811 etching and mezzotint National Gallery of Victoria, Melbourne Felton Bequest, 1949
(cat. no. 106)

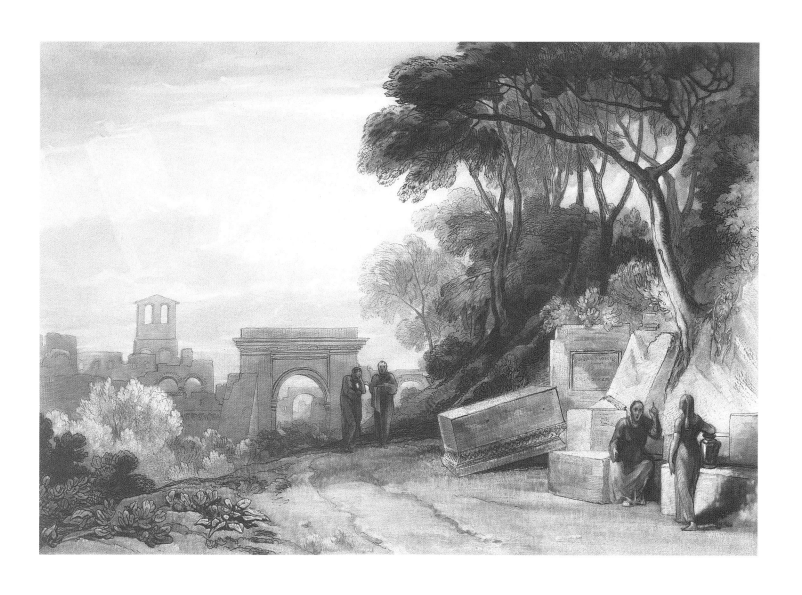

S.W. Reynolds engraver, after **J.M.W. Turner** *The Woman of Samaria* from *Liber Studiorum*, part XIV, 1 January 1819 etching and mezzotint National Gallery of Victoria, Melbourne Felton Bequest, 1949 (cat. no. 114)

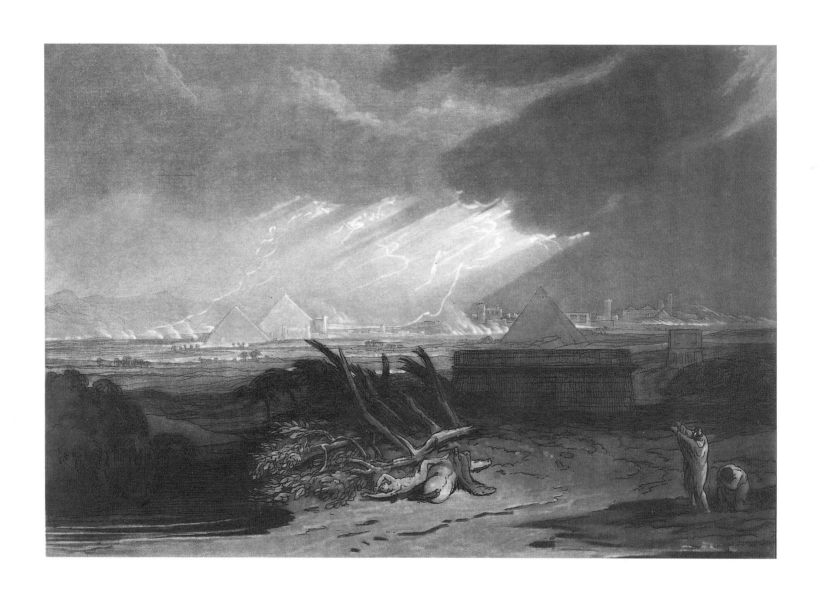

C. Turner engraver, after **J.M.W. Turner** *The Fifth Plague of Egypt* from *Liber Studiorum*, part III, 10 June 1808 etching and mezzotint National Gallery of Victoria, Melbourne Felton Bequest, 1949 (cat. no. 104)

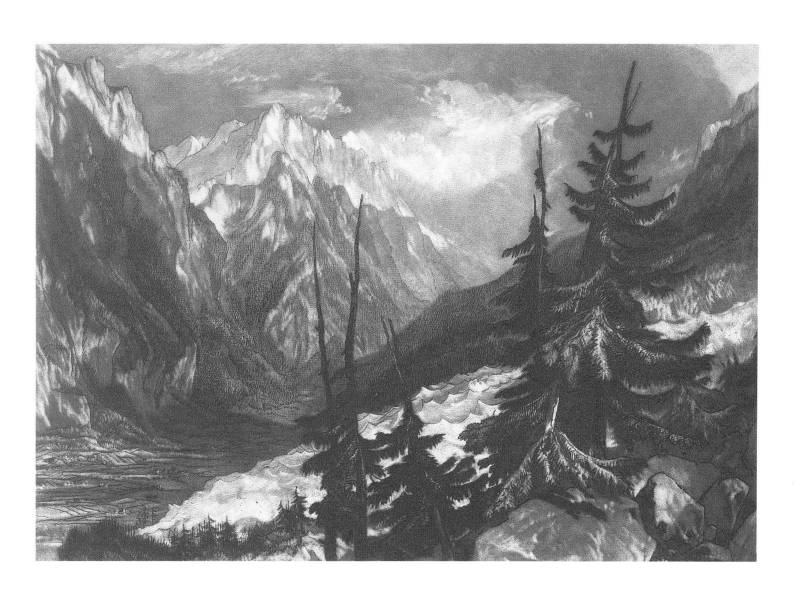

J.M.W. Turner *The Source of the Arveron* from *Liber Studiorum*, part XII, 1 January 1816 etching and mezzotint National Gallery of Victoria, Melbourne Felton Bequest, 1949 (cat. no. 113)

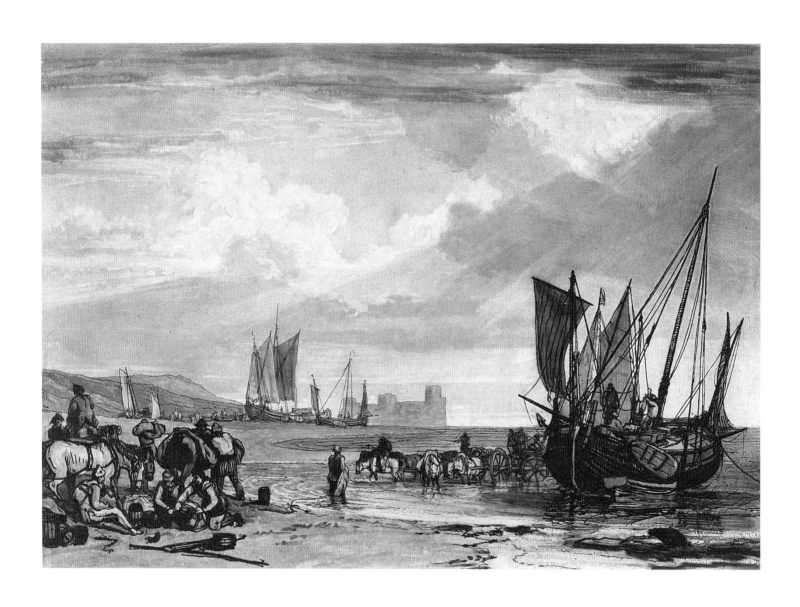

C. Turner engraver, after **J.M.W. Turner** *Scene on the French Coast* from *Liber Studiorum*, part I, 11 June 1807 etching and mezzotint National Gallery of Victoria, Melbourne Felton Bequest, 1949 (cat. no. 101)

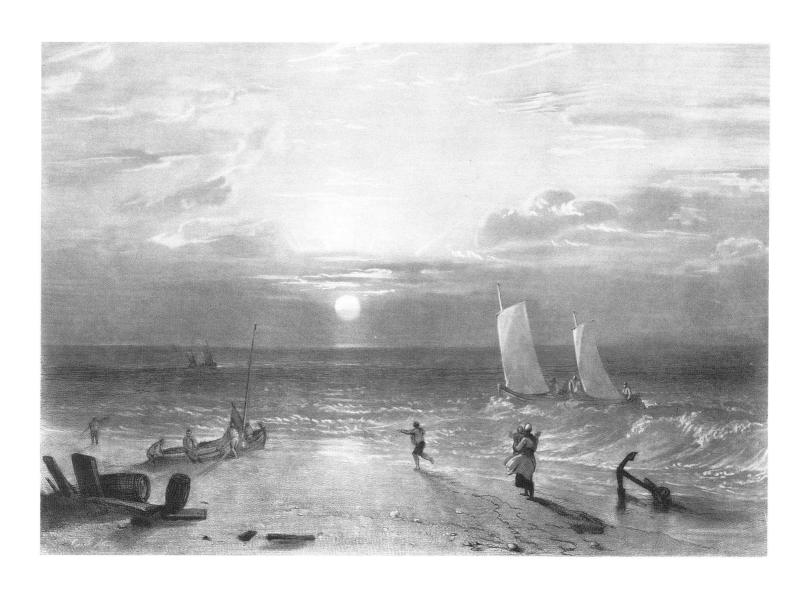

W. Annis and **J.C. Easling** engravers, after **J.M.W. Turner** *The Mildmay Seapiece* from *Liber Studiorum,* part VIII, 11 February 1812 etching and mezzotint National Gallery of Victoria, Melbourne
Felton Bequest, 1949 (cat, no. 111)

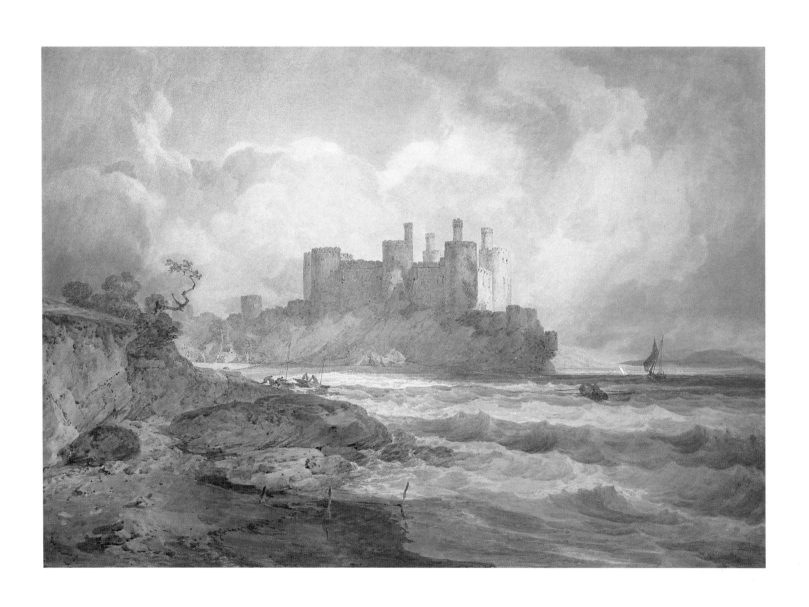

Conway Castle, North Wales *c.*1800 watercolour J. Paul Getty Museum, Malibu, California (cat. no. 41)

List of Works in the Exhibition

* Denotes works shown only at the National Gallery of Australia, Canberra

** Denotes works shown only at the National Gallery of Victoria, Melbourne

Paintings

1
Fishermen at Sea R.A. 1796
oil on canvas
91.5 x 122.4 cm (36 x 48-1/4")
Tate Gallery, London
Purchased 1972 (BJ 1)

2
Dunstanborough Castle, N.E. Coast of Northumberland. Sunrise after a Squally Night R.A. 1798
oil on canvas
92.0 x 123.0 cm (36-1/4 x 48-1/2")
National Gallery of Victoria, Melbourne
Gift of the Duke of Westminster, 1888 (BJ 6)

3
Dunstanborough Castle c.1798
oil on canvas
47.0 x 69.0 cm (18-1/2 x 26")
Dunedin Public Art Gallery, New Zealand (BJ 32)

4
A Scene on the English Coast c.1798
oil on panel
25 x 30.3 cm (9-3/4 x 12")
Phillips Collection, Washington DC (BJ 33a)

5
Dolbadern Castle, North Wales R.A. 1800
oil on canvas
119.5 x 90.2 cm (47 x 35-1/2")
Royal Academy of Arts, London (BJ 12)

6
Fishermen upon a Lee Shore, in Squally Weather R.A. 1802
oil on canvas
91.4 x 122.0 cm (36 x 48")
Southampton City Art Gallery, Hampshire (BJ 16)

7
Seascape with a Squall coming up c.1803–04
oil on canvas
45.7 x 61.0 cm (18 x 24")
Tokyo Fuji Art Museum (BJ 143)

8
Boats carrying out Anchors and Cables to Dutch Men of War, in 1665 R.A. 1804
oil on canvas
101.6 x 130.8 cm (40 x 51-1/2")
Corcoran Gallery of Art, Washington DC
William A. Clark Collection (BJ 52)

9
Walton Bridges c.1806
oil on canvas
92.2 x 122.4 cm (36-1/2 x 48-3/4")
National Gallery of Victoria, Melbourne
Felton Bequest, 1920 (BJ 60)

10
Shoeburyness Fisherman hailing a Whitstable Hoy 1809
oil on canvas
91.5 x 122.0 cm (36 x 48")
National Gallery of Canada, Ottawa (BJ 85)

11
Port Ruysdael R.A. 1827
oil on canvas
92.0 x 122.5 cm (36-1/4 x 48-1/4")
Yale Center for British Art, New Haven
Paul Mellon Collection (BJ 237)

12
East Cowes Castle, the Seat of J. Nash, Esq.; the Regatta beating to Windward R.A. 1828
oil on canvas
90.2 x 120.7 cm (35-1/2 x 47-1/2")
Indianapolis Museum of Art, Indiana
Gift of Mr and Mrs Nicholas Noyes (BJ 242)

13
Calais Sands, Low Water, Poissards collecting Bait R.A. 1830
oil on canvas
73.0 x 107.0 cm (28-1/2 x 42")
Bury Art Gallery and Museum, Lancashire (BJ 334)

14
The Evening Star c.1830
oil on canvas
91.1 x 122.6 cm (35-3/4 x 48-1/4")
Trustees of the National Gallery, London
Bequeathed by the artist, 1856 (BJ 453)

15
Fort Vimieux R.A. 1831
oil on canvas
71.1 x 106.7 cm (28 x 42")
Private Collection (BJ 341)

16
Wreckers — Coast of Northumberland, with a Steam Boat assisting a Ship off Shore R.A. 1834
oil on canvas
90.4 x 120.7 cm (35-1/2 x 47-1/2")
Yale Center for British Art, New Haven
Paul Mellon Collection (BJ 357)

17
St Michael's Mount, Cornwall R.A. 1834
oil on canvas
61.0 x 77.4 cm (24 x 30-1/2")
Trustees of the Victoria and Albert Museum, London (BJ 358)

18
Keelmen heaving in Coals by Moonlight R.A. 1835
oil on canvas
90.2 x 121.9 cm (35-1/2 x 48")
National Gallery of Art, Washington DC
Widener Collection (BJ 360)

19
The Burning of the Houses of Lords and Commons, 16th October, 1834 1835
oil on canvas
92.0 x 123.0 cm (36-1/4 x 48-1/2")
Philadelphia Museum of Art
John Howard McFadden Collection (BJ 359)

20*
The Burning of the Houses of Lords and Commons, October 16, 1834 R.A. 1835
oil on canvas
92.5 x 123.0 cm (36-1/2 x 48-1/2")
Cleveland Museum of Art
Bequest of John L. Severance (BJ 364)

21
Rough Sea with Wreckage c.1830–35
oil on canvas
92.0 x 122.5 cm (36-1/4 x 48-1/4")
Tate Gallery, London
Bequeathed by the artist, 1856 (BJ 455)

22
Modern Italy — The Pifferari R.A. 1838
oil on canvas
92.5 x 123.0 (36-1/2 x 48-1/2")
Glasgow Museums: Art Gallery and Museum, Kelvingrove (BJ 374)

23
Ancient Italy — Ovid banished from Rome R.A. 1838
oil on canvas
94.6 x 125.0 (37-1/4 x 49-1/4")
Private Collection (BJ 375)

24
Campo Santo, Venice R.A. 1842
oil on canvas
62.2 x 92.7 cm (24-1/2 x 36-1/2")
Toledo Museum of Art
Gift of Edward Drummond Libbey (BJ 397)

25
Snow Storm — Steam Boat off a Harbour's Mouth making Signals in Shallow Water, and going by the Lead. The Author was in this Storm on the Night the Ariel left Harwich R.A. 1842
oil on canvas
91.5 x 122 cm (36 x 48")
Tate Gallery, London
Bequeathed by the artist, 1856 (BJ 398)

26
Van Tromp, going about to please his Masters, Ships a Sea, getting a Good Wetting R.A. 1844
oil on canvas
91.4 x 121.9 cm (36 x 48")
J. Paul Getty Museum, Malibu, California (BJ 410)

27
Rough Sea c.1840–45
oil on canvas
91.5 x 122 cm (36 x 48")
Tate Gallery, London
Bequeathed by the artist, 1856 (BJ 471)

28
Venice with the Salute c.1840–45
oil on canvas
62.0 x 92.5 cm (24-1/2 x 36-1/2")
Tate Gallery, London
Bequeathed by the artist, 1856 (BJ 502)

29**
Seascape: Folkestone c.1845
oil on canvas
88.3 x 117.5 cm (34-3/4 x 46-1/4")
Private Collection (BJ 472)

30
Sunrise with Sea Monsters c.1845
oil on canvas
91.5 x 122 cm (36 x 48")
Tate Gallery, London
Bequeathed by the artist, 1856 (BJ 473)

31
Landscape with a River and a Bay in the Distance c.1845
oil on canvas
94.0 x 123.0 cm (37 x 48-1/2")
Musée du Louvre, Paris (BJ 509)

32
Inverary Pier, Loch Fyne: Morning c.1845
oil on canvas
91.5 x 122.0 cm (36 x 48")
Yale Center for British Art, New Haven
Paul Mellon Collection (BJ 519)

33
Val d'Aosta c.1845
oil on canvas
91.5 x 121.9 cm (36 x 48")
National Gallery of Victoria, Melbourne
Purchased with the assistance of the National Gallery
Society of Victoria, 1973 (BJ 520)

Works on Millboard

34
Shore Scene with Waves and Breakwater c.1835
oil on millboard
23.0 x 30.5 cm (9 x 12")
Tate Gallery, London
Bequeathed by the artist, 1856 (BJ 486)

35
Ship in a Storm c.1840–45
oil on millboard
30.0 x 47.5 cm (11-3/4 x 18-3/4")
Tate Gallery, London
Bequeathed by the artist, 1856 (BJ 489)

36
Yellow Sky? c.1840–45
oil on millboard
30.0 x 47.5 cm (11-3/4 x 18-3/4")
Tate Gallery, London
Bequeathed by the artist, 1856 (BJ 494)

Watercolours

37
Dunstanborough Castle from the South 1797
pencil, watercolour and bodycolour on buff paper
with touches of black ink
19.8 x 27.8 cm (7-3/4 x 11")
Tate Gallery, London
Bequeathed by the artist, 1856 (TB: XXXIIIS D 00890)

38
Dunstanborough Castle from the South 1797
pencil, grey wash, bodycolour on buff paper
with touches of black ink
26.3 x 33.5 cm (10-1/4 x 13-1/4")
Tate Gallery, London
Bequeathed by the artist, 1856 (TB: XXXVIS D 01113)

39
Dunstanborough Castle c.1798–1800
watercolour, pencil and bodycolour with scratching out
34.9 x 48.3 cm (13-3/4 x 19")
Laing Art Gallery: Tyne and Wear Museums,
Newcastle upon Tyne (W 284)

40
Abergavenny Bridge, Monmouthshire,
clearing up after a Showery Day R.A. 1799
watercolour
41.3 x 76.0 cm (16-1/4 x 30")
Trustees of the Victoria and Albert Museum, London
(W 252)

41**
Conway Castle, North Wales c.1800
watercolour, pencil and gum arabic
53.6 x 76.7 cm (21 x 30-1/4")
J. Paul Getty Museum, Malibu, California (W 270)

42
Linlithgow Castle c.1801
watercolour
25.7 x 41.5 cm (10 x 16-1/4")
National Gallery of Victoria, Melbourne
Gift of Sir Thomas Barlow, 1953 (W 321)

43
Scarborough Town and Castle: Morning:
Boys catching Crabs R.A. 1811
watercolour
68.7 x 101.6 cm (27 x 40")
Private Collection, on long term loan to the
Art Gallery of South Australia, Adelaide (W 528)

44
Weymouth, Dorsetshire c.1811
for the *Picturesque Views on the Southern Coast of England*
watercolour with scratching out
14.8 x 22.0 cm (5-3/4 x 8-1/2")
Yale Center for British Art, New Haven
Paul Mellon Collection (W 448)

45
Lyme Regis, Dorsetshire: A Squall c.1812
for the *Picturesque Views on the Southern Coast of England*
watercolour
15.3 x 21.7 cm (6 x 8-1/2")
Glasgow Museums: Art Gallery and Museum,
Kelvingrove (W 451)

46
Teignmouth, Devonshire c.1813
for the *Picturesque Views on the Southern Coast of England*
watercolour with scratching out
15.2 x 22.2 cm (6 x 8-3/4")
Yale Center for British Art, New Haven
Paul Mellon Collection (W 452)

47
Tor Bay, from Brixham c.1816–17
for the *Picturesque Views on the Southern Coast of England*
watercolour
15.8 X 24.0 cm (6-1/4 x 9-1/2")
The Syndics of the Fitzwilliam Museum, Cambridge
(W 468)

48
High Force, Fall of the Tees, Yorkshire 1816–18
watercolour
28.3 x 40.3 cm (11-1/4 x 15-3/4")
Art Gallery of New South Wales, Sydney (W 564)

49
Landscape: Composition of Tivoli R.A. 1818
watercolour
67.6 x 102.0 cm (26-1/2 x 40-1/4")
Private Collection (W 495)

50
A First Rate taking in Stores 1818
pencil and watercolour
28.6 x 39.7 cm (11-1/4 x 15-1/2")
Cecil Higgins Art Gallery, Bedford (W 499)

51
Weathercote Cave c.1818
watercolour
29.9 x 42.1 cm (11-3/4 x 16-1/2")
Trustees of the British Museum, London
(W 580 BM1910-2-12-281)

52
Venice: San Giorgio Maggiore from the Dogana 1819
watercolour
22.4 x 28.7 cm (8-3/4 x 11-1/4")
Tate Gallery, London
Bequeathed by the artist, 1856
(TB: CLXXXI-4 D15254)

53
Venice: The Rialto c.1820
watercolour
28.6 x 41.3 cm (11-1/4 x 16-1/4")
Indianapolis Museum of Art, Indiana
Gift in memory of Dr and Mrs Hugo O. Pantzer
by their children (W 718)

54
Whiting Fishing off Margate, Sunrise 1822
watercolour
42.6 x 64.8 cm (16-3/4 x 25-1/2")
Private Collection (W 507)

55
Shields, on the River Tyne 1823
watercolour
15.4 x 21.6 cm (6 x 8-1/2")
Tate Gallery, London
Bequeathed by the artist, 1856
(W 732 TB: CCVIII-V D18155)

56
Sidmouth c.1824
for *The Ports of England*
watercolour with scratching out
18.4 x 26.3 cm (7-1/4 x 10-1/4")
Whitworth Art Gallery, Manchester (W 759)

57
The Bass Rock c.1824
watercolour
15.9 x 25.4 cm (6-1/4 x 10")
National Museums and Galleries on Merseyside:
Lady Lever Art Gallery, Port Sunlight (W 1069)

58
Shakespeare Cliff, Dover c.1825
watercolour
18.1 x 24.5 cm (7-1/4 x 10")
The Syndics of the Fitzwilliam Museum, Cambridge
(W 764)

59
Okehampton Castle, Devonshire c.1826
for the *Picturesque Views in England and Wales*
watercolour
28.3 x 41.0 cm (14-1/4 x 16-1/4")
National Gallery of Victoria, Melbourne
Felton Bequest, 1905 (W 802)

60
Lancaster Sands c.1826
for the *Picturesque Views in England and Wales*
watercolour
27.8 x 40.4 cm (11 x 16")
Trustees of the British Museum, London (W 803)

61
Richmond, Yorkshire c.1826
for the *Picturesque Views in England and Wales*
watercolour
27.5 x 39.7 cm (10-3/4 x 15-1/2")
Trustees of the British Museum, London (W 791)

62
Virginia Water c.1829
for the *Picturesque Views in England and Wales*
watercolour
28.9 x 44.2 cm (11-1/4 x 17-1/2")
Private Collection (W 520)

Shoreham c.1830 watercolour Blackburn Museum and Art Gallery, Lancashire (cat. no. 68)

63
Alnwick Castle, Northumberland c.1829
for the *Picturesque Views in England and Wales*
watercolour
28.3 x 48.3 cm (11-1/4 x 19")
Art Gallery of South Australia, Adelaide
South Australian Government Grant, 1958 (W 818)

64
Holy Island, Northumberland c.1829
for the *Picturesque Views in England and Wales*
watercolour, pen and black ink and bodycolour
with scratching out
29.2 X 43.2 cm (11-1/2 x 17")
Trustees of the Victoria and Albert Museum, London
(W 819)

65
Gosport, Entrance to Portsmouth Harbour c.1829
for the *Picturesque Views in England and Wales*
watercolour
28.5 x 41.9 cm (11-1/4 x 16-1/2")
Private Collection (W 828)

66
Pembroke Castle, Wales c.1829
for the *Picturesque Views in England and Wales*
watercolour with scratching out
29.8 x 42.6 cm (11-3/4 x 16-3/4")
Trustees of the Holburne Museum and Crafts Study
Centre, Bath, Somerset (W 832)

67
Plymouth, Devonshire c.1830
for the *Picturesque Views in England and Wales*
watercolour with scratching out
28.0 x 41.2 cm (11 x 16-1/4")
Trustees of the Victoria and Albert Museum, London
(W 835)

68
Shoreham c.1830
for the *Picturesque Views in England and Wales*
watercolour
21.0 x 31.2 cm (8-1/4 x 12-1/4")
Blackburn Museum and Art Gallery, Lancashire (W 883)

69*
A Storm on Margate Sands 1830s
watercolour and bodycolour on buff paper
20.5 x 27.8 cm (8 x 11")
Courtauld Institute Galleries, London
Stephen Courtauld Bequest (W 1391)

70
Colour study: The Burning of the Houses of Parliament
1834
watercolour
23.2 x 32.6 cm (9-1/4 x 12-3/4")
Tate Gallery, London
Bequeathed by the artist, 1856
(TB: CCLXXXIII-1 D27846)

71
Colour study: The Burning of the Houses of Parliament
1834
watercolour
23.2 x 32.6 cm (9-1/4 x 12-3/4")
Tate Gallery, London
Bequeathed by the artist, 1856
(TB: CCLXXXIII-6 D27851)

72
Lyme Regis, Dorsetshire c.1834
for the *Picturesque Views in England and Wales*
watercolour and bodycolour with scratching out
29.2 x 44.8 cm (11-1/2 x 17-1/2")
Cincinnati Art Museum
Gift of Emilie L. Heine in memory of
Mr and Mrs John Hauck (W 866)

73*
Flint Castle, North Wales c.1834
for the *Picturesque Views in England and Wales*
watercolour
26.5 x 39.1 cm (10-1/2 x 15-1/2")
National Museum and Gallery of Wales, Cardiff (W 868)

74*
Longships Lighthouse, Land's End c.1835
for the *Picturesque Views in England and Wales*
watercolour
28.1 x 43.2 cm (11 x 17")
J. Paul Getty Museum, Malibu, California (W 864)

75
Beaumaris, Isle of Anglesey c.1835
for the *Picturesque Views in England and Wales*
watercolour and bodycolour with scratching out
29.5 x 42.0 cm (11-1/2 x 16-1/2")
Henry E. Huntington Library and Art Gallery,
San Marino, California (W 865)

76
Storm off the East Coast c.1835
watercolour, chalk and bodycolour on buff paper
20.9 x 27.3 cm (8-1/4 x 10-3/4")
Sheffield City Art Galleries, Yorkshire (W 924)

77
St Michael's Mount, Cornwall c.1836
for the *Picturesque Views in England and Wales*
watercolour with some bodycolour
30.5 x 43.9 cm (12 x 17-1/4")
University Art Gallery, Liverpool (W 880)

78
Sunset at Sea, with Gurnets c.1836
watercolour, black chalk and bodycolour
with scratching out on buff paper
21.8 x 28.4 cm (8-1/2 x 11-1/4")
Whitworth Art Gallery, Manchester (W 1396)

79
*Venice: Moonrise, the Giudecca
and the Zitelle in the Distance* c.1840
watercolour
22.0 x 31.9 cm (8-1/2 x 12-1/2")
Tate Gallery, London
Bequeathed by the artist, 1856
(TB: CCCXV-10 D32126)

80
Venice: A Storm 1840
watercolour
21.8 x 31.8 cm (8-1/2 x 12-1/2")
Trustees of the British Museum, London
(W 1354 BM1915-3-13-50)

81
Venice: Looking across the Lagoon 1840
watercolour
24.4 x 30.4 cm (9-1/2 x 12")
Tate Gallery, London
Bequeathed by the artist, 1856
(TB: CCCXVI-25 D32162)

82
Yarmouth Sands 1840
watercolour with scratching out
24.7 x 36.0 cm (9-3/4 x 14-1/4")
Yale Center for British Art, New Haven
Paul Mellon Collection (W 1406)

83
Yarmouth Roads c.1840
pencil and watercolour with scratching out
24.1 x 35.6 cm (9-1/2 x 14")
National Museums and Galleries on Merseyside:
Lady Lever Art Gallery, Port Sunlight (W 1409)

84
The First Steamer on Lake Lucerne c.1841
pencil and watercolour with scratching out
23.1 x 28.9 cm (9 x 11-1/4")
University College, London
College Art Collections (W 1482)

85
Steam Boat and Storm c.1841
watercolour
23.2 x 28.9 cm (9-1/4 x 11-1/2")
Yale Center for British Art, New Haven
Paul Mellon Collection (W 1484)

86
'The Red Rigi': sample study c.1841–42
watercolour
22.8 x 30.2 cm (9 x 11-3/4")
Tate Gallery, London
Bequeathed by the artist, 1856
(TB: CCCLXIV-275 D36123)

87
Study for 'The Blue Rigi' c.1841
watercolour
24.1 x 30.9 cm (9-1/2 x 12-1/4")
Private Collection

88
'The Red Rigi' 1842
watercolour
30.5 x 45.8 cm (12 x 18")
National Gallery of Victoria, Melbourne
Felton Bequest, 1947 (W 1525)

89
'The Blue Rigi' 1842
watercolour
29.7 x 45.0 cm (11-3/4 x 17-3/4")
Private Collection (W 1524)

90
Brunnen on the Lake of Lucerne 1842
watercolour
30.2 x 46.4 cm (11-3/4 x 18-1/4")
Private Collection (W 1527)

91**
Constance 1842
watercolour, bodycolour, pen and ink with scratching out
30.7 x 46.4 cm (12 x 18-1/4")
York City Art Gallery
Purchased with the aid of the Victoria and Albert
Museum and the National Art Collections Fund, 1984
(W 1531)

92
*Goldau, with the Lake of Zug in
the Distance: sample study* c.1842-43
pencil and watercolour with pen
22.8 x 29.0 cm (9 x 11-1/2")
Tate Gallery, London
Bequeathed by the artist, 1856
(TB: CCCLXIV-281 D36131)

93**
Goldau 1843
watercolour
30.5 x 47.0 cm (12 x 18-1/2")
Private Collection (W 1537)

94*
The Pass of St Gotthard, near Faido 1843
pencil and watercolour with scratching out
30.5 x 47.0 cm (12 x 18-1/2")
The Pierpont Morgan Library, New York
The Thaw Collection (W 1538)

Sidmouth c.1824 watercolour Whitworth Art Gallery, Manchester (cat. no. 56)

95
Bellinzona from the Road to Locarno 1843
watercolour with scratching out
29.2 x 45.7 cm (11-1/2 x 18")
City of Aberdeen Art Gallery and Museums Collections
(W 1539)

96
Storm in the St Gotthard Pass.
The First Bridge above Altdorf 1845
watercolour with scratching out
29.0 x 47.0 cm (11-1/2 x 18-1/2")
Whitworth Art Gallery, Manchester (W 1546)

97
A Harpooned Whale 1845
pencil and watercolour
23.8 x 33.6 cm (9-1/4 x 13-1/4")
Tate Gallery, London
Bequeathed by the artist, 1856
(TB: CCCLVII-6 D35391)

98
Storm Clouds, looking out to Sea 1845
watercolour
28.7 x 33.5 cm (11-1/4 x 13-1/4")
Tate Gallery, London
Bequeathed by the artist, 1856
(TB: CCCLVII-11 D35397)

99
The Lauerzersee with Schwytz and the Mythen
c.1845–51
watercolour, pen and red ink with scratching out
33.7 x 54.5 cm (13-1/4 x 21-1/2")
Trustees of the Victoria and Albert Museum, London
(W 1562)

Prints

100
C. TURNER engraver, after J.M.W. TURNER
The Woman and Tambourine
from *Liber Studiorum,* part I, 11 June 1807
etching and mezzotint
18.3 x 26.7 cm (image); 20.8 x 29.1 cm (plate);
29.0 x 43.8 cm (sheet)
National Gallery of Victoria, Melbourne
Felton Bequest, 1949 (F 3 (i))

101
C. TURNER engraver, after J.M.W. TURNER
Scene on the French Coast
from *Liber Studiorum,* part I, 11 June 1807
etching and mezzotint
18.3 x 25.8 cm (image); 21.0 x 29.1 cm (plate);
29.6 x 43.8 cm (sheet)
National Gallery of Victoria, Melbourne
Felton Bequest, 1949 (F 4 (i))

102
C. TURNER engraver, after J.M.W. TURNER
The Straw Yard
from *Liber Studiorum,* part II, 20 February 1808
etching and mezzotint
18.3 x 25.4 cm (image); 20.7 x 29.0 cm (plate);
30.0 x 43.4 cm (sheet)
National Gallery of Victoria, Melbourne
Felton Bequest, 1949 (F 7 (i))

103
C. TURNER engraver, after J.M.W. TURNER
Dunstanborough Castle
from *Liber Studiorum,* part III, 10 June 1808
etching, aquatint and mezzotint
18.1 x 26.4 cm (image); 20.7 x 29.0 cm (plate);
30.1 x 43.6 cm (sheet)
National Gallery of Victoria, Melbourne
Felton Bequest, 1949 (F 14 (i))

104
C. TURNER engraver, after J.M.W. TURNER
The Fifth Plague of Egypt
from *Liber Studiorum,* part III, 10 June 1808
etching and mezzotint
18.0 x 25.9 cm (image); 20.9 x 29.0 cm (plate);
25.2 x 35.9 cm (sheet)
National Gallery of Victoria, Melbourne
Felton Bequest, 1949 (F 16 (iii))

105
C. TURNER engraver, after J.M.W. TURNER
Little Devil's Bridge
from *Liber Studiorum,* part IV, 29 March 1809
etching and mezzotint
17.7 x 25.7 cm (image); 20.8 x 28.9 cm (plate);
25.2 x 35.9 cm (sheet)
National Gallery of Victoria, Melbourne
Felton Bequest, 1949 (F 19 (f))

106
C. TURNER engraver, after J.M.W. TURNER
The Temple of Minerva Medica
from *Liber Studiorum,* part V, 1 January 1811
etching and mezzotint
18.3 x 26.7 cm (image); 20.9 x 29.2 cm (plate);
28.4 x 41.3 cm (sheet)
National Gallery of Victoria, Melbourne
Felton Bequest, 1949 (F 23 (v))

107
C. TURNER engraver, after J.M.W. TURNER
London from Greenwich
from *Liber Studiorum,* part V, 1 January 1811
etching and mezzotint
17.8 x 26.6 cm (image); 20.8 x 29.0 cm (plate);
29.8 x 44.0 cm (sheet)
National Gallery of Victoria, Melbourne
Felton Bequest, 1949 (F 26 (i))

108
R. DUNKARTON engraver, after J.M.W. TURNER
Young Anglers
from *Liber Studiorum,* part VII, 1 June 1811
etching and mezzotint
18.0 x 26.2 cm (image); 20.9 x 29.0 cm (plate);
30.0 x 44.2 cm (sheet)
National Gallery of Victoria, Melbourne
Felton Bequest, 1949 (F 32 (i))

109
J.C. EASLING engraver, after J.M.W. TURNER
St Catherine's Hill near Guildford
from *Liber Studiorum,* part VII, 1 June 1811
etching and mezzotint
18.6 x 26.5 cm (image); 21.2 x 29.4 cm (plate);
28.7 x 39.7 cm (sheet)
National Gallery of Victoria, Melbourne
Felton Bequest, 1949 (F 33 (iii))

110
J.M.W. TURNER
Crypt of Kirkstall Abbey
from *Liber Studiorum,* part VIII, 11 February 1812
etching and mezzotint
18.1 x 26.4 cm (image); 21.0 x 29.1 cm (plate);
29.8 x 43.1 cm (sheet)
National Gallery of Victoria, Melbourne
Felton Bequest, 1949 (F 39 (i))

111
W. ANNIS and J.C. EASLING engravers,
after J.M.W. TURNER
The Mildmay Seapiece
from *Liber Studiorum,* part VIII, 11 February 1812
etching and mezzotint
18.1 x 26.5 cm (image); 21.2 x 29.4 cm (plate);
29.6 x 43.4 cm (sheet)
National Gallery of Victoria, Melbourne
Felton Bequest, 1949 (F 40 (iii))

112
J.C. EASLING engraver, after J.M.W. TURNER
Frontispiece
from *Liber Studiorum,* part X, 23 May 1812
etching and mezzotint
18.8 x 26.4 cm (image); 21.1 x 29.3 cm (plate);
28.9 x 44.3 cm (sheet)
National Gallery of Victoria, Melbourne
Felton Bequest, 1949 (F 1 (i))

113
J.M.W. TURNER
The Source of the Arveron
from *Liber Studiorum,* part XII, 1 January 1816
etching and mezzotint
19.1 x 27.1 cm (image); 21.7 x 29.4 cm (plate);
23.7 x 31.5 cm (sheet)
National Gallery of Victoria, Melbourne
Felton Bequest, 1949 (F 60 (iii))

114
S.W. REYNOLDS engraver, after J.M.W. TURNER
The Woman of Samaria
from *Liber Studiorum,* part XIV, 1 January 1819
etching and mezzotint
18.2 x 26.4 cm (image); 20.8 x 29.0 cm (plate);
29.0 x 42.8 cm (sheet)
National Gallery of Victoria, Melbourne
Felton Bequest, 1949 (F 71 (i))

115
R. BRANDARD engraver, after J.M.W. TURNER
Lancaster Sands 1828
from *Picturesque Views in England and Wales*
engraving: engraver's proof with letters
16.5 x 23.6 cm (image); 25.5 x 30.7 cm (plate);
37 x 42.7 cm (sheet)
Art Gallery of New South Wales, Sydney
Gift of Mrs Arthur Acland Allen, 1940 (R 227)

116
W. TOMBLESON engraver, after J.M.W. TURNER
Holy Island, Northumberland 1830
from *Picturesque Views in England and Wales*
engraving: published state, one of four
16.6 x 24.5 cm (image); 25.2 x 30 cm (plate);
37.1 x 42.8 cm (sheet)
Art Gallery of New South Wales, Sydney
Gift of Mrs Arthur Acland Allen, 1940 (R 243)

117
S. FISHER engraver, after J.M.W. TURNER
St Michael's Mount, Cornwall 1838
from *Picturesque Views in England and Wales*
engraving: published state, one of four
16.7 x 24.1 cm (image); 24.2 x 32 cm (plate);
36.9 x 42.8 cm (sheet)
Art Gallery of New South Wales, Sydney
Gift of Mrs Arthur Acland Allen, 1940 (R 304)

118
W.R. SMITH engraver, after J.M.W. TURNER
Longships Lighthouse, Land's End 1839
from *Picturesque Views in England and Wales*
engraving: published state, one of four
16.4 x 25.1 cm (image); 25.4 x 33 cm (plate);
36.8 x 42.2 cm (sheet)
Art Gallery of New South Wales, Sydney
Gift of Mrs Arthur Acland Allen, 1940 (R 288)

The Bass Rock *c*.1824 watercolour National Museums and Galleries on Merseyside: Lady Lever Art Gallery, Port Sunlight (cat. no. 57)

Prints

Photographic Credits

Contributing Authors

David Blayney Brown
Curator of the Clore Gallery, Tate Gallery, London

John Gage
Professor, Department of the History of Art, University of Cambridge, England

John Golding
artist and leading historian of modern art

Evelyn Joll
formerly a Director of Agnew's, London, and co-author of *The Paintings of J.M.W. Turner* (rev. edn, 1984)

Michael Lloyd
Assistant Director, Development and Management of the Collections, National Gallery of Australia, Canberra

Margaret Plant
Professor of Visual Arts, Monash University, Melbourne

Andrew Sayers
Curator of Australian Drawings and Colonial Paintings, National Gallery of Australia, Canberra

Andrew Wilton
Keeper of British Art, Tate Gallery, London

Irena Zdanowicz
Senior Curator of Prints and Drawings, National Gallery of Victoria, Melbourne